The Art of Collecting
Photography

For Matthew ...

An AVA Book
Published by AVA Publishing SA
Rue des Fontenailles 16
Case Postale
1000 Lausanne 6
Switzerland
Tel: +41 786 005 109
Email: enquiries@avabooks.ch

Distributed by Thames & Hudson
(ex-North America)
181a High Holborn
London WC1V 7QX
United Kingdom
Tel: +44 20 7845 5000
Fax: +44 20 7845 5055
Email: sales@thameshudson.co.uk
www.thamesandhudson.com

Distributed by Sterling Publishing Co., Inc.
in the USA
387 Park Avenue South
New York, NY 10016-8810
Tel: +1 212 532 7160
Fax: +1 212 213 2495
www.sterlingpub.com

in Canada
Sterling Publishing
c/o Canadian Manda Group
One Atlantic Avenue, Suite 105
Toronto, Ontario M6K 3E7

English Language Support Office
AVA Publishing (UK) Ltd.
Tel: +44 1903 204 455
Email: enquiries@avabooks.co.uk

ISBN 10: 2-88479-028-4
ISBN 13: 978-2-88479-028-4

10 9 8 7 6 5 4 3 2 1

Design by Browns/NYC
Index by Indexing Specialists (UK) Ltd.
Additional captions by Sarah McDonald

Production and separations by
AVA Book Production Pte. Ltd., Singapore
Tel: +65 6334 8173
Fax: +65 6259 9830
Email: production@avabooks.com.sg

All reasonable attempts have been made
to secure permissions and trace and
correctly credit the copyright holder of the
images reproduced. However, if any are
incorrect or have been inadvertently
omitted, the publisher will endeavour to
incorporate amendments in future
editions.

All quoted prices are correct at the time
of press.

The Art of Collecting Photography Laura Noble

'Sustenance #101', 2003. Neeta Madahar

Contents

Foreword

Photography has always been 'collected', from its earliest period, following the medium's discovery in the mid-nineteenth century, which saw a craze emerge for collecting *cartes de visite* (visiting cards) of Queen Victoria and other luminaries, until the present day, when snapshots of family life are accumulated at an astounding rate. Whether ceremoniously mounted in photograph albums, hidden away in dusty boxes in the attic, or digitally saved on a CD, family snapshots represent the ultimate 'meta-collection', and whether intentionally or not these photographic records of holidays, special events or even the most mundane moments create a 'collection' of sorts. For many individuals the snapshot is their first access point to both photography and collecting.

What constitutes a 'collection' is now subject to considerable debate and interrogation. Recently, collections of anonymous photographs, snapshots and vintage prints, by a range of unknown photographers, have been assembled and displayed in major museums around the world, to great critical acclaim. Selected with the visual intelligence and focus of a well-informed eye, the results have been illuminating and instructive, revealing not only photography's accessibility as a medium, but also its inherent ambivalence.

The Art of Collecting Photography examines the rich and fertile world of collecting from the perspective of both the informed amateur and the established collector. Whether you are starting from scratch or have already formed a sizeable collection, there is a good deal of valuable information, recommendations and tips within these pages to interest you, and help create a collection that reflects your personal taste.

For the novice, the short introduction to the history of the medium is accompanied by a useful analysis of key images that could inform a collecting 'policy'. For those who are already 'hooked' on collecting, there is advice about how to structure a collection, which is accompanied by recommendations from a range of photographic experts. Rather than concentrating on big names and rare images, Laura Noble reveals – by taking advantage of the enormous range of images available – how the collector can gain confidence and enjoyment in discovering neglected figures within the canon, or alternatively embark on talent-spotting new or emerging practitioners. More importantly, she highlights the important role that enjoyment, passion and commitment play in the creation of a collection.

In addition to covering important considerations that one needs to know in order to build a proper collection – from preservation and conservation of prints to understanding commonly-used terms and processes – the book provides specialist advice about where to go to obtain further information and expertise, both in terms of viewing work (at galleries, auctions, events and fairs), as well as suggesting additional research methods (through books, journals and the Internet). This provides the interested collector with a solid grounding in the skills of photographic 'literacy', which will ensure you make informed and creative decisions.

Over the past two decades there has been a seismic change in our attitudes towards photography; no longer the 'poor cousin' of the art world, the medium now sits very much at the centre of many artists' practice. Coupled with this is recognition by the art community of photography's versatility within the commercial arena. When visiting international art fairs, auctions, biennales and other art events, the casual viewer cannot fail to be struck by the preponderance of photographic material. As the boundaries between classic (straight) and art photography continue to blur, new momentum surrounds events such as Paris Photo and Photo-London. Armed with some of the knowledge contained within this book, new collectors will gain greater confidence in how to manoeuvre their way through these worlds and establish their own framework for collecting.

In the end, collecting should be a rich and satisfying journey of discovery, one in which you have the opportunity of exploring unchartered waters, making new discoveries and understanding how the rich and complex medium of photography permeates all aspects of our lives.

Brett Rogers, May 2006

Introduction

'Satiric Dancer', 1926. André Kertész
Surely one of Kertész's most famous
photographs, we can still appreciate the instant
appeal of dancer Magna Förstner's playful nature;
posed upon a couch, her limbs mimicking the
contours and sharp angles of the sculpture to the
left of the picture. Taken at Etienne Beöthy's
studio, Kertész himself credits Magna with the
idea for the pose, which was achieved in one
take. The photograph's art-deco aesthetic turns
Magna into a work of art herself.

Establishing a collection of photographs is an art in itself. Photography is a multifaceted medium with a rich and distinguished history, an ideal combination that has ensured its enduring attractiveness to the collector.

While we may consider photography to be a distinctly modern medium, its practical beginnings actually date back to the late Renaissance period, when early optical techniques were used to help painters represent perspective correctly. The sixteenth-century camera obscura focused natural light through a small opening to project an inverted image on to a facing wall or screen, swiftly becoming an invaluable artistic tool. Eventually, the size of this tool decreased from the cumbersome and restrictive scale of an entire room to a portable box, and allowed an image to be cast on to glass so it could then be easily and neatly traced. Coupled with the advent of new photochemical processes, the basic format of the modern camera was established. In a short space of time, this relatively simple collection of processes and developments came together in a device that has not only transformed the way we record images, but also the manner in which we see and understand the world, measure proof and perceive truth.

This innovation fundamentally expanded the representational possibilities an artist could achieve in a way never previously imaginable. The ability to record images with such consistent accuracy of form, perspective and detail encouraged higher expectations from an audience viewing two-dimensional imagery. As is the case today, as standards were raised viewers raised their own expectations and aspirations accordingly, and thus photography was destined to have a profound influence on the artistic arena.

Many of the fine arts initially developed out of social and political necessity, and the medium of photography was no exception. Its evolution was originally driven by the requirements to influence, inform and sell to the masses; everything and anything from religious dogma to household soap. Much commercial imagery was dominated by traditional painterly forms and genres, such as landscape and portraiture, which were already familiar and understandable compositions to the viewing public.

Coupled with advances in scientific enquiry and, as the opportunity to travel became a realistic possibility for the masses, a greater fascination with the world around us, the rapid rise of the commercial photographic genre seemed almost inevitable. As photography became cheaper and increasingly accessible it rapidly emerged as a universal medium, a factor that has curiously seen its cultural stature tainted by its very ubiquity. In contrast, however, this increased accessibility to imagery was to stimulate a much broader interest in collecting artworks, an activity that was previously restricted to the more affluent. For the first time, the decorative arts could be brought into the homes of those with little money or status, and portraiture was no longer restricted to monarchs and leaders, but open to all who desired it.

Despite its popularity, photography was inextricably linked to commerce and its status as the premier contemporary language of portraiture and advertising could have easily sealed its fate to remain outside the art historical canon. As a result, photography became, and in some cases remains, the apostate of the fine art family and is often required to justify itself far more frequently than any other form of art practice.

The vast number of clearly definable themes and genres into which contemporary photography is divided, more so than any other media, is both a result of and a reaction to this stigma; with clear boundaries drawn between commercial products and fine-art mutations of the media, between what is viewed as proper and as vulgar. Lovers and collectors of photography, however, take little heed of the idiosyncrasies of the theorist and there is a vibrant collectors' market across all manifestations of the medium.

Traditionally, photographers have been defined by their appropriation of subject matter already existing in the wider artistic arena; portraiture or landscapes for example. The art photographer, however, does not simply imitate these, but instead establishes a dialogue with traditional themes, and may even strive to improve upon the 'reality' of the representation to a degree that can rival other mediums.

In the early years, when some traditionalists felt that classical fine-art techniques were under threat, photography was said to offer little more than a cold, mechanical representation of forms, whereas other media, such as painting and sculpture, could imbue representation with intangible qualities such as 'soul' or 'poetry'. But in fact, photography is incredibly versatile and can utilise techniques and ideas gleaned from the approach of other media to similar subjects. Consider, for example the most fundamental and traditional aspect of artistic practice; the still life. Whilst a painter may use paint or ink to render their subject, interpreting light and shade to duplicate the form and set a mood and a tone, a photographer can likewise manipulate the light and texture of a particular scene by physically altering their light source or by using filters to emphasise contrast and tonality. A photographer can use all the compositional techniques of the painter and even create an abstract interpretation through use of optical tricks. Furthermore, in the darkroom, a new palette of possibilities is opened up.

Beyond subject and conceptual considerations, the most important distinction that separates photography as a genre from other forms of artistic media is the relative speed and ease that alterations to the image can be achieved, which is phenomenal by comparison to labouring over numerous sheets of paper or canvases to produce a desired result. In addition to this, duplicates of a single negative can quickly printed and manipulated, and this ability to mass-produce both segregates and liberates photography.

The ease of image capture and reproduction cultivated experimentation, and photography rapidly began, and continues, to produce its own separate and distinct fine-art language. Of course with the vast array of digital manipulation now available, anything is possible. The collector must be mindful of the fact that it is easy to be seduced by so much choice, and the photographer must be sufficiently disciplined in order to produce an image that delivers a strong sense of authorship.

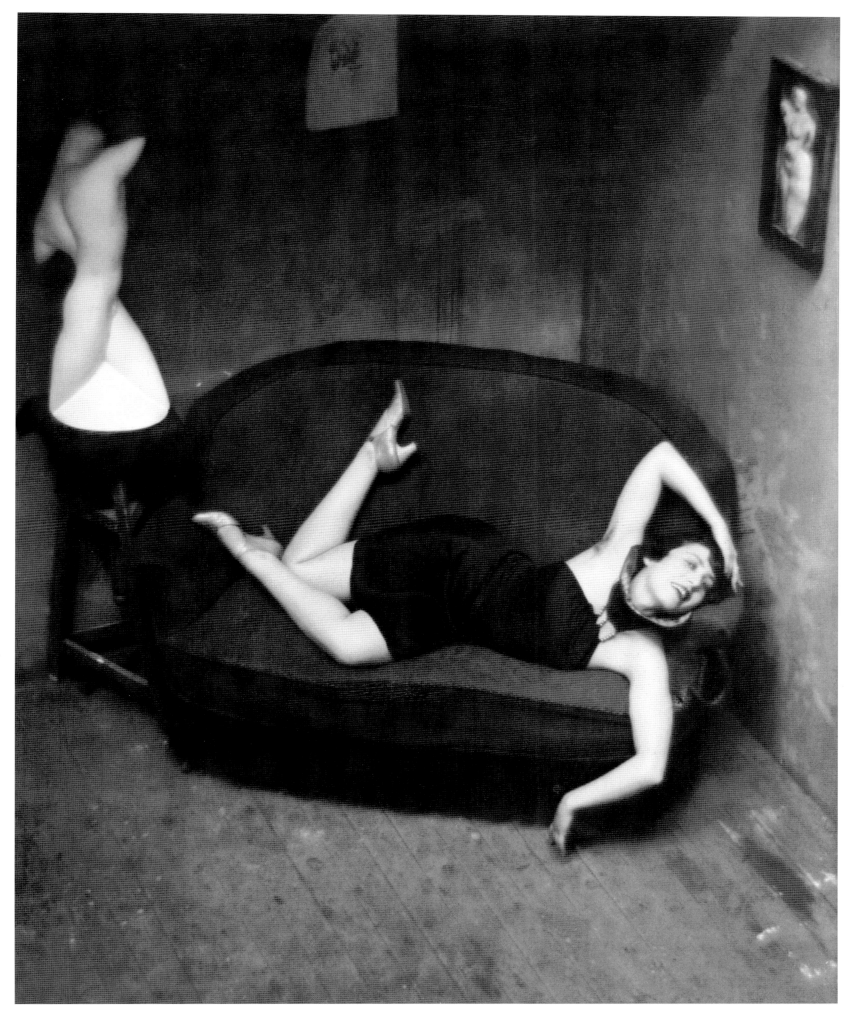

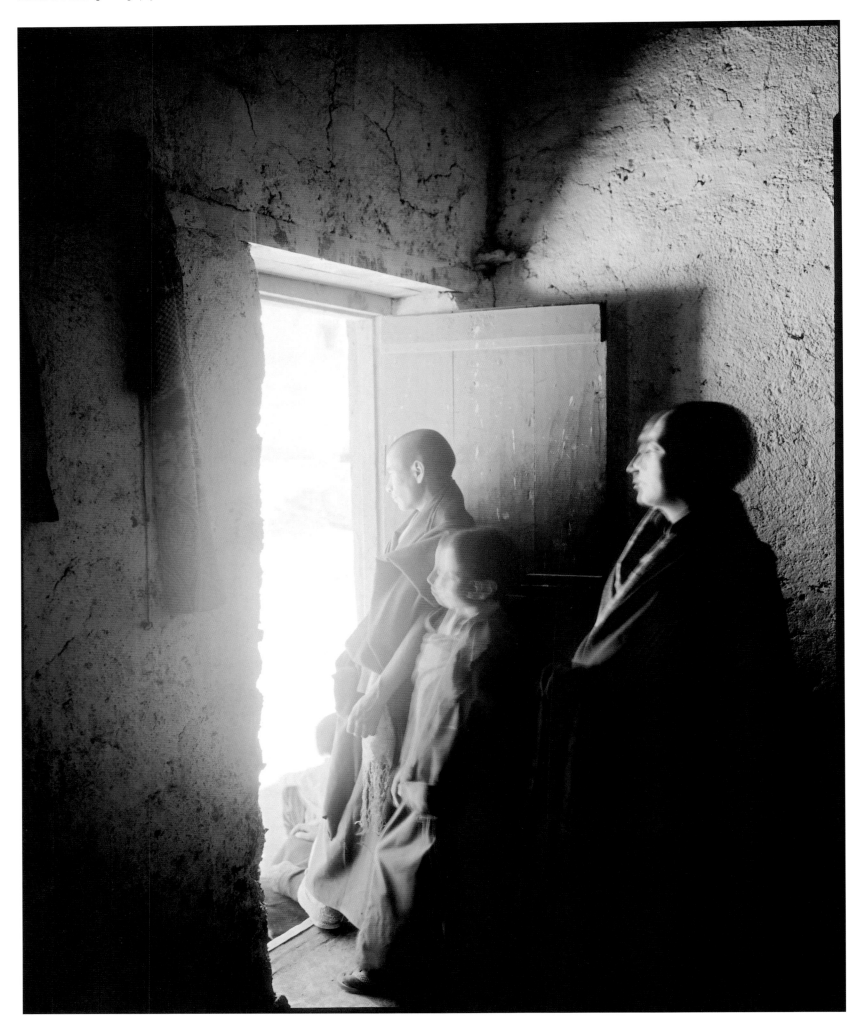

'Monks Watching a Religious Festival, Lamayuru Monastery, Ladakh, India', 1998. Linda Connor
There is a timeless quality to this image, achieved both by the traditional monastic scene and Connor's printing technique. Connor contact-prints her negatives using sunlight on the printing-out paper; once toned, these prints are reminiscent of nineteenth-century photographs. Connor's sensitive distance from the monks allows the intimacy of the scene to unfold naturally. Photographing the observers rather than the dancers themselves allows us to absorb the atmosphere as much, if not more than, a photograph of the performance would. The radiance of light becomes as much a subject of the image as the monks.

The craft of the art remains important and is a link to the revered physical touch of the artist. This is illustrated by the highly collectable interest in the pioneers of early photography. One would hope that this is not only due to the value, rarity and historical importance of these early prints, but also due to the fact that the distinctive craft of the photographer is recognised and appreciated. Many of the early processes that were used by these pioneers are now virtually obsolete, although some interest in reviving such techniques has recently resurfaced as the historic notions of photography are appreciated to a larger degree. Together with the limiting of prints, this is perhaps a means of photography regaining some exclusivity or singularity, which is perceived by some as the necessary defining quality of the art object.

It is also important for photographers to retain some sense of identity or consistent personality in their work. In other, more traditional, arts the marks made by the artist's hand are often so overtly individual that a recognisable style is relatively easy to obtain. The confident freedom of a drawing by Picasso is instantly recognisable, whereas, by its very mechanisation, the photograph must work harder and via other means to provide the same clues of authorship.

In all its multiplicity and ubiquity, photography sits perfectly as a collectable medium. In the modern world we are used to a constant and relentless bombardment of images. Perhaps, without even knowing it, we already have access to the photographic literacy that is required in order to begin collecting. However, to truly explore this field, we need to gain a deeper understanding of our relationships with the images that we take for granted. From familiarity with family snapshots to owning a camera and deciding our own compositions, our saturation in imagery spans an entire lifetime and our available selection of images is limitless.

Photography is the most convenient and widespread way in which to document events and memories or mark the passing of time, and it does so with a perceived timelessness that satiates the appetite for both visual stimulation and the need to remember. Indeed, it is difficult to imagine a world without photography. The imagery we choose to display around our homes is already the result of decisive editing; a considered choice that reflects the way in which we want the world to view us. In this respect we are already collectors, exhibiting our character and identity in a unique way. To broaden this interest into a succinct and specific body of work, by actively deciding to build an organised collection, should be a truly exciting endeavour. Rather than being intimidating, the vastness of photographic genres and subjects is a large part of the medium's appeal, and allows us to choose from an immense catalogue of work that contains enough scope to suit most individuals. With the right components, a truly individual collection can be created to enjoy and share for life. A successful collection represents an extension of our own identity, to be passed on as an investment to later generations.

Instead of remaining a passive observer, collectors should actively seek out the images they desire. Attending the growing number of photographic exhibitions in order to build a greater understanding of the medium is essential. Publications that display the work of numerous photographers can make one feel a little overwhelmed, however, those featured will often reflect the current photographic climate. This not only assists our familiarity with photographers and their work, but also provides clues to 'collectable' photography. The Internet has also become an invaluable tool for seeking and gathering information. Its growing popularity has ensured that most galleries now have websites, which provide a quick and easy means to observe their programmes and determine if the gallery's interests are suited to your taste. By utilising these tools, conducting your research can be as enjoyable as finding the elusive images for your collection.

Ultimately the photography collector is required to re-examine his or her own personal taste. We are already exposed to a vast array of raw imagery, which subconsciously shapes our visual preferences, but we must learn to identify the components that comprise those preferences so we can then distinguish them in photographs. Many collectors identify themes in photography that relate to their own past histories, building collections which provide a link to the present where the underlying subject or aesthetic can be affirmed through the eyes of another. The joy of an image often stems from a shared connection with the artist and so, subsequently, the joy of the collection often stems from the connections shared between the many photographers and the collector. This direct form of communication dissipates barriers, and allows instinctual decisions to enhance educated judgements. By becoming literate in the language of photography, we do not merely train ourselves to appreciate this plethora of imagery on its own terms, but are also allowed to embrace the myriad of perceptions of other artists and visionaries.

Since the early twentieth century, the affordability and availability of the photographic image means that the once closed world of the art collector is now available for all to seize. While the collecting of rare and thus more expensive works by pioneering photographers has once again become the domain of the affluent investing elite, the interest in a wide range of previously neglected photographers and subjects, along with the healthy flow of new works appearing on the market, means that there is room for collectors at every level.

Explaining all the components of the photographic canon cannot of course be collated into one book, or arguably into one lifetime. However, by setting out a clear framework by which one might structure a collection, I aim to clarify the parameters of photographic development, which will provide the budding collector with sufficient knowledge of the medium to act as a springboard for further study, and allow access to the many pleasures that can be obtained from collecting photography, ranging from the financial to the spiritual, and all points in between.

Chapter One
A Brief History of Photography

The most important starting point for the collector is to ensure possession of a sound working knowledge of the history of photography. This will not only familiarise you with the myriad techniques of the medium, but will also allow you to properly identify the source of your own aesthetic interests, and expand the potential scope of the type of collection you wish to assemble.

The Importance of Historical Context

Historical knowledge of the photographic medium will greatly increase your ability to identify future trends and developments. When approaching photographers, galleries and auction house representatives, or indeed fellow collectors, you will find that you will be treated with far greater respect if you are knowledgeable about the medium, and are able to talk confidently around the subject. In addition, the historical content of an image may enhance its financial value (the specifics of this are discussed in further detail in chapter three), so an understanding of photography's historical context and significance is an invaluable asset in this respect.

Even if your collection is only focused on a single area of the photographic canon, you must still be mindful that it is part of a greater historical whole. While you may only be interested in a specific theme or period, the ability to place that particular area of photography into its historical context is important, as this will inform every stage in the collecting process. Historical context is not only necessary should you wish to confidently establish the provenance of a particular image (or to assist a proper identification of an era), but it is only through understanding the broader historical perspective that you will become fluent in the visual language of an image.

Furthermore, in the postmodern era, artists have become increasingly self-referential. Therefore, even if you are primarily concerned with emerging photographers, it remains essential to be aware of the historical dialogues and references within their work, as well as the origins of those photographers' influences.

Understanding the History of the Medium
Simplistically, the visual language of any art form continually expands, from the point of its invention, and as the medium is refined and adapted. Each subsequent new development transfers some of the past substance into a new form.

Notice that, after the pioneering stages, the earliest forms of photography drew its themes and compositions from the established models of painting and drawing, before branching out into new contemporary inventions. Photography had a particularly long gestation period prior to its explosion in the last hundred years. Thus, the key periods in photographic history are divided into two main periods: 1500–1899 and the course of the twentieth century.

Between 1500 and 1900, we witness the invention of the medium and photographic pioneers experimenting with the processes and techniques that led us toward the camera and the photographic image in their most basic forms. During the twentieth century, we observe how these inventions were refined and artistically developed – in contrast to the previous century, where the technological limitations of the day presented a much less flexible and stable medium. The creative concerns of the medium broadened and genres, movements, groups and styles flourished independently within the photographic community.

As the accessibility of the medium grew, so too did the variety of photographic practice. As photography's role expanded, a new lexicon and visual language became necessary in order to incorporate the many and different ways of seeing and reading a photographic image. The impact of mass production in the late 1800s changed the face of the oeuvre so dramatically that by separating the two distinct eras one can almost perceive photography in its infancy and adolescence respectively.

Until 1900 the development of photography was a specialist and exclusive field, intent on firmly establishing a suitable process and common technique. To explain this period clearly, each of the key developments leading to the invention of the medium has been outlined. The twentieth century saw such an explosion of interest and activity in the medium that each decade has been examined in detail.

'Hidden', 1991. John Kippin
Kippin's concerns with the landscape, environment and memory are distilled through his brooding photography, often using objects already existing in the landscape, but which act as catalysts to memories. In this photograph, a dark and moody scene evokes thoughts of 'hidden' emotion. The looming and foreboding clouds cast a tumultuous swathe across the hills, perhaps conjured up in sympathy with the plane carcass. 'Hidden' also refers to the location shown in the photograph, which is a Ministry of Defence military range, tucked away in a national park in Northumberland.

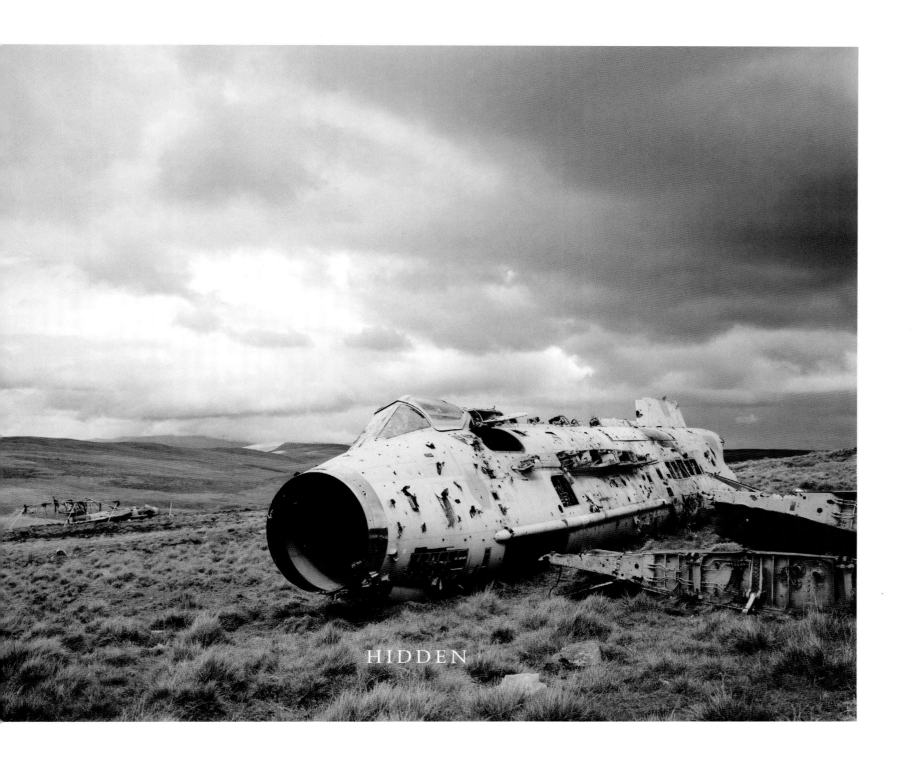

HIDDEN

1500–1899: The Early Development of Photography

From the earliest, most primitive manifestations of the arts, we have coveted the ability to capture and record the world around us; to preserve our achievements, our loved ones and our legacy. In painting and drawing, and through song, music, stories and poetry, we have tried to capture the true essence of our surroundings. The dream of a photograph – a perfect captured moment of time – existed long before the processes that would eventually make it a reality were discovered. In 350BC, Aristotle first described observing an eclipse that was projected on the ground through a sieve, yet the refinement and development of photographic processes as we know them took an aeon. Each new refinement took many decades to complete before the next development brought resolution of the technique nearer.

1500–1700
As early as the sixteenth century, artists and scientists alike were well aware that light passing through a small hole (aperture) in one wall of a darkened chamber would project an inverted image on to the opposite wall. The construction designed to produce this simple yet revolutionary effect was called the camera obscura.

By the eighteenth century, this simple design had evolved into a small, portable box with a glass lens that covered the aperture; an innovation which enabled the production of a sharper and brighter image. During this period, the device was primarily used as an aid for draughtsmen and artists.

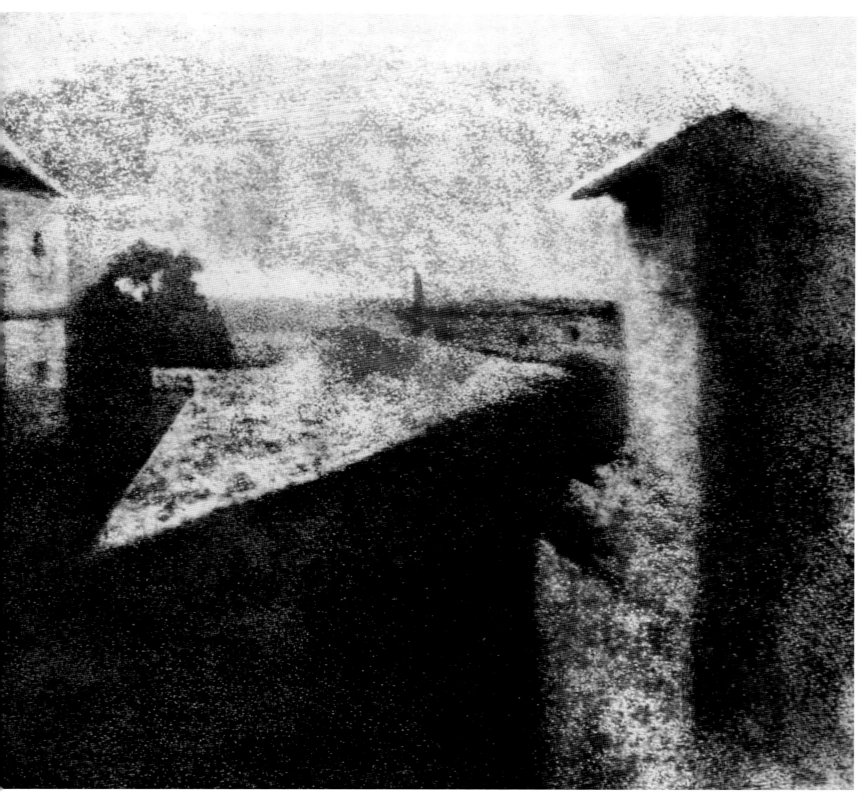

'View from the Window at Le Gras', c.1826.
Joseph Nicephore Niepce
Taken at his estate Saint-Loup-de-Varennes, France, in 1826–27, Niepce's heliograph was produced by exposing a bitumen-coated pewter plate in a camera obscura for a period of eight hours. Although his grainy view didn't capture popular imagination, Niepce had succeeded in fixing an image, and in doing so laid the foundations for Daguerre's later success.

1700–1840

In 1727, Johann Heinrich Schulze discovered that particular chemicals, specifically silver halides, would darken when exposed to light. This fundamental discovery laid the foundations for the basic scientific process of photography.

Between the mid-eighteenth and mid-nineteenth centuries, a number of individuals realised the potential of introducing the camera obscura to these chemical techniques in order to permanently capture a projected image. Three French pioneers, Hippolyte Bayard, Louis J. M. Daguerre and Joseph Nicephore Niepce were, to a degree, all successful in their development of this process. In Britain, William Henry Fox Talbot made the earliest (known) surviving photographic negative on paper in the late summer of 1835: a small photogenic drawing of the oriel window in the south gallery of his home, Lacock Abbey.

On 19 August 1839, Daguerre's photographic process was the first to be made public. The daguerreotype produced a single, positive image on a metal plate. This process, however, was only capable of producing a unique, single-use optical plate and was advanced upon in the following year by Talbot's development of the calotype. The calotype produced a negative image on treated paper. A positive image could then be made from this negative by shining light through it, which allowed the potential for an infinite number of prints to be created from a single source.

With the introduction of the calotype, the basic science of photography was almost complete. To say that this process of near-perfect visual reproduction was revolutionary is an understatement. However, photography still was barely in its infancy and was popularly considered a mechanical medium that excluded personal intervention, which at the time was believed by many to be the predominant quality that defined 'art'. In contrast, supporters of this new medium thought that photography had the potential to supersede the fine arts, and many felt that its arrival signalled the decline of painting. Obviously, neither of these schools of thought were proven right, but they underline the prejudices that continued throughout the medium's history.

Regardless of criticism and concern, the simplicity of the photographic process enabled its use to spread quickly beyond the arts and, in the absence of academic convention or established theory, a great deal of experimentation was evident during this period.

Left: 'The Three Daughters of the Fifth Duke of Richmond'. Anon
Early photographic pioneers were often amateurs who could afford the expense and time required to experiment with the calotype process, and they often turned to their society friends and family for subject matter, as is exemplified here. The countesses' poses, all turning from the camera, suggests that the artist is more interested in figurative composition than formal portraiture, but their hidden faces add an enigmatic air to the image. The soft quality of the image, with visible paper fibres, is characteristic of a salted-paper print.

Below: 'York Minster from Lop Lane', 1845. William Henry Fox Talbot
Talbot's position as a photographic pioneer is irrefutable and museums, historians and collectors alike rightly covet good examples of his work. In this calotype, the domestic architecture of Lop Lane creates an unusual foreground with which to view that evergreen muse, York Minster. By using a less than traditional vantage point, Talbot aggrandises the much smaller buildings in relation to the cathedral, juxtaposing the house of God with parishioners' homes in a skilful and structurally fascinating image.

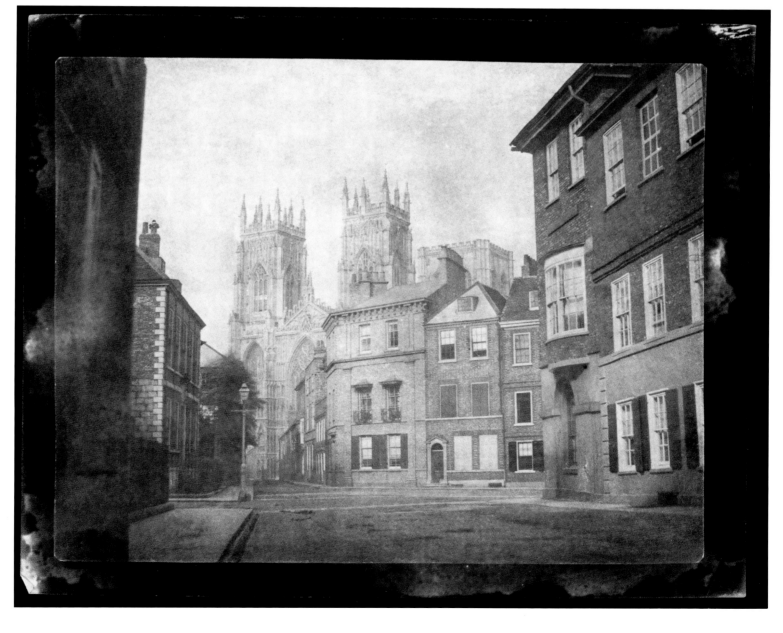

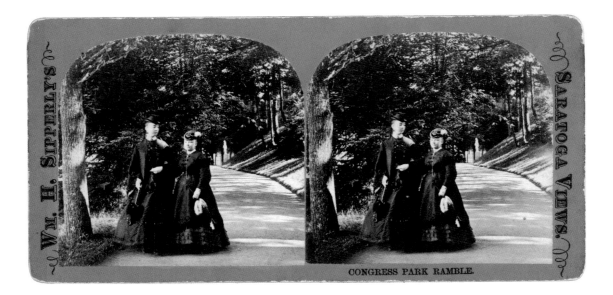

1840–1850

In the early 1840s, the daguerreotype proved popular among the Industrial Revolution's burgeoning middle classes. In 1843 Albert Sands Southworth and Josiah Hawes made the first daguerreotype portraits, in response to the demands of this newly affluent market. Portraiture was to become one of the most popular uses of the daguerreotype, yet the format was to prove expensive, delicate and very difficult to duplicate. This inevitably led to a widespread adoption of Talbot's pioneering calotype processes.

In 1844 Talbot founded The Reading Establishment, a factory that mass-produced photographic prints and illustrated publications for commercial sale. From 1844 to 1846, Talbot's factory published *The Pencil of Nature* in six parts. Comprising 24 of Talbot's own calotypes, it is regarded by many as the first photographically-illustrated book to be commerically produced. This publication was a labour of love for polymath Talbot, who hoped it would demonstrate the multiple uses (from the scientific to the artistic) for which photography was suitable. It is of note that Anna Atkins, a friend of Talbot's, published *Photographs of British Algae* in 1843, an album illustrated with cyanotype plant impressions: a monochromatic paper printing process with a distinctive blue tint. However, Atkins's claim to the production of the first photobook is often overlooked as it was privately printed and given less recognition as a result.

Talbot continued to produce a large body of work in the medium that he helped create. His commercial endeavours continued with the launch of his unsuccessful subscription series of 23 calotypes, *Sun Pictures in Scotland*.

Trained artists continued to use photography as an educational tool in other media – in much the same way as the camera obscura had been used – or for recording work in other media. However, once exposed to the new invention, many of these artists found themselves increasingly attracted to the possibilities of the medium. An example of this can be found in the work of David Octavius Hill and Robert Adamson. Hill, a Scottish landscape painter, enlisted Adamson, a photography enthusiast, to assist him with the production of a series of photographic portraits, which were intended as source material for a commissioned painting. Once he saw the fruits of their labour, Hill was struck by the potential of future collaborations with Adamson and excited by the possibilities of combining photographic technical skill with a painterly appreciation of lighting and composition. The two men set up a photographic studio and entered into a partnership that yielded around 1600 photographic images covering a broad range of subjects.

In France, other former painters such as Edouard Baldus, Gustave Le Gray and Henri Le Secq proved that the intuition of the photographer could produce an image as distinctive and personal as those in other media. These individuals swiftly realised the importance of photography and chose to concentrate exclusively on the medium by forming the Société Française de Photographie, with the intention of recording images of important people, places and events for posterity.

The evolution of the photographic process also continued apace. In 1849 the stereoscopic viewer was developed by Sir David Brewster. Its basic working principle was that, by use of a stereo camera, a double image could be produced, which when placed in a viewer rendered a three-dimensional image. Stereoscopic viewers and stereographs were produced in large quantities and were incredibly popular, in fact many are still coveted collectors' items today. In 1850 Gustave Le Gray further improved Talbot's basic process when he introduced the waxed-paper negative. Ironing beeswax on to a paper negative improved transparency and produced a positive print of much finer detail.

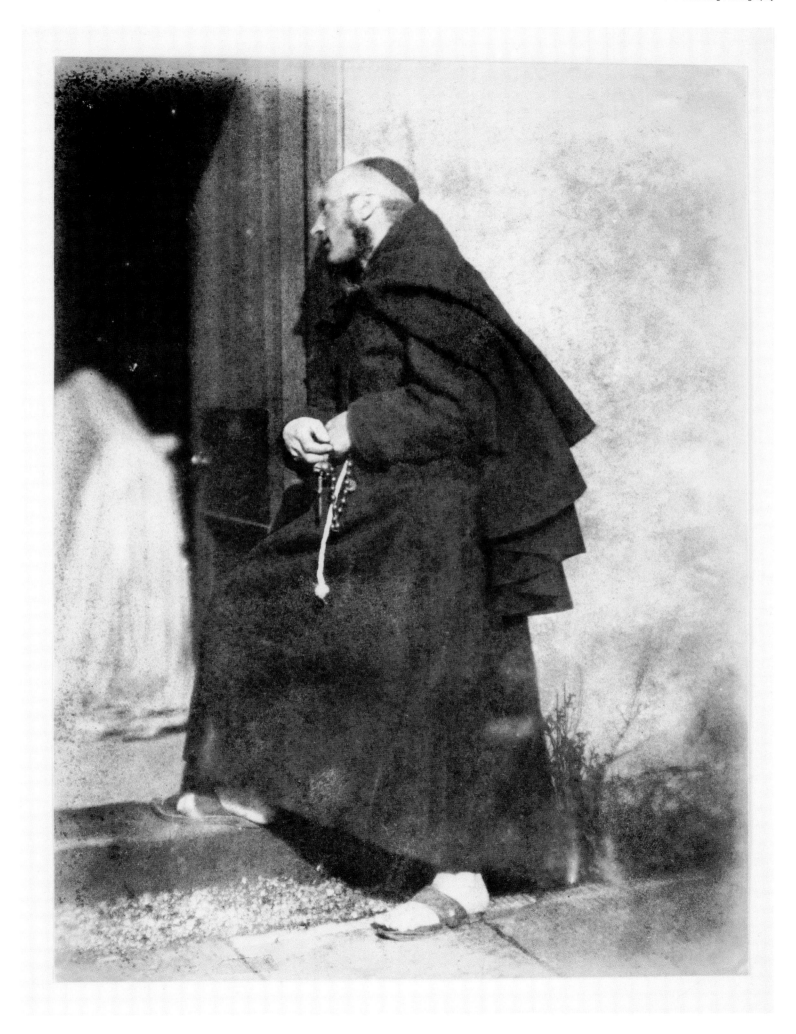

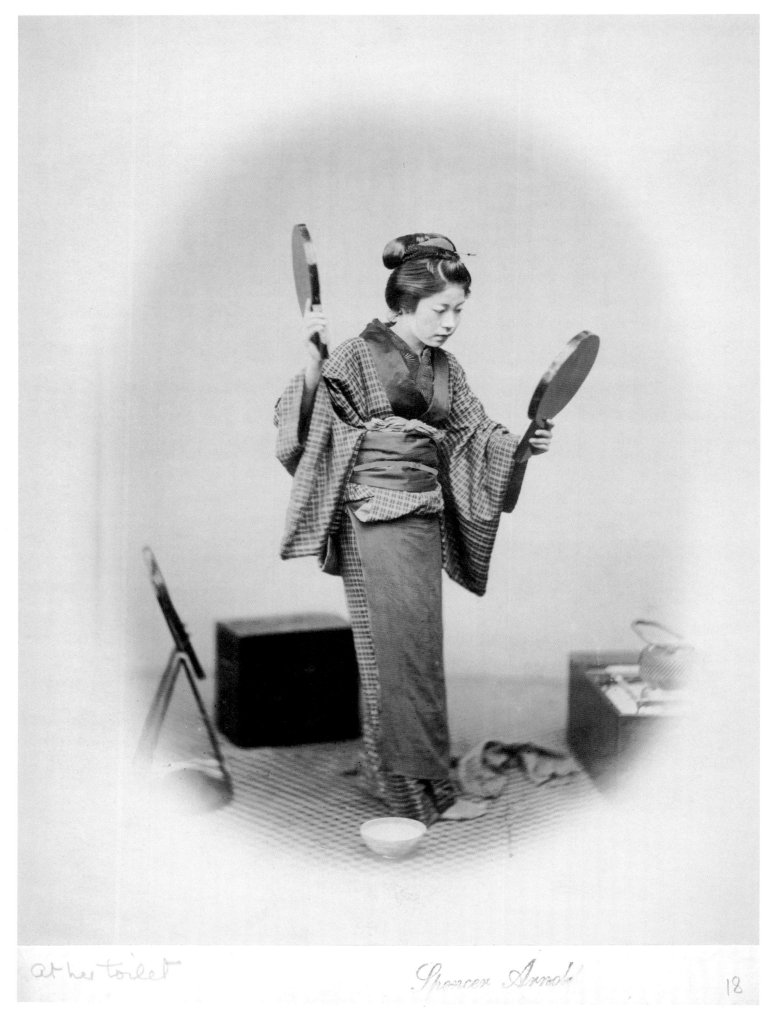

at her toilet

Spencer Arnold

18

1850–1860

Many of the early photographic pioneers were essentially amateurs, working in a medium too new to be part of an establishment. Even the artists of the Société Française de Photographie effectively abandoned their professions by dedicating themselves to photography, which was at this stage neither an art form nor a viable commercial entity. By the 1860s, however, photography was to gradually become dominated by professionals.

This transition began as new technology streamlined the photographic process, and broader interest in the medium spread. In 1851, Frederick Scott Archer developed a process that replaced Talbot's paper negative with a glass plate. Albumen prints produced a much sharper and more finely detailed image. Commercial artists and printmakers, whose businesses continued to thrive, quickly seized upon these new techniques and encouraged further refinements.

The majority of commercial, mass-produced images of the late 1800s tended to consist primarily of landscapes and portraits, their popularity stretching back to the precedents set by earlier painters and printmakers. Previously, the personal collection of painted and etched decorative works of art was a pursuit largely reserved for the affluent and upwardly mobile. Similarly, portraiture had almost certainly been reserved to those with higher status and of more affluent means. Even just 20 years earlier, daguerreotypes had still been rather costly. However, as a direct result of an increasing commercial demand, and pressure from photographers to develop cheaper and more versatile processes, swift advances were being made. Soon, photography had evolved sufficiently enough to swiftly reproduce high-quality representations, and this was to change the perception of portraiture almost overnight. André-Adolphe-Eugène Disdéri was one of the first photographers to exploit this and produced a number of affordable personal portraits, but many others would follow in his footsteps.

Driven by its growing recognition as a commercial service, photography had grown immensely popular. As the popularity of photography grew, so too did the demand for exhibiting photographs as fine-art forms. The first international open competition for photography was staged during the Great Exhibition in 1851, which was held at Crystal Palace, London. The competition received 700 entries from six countries, including a number from the USA and France.

In France, the public appetite for photography, in all its guises, was growing and the establishment was truly embracing photography. In September 1851 the Imprimerie Photographique factory was opened by Louis-Désiré Blanquart-Evrard at Loos-lès-Lille. The factory produced unlimited numbers of positive prints from glass and paper negatives for both artists and amateurs alike. Blanquart-Evrard's contribution to the growth of the medium was considerable. Amongst the books produced at the factory were Maxime Du Camp's *Égypte, Nubie, Palestine et Syrie* (1852), and Auguste Salzmann's *Jerusalem* (1854).

Left: 'At Her Toilet'. Felice Beato
With overseas travel limited to the privileged few, foreign and exotic images were popular and photographers such as Beato satiated an increasing demand for Eastern genre studies. Viable colour processes were still a long way in the future, and hand-coloured albumen prints like this were not uncommon. Japanese watercolourists were the most skilled exponents and Beato's delicately coloured images are among the finest examples.

Right: 'The Nave from the South End'. Philip Henry Delamotte
Delamotte was commissioned to document the rebuilding of London's Crystal Palace (1854–55), and produced, from wet-plate collodian negatives, a series of 160 albumen prints that displayed every aspect of the construction and exhibits. As few as 15 to 20 sets were originally published, which makes these photographs highly sought after.

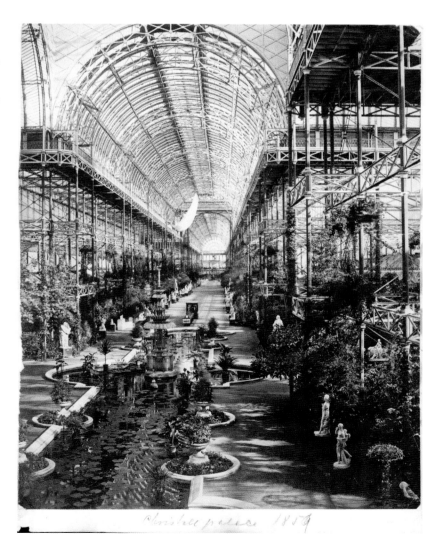

In the same year, the Commission des Monuments Historiques, a French government agency, tasked five prominent photographers – Baldus, Bayard, Le Gray, Mestral and Le Secq – to undertake photographic surveys of ancient monuments and historic buildings: the *Missions Héliographiques*. Photographic records of such subjects were, and remain, highly collectable, due to the fact that many of these monuments would be inevitably and often irreparably altered by time, neglect and wear and tear. The capture of ephemeral images and photographs of places and spaces that most people would never have the opportunity to visit was a popular theme of early photography.

Another notable example can be found in the work of Carleton Watkins and Charles Leader Weed, who used mammoth plate cameras to take photographs of the Yosemite Valley in California, on negatives that were approximately 16 x 20 inches. These images were internationally acclaimed, and Watkins's images are particularly important, as he was quite literally a pioneer, travelling to the American West during the gold rush of 1854 and capturing photographs of the untouched wilderness before colonial settlement.

The photographic coverage of the Crimean War in 1855 by Roger Fenton, Charles Langlois and James Robertson brought a brutal new focus to the reality of war to a wider audience, unlike painting, which had often romanticised and dramatised conflicts. Although technical restrictions prevented graphic imagery, the emergence of photography in this context would influence a profound change in attitudes, and prove that the medium could not only capture images for posterity, but also utilise its immediacy to influence contemporary social and political attitudes. Later, George Barnard, Alexander Sullivan and Timothy O'Sullivan would extensively photograph the American Civil War.

Other pioneering moments during this period included French photographer Nadar's first successful aerial photograph, which was taken from an air balloon in 1858. Notably, Nadar was also the first photographer to use artificial light to photograph Parisian catacombs and sewers.

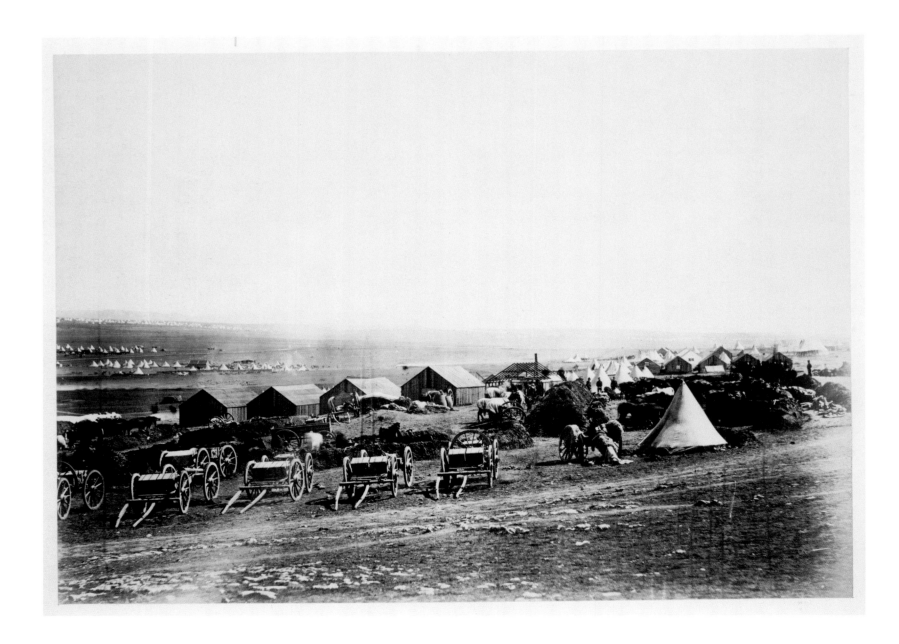

Left: 'Artillery Waggons. Balaklava in the Distance', 1855. Roger Fenton
Photography's leading role in documenting history was formally confirmed during the Crimean War. Fenton played a major part in this, producing 360 large format, glass-plate negatives of the Crimean conflict, in fewer than four months. Although he did not actually photograph combat, his contribution reveals the acceptable, non-democratic standards of the day. Fenton's talent for photographing the landscape of war, both from historic and aesthetic perspectives, is shown here. The choice of composition shows a distinctive vision that Fenton wished to convey to his audience, restraining any possibility of their revelling in the horrors of war.

Below: 'Sarcophage Judaique', 1854. Auguste Salzmann
Salzmann's two-volume *Jérusalem* (1856) was produced in order to settle an archaeological argument concerning origin of the tombs and monuments of the Middle East. Utilising the perceived 'irrefutable truth of the medium of photography' Salzmann hoped to prove that these constructions were built prior to the Greco-Roman period. The resultant images are, however, deeply evocative and poetic. The paper fibres that are clearly visible within the calotype process mean the resultant images are rarely sharp, but the strong, natural light casts this embossed sarcophagus in dramatic relief.
The quality, rarity and historical importance of these 174 photographs means they consistently fetch large sums at auction.

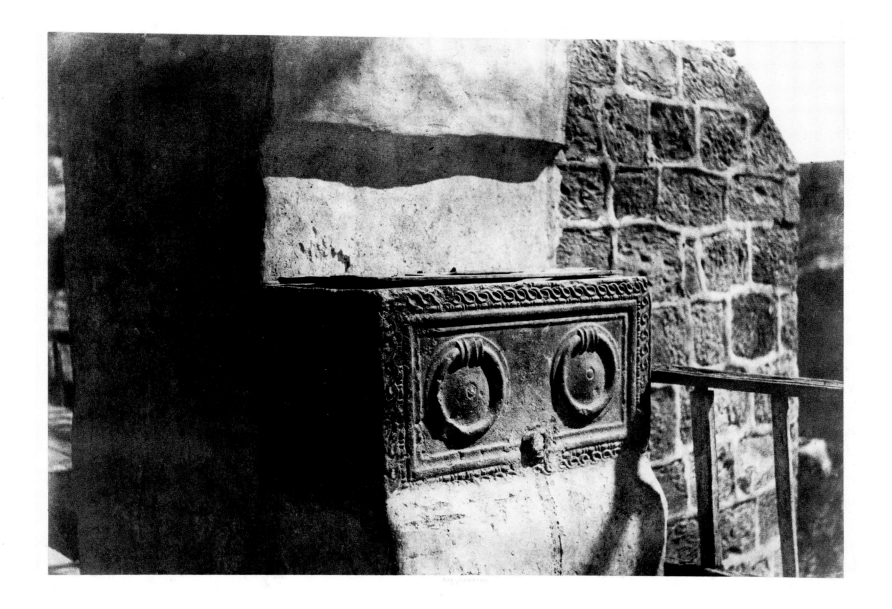

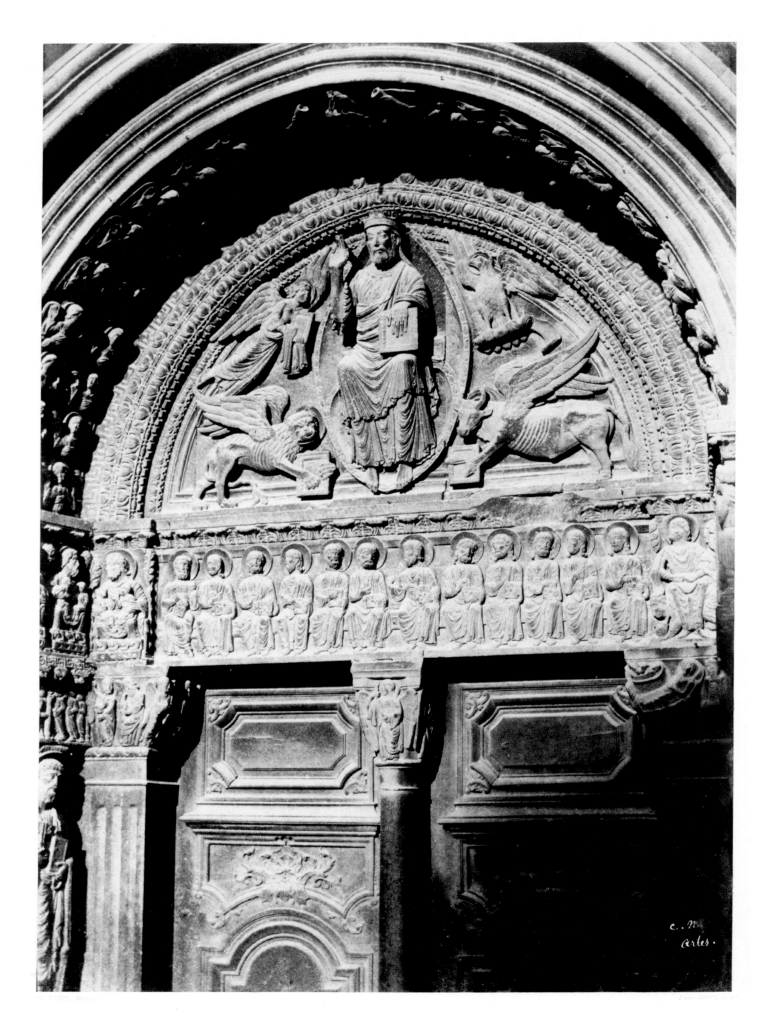

Right: 'Ile de Fileh: Vue Générale Prise du Point 1', 1851. Felix Teynard
Teynard's photographs of monumental desert architecture are considered to be some of the most important images of the nineteenth century: an era thought to represent the height of architectural photography. Teynard's studies summon up the former grandeur and history of his chosen sites, and his use of the calotype process imbues a sense of distant otherworldliness. Here, Teynard captures a moment of awe: the building stretches poetically toward the distant water, the print softening the unyielding columns with an ethereal quality, as if the scene has been conjured from his imagination.

Left: 'Tympanum, St. Trophime, Arles', 1852. Charles Negre
To have both print and negative reveals the quality (and value) of each through the detail retained from the printed image, both architecturally and photographically.

Negre's early training as a painter with Delaroche saw him use photography to complement his work. As a prolific recorder of Parisian architecture, his work characterised the buildings' environmental surroundings as well as their specific details of interest. The fine printing of this image allows for close inspection of the depth of the relief sculpture within the arch.

Below Right: 'The Pyramids at El-Geezeh', 1858. Francis Frith
Consistently fetching higher and higher prices at auction, Frith's images from Egypt, Sinai and Jerusalem are still some of the finest nineteenth–century photographic records of the region. Frith's work further increases in rarity due to the erosion of many of the architectural subjects, in a constantly shifting landscape, in the years since they were captured. The detail in the textures, from the foreground right through to the pyramids, is magnificently and skilfully recorded. We are left to marvel at the splendour of the landscape and the crisp light accentuating the architectural forms. Frith's success in depicting Egypt and the Middle East in often inhospitable conditions resulted in scenes such as this one. Considering the technical difficulties, these are images that rival even those of the most successful landscape photographers today.

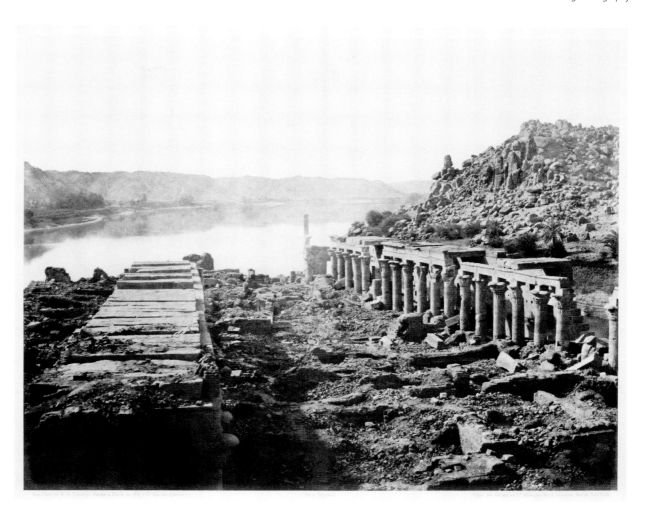

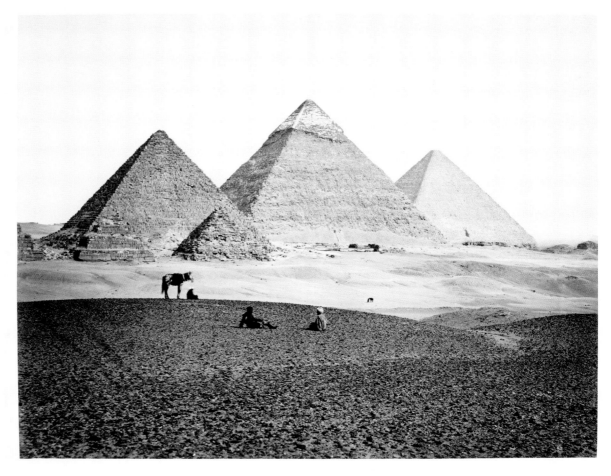

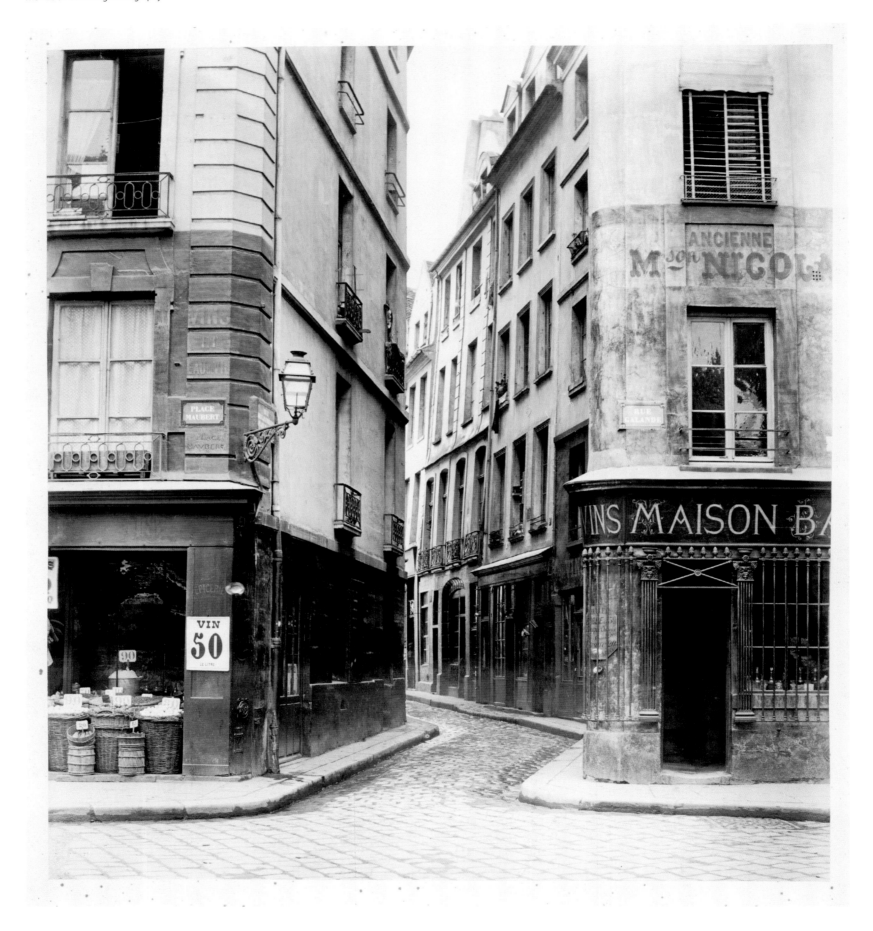

1860–1880

At the peak of its colonial power, Victorian Britain enthusiastically embraced photography. Travel photography in particular became extremely popular as it allowed images from the many distant shores of the British Empire to be viewed, catalogued and categorised. Pictorial views sold as popular collectable souvenirs to tourists, as did *cartes de visite* (visiting cards), which often featured portraits of well-known dignitaries. The ephemeral nature of these objects, along with other examples of pioneering photographic trends, would later foster a strong specialist market for collectors.

The Victorian approach to meticulous scientific study paid dividends in other areas too. In 1872, the American photographer and inventor Eadweard Muybridge was commissioned to photograph a sequential study of a racehorse in motion. This commission instigated a series of human and animal motion studies, which culminated in the publication of *Animal Locomotion* in 1887. Influenced by the working principles of the 'kinematoscope' (a popular Victorian novelty whereby a cranked handle rotated a series of sequential stereoscopic images, thus giving the impression of movement), Muybridge began to project his studies and so embarked upon the first experiments with cinematic pictures.

Additionally, as early as 1861, Sir James Clerk Maxwell demonstrated a colour photography process, although there was still some way to go before colour photography became commonplace.

Left: 'Rue des Lavandières', c.1867.
Charles Marville
Marville was the official photographer of Paris in 1862. In this image he positions the camera directly opposite a side street, and in doing so creates a framed symmetry that exploits the contrast between the eccentric angles within the alleyway and the straight lines of the facing buildings. Marville's systematic approach to photographing Paris created an evocative body of work that personified the city's unique character.

Right: 'Akbar's Tomb, Agra', c.1867.
Samuel Bourne
Bourne's extensive production of landscape, architectural and historic photographs, taken from his travels across the Indian sub-continent, are still much revered today for their quality and compositional prowess. The composition of this marvellous image of Akbar's Tomb in Agra encourages the viewer's eyes to look outward, with those of the figures in the foreground, to the pale Taj Mahal in the distance. The architectural interest in the tomb is not allowed to be overshadowed by the beauty of the scene, but is distinctively represented through the strong tonal elements of dark archways, which highlight the structure and design of this famous mausoleum.

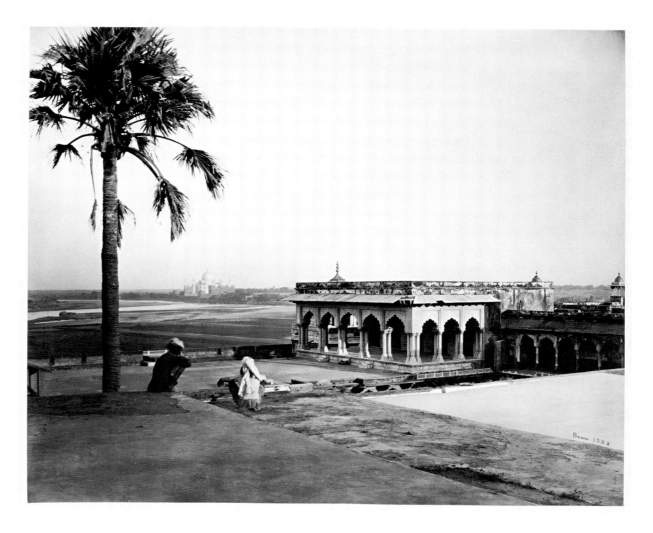

1880–1899

The development of halftone reproductive printing allowed the photograph to become an established illustrative fixture in newspapers and magazines by the late 1880s.

In 1888, George Eastman perfected the Kodak camera. It was the first camera designed specifically for rolled film and was to trigger a fundamental change in the way photographs were viewed, collected and produced. Crucially, Eastman's camera eliminated the technical processes of developing. It was sold with sufficient film for 100 exposures. Once the roll had been completed the entire camera was returned to the factory, where the images were developed and printed and the camera reloaded. As was encapsulated in their sales slogan, with a Kodak camera you pressed the button, and they did the rest.

Eastman's innovation allowed a whole new genre of amateur photography, not in the sense of the non-commercial, experimental photography of the likes of Julia Margaret Cameron, but genuine amateurs who only needed to point and shoot and need never understand the intricacies and chemical complexities of the darkroom. This development changed the medium forever. It became an art form that was truly accessible to all, distinctions between its purpose and its role were blurred and photography was wide open to interpretation, innovation and experimentation.

In 1889 an influx of novelty cameras flooded the market. Most were inexpensive, used plates or cut film and had low-quality lenses. They were, however, hugely popular, particularly the miniatures. Cameras such as the Rene Dagron took 450 photos on each glass plate. These miniature images could be mounted inside novelty items, often with a magnifying lens embedded into the object so that the photograph could be viewed. Detective cameras were also popular. These appealed to both sexes and were designed to be concealed in bowler hats, books, watches, walking sticks, parcels, waistcoats or handbags.

The introduction of and demand for such cameras signified that photography had now reached a level of stability and was widely accepted by the public. Furthermore, Thomas Edison's invention of the 35mm film strip – a format that would become an accepted standard in compact cameras, even to this day – would be a major contribution to experimentation with the moving image towards the end of the decade; a move many saw as the next logical step to take following the successful development of the still image.

In 1894, Louis Lumière invented the cinematograph. This device was a combined movie camera, developer and projector. The following year, Louis, and his brother Auguste, publicly premiered their first motion picture, *Arrival of a Train*, in Paris and patented both the process and equipment.

By the close of the century, photography's extended family had begun to grow in a rapid and successful manner. This proved that the medium was to remain at the forefront of public consciousness and raised expectations about the future possibilities for it.

'Gathering Water Lilies', 1886.
Peter Henry Emerson
No book on collecting photography would be complete without the inclusion of this classic image, taken from Emerson's illustrated book, *Life and Landscape on the Norfolk Broads*.

The leading light of the 'naturalist' school of photography in England, Emerson's subjects were often that of man in nature, rendered in exquisite images, as is the case with this platinum print. Idyllic scenes such as this directly influenced the Photo-Secession movement in the USA.

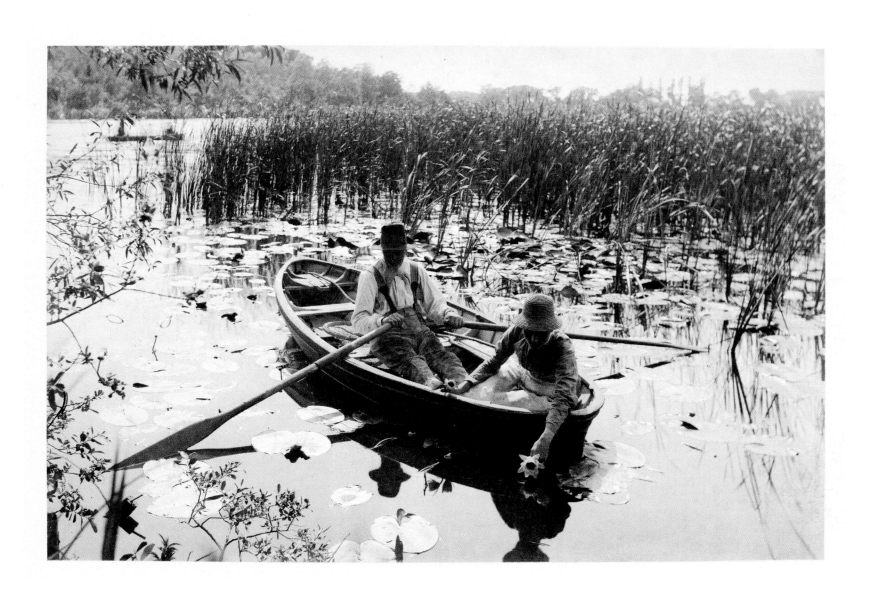

Key Developments of the Twentieth Century

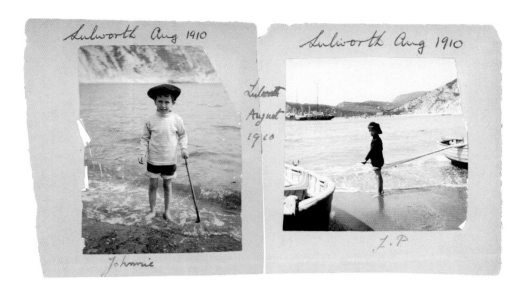

The dawn of the twentieth century saw a new approach to nearly every aspect of photographic practice. The basic technical processes that had gradually evolved during the previous centuries were now fully established and widely disseminated, primed to propagate a new era of experimentation. Of course, there were to be many further peripheral refinements to film, lens and flash, but the production fundamentals of the photographic image were to remain largely unchanged for almost the next hundred years. Instead, the uses of photography experienced the most radical shifts.

Traditional genres remained, but as time and technology progressed, the medium had matured sufficiently enough for it to be freed of the practical restraints of its earlier years. With increasing accessibility and affordability, photography extended its uses to all corners of society, eventually adopting a truly global perspective. Once properly in the public domain, the entire agenda of photography was challenged; what had been considered too unimportant or mundane to photograph by the pioneers was reappraised by a far more diverse collection of enthusiasts. From scientific studies to family snapshots, the last, unquestionably dynamic, century has been recorded in every way and for every reason imaginable.

The level of detail that photography allows us to record and represent our lives with has changed the very way in which we view the world and perceive our own personal and global histories. Compared to the radical events of the nineteenth century one might be tempted to dismiss later developments as a trivial footnote in the history of photography, but this could not be further from the truth. A time before the photograph now seems impossibly distant, and a by-product of this telescopic effect is the ease with which we forget that it was only during the turbulent years of the twentieth century that photography really did come of age.

The dogged persistence and artful ingenuity of the early pioneers had introduced a revolutionary new tool to the world, but the dawn of the twentieth century provided an opportunity for a new generation to nurture the medium, explore its full potential and to establish it as an independent art form. From the early 1900s to the present day, each passing decade produces a multitude of new movements, techniques and themes. Some of these were to have great impact, while others faded into obscurity, but all are of interest. For the collector, the beauty of this complex tangled web of genres, movements, techniques, themes and subjects is that there truly is something for everyone.

Left: 'York Minster: Doorway to the Chapter House', c.1900. Frederick Evans
Renowned for his emotive architectural imagery, Evans's commitment to pure platinum photography and lighting effects retain a great appeal today. In this instance, the light falling upon the doorway to the chapter house draws attention to the patterning and texture of the subject, and retains the architectural interest of the whole building through the compositional inclusion of the interior behind the door, which reveals the illuminated stained-glass windows. The combination of these elements transcends the notion of a purely architectural study and provides us with a delightful and meaningful image.

Far Left: 'Johnnie and J. P.', 1910. Anon
The Kodak 'instantaneous' camera brought photography within the reach of the masses and the 'snapshot' was born. Although arguably lacking the artistic merit of the 'professional' photograph, time often lends these images great charm as well as nostalgic and historical interest in period details. Often mounted in albums, which can have inherent value of their own, amateur snaps such as these are increasingly being re-evaluated.

1900–1920

Key Movements
Pictorialism (1890–present)
Photo-Secession Group (est. 1902)

Key Techniques and Developments
Kodak's Brownie camera introduced (1900)
Kinemacolor invented (1913)

Key Photographers
Alvin Langdon Coburn, Lewis Hine, Alfred Stieglitz,
Paul Strand

Overview

At the turn of the century, the mechanisation of industry, which had begun during the preceding hundred years, continued apace, driving massive social and economic shifts. Over the coming years, there were to be exponential advances in technology; a trend that would continue throughout the twentieth century. Along with the inventions of the electric light bulb, the telephone, the automobile and the cinema, the camera was a nineteenth-century invention that captured the imagination of the public and as such would come to define the new era.

A distinctive feature of the twentieth century was the greater democratisation of power and wealth, and at the turn of the century this was reflected in the growing economic powers of Europe and the USA. As a result, opportunities and pursuits that were previously only available to a small proportion of the population were increasingly accessible to all. These social changes proved to be highly influential on the direction of photographic development, as many commercial printmakers now found it difficult to compete with the increasing quality, affordability and availability of personal photography. This sudden decline in the commercial dominance of the process allowed artists to assert their authority over the new medium and so shape its development.

The twentieth century was the first to be fully captured in photography from beginning to end, and yet at its dawn uncertainty hovered over the medium. The defining artistic images of the First World War are often those found in paintings and in literature; there is a notable absence of photographic wartime record despite the prevalence of the medium. The future of photography was waiting to be claimed, but its purpose, language and position within the artistic arena was still to be determined.

An important movement that rose to prominence over these opening decades was pictorialism, which asserted that the medium of photography must emulate painting or drawing if it was to be accepted as an art form. Pictorialist prints are often sepia-toned or black and white, and many darkroom techniques are used to achieve a formal resemblance to paintings, etchings or pastel drawings.

A key figure in the pictorialist movement was Alfred Stieglitz, founder of the breakaway Photo-Secession Group. The work of this group was pictorialist, yet devoted to contemporaneous subject matter. The group's main purpose was to promote photography as a fine-art form. Other notable members included Alvin Langdon Coburn, Edward Steichen, Gertrude Käsebier and Clarence White.

Freed from restrictive pictorialist dogma, the photo-secessionists encouraged experimentation. The Little Galleries of the Photo-Secession exhibition, which opened on 24 November 1905 in New York, marked the beginning of photography reaching beyond the provincial confines of pictorialism, asserting its artistic independence, and pushing the boundaries of representation further to inspire, amaze and, on occasion, provoke.

To advance the same views, Stieglitz launched *Camera Work* in 1903. The magazine's quarterly issues displayed the portfolios of photo-secessionists with exquisite results. The passion and integrity of the photo-secessionists' pursuit of tonality, composition and quality brought them to the forefront of the medium. The processes and printing techniques of Coburn, for example, and his use of gum to enhance the contrast of his platinum prints, caught the eyes of many, including Walker Evans, who described Coburn's 'London Bridge' as 'perhaps the very truest rendering of sunlight photography has yet achieved'.

Camera Work ceased publication in 1917. It was fitting that the last issue focused on the work of Paul Strand, the man Stieglitz considered the most important photographer working at that time. Strand's 'Blind Woman' was indicative of the modernist approach to photography that was to flourish in the coming years.

Technical Developments

By the beginning of the twentieth century, the basic elements of photography as we know them today were firmly in place. Wet photography – as photography utilising exposed chemically treated film was later termed – was to undergo many refinements, but its basic process was to remain largely unchanged and unchallenged for the next hundred years.

However, it would be incorrect to underestimate the impact of the technical refinements of this period, no matter how minor they may at first appear. In 1916 the first optical rangefinder was produced and high-speed lenses were soon to follow. Advances in the capabilities of lenses or in the automation of processes, for instance, did not merely make an image easier to capture, they also allowed a camera to be operated in an environment where it was previously unable to do so. These advances also allowed an image previously denied not only to the photographer's lens but also to the naked eye to be captured. The new perspectives and images that were generated as a result invited fresh audiences and potential uses for photography.

At the beginning of the century, Kodak continued to stake its claim as the market leader of mass-produced camera equipment. Kodak's emphasis was on affordability, releasing the $1.00 Brownie camera and selling self-loading film at just ten cents a roll.

As early as 1913, Charles Urban and George Albert Smith had developed Kinemacolor, which was the first commercially successful colour photographic process. There were, however, many subsequent attempts to refine this process and satisfactorily reproduce colour images.

'Autoradiograph', 1903. Henri Becquerel
In 1896, French scientist Henri Becquerel accidentally discovered radioactivity when, in preparation for an experiment, he wrapped a sample of uranium salts next to a photographic plate and was rewarded with a spontaneously exposed image. Investigation of the phenomenon of these 'autoradiographs' led Becquerel to receive a Nobel Prize for his groundbreaking study of nuclear radiation.

The threefold appeal of this work (collectable, scientific and aesthetic), ably exhibits the potential diversity of photography. At first glance, and without the scientific backstory, we simply observe an image of a deep black hole with a shape that is suggestive of a caterpillar curving around it. The abstract form could perhaps be interpreted as similar to those of László Moholy-Nagy's photograms or perhaps even the symbolist paintings of Odilon Redon; expanding the appeal of this work beyond the scientific to the artistic.

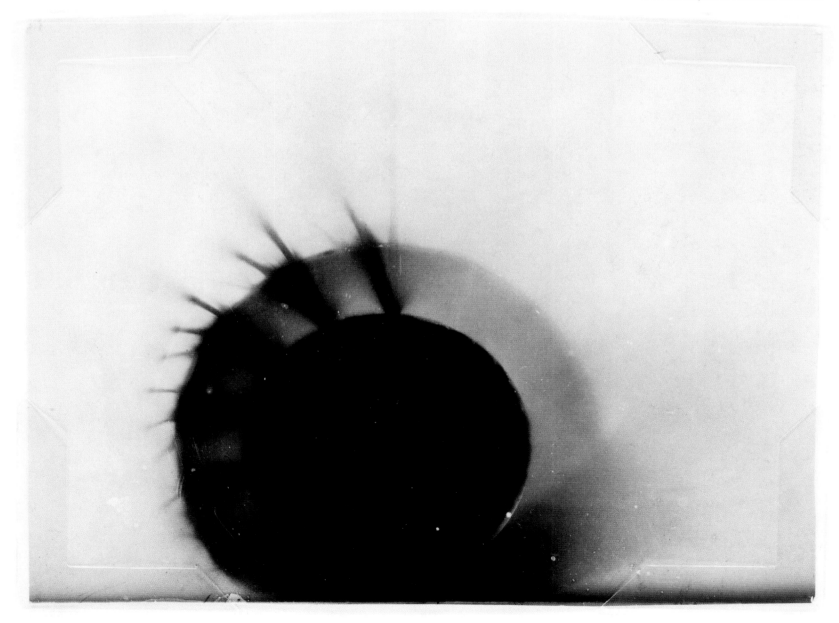

The 1920s

Key Movements
Dada (1919–1945)
Modernism
New Objectivity
Modernism (–1940s)
The Bauhaus School (1919–1933)

Key Techniques and Developments
Photocollage technique
Dye transfer process introduced
First wirephoto transmission (1923)
The 35mm Leica camera launched (1925)

Key Photographers
Eugene Atget, Salvador Dali, Frantisek Drtikol,
Angus McBean, Vladimir Mayakovsky,
László Moholy-Nagy, Albert Renger-Patzsch,
Rodchenko

'Composition', 1929. Frantisek Drtikol
Drtikol's imagery was strongly influenced by the symbolist and Art Nouveau movements, whose styles he employed in order to create dynamically structured and striking photographs such as this. The way in which Drtikol utilised the female form to become a part of the internal architecture of his compositions – facilitated through a combination of geometric props and vibrant lighting – was incredibly effective. The lighting highlights the angular pose of the model's slender figure from the left side of the frame and shrouds the rest of her body in dark shadow, duplicating the harsh edges of the scenery.

Overview

By the roaring 1920s, industries that had expanded during the First World War fuelled an economic boom, particularly in the USA. Considered to be a decade of modernism, the 1920s saw Europe and the USA enter the 'jazz age': a period of avant-garde experimentation in literature and the arts.

The modernist movement was a concerted reaction to the legacy of the classicism that had dominated the nineteenth-century artistic arena. In photography, this produced a direct attempt to move away from a reliance on traditional compositions and forms derived from painting, and a shift towards an assertion that the medium was a truly independent component of the fine arts, complete with its own new and unique visual language. Some critics, of course, protested: traditionalists rejected photography as an art form because it was a means of reproduction so ubiquitous that anyone could capture an image, regardless of their intent or skill. Furthermore, photography was derided for its commerciality and its inescapable associations with mass media and production. It is ironic that these very same factors were seen as advantageous by modernist photographers, who felt that such ease of capture and reproduction was liberating and enabled them to take risks with a medium that they thought could truly become a new form of art for a new century. Hungarian-born American artist László Moholy-Nagy encapsulated this attitude in his 1925 book *Painting, Photography and Film*. He observed the vast range of images that the camera could capture from a single source, and saw that with so many possible variations in scale and time a new way of viewing our world could be created. Moholy-Nagy referred to this concept as 'new vision'.

Influenced by American Dadaist painter Man Ray, Moholy-Nagy experimented with photograms using three-dimensional objects that were placed directly on to photographic plates or paper and then exposed to light. The results from these camera-less photographs were non-representational forms of light, producing undetailed shapes, which were more akin aesthetically to abstract painting than to photography. Moholy-Nagy's approach to art was inventive and progressive; incorporating many different mediums into his work. Originally a teacher at the Bauhaus school of design in Weimar, Germany, Moholy-Nagy was one of a group of artists – including Lyonel Feinger, Wassily Kandinsky and

Paul Klee – whose primary concern was to bring art and design into the domain of everyday life. Founded by Walter Gropius in 1919, the Bauhaus practised a distinctly refined geometric and simple style, and this aesthetic lent itself well to many scientific types of photography such as macro-, micro- and X-ray photography.

Modernism often tended to favour an abstraction of form and a more unconventional approach to representation. American photographer Paul Strand embraced this; his photographs progressively became more abstracted and ignored the conventional use of perspective. Strand utilised the everyday and mundane to create abstract designs; without using any 'trickery' he focused on pure objectivity, thus keeping the objects used in his compositions recognisable. Alvin Langdon Coburn's approach to abstraction also incorporated visual patterns. He used three mirrors (forming a triangle) and crystals to produce vortographs, which resulted in the kaleidoscopic, repetitive imagery of objects viewed through them. This multiple imagery lent itself visually to techniques used by abstract painters, but with a stronger residual reality through the nature of the photographic outcome.

New objectivity, like the Bauhaus, began in Weimar as a reaction to expressionism and was based on the ethos that the artist should not manipulate an external subject, but simply record it. Albert Renger-Patzsch was a pioneer of the movement. His work concentrated on depicting utmost realism of close-up images of both manmade and natural forms. He believed that the photographic quality of the image was paramount as a means of representing texture and reality in a pure sense. The ethos of new objectivity was to have a profound influence on other photographers, most notably in the field of social documentary. August Sander, for instance, took portraits of all levels of society, which were photographed in a manner that allowed the subjects to present themselves naturally.

Surrealism, a part of the broader modernist shift, was a movement founded by André Breton in 1924, and was also a reaction to the staid traditionalism prevalent at the time. By looking at art in a more flexible and aesthetically challenging way, using techniques such as double printing and negative printing, and adopting methods used in trick photography to create

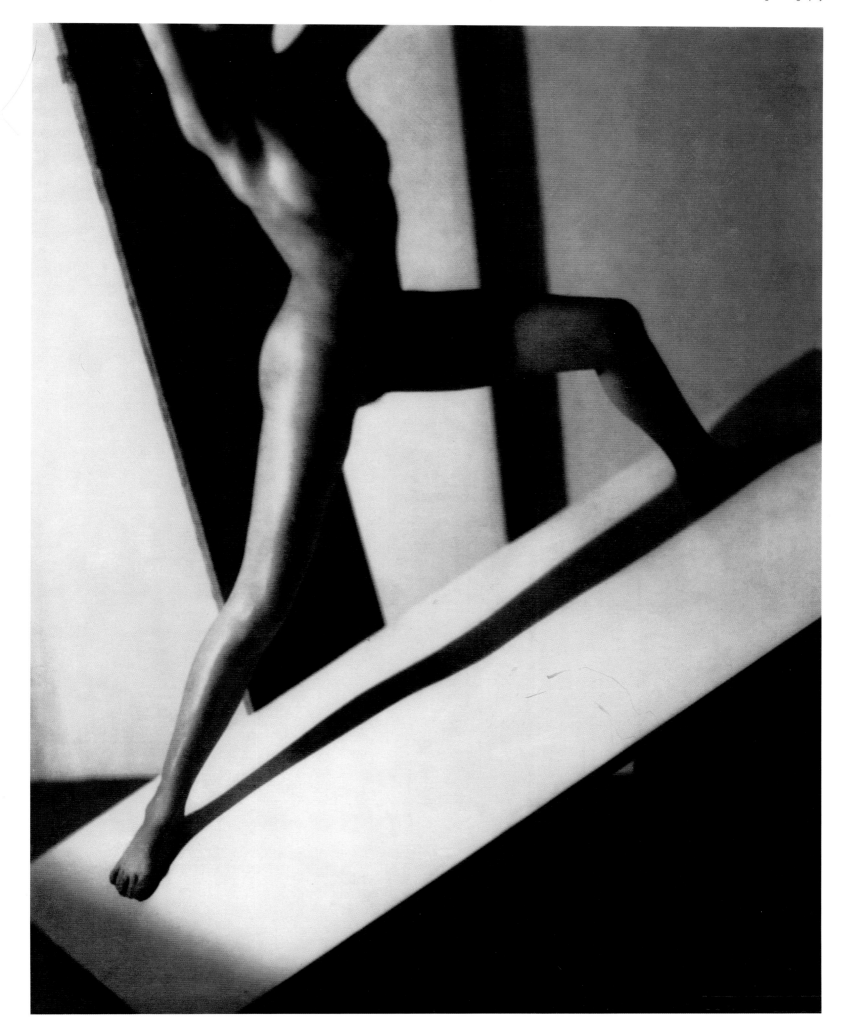

movement and strange forms, the way in which the world could be photographically explored and represented was altered. The human body was addressed most radically, and photographers such as Man Ray found new, surreal ways to present it. His solarised portraits and surrealist interpretations of form included the iconic 1924 image 'Le Violin d'Ingres', which combined the visual similarity of a naked torso to that of the shape of a violin, and incorporated representations of the 'f' shaped acoustic holes in the appropriate position on the torso to further the association. Hungarian-born photographer André Kertész also produced a remarkable series of distorted nudes, whose contorted and grotesque forms were achieved using mirrors. This 'hall of mirrors' style shocked the public and later influenced British photographer Bill Brandt to elaborate on the nude and its proportions through the manipulation of perspective.

A key experimental technique – not only characteristic of the surrealists, but also amongst the broader photographic community – was photomontage and photocollage. While this was not a new format, photocollage became increasingly popular throughout Europe and the USA during the 1920s, partly due to the fact that the artists were eager to utilise discarded photography because of its mass-media associations. If photography, in all its mundane, mass media, ephemeral glory had become the language of the modern world, then it was considered to be the perfect means by which to address that world. The most famous photomontage artist was John Heartfeld (a pseudonym for Helmut Herzfelde), whose work was predominantly used as anti-Nazi propaganda in Germany in the late 1920s. Other key photographers using this technique were Alexander Rodchenko, Raoul Hausmann and Hannah Höch.

The wider interest in photography among movements such as the surrealists also served to draw attention to the work of other photographers, who might well have otherwise languished in obscurity. The work of Eugène Atget, for example, caught the eye of Man Ray and Bernice Abbott, who were attracted to his strange juxtapositions of real life in the streets of Paris.

Technical Developments
The Ermanox became available in 1924, complete with an Ernostar f/2 lens, which made available-light photography a reality where previously flash had been required. However, the release of the 35mm Leica signalled the end for the Ermanox. The Leica camera was introduced in 1925 and was the first practical camera to use 35mm film. This was the final major development in the basic photographic process. The Leica swiftly became a favourite among photojournalists and 35mm film allowed photographers to work at greater speed and using the available light, which changed the path of photojournalism and social documentary forever. Photojournalists also benefited from the first wirephoto transmission, which was made in 1923.

'Rebecca, New York', 1922. Paul Strand
Strand's portraits of his first wife, Rebecca, remain engaging to collectors today for their intimacy; many were kept in relative obscurity by Strand himself. The proximity of Rebecca's face to the camera's lens, coupled with a slight movement that brings the image just out of focus, accentuates a feeling of closeness, as if the moment was discreetly stolen while she slept. Strand's signifying style is not present here, but the influence of his friend and fellow photographer Alfred Stieglitz is quite apparent.

The 1930s

Key Movements
Group f.64

Key Techniques and Developments
Solarisation techinique
Kodachrome film introduced
Rolleicord camera launched

Key Photographers
Ansel Adams, Margaret Bourke-White,
Imogen Cunningham, Dorothea Lange, Man Ray,
Willard Van Dyke, Weegee, Edward Weston

Overview

Until the 1930s the influence within both the fine-art and photographic arenas had been largely European. However, during the 1930s the focus of Western cultural history gradually shifted towards the USA. Furthermore, dark clouds were gathering over Europe; by 1933, the creative powerhouse of the Weimar Republic was dissolved as the National Socialist party, under the leadership of Adolf Hitler, seized power in Germany. This led to the closure of the Bauhaus and a curtailment of creative freedom. As a result, many of Germany's artists fled to the USA propagating their views and ideas.

In North America, the glamour of the roaring twenties had been succeeded by the harsh realities of the Depression. In photography, this shift was reflected in an equal desire for works of both social realism and glamorous escapism. The exploits of Chicago gangsters became a national obsession, from Al Capone and the Chicago mafia, to their fictional counterparts in hard-boiled film noir. This fostered an insatiable appetite for sensationalistic photographers, such as the infamous Weegee, and set the format for tabloid photography as we know it today; an evergreen strain of photojournalism that somehow sates the appetite for both realism and escapism.

'Heavier' documentary photography was equally popular. Dorothea Lange's 'Migrant Mother' was to become one of the defining images of the Depression, and 1936 saw the creation of *Life* magazine, a publication devoted entirely to photojournalism, which set the benchmark for years to come. American photographer Margaret Bourke-White took the cover photograph for the first issue.

Many movements and concerns of the previous decade continued to exert a powerful influence in the 1930s. In 1930 Edward Weston took the now sought-after image 'Pepper No. 30', which exemplifies the core principles of new objectivity. This image has since become a favourite among many collectors for its print quality and simplicity of form.

However, the 1930s saw notable reactions to the modernist dogma as some photographers attempted to perfect more traditional genres and subjects, such as landscape. In 1932, Ansel Adams founded Group f.64, which was dedicated to revisiting the traditional approach to photography. The photographers of this group used large cameras with small apertures in an attempt to accurately record the light of nature. As well as Adams, the group was comprised of Imogen Cunningham, Willard Van Dyke and Edward Weston. Group f.64 agreed that photography could be an important medium in itself, but rejected the artificiality of pictorialism. To this extent they issued a manifesto in which they declared that photography should instead concentrate on its own innate strengths of representation, incorporating a broad range of tones, sharp imagery and total focus of the image. They also felt that the very idea of multiplicity – that many images could be produced from a single image – was a strength that could be exploited. Adams in particular felt that the mass-production of the image should not be viewed as undermining the craft of photography, and was instead an opportunity to achieve some kind of perfection.

There were further encouraging signs that photography was becoming accepted as an art form in itself. In 1938 Walker Evans held his first exhibition at the Museum of Modern Art, showing selections that would later form his landmark publication *American Photographs*.

Internationally, other important photographers were breaking new ground. In Europe, Brassaï encapsulated the spirit of Parisian nightlife through his revealing documentary study *Paris de Nuit*, a collection of romantic, melancholic images of the city's street scenes, cafés, brothels and cabarets. Brassaï's publication influenced many photographers, including Bill Brandt, who subsequently produced *A Night in London* in 1938.

At the close of the decade, however, the Second World War was to overshadow the aesthetically focused arguments of photographers and set a new, and urgent, challenge to the medium.

'The Falling Soldier', 1936. Robert Capa
Surely one of the most famous images in the photographic canon. Capa's passionate war photography earned him the title of 'Greatest War Photographer in the World' from the prestigious *Picture Post* magazine. Still shocking today, this captured moment remains the most powerfully haunting reminder of the Spanish Civil War. Classically romantic in its composition, this image is reminiscent of 'Execution of the Defenders of Madrid, 3rd May, 1808', which was painted by Francisco José de Goya in 1814. In Capa's photograph the outstretched arms of the soldier (later identified as Federico Borrell), clothed in his white shirt, echoes the form of Goya's doomed Spanish rebel; both individuals representing the harsh sacrifice made by many for a country torn asunder.

Growing developments in camera and film technology allowed photographers the freedom from carrying cumbersome equipment in the field, which meant that photographing the frenzy of war was now an attainable reality.

The importance of photography in recording not just conflict, but all manner of social and cultural change, came to the fore during this decade. The public embraced magazines such as *Life* and *Picture Post* and in both instances their readership expanded dramatically from their very first issues. The significance of magazines such as these to the genres of photojournalism and reportage cannot not be overstated.

Life magazine was founded in the USA by Henry Luce, and launched on 23 November 1936, exerting a strong influence on the opinions of the burgeoning American middle classes. By its third year *Life*'s readership was over three million. Using the latest advances in printing the magazine became the first journal to publish photographs on coated paper, and its print quality far superseded anything used in the magazine industry at the time to reproduce images. The large format of the magazine displayed the photographers' work to its full advantage, making household names of its contributors, and had a profound influence on the magazine publishing industry.

Similarly, the *Picture Post,* which launched in the UK on 1 October 1938, was an overnight success, achieving a weekly circulation of 1,600,000 copies just six months after its launch. In the case of both publications, circulation rose sharply with the advent of the Second World War.

Technical Developments

The 1930s saw further technical refinements in photography. In 1932 the first light meter with photoelectric cells was introduced and in 1935 Eastman Kodak marketed their colour Kodachrome film. Kodak had previously launched colour slide film in 1934.

With the introduction in 1938 of the Super Kodak 620, complete automation of camera exposure systems moved a step closer to realisation. A very costly snapshot camera, the Kodak 620 was the first to incorporate a fully-automated method of exposure control. Only a few of these cameras were made before the Second World War stopped production, but the Super Kodak 620 indicated what was now technically possible.

In 1931, Harold Edgerton further vindicated Moholy-Nagy's assertion that photography could reinvent our own perception of the world, with his invention of the repeatable electronic short-duration flash. This enabled photographers to capture split-second images, literally fragments of frozen time, in clarity unmatched by the eye. His sublime images of a breaking milk droplet and a bullet piercing an apple have since become iconic.

Issues of the *Picture Post*.
Life magazine's British equivalent was Edward Hulton's national weekly *Picture Post*, which was edited by Stefan Lorant. Lorant's introduction of the 35mm picture essay format, and European talent such as Kurt Hutton, Felix H. Man and Bill Brandt re-invigorated newspaper and magazine reportage. First published in 1938, *Picture Post* was a phenomenal success and read by more than half the population. Its bold, innovative use of photography influenced a generation of gifted British photojournalists including Bert Hardy, Thurston Hopkins and Grace Robertson.

The 1940s

Key Movements
Self-Expressionism

Key Techniques and Developments
Kodak Ektachrome film introduced
Polaroid camera launched
Hasselblad 1600F camera introduced
Nikon 35mm camera launched
Magnum founded (1947)
Contax S SLR camera introduced (1949)

Key Photographers
Robert Capa, Henri Cartier-Bresson, W. Eugene Smith

'Jerome 21, 1949'. Aaron Siskind
Taken while with surrealist photographer Frederick Sommer, this image has become a favourite amongst the collecting community and curators alike. Siskind's well-known abstract, expressionist style has influenced fellow artists. The Arizona ghost town Jerome was the perfect location for Siskind, with its dilapidated buildings scorching in the desert heat. The tactile planes of peeling paint, so expertly captured by Siskind's 5x7-inch view camera, are tempting to our eyes and fingers alike.

Overview

The Second World War raged from 1939 to 1945, generating more casualties than any other conflict in living history. Its impact was profound, and newer, lightweight technology afforded many of those fighting their own cameras, which meant that this was a war recorded, quite literally, from every angle. It is notable that many iconic images of the conflict are actually from amateur archives.

Lee Miller, former assistant to Man Ray, was one of the few women who photographed the Second World War. Her reportage images, captured throughout Europe as a war correspondent for the US Army, led her to be one of the first photographers to enter the concentration camps at Buchenwald and Dachau.

Robert Capa freelanced as a war correspondent for *Collier's* and *Life* magazines from 1941 to 1946. His emotive photographs of the large-scale combat of the Second World War are among some of the most celebrated examples of photojournalism to date. Capa's compassionate and moving photo essay, *The Mothers of Naples,* depicts the agonies of war through its legacy, in the faces of the soldiers' mothers who are shown grieving for their loved ones.

The popularity of such photographic essays grew in the late 1940s as photographers, such as W. Eugene Smith, began to realise the power that a series of photographs, and their accompanying text, had. His famed *Country Doctor*, a 1948 photo essay for *Life* magazine, utilised the visually communicative strength of photography at a time before most people owned a television.

The Second World War certainly increased the profile of, and the demand for, high-quality photojournalism. In 1947, two years after the war's end, Robert Capa, Henri Cartier-Bresson, George Rodger, David (Chim) Seymour, and William Vandivert founded the Magnum Photographic Agency. Based in Paris and New York, Magnum differed from other photographic agencies because it was a co-operative, entirely owned and controlled by its members. The maintenance of Magnum's prestigious documentary presence in the photographic canon is largely due

to the stringent membership procedures undertaken by all its prospective fellows. It produced an outstanding calibre of photographic talent over the years, including Abbas, Eve Arnold, Werner Bischof, Cornell Capa, Bruce Davidson, Elliot Erwitt, Burt Glinn, Philip Jones Griffiths, Hiroji Kubota, Susan Meiselas, Martin Parr, Marc Riboud and Chris Steele-Perkins, to name but a few.

Also of note, in 1941 the Museum of Modern Art (MoMA) in New York established a department dedicated to photography. This important move was the first instance of official recognition of photography from a fine-art establishment.

By the close of the decade, the International Museum of Photography had been established at George Eastman House in Rochester, New York. The museum's charter to 'educate by the teaching of the history of photography through exhibits' remains a guiding light today.

Technical Developments

In the 1940s there was further development of convenient, affordable and high-quality photographic equipment. In 1946, Eastman Kodak introduced the Kodak Ektachrome, which was the company's first colour film that photographers could process themselves.

This decade also saw an influx of new cameras, many of which would prove to stand the test of time. In 1947, Edwin Land marketed the first Polaroid camera. The following year, the first 35mm Nikon camera was introduced, along with the seminal Hasselblad 1600F. The Hasselblad 1600F was the first publicly available camera from the company founded by Swedish inventor Victor Hasselblad, which had previously made precision camera equipment only for the armed forces.

'Graham Jackson; Franklin D. Roosevelt [Death]', 1945. Ed Clark
Following its publication in *Life* magazine on 17 April 1945, this photograph came to symbolise America's grief following President Roosevelt's death. Even without any connection to the actual events, it is difficult not to be moved by the tears running down the accordion player's face. His eyes look up to the sky in silent evocation, almost as if he is asking himself 'why?' It is a universal gesture of grief captured perfectly by Clark. The two equally devastated women looking to their right further heighten the focus on the player, leaving little ambiguity. Clark's decision to focus on the grief of ordinary Americans proved not only to be a fitting epitaph to a much-loved President, but a meditation on mass grieving that transcends its origins as matter of public record.

'Solarized Nude', 1941. Andreas Feininger
Although mostly known for his architectural photography, Feininger's solarised nudes are a beautiful example of the technique popularised by Man Ray and Lee Miller. The lack of features on the face and body of the model allows the viewer to focus on the sculptural outline of her figure, imbuing the contours with a draughtsman's delicacy. Influenced both by his father, (Bauhaus painter and teacher Lyonel Feininger), and his architectural training, Feininger's photographs have a distinctive surety of form. In this case, his confident approach towards the model, seen in her brazen pose, celebrates the human form with great aplomb.

'Margaret Bourke-White', 1943. Margaret Bourke-White

As a well-known photographer for *Life* magazine, Margaret Bourke-White was among the first photographers to realise the value of aerial photography. In this self-portrait we see the strength of a woman who thrived as a documentary photographer, even in the most adverse conditions, with good-humoured determination. Use of a low camera angle for this full-length shot heightens her stature within it. This justly represents the attributes of her character, profession and solidarity with other women during the Second World War, a time that saw so many women assert their talents beyond the traditional norms of the day to help the war effort.

The 1950s

Key Movements
Situationalism

Key Techniques and Developments
Many competing 35mm cameras introduced
The Contax D camera unveiled (1952)
Introduction of the Nikon F camera; the first SLR from Nipon Kogaku (1959)
The Voightländer Bessamatic Zoomar lens introduced (1959); the first SLR zoom lens

Key Photographers
Richard Avedon, Robert Frank, William Klein
Irving Penn, Dennis Stock

Overview
The 1950s was a post-war period of economic boom in the West, and increased consumer spending propagated new commercial opportunities for photographers. Among those who rose to prominence during this decade were American photographers Irving Penn and Richard Avedon, who became known for their work in advertising and fashion photography. In contrast, other photographers were driven to work in a more insular manner, turning a critical lens towards their own societies.

American photographer Minor White founded the significant and influential *Aperture* magazine in 1952 along with prominent fellow photographers Ansel Adams, Dorothea Lange, Barbara Morgan and Beaumont and Nancy Newhall. White edited *Aperture* for 23 years.

In the 1950s, photography had become increasingly popular, although was still able to stir up a little controversy. William Klein's unorthodox use of the camera, typified by an experimental style that included enlarging abstract photograms to mural size, caught the attention of *Vogue* magazine's art director Alexander Liberman. On Liberman's invitation, Klein returned to New York from Paris, where he created an abrasive and controversial body of work that resulted in the 1956 book, *Life is Good and Good for You in New York: Trance Witness Revels*. The title reflects the book's contents, which provoked both a positive and negative response. His darkroom manipulations provided thoroughly expressive, blurred, grainy, contrasting and wide-angled distortions, presenting a somewhat foreboding and radical interpretation of the city; a satirical and iconoclastic study. In Paris, however, the work seemed to strike a chord and received crital acclaim.

Robert Frank's seminal monograph *The Americans* also courted similar controversy. Swiss-born Frank was the first European to receive a Guggenheim Fellowship, and this enabled him to travel across America, documenting his journey en route. The resulting monograph, *Les Américains*, was published in 1958, followed by the English-language edition in 1959. Frank took 28,000 snapshots, editing the portfolio down to 80 images for his album. *The Americans* was a controversial and ironic commentary on the emptiness of modern America and was to be an inspiration for generations of young photographers, among them William Eggleston, who was shortly to become a frontrunner in the photographic movement.

As well as controversy, the medium was also to prove capable of creating a popular 'buzz'. The groundbreaking 'Family of Man' exhibition, organised by Edward Steichen in 1955 and held at the Museum of Modern Art (MoMA) in New York, was a huge success. The exhibition's aim was to celebrate mankind, from birth to death, touching on all aspects of the human experience. It exhibited 508 photographs from 68 countries, which were selected from tens of thousands of submissions. The curation of the show was designed to bear a resemblance to the popular format of magazines such as *Life* and *Look*, with images hung at different levels and printed in different sizes in order to maximise the impact of the work. The book that accompanied the exhibition is still in print and reads very much like a who's who of key photographers.

African-American artist Roy DeCavara published *The Sweet Flypaper of Life* in 1955. This book depicted an uncommon glimpse of Harlem, one that revealed oft-morose yet humane details of everyday life. Its images were accompanied by commentary from Langston Hughes and the book received great recognition. In 1952 DeCavara became the first African-American to be awarded a Guggenheim Fellowship.

Technical Developments

Miniaturised electronic components, first developed during the Second World War, had many post-war applications and one of these was to advance the simplification of the camera even further with the inclusion of automatic exposure systems, which became common to the majority of inexpensive cameras.

The once thriving photography industry in Japan was quick to recover from the wartime devastation. Initially concentrating on low-cost, low-quality mass production, by the late 1950s Japanese cameras started to acquire a world-class reputation.

'Broadway Convertible'. Louis Faurer
Faurer's images of Philadelphia and New York in the 1950s capture the vibrancy and pressure of urban life. The streets of New York are the perfect place to reveal the dynamism of both the city and its people. In this photograph a group of young people enjoy the bright lights of the metropolis during a night on the town. The signs that surround them are reflected on the bonnet of the car, bringing an otherwise dark surface to life, a decisive moment that enhances the excitement of the people within it.

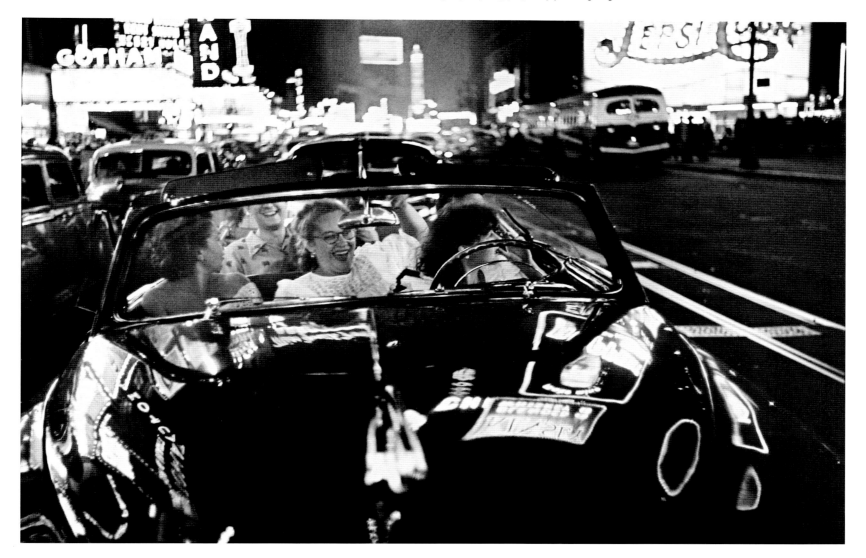

The 1960s

Key Movements
Conceptual Art
Pop Art
Minimalism

Key Techniques and Developments
Polaroid instant colour film launched (1963)
Kodak Instamatics introduced (1963)
Cibachrome process introduced (1963)
Flash cube introduced (1965)

Key Photographers
Eddie Adams, Bernd and Hilla Becher,
William Klein, Ed Ruscha, Andy Warhol

Overview

Appropriately enough for a decade that witnessed radical political and social upheavals, the 1960s also saw an increased blurring of the boundaries between fine art and photography; the latter becoming an increasingly popular tool at the disposal of artists working across a range of intermedia projects. Pop artists such as Andy Warhol, Robert Rauschenberg and Peter Blake regularly incorporated photography into their work.

Warhol's experiments in film, photography and other media epitomised the decade. Warhol was renowned for his self-referential approach to art and his photographic work was no exception. While encompassing a wide variety of media, the pop-art phenomenon of the 1960s was influenced by photography in numerous ways. Andy Warhol's interest in mass media led him to emulate the aesthetic of tabloid newspapers; his 'Disaster' paintings showed repetitive violent images of scenes such as electric chairs and car wrecks and his screen-printed images of cultural icons, among them Marilyn Monroe, Elvis Presley and Jackie Onassis, demonstrated a fascination with fame that would eventually extend to Warhol himself. However, Warhol's offhand documentary photographs of the Factory scene are more than historical curios, as they would prove to be highly influential upon later photographers.

The same notions of mass production and cultural popularity that fascinated Warhol also interested the artist and photographer Ed Ruscha. His conceptual photographic title, *Twenty-six Gasoline Stations* (1963), displayed banal images of gas stations along Route 66 and is a notable snapshot study of the pop-art era. Another artist whose foray into photography proved fruitful was the avant-garde American artist Robert Rauschenberg. Rauschenberg incorporated photographic reproductions into his paintings, constructed large silk-screen prints with collage, and also referenced images from topical news and personal themes with his sculptures.

In 1966, Cornell Capa founded the International Fund for Concerned Photography, as a means of preserving the legacy of his brother – who had been tragically killed eight years earlier while on an assignment in Indochina for *Life* magazine – and Robert's colleagues Werner Bischof, David (Chim) Seymour and Dan Weiner Robert, whose untimely deaths in the 1950s had left a void in the photographic world.

Bernd and Hilla Becher began taking portraits of modern industrial buildings and were further encouraged by American conceptual and minimalist artists including Carl Andre, who wrote an early article on them for *Art Forum*. The Bechers' clinical and scientific approach to photography appealed to the sensibilities of the conceptual and minimalist movements. Their photographs catalogued numerous industrial forms including water towers, coke ovens, gas tanks, mineheads and other anonymous structures, and their chosen methods of exhibiting their work, sometimes in grid form, also proved surprisingly influential in the photographic field.

By this point, the medium of photography had become so ubiquitous that the concept of a 'defining image', one which becomes so familiar and representative of its time that it transcends both its genre and photographer, began to gather pace. The turbulent year of 1968 saw the Tet Offensive in Vietnam, the assassination of Robert Kennedy, and the first orbit of the moon by a manned spacecraft, and all were immortalised on film. While thousands of exposures were posted back from Vietnam, it is hard to forget Eddie Adams's Pulitzer-winning picture of General Loan executing a Viet Cong prisoner. Similarly Bill Eppridge's 'Robert Kennedy Moments After He Was Shot' belies its chaotic origins through the sheer, unexpected strength of the composition. Perhaps the most significant and sublime image of 1968 was the very first photograph of Earth from the Moon, a picture that may have had the same effect on the 1960s viewer as the pioneer images had on their own contemporary audience.

Technical Developments

In 1963, Polaroid developed their instant colour film and the distinctive and now familiar Polaroid photograph – a thick, tinted square image framed by a chunky, white border – was to become as representative of the 1960s and 1970s as Woodstock and disco fever respectively.

In the same year, the Cibachrome printing process was also introduced. Cibachrome prints are made from slides or colour transparencies in a system that is quite different to traditional colour printing. The image is formed on a plastic base (rather than on paper), which produces a print with excellent colour intensity, sharpness and reproductive accuracy. Cibachrome prints are still prized for their longevity today by collectors and museums alike.

In 1965, the flash cube was introduced. This portable illumination was another iconic motif of the decade and enabled amateur photographers to take pictures in darkened environments with relative ease.

'Jarabina', 1963. Josef Koudelka
Koudelka's collective work, *Gypsies*, published in the 1960s in his book of the same name, recorded the plight of the disappearing Eastern Slovakian gypsy communities during the decade. Taken from a higher point than that of the handcuffed subject, Koudelka allows us to be privy to the despairing isolation of this man's impending trial. Koudelka's ability to empathise with the human condition without judgement is quite evident here.

The 1970s

Key Movements
Conceptual Art
Neo-Expressionism

Key Techniques and Developments
Polaroid SX–70 introduced

Key Photographers
William Eggleston, Richard Misrach, Richard Prince,
Cindy Sherman, Stephen Shore, Joel Sternfeld

**'Untitled', 1960–80 (Exact Dates Unknown).
Miroslav Tichý**
Taken with a makeshift camera concealed in his shirt, Miroslav Tichý captured intriguing images of women, passing by blissfully unaware, in a small town in the east region of Moravia in the Czech Republic (formerly Czechoslovakia). In this photograph, Tichý's voyeuristic approach works on opposing levels. On one level this somewhat sinister methodology is redeemed by the anonymity of his subject. However, by not revealing the woman's identity in this faceless portrait Tichý allows his seemingly illicit surveillance to be transferred to the viewer and as such they too become a willing participant in the act.

Overview

The 1970s saw the social revolutions of the 1960s come into fruition. In photography, an 'establishment', complete with its own art history and reference points, gradually began to take shape. Significant recognition of the relative value of different photographers also began to develop during this decade, and this produced a sudden increase in the collectors' market. In 1970 Sotheby Parke Bernet Inc., New York held the first significant photograph and photographic equipment auction, and many subsequent auctions of work would follow over the decade.

During the 1970s, many past luminaries exerted a powerful influence over young photographers. Bernd Becher, for example, taught at the Düsseldorf Art Academy; his noteworthy students included Andreas Gursky and Candida Höfer.

While it would appear that photography had finally reconciled its insecurity of status within the fine-art canon, there were some new developments within the 1970s that allowed the boundaries to be pushed further still. For example, it was only in 1971, a year after her death, that Diane Arbus became the first American photographer to be exhibited at the Venice Biennale.

Throughout the decade experimentation also continued. The work of artist Georges Rousse typified the postmodern approach to photography that would bloom over the coming years. Rousse's images combine installation art with painting and photography. His work is typified by painting the three-dimensional surface area of a space, usually inside derelict buildings, which he then carefully positions within an actual space in order to photograph it. This produces an image that 'deceives' the viewer into perceiving the painting to be part of the photographed 'reality'. The eye perceives the overlay of colour, grids or shapes within the composition as an added and manipulated photographic layer, but in fact it is simply a reproduction of an actual object that has been carefully aligned to sit within the space and painted to fit a specific perspective.

A seismic shift during this decade was the emergence of 'new colour' photographers. This brought a fuller appreciation of the colour photograph to both the medium and the fine-art arena. Its previous association with advertising and commercial purposes had meant that, until now, the colour photograph had often been considered unworthy and not taken seriously by the arts canon.

One photographer who seized upon these negative, commercial associations and exploited them through his work was the New York-based artist Richard Prince. He appropriated advertising imagery in order to exploit the vagueness of commodity and the ideology of consumption in America. His 1977 series 'Untitled (Living Rooms)' re-photographed details of advertisements, thus reducing them to prosaic scenes of luxury. In a similar vein, his

1978 series 'Untitled (Three Men Looking in the Same Direction)' and his 1980 series 'Untitled (Three Women Looking in the Same Direction)' conceptually proved that if these details were taken out of their usual context they could be read in new ways: as a critique of American consumer culture.

From 1973 to 1974, and towards the end of his life, the legendary photographer Walker Evans – who had once bluntly described colour photography as 'vulgar' – began using a SX–70 Polaroid camera (Evans did, however, refer to the camera as his 'toy', suggesting that he perhaps still had reservations as to the validity of the colour Polaroid). Regardless of his scepticism, the results were remarkable and in 2002, long after his death, a book of this work was published to great acclaim. In 1976, American photographer William Eggleston's acclaimed exhibition at MoMA, New York was seen to legitimise colour photography as a serious medium for artists, once and for all.

In 1974, the International Centre of Photography (ICP) was established in New York City as a permanent home for the collection that Cornell Capa had amassed through the International Fund for Concerned Photographers. The ICP focused on the humanitarian documentary work of great photographers, with the aim of keeping such work visible to the public eye. Situated on Fifth Avenue's 'museum mile', the ICP Centre has become a driving force in the promotion of photographic display and education, and has staged more than 500 exhibitions to date.

Other key developments in this era include Robert Mapplethorpe's 'Polaroids' exhibition held in 1976, and the publication of Susan Sontag's *On Photography* in 1977. Sontag's collection of essays remains in print today and is still a core text for a number of photographic courses.

Finally, between 1977 and 1980, Cindy Sherman produced 'Untitled Film Stills', a black-and-white series in which she posed as a variety of B-movie actresses. Her stereotypes exemplified the male gaze, as she perceived it. Her continued success places her amongst the highest earning female photographers today.

Technical Developments

The process of automating most camera functions was completed in the late 1970s, when the first point-and-shoot cameras appeared on the market. Konica was the first to manufacture such a camera, but many others were soon to follow.

The evolution of professional camera designs tended to be a more gradual process. In the 1970s professional cameras became available with automatic exposure-control systems, and several advanced professional cameras offered automatic focusing.

The 1980s

Key Movements
Postmodernism

Key Techniques and Developments
Apple introduces its first Macintosh computer (1984)
Electronic scanners are introduced (1988)
The first all-digital cameras are introduced (1988)

Key Photographers
Nan Goldin, David LaChapelle, Robert Mapplethorpe,
Helmut Newton, Richard Prince

Overview

The 1980s was a decade characterised by excess, economic boom and bust, conspicuous consumption and a conservative backlash to some of the social upheavals that had taken place in the preceding 20 years. These factors all exerted an influence on the photography of the period.

Perhaps the most direct form of influence was in the soaring prices of photographs at auction. John Paul Getty Museum's 1984 acquisition of a photographic collection was a particularly sound investment. It amassed eighteen important photographic collections for the price of US$25 million, a comparative steal. The museum also began to collect family snapshots to encompass the collective experience of ordinary Americans. The snapshot began to rise as a collectable medium of import and is now culturally and historically appreciated by the photographic world.

From a broader cultural perspective, the 1980s experienced a shift from modernism to postmodernism, which is a movement typified by pastiche, self-referentiality, irony and eclecticism. Elements of postmodernism can be identified in artistic movements as far back as the 1920s, but the 1980s established – if not clearly delineated – postmodernism as a cultural phase.

As a result, the categorisation of genres in the photographic medium began to blur further. Photographs could no longer be classified in finite terms such as 'fine art' or 'documentary'. A prime example of this can be seen in the work of Nan Goldin, who could be considered as both a fine-art photographer and a documentary photographer. The beauty of Goldin's images and the way in which they are presented in books, screened to music or displayed in galleries would suggest that her work was firmly within the boundaries of 'fine art'. However, the subjects she tackles, such as domestic violence, drug use and AIDS, are areas traditionally associated with documentary photography.

Magazines and journals began to lead the way in this acceleration of indefinite genres. Fashion photography of the day often appropriated themes from other genres to bring new and interesting ways of selling a lifestyle as well as the merchandise. It wasn't just about the clothes any more: authorship became a precursor for many fashion photographers. The associated kudos of being professionally photographed was replaced by that of whom you were photographed by. The success of 'superstar' photographers such as David LaChappelle and Mario Testino were an indication of this state of flux, which continues to endure in today's photographic world.

LaChappelle creates fantastic, surreal, colourful worlds brimming with humour and irony, but never at the expense of the lavish glamour which makes his work instantly recognisable. His

fortuitous meeting with Andy Warhol, backstage at a Psychedelic Furs concert in 1988, proved to be the beginning of a bright and illustrious career for the photographer and director. This meeting led to his first professional job, at only 18 years of age, for Warhol's *Interview* magazine. LaChapelle's subsequent rise to photographic dominance in the 1990s, especially in the world of fashion photography, has been nothing short of miraculous. His prolific body of work includes numerous celebrity portraits, album covers and fashion photographs that are instantly recognisable for their wacky, colourful and outrageous style. *American Photo* magazine ranked him among their top ten most important people in photography in the world, a grandiose claim, but representative of the accolades often made about this extraordinary photographer.

In many ways, fashion photography experienced something of a renaissance during the 1980s. A key work of the period was Helmut Newton's 'Beauté – Silhouette 82', which was published in French *Vogue* in November 1981. These images marked a changing attitude towards the role and perception of women in society and in fashion. Newton's two images showed the same four women identically posed: nude (apart from their high heels) in one shot and smartly clothed, confidently walking towards the camera, in the other. Now, probably Newton's best-known work, this striking juxtaposition of femininity was not passive, but aggressive. After the work's publication it became commonly known under the motif 'they're coming'!

The era also produced some distinctive new voices. The body of work produced by Robert Mapplethorpe from 1980 to 1983 entitled 'Lisa Lyon' – and including films, book projects and exhibitions – has since become one of his definitive works. Rendered in his inimitable classical style, Mapplethorpe's muse for this work was the titular Lisa Lyon, the first female bodybuilding world champion. Initially this work could have been seen as a departure from his somewhat disingenuous image as a photographer concerned with homoerotic and sado-masochistic subject matter, but through Lyon's assertive posturing, Mapplethorpe addressed some of the same concerns that had always underlined his work. Power was no longer the sole privilege of the male sex, and this muscled woman stood as a testimony to an era obsessed with wealth and power.

In 1983 Richard Prince re-photographed an image of Brooke Shields that had been taken by commercial photographer Gary Grossman when she was ten years old ,and controversially showed her in the nude. The sensitive nature of this extremely provocative image was heightened due to the fact that Brooke's mother had given her consent for Grossman to take the original photograph, but subsequently attempted to prevent its publication. The controversy surrounding the image posed Prince with many problems. He realised the potential implications of exhibiting the

work, and so quietly established a 'gallery' (Spiritual America) where the work could be viewed by appointment only. In doing so, he avoided direct association with the image. The moral dilemmas that this raised are a reflection on the changes in art and photographic practice in the postmodern age.

If the 1980s embraced fashion and glamour, albeit with a subversive undercurrent, the decade was a little harder on its more controversial artists. In 1988 American artist Andres Serrano received a grant for US$15,000 from Awards in the Visual Arts, which was partially funded by the National Endowment for the Arts (NEA). The large-scale image he subsequenty produced caused a wave of controversy: a colour photograph, entitled 'Piss Christ', depicted a small plastic crucifix submerged in urine. Without the explanatory title, the image appears to be a rather conventional, almost beautiful piece of religious art. The American Family Association and US Senator Jesse Helms were among numerous groups and individuals who vehemently opposed the work and

fuelled debate over whether or not federal government should fund such works of art. Serrano was vilified, the exhibiting gallery closed, and as a result, NEA annual funding was slashed by around US$70 million and has yet to fully return to the funding levels of the mid-1980s.

On a more celebratory note, 1989 marked the 150th anniversary of photography, taking the 1839 development of the daguerreotype as the beginning of the medium proper, and a number of large-scale exhibitions were staged to celebrate this.

Technical Developments
By the end of the 1980s the first digital cameras had been developed, although the full impact of this transition would not be felt until the next decade. Japan, sharing in the mass consumerism and economic prosperity of the decade, had begun to dominate the camera market and was competing with the US to become the world leader in new technology.

'Untitled (Fashion)', 1982–84. Richard Prince
Resolutely powerful in this portrayal of Debbie Harry, Richard Prince raises her to iconic status with this striking portrait. The strong, heightened definition between the light and dark areas of her face allows the appropriation of a pop-art style, with its graphic nature, to be read much like a Warhol screen print.

The 1990s (and beyond)

Key Movements
Neo-Romanticism
Postmodernism (especially in landscape)

Key Techniques and Developments
Adobe Photoshop introduced (1990)

Key Photographers
Noyobuyoshi Araki, Andreas Gursky,
Naoya Hatakeyama, Andres Serrano,
Thomas Struth, Mario Testino

Overview

Following the collapse of the Soviet Union and the end of the Cold War, the 1990s saw a progression of trends in commercial and social globalisation that had been established in the previous decade. Global capitalism spread and favourable economic conditions saw consumerism grow rapidly, even in less affluent countries.

Photography continued to grow in value and esteem, with key works reaching extraordinary prices. A print of Man Ray's 'Glass Tears', for example, was privately sold to New York collector John Pritzker for US$1 million in 1995.

In such a wide and enthusiastic market, many niche interests regularly draw attention to unexpected areas of collectable photography. In the late 1990s, the anonymous snapshot became the subject of many exhibitions worldwide. Such collections were also the subject of many books, including *Other Pictures: Anonymous Photographs from the Thomas Walther Collection, Real Photo Postcards: Unbelievable Images from the Collection of Harvey Tulcensky* and *Snapshots: The Photography of Everyday Life 1888 to the Present*, which was also the subject of a major exhibition in 1998 at the San Francisco Museum of Modern Art.

Photographers also continued to take their place at the forefront of the fine-arts canon. The first photographer to win the prestigious Turner Prize in the UK was Wolfgang Tillmans in 2000. Of this decision, the *Independent* newspaper commented, 'photography is art. That … is official after the decision … to award a photographer the Turner Prize for the first time'.

In 2003, the Tate Modern in London held the 'Cruel and Tender' exhibition. Taking its title from a quote by Lincoln Kirstein – who described the work of American photographer Walker Evans as 'tender cruelty', referring to the factual yet subjective nature of his work – traditions of realism were the guiding factor in the curation of this show. 'Cruel and Tender' was a landmark exhibition of 24 influential photographers and the first exhibition devoted to photography to be shown at the Tate Modern. Generally considered a popular success, this exhibition represented the Tate's acknowledgement of photography as a fine-art medium and key component of contemporary visual culture.

The development and popularity of photography has continued with the impact of the digital revolution. With increased access to newer and ever cheaper technology, there are more ways to capture, process, print and share photographs than ever before. The instant gratification may seem frivolous, but the inclusive nature of photography has always been one of the medium's strengths and has ensured its continued popularity.

Technical Development

The 1990s marked the beginning of the digital revolution. Digital images could now be easily manipulated, stored and printed on most home computers. With new products and higher quality cameras, printers and scanners flooding the market, the possibilities open to amateur and professional photographers expanded daily and continues to do so.

Digital photography is fast becoming the medium of choice for amateur, and an increasing number of professional, photographers. Although a vast number of professional photographers still use traditional processing methods, digital printing is gaining popularity due to its flexibility and available manipulation possibilities.

Sales in black-and-white photographic equipment have fallen and, according to *The British Journal of Photography* (August 2005), are continuing to decline by six per cent every year. Similarly, reloadable 35mm film camera sales have noticeably dropped, and some traditional camera retailers are now choosing to exclusively stock digital cameras. In July 2004, Kodak announced that they would no longer market Kodak-branded cameras in the developed world, and Nikon have discontinued involvement with the compact camera market.

'River Series, No. 4', 1993.
Naoya Hatakeyama.
Hatakeyama's observations of Tokyo are multi-layered, staggering deconstructions of the urban environment, shown here by use of an elongated composition to emphasise the city's claustrophobia. Hatakeyama creates a distortion of time and a visually alluring and uncomfortable space simultaneously.

Due to the placement of the camera, the bank interrupts the path of the light as it drops from an angle to a vertical, giving the impression that the photograph has been cut in half. This extraordinary visual trick allows the two elements of water and concrete to separate. This, coupled with the image's vivid colour, provides an ethereal quality, which is set against reality and thus is holding the image in flux.

Chapter Two
Profiled Photographers

In order to hint at the potential scope of your collection, and provide a more intimate level of detail to the sprawling and occasionally daunting history of the medium, the images reproduced in this chapter have been specifically selected to demonstrate a broad range of photographic genres and are representative of a number of eras.

Each profiled photographer here is deemed to have made some contribution to the medium, or else displayed a quality in their work that has assured its 'collectability'. Each photograph is accompanied by contextual and insightful commentary, and general information about the photographer's body of work is also provided.

This chapter should not be treated as a comprehensive list of collectable photographers, but as an introduction to the wealth of different photographic personalities, techniques, genres and styles, one which will properly equip you for your photographic journey in collecting. Use the following profiles to explore different examples of how to read and understand an individual image, and identify those ideas and themes that spark a personal interest.

Berenice Abbott
Newsstand, E. 32nd and 3rd Avenue

Nationality: American, b.1898,
Springfield, OH (USA), d.1991
Genre: Social Documentary/Landscape
Date: 1935
Print: Silver Bromide
Edition: 30
Price:
Size: 8 x 10 inches

The Photograph
This is one of the 300 negatives made for
Abbott's 'Changing New York' project,
which was inspired by Eugène Atget's
photographic documentary of Paris.

This image presents us with a sea of faces
within the metropolis, not captured in the
flesh, but displayed across a newsstand.
The myriad of movie stars is seemingly
within the general public's grasp through
the newsstand's celebrity magazines,
which were a thriving medium at the
time. The magazines' cover stars seem to
gaze out towards the pavement, pleading
to be noticed, as if competing to attract
the attention of passersby.

The clarity of the image allows us to
virtually step on to the pavement and
browse for ourselves, just as the man to
the left of the image does. By placing
her camera at an angle to the stand,
Abbott leads us right into the frame; a
quality common to much of her work.
This trailblazer's architectural and
documentary images of New York
are still a touchstone in American
photography today.

The Photographer
This pioneering American photographer
began her career as a photographic
assistant to Man Ray. Immersed in the
intellectual and social world of Paris,
Abbott soon began taking portraits
herself and her subjects included
significant cultural figures such as Edward
Hopper, Jean Cocteau, James Joyce and
Max Ernst.

Taking an interest in Eugène Atget's
work, Abbott was instrumental in
introducing his photographs to
America, and was visibly inspired by
his documentary images of Paris, which
is clearly evident in her later work in
New York.

Upon her return to America in 1929
Abbott undertook her most seminal
project: 'Changing New York'. The
Works Project Administration sponsored
Abbott and provided her with a salary
and staff with which to produce a
book of the same name. This work
covered every element of New York in
flux: its people, buildings and urban
landscapes. Skyscrapers and landmarks
were immortalised by Abbott's keen eye
and her images are still instantly
recognisable today.

In 1944 Abbott became the picture editor
for *Science Illustrated* and spent two
decades photographing work for science
textbooks as well as collaborating on
books for children.

Later, Abbott moved to Maine and
explored her new surroundings,
producing a book entitled *Portrait of
Maine*. Abbott's work from her time there
provides a perfect counterpoint to her
earlier photographs of New York.

Robert Adams
Sheridan Boulevard, Lakewood

Nationality: American, b.1937, Orange, NJ (USA)
Genre: Landscape
Date: 1970–72
Print: Gelatin Silver Print
Edition: None
Price: £6000/US$11,000
Size: 6 x 6 inches

The Photograph
The Dunlop signage points to the garage forecourt, but leads our eye beyond the perimeters of the manmade and into the natural beauty of the sky above. This graphic and linear layering of elements is photographed at an angle, which elevates an otherwise banal subject to an intriguing composition. Within this photograph, Adams captures the acceleration of American consumerism and the country's economic, social and practical dependence on the automobile.

As part of his 'The New West' series, Adams's non-judgemental treatment of the mountains, prairies and foothills, and the cities and suburbs that co-exist within them, produced an uneasy and yet somehow restful tension between the two extremes. This example is a glimpse of a truly 'American' scene that, despite its connotations, retains an aesthetic beauty to which Adams's work has become a defining force.

The Photographer
The changing landscape of America has been the subject of many great photographers of the twentieth century. Few however have influenced so many through their style and vision as Robert Adams. By exposing the beauty around him and combining the often stark, brittle and hard-edged manmade surfaces laid upon the landscape, Adams's work has developed a unique photographic identity.

Embodying America through the physical alteration of its landscape, Adams 'surveys' an area with his camera, and leaves the viewer to critique it. Often recognisable by his use of stark, harsh light, Adams's affection for the landscape always permeates in the most unlikely locations.

In his scrutiny of the eastern edge of the Rocky Mountains in Colorado, which resulted in a series of nightscapes, Adams conveyed the same contrasting distinctions of mankind's encroachment into the wilderness. In his 'Summer Nights' series, Adams demonstrates how the land poetically blends with the buildings, concrete and lights of Denver under the cover of darkness. Instead of the harsh sunlight, bright moonlight softens the eerie tranquillity of the landscape and the result is a deeply sensitive and gentle document of the area. Such sensitivity is prevalent in all of Adams's work, but it remains far from sentimental. This charges his images with a profound intensity, which quietly unveils the epic stature of all he surveys.

Anderson & Low
National Danish Gymnastic Team #1

Nationality: Anderson: British, b.1961, London (UK); Low: British, b.1957, Kuala Lumpur (MAL)
Genre: Nude/Fine Art
Date: 1998
Print: Toned Silver Gelatin Print
Edition: 10
Price: £5500/US$9500
Size: 60 x 48 inches

The Photograph
With this dramatic composition, Anderson & Low seamlessly merge iconic Graeco-Roman depictions of athleticism with a more contemporary sensibility. As part of a series of photographs taken of the Danish National Gymnastic Team, Anderson & Low explored the four elements: earth, air, fire and water.

In this image (earth), the gymnasts appear strong and statuesque, demonstrating their physical prowess and gymnastic ability. The tones in the photograph serve to accentuate the historical references to the nude in art, and Anderson & Low photographically reference the way in which nude and anatomical studies of the human form have been drawn, painted and sculpted for centuries. By using light, shade, composition and printing techniques to heighten the muscle tone of the athletes, Anderson & Low have photographically rendered the male form, just as da Vinci might have done so with cross-hatching in ink. This combination expresses a mutual admiration of both the artists and subject to produce winning results.

The Photographers
Jonathan Anderson and Edwin Low have proved to be an enduring and compatible partnership since 1990. The quality of their printing processes, a rigorous sense of composition and an awareness of art history has firmly established their place in the photographic world. Their body of work includes landscapes, architectural images, nudes and portraiture.

Early architectural nightscapes set a precedent for their use of available light, so as not to dispense with the ambience of the environmental elements of each site. This characteristic is enhanced in their athletic portraiture, and enables the energy and dynamic attitudes of their subjects to shine through. Anderson & Low's portraits of American military athletes at three academies in the USA depict the modern hero in mortal terms, sustaining the sense of the individual within the confines of the military unit they are a part of. Photographed in uniform and in sporting pursuits, the images present the emotion and dedication of these young cadets in equal measure.

An essentially humanist approach is adopted with every Anderson & Low project, delivering a strong and common methodology in their visual language.

Nobuyoshi Araki
Personal Photographic Emotionalism

Nationality: Japanese, b.1940, Tokyo (JAP)
Genre: Portraiture/Social Documentary
Date: 2000
Print: Silver Gelatin Print
Edition:
Price:
Size:

The Photograph
Although highly erotic, Araki's composition here is full of symbolism and control. The careful placement of objects at the woman's feet suggest the importance of power and hierarchy within a male-dominated society. Despite the woman being the focal point of the composition she is subordinate to the objects, which are loaded with direct and indirect sexual connotations. They convey and enhance the pursuit of male pleasure through subservience.

A picture of a woman as a toy or a plaything is titillating, yet Araki's perspective in this scenario is that of a photographer, not of a prospective client. Araki is intent on ensuring that his audience understands he has created a scene to be photographed, and not photographed a scene that he has stumbled upon by chance.

The Photographer
The realities of Tokyo's sex industry have been an enduring fascination for Nobuyoshi Araki. Laying it bare for all to see, Araki's prolific output reflects the scale of the industry as well as its multiple layers and historical traditions, many of which are still prevalent today. Araki does not avoid the uncomfortable truths of the industry; he instead lays them bare for the viewer.

Recurring themes such as Japanese history and culture, birth, life and death are often suggested through symbolism in Araki's work. Producing numerous monographs, Araki has become increasingly collectable for both photography and book collectors alike, and his work reflects many elements of his own life and relationships as well as those of his subjects together, without distinguishing one from the other. These blurred edges form a cacophony of visual references, which include flowers, cats, people, street scenes and studio portraiture. Using vibrant colour as well as black and white generates a continual movement from the past to the present, which keeps Araki's work fresh and challenging in equal measure.

Eve Arnold
Marilyn Monroe During Filming of *The Misfits*

Nationality: American, b.1913, Philadelphia, PA (USA)
Genre: Portraiture
Date: 1960
Print: Silver Gelatin Print
Edition:
Price:
Size: Various

The Photograph

Eve Arnold was one of the photographers present during the filming of *The Misfits*, which was beset with many difficulties due to Monroe's lateness and tangible personal problems. Arnold had photographed Monroe many times throughout her career and the nature of their relationship is often visible in Arnold's sensitive portrayals of her.

In this work, Monroe's anxiety transpires in her worried expression and awkward stance, but does not compromise her undeniable beauty. This appears to be a snapshot of an unguarded moment, depicting the less glamorous side of acting. Arnold's quiet, behind-the-scenes observation reveals Monroe in another light: not as a superstar, but instead an ordinary and fragile human being.

The Photographer

Working extensively on film sets and having close access to a multitude of stars, Eve Arnold's photography is imbued with intimacy without being intrusive. Her revealing pictures of an aging Joan Crawford during the filming of *The Best of Everything* display a personal dialogue charting Crawford's attempts to avert her inevitable maturity. Arnold's images of Crawford in a girdle or having a facial, and close-up details of her applying make up, expose her efforts to retain her aesthetic identity within an industry obsessed with eternal youth and everlasting beauty. The dexterity Arnold has to be a trusted observer of private moments such as these is surely as revealing as the images themselves.

As a member of the Magnum Photographic Agency for more than fifty years, Eve Arnold's prolific portfolio has secured her fame in the photographic canon. No matter where her work took her, Arnold's approach to photography consistently demonstrated her resolute determination to visually tell a story through extended investigation of her subjects.

Photographing in both black and white and in colour, Arnold has become an iconic figure, a determined woman in what was a predominantly masculine world of photojournalism. Her fearless, humanist approach allowed her access to the lives of many remarkable people both famous and unknown, and Arnold's portraits will surely leave an impression on those fortunate enough to view them.

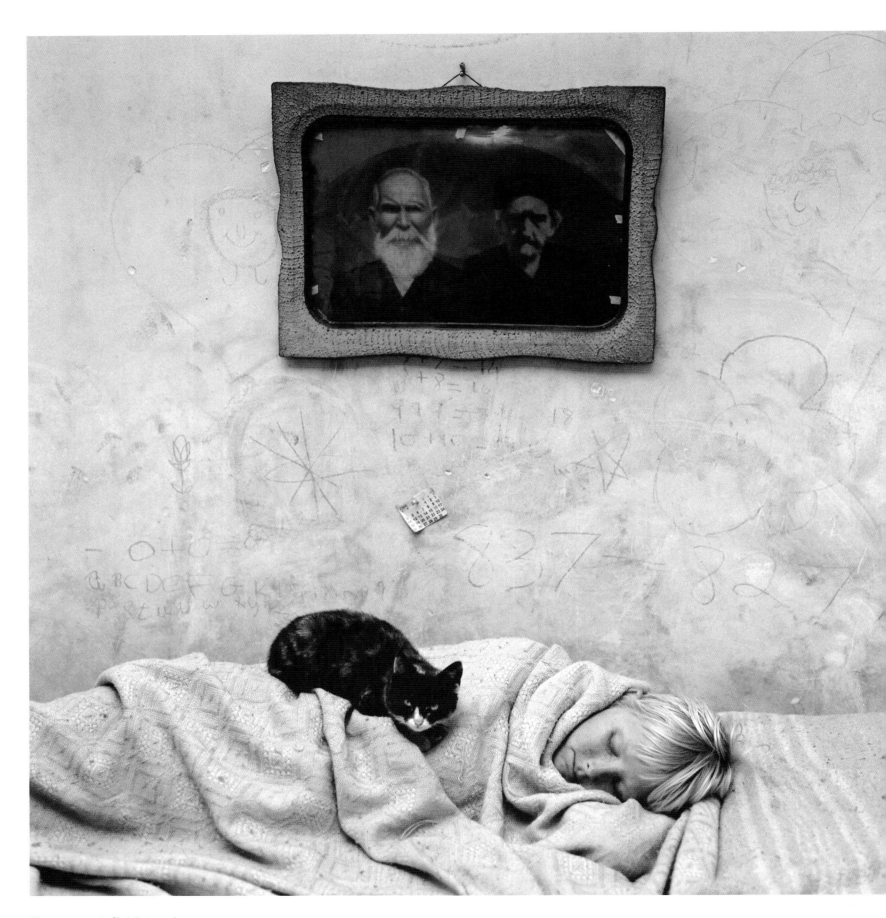

Roger Ballen
Portrait of a Sleeping Girl

Nationality: American, b.1950,
New York, NY (USA)
Genre: Social Documentary/Portraiture
Date: 2000
Print: Selenium-toned, Fibre-based
Silver Bromide
Edition: 35
Price: £2850/US$5000
Size: 16 x 16 inches

The Photograph
This image is one of a number of
photographs taken in a series entitled
'Outland'. Ballen, traditionally a
documentary photographer, crossed over
into the realms of art photography using
placement and composition to a greater
extent, specifically to guide his more
abstract aesthetic. This award-winning
image is typical of what Ballen calls his
'documentary fiction', whereby the
photograph's disturbing realities collide
with the beauty of its textural qualities
and Ballen's constructed arrangements.

This domestic scene is full of both hard
and soft edges. The outline of the girl,
and her cat, lying on the bed creates a
landscape that is not dissimilar to a
hillside; the picture hangs above the bed
just as the sun might hang in a cloudy
sky, to further enhance this visual simile.
We are given harsh realities that are
mixed with a nod to traditions more akin
to painting; the aesthetic concerns
override the social context. This balance
has a tendency to trouble the viewer
more than a 'straight' documentary
photograph would, and as such lingers in
the memory long after it is seen.

The Photographer
Ballen's work has caused controversy for
many reasons, not least for exposing the
squalor and degradation of poor white
people living in 'dorps' (isolated, small
rural towns in South Africa). Since 1981
Ballen has portrayed these subjects
extensively, despite an oppressive
apartheid regime that would have
preferred for his work to remain unseen.
These tableaux reveal the life of people
living on the fringes of society who collude
with Ballen to act out scenarios in their
own environments. There are opposing
arguments as to the intent of Ballen's
pictures. Some see them as the
exploitative ridicule of people who do not
understand the voyeuristic and grotesque
outcome of his work. Others see it as
empowering an already belittled group,
which would otherwise not have received
attention. Whatever the opinion, there is
no denying the power and presence of his
work in the photographic canon as a
whole.

Hans Bellmer
La Poupeé

Nationality: German, b.1902, Katowice (now POL), d.1975
Genre: Surrealism
Date: 1935/1949
Print: Vintage Silver Gelatin Print, Hand-coloured with Applied Aniline Dyes
Edition: None
Price:
Size: 5¾ x 5⅝ inches

The Photograph

This image was included in *Jeux de la Poupeé* (The Games of the Doll), a book published in 1949 by Editions Premières in Paris. The image appeared alongside an introduction and a selection of poems by Paul Eluard. Eluard, who worked with both Man Ray and Picasso, selected 'La Poupeé' along with thirteen other images, which were all to serve as inspiration for the book's poems.

Utilising a technique popularised on postcards at the turn of the century, Bellmer hand-coloured this image using a small flat brush to apply the aniline dyes. Despite using delicate colours such as pink and mauve, they appear unnatural and disquieting. Bellmer's doll sculptures were made so that they could be disjointed and reassembled into the most extraordinary arrangements. In this image the doll appears confined and contorted, as if it were trying to escape. This vulnerable-looking puppet is further fetishised by its exposed position on the ground, and photographing it from above further intensifies the sexual connotations of the work. Bellmer amplifies the dramatic impact of the picture by opposing the elements against one another. The harsh lighting is softened by the colour, yet the shadow brings the colour forward, which exaggerates the bulbous shape of the doll. Bellmer's talent to stimulate emotions that disturb and excite in equal measure is quite remarkable.

The Photographer

This German surrealist's doll fetish began with exposure to the work of a talented puppet maker named Lotte Pritzel, and was intensified when he saw 'Coppelia' in 1932, a ballet that featured a doll in its starring role.

Bellmer's photographic oeuvre was as adaptable as his feminine, erotic, rotund and voluptuous dolls. By inventing tints to lie over black-and-white photographs made with transparencies of pink or blue the aesthetic could be changed instantly. The psychological fascination with the motives behind Bellmer's work, which is still able to disturb and shock, remains a constant source of fascination today. Bellmer's competency in many areas earned him great respect in the photographic canon.

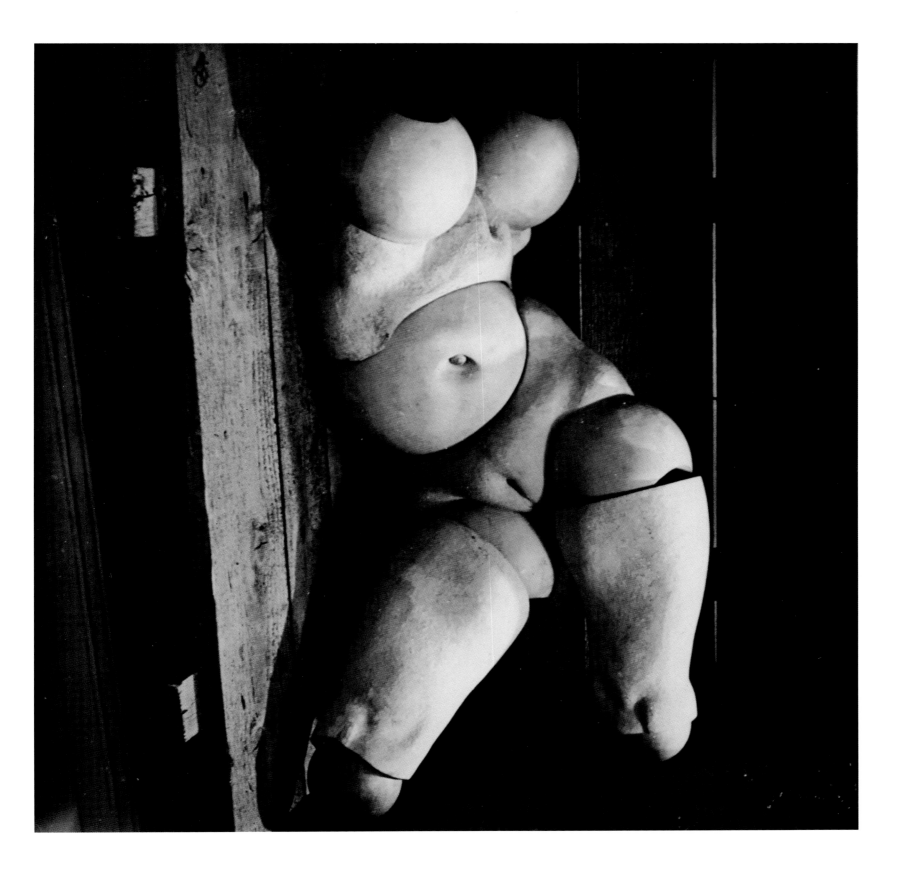

Ernest James Bellocq
Storyville Portrait

Nationality: American, b.1873,
New Orleans, LA (USA), d.1949
Genre: Portraiture
Date: c.1912
Print: Gold-toned Printing-out Paper
Edition:
Price:
Size:

The Photograph
As is the case with many of Bellocq's portraits of prostitutes working in New Orleans, the ease of his sitter is evident here. Striking a somewhat amused pose, the sense of fun in this portrait makes it a true joy to look at. Among the many elements vying for attention in the room, the sitter's stripy stockings take centre stage. Illuminated from the light coming in through the window, we are drawn to the crossed curvaceous legs of the sitter, and our eyes are then led towards the table and the assortment of objects upon it. Among these items is a curious selection of miniature chairs and tables that are adorned with feathers. Although Bellocq's artistic intentions are not known, the arrangement could be a still-life analogy of other pieces of furniture and sitters present in the room.

The feminine presence in the room, including the framed pictures hanging on the wall behind the sitter, resonates. Bellocq could have taken some or all of these framed photographs, whose characteristics are very similar to those found in his own work.

The Photographer
Very little is known about the much revered Bellocq. His photographs, taken in the parlours of Storyville (a notorious red-light district of New Orleans) in the early part of the twentieth century, subsequently came into the possession of distinguished American photographer Lee Friedlander. Friedlander printed the images from their original glass plates in 1970 and in doing so thrust the mastery of Bellocq into the public domain.

Rumour prevails as to the details of Bellocq's life and other work, including a Chinatown series and pictures taken from inside opium dens that have never been found. He was a commercial photographer whose private photographs are assumed by many to be a labour of love. His sitters often appear to be comfortable in his presence and friendly towards him, suggesting more than a passing acquaintance between the two.

The condition of the found plates was equally intriguing. Of the 89 discovered, all in various states of corrosion, the Storyville plates had been purposely vandalised, some of them with the sitters' faces scratched out. This malicious act also remains a mystery, but that the plates were not simply smashed is fortuitous, as it allowed a new audience to view the beauty of Bellocq's accomplished and fascinating work.

Werner Bischof
Women Praying for their Men at War

Nationality: Swiss, b.1916, Zurich (SW), d.1954
Genre: Social Documentary
Date: 1952
Print: Silver Gelatin Print
Edition:
Price:
Size: Various

The Photograph
This defiant statement against war is made without directly exposing the harrowed expressions of these women. By photographing them fervently praying, their soles upturned, we are left only to imagine their pain.

Bischof powerfully encapsulates emotion and empathy without disturbing or intruding upon these women's very private moment. The shoes on the floor look as hard as the stones they rest on, suggesting the life that these women lead is not easy. We are not supposed to feel comfortable looking at this photograph. There is an element of contemplation on the photographer's part here that is almost audible.

The Photographer
Bischof's offerings as a fine-art and commercial photographer, exploring light and form through still life, nude and nature studies were incredibly successful. Bischof mastered the principles of new vision and later became increasingly interested in surrealism, especially with Man Ray's photographic practices.

However, the Second World War and its aftermath changed the course of Bischof's work forever. His concern with cultural preservation and those communities coming to terms with their wartime experiences and rebuilding their lives in an unforgiving economic climate became a dominant theme. Documenting social injustices and the displaced and needy around the world enabled Bischof to reflect the human condition in his photographs. His undoubted respect for those whom he photographed resulted in some of the most unforgettable, empathic images in the photographic medium.

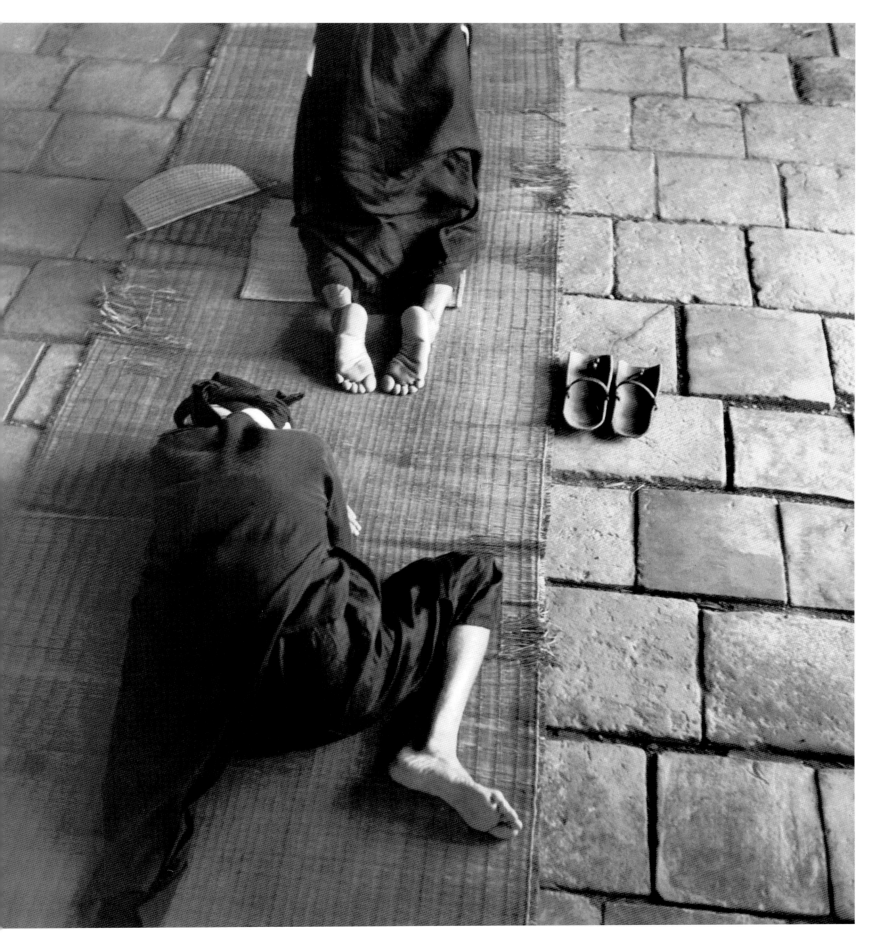

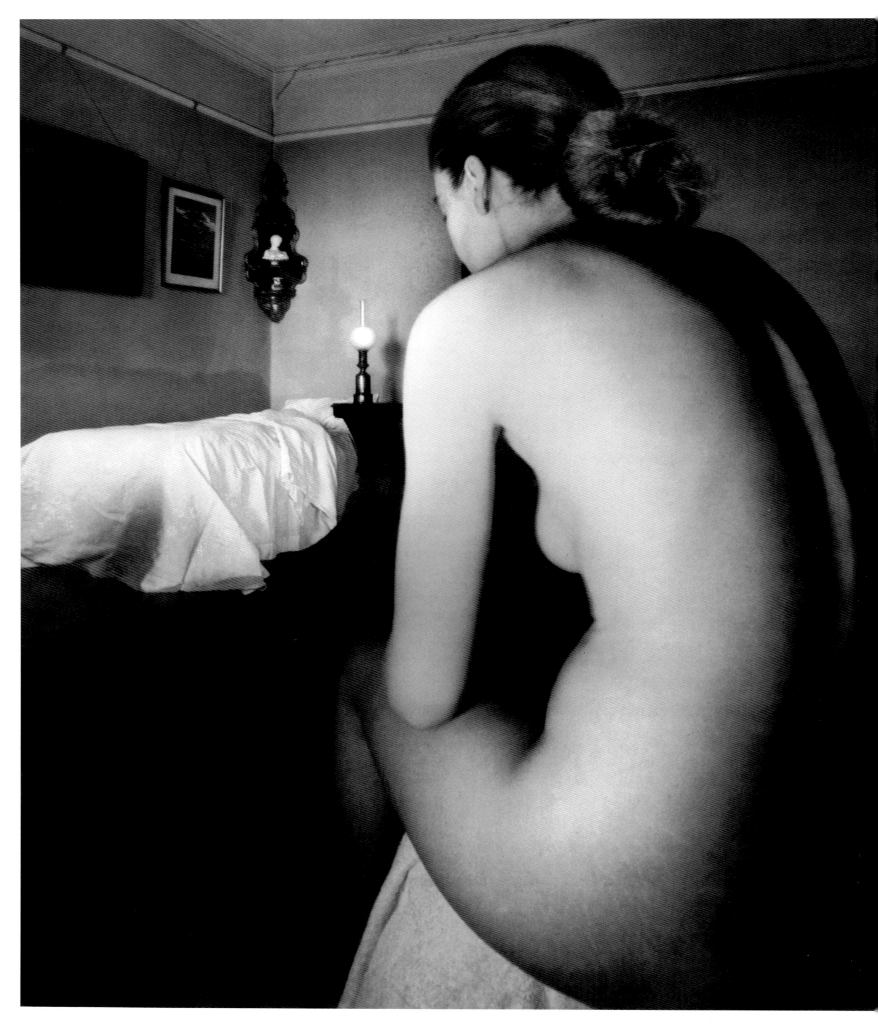

Bill Brandt
Nude, Campden Hill 1949

Nationality: British, b.1904, London (UK), d.1983
Genre: Nude
Date: 1949
Print: Silver Gelatin Print
Edition:
Price:
Size: 9½ x 7¾ inches

The Photograph

The isolation prevalent in this haunting and claustrophobic nude is all the more acute due to the distortion of scale, which has been achieved by Brandt's positioning of the camera. By forcing the perspective, his model becomes the largest thing in the room. Her hunched pose is accentuated by the light, which picks up the shape of the curvature of her spine. By highlighting the body, the lamp and the white bed sheets Brandt creates a triangle of focal points to lead the eye around the room. Contrasting light and dark shapes also lend a surreal quality to the image.

Just as André Kertesz used mirrors to distort the nude in his 1930s images, Brandt adopted a different 'physical' approach and used the models themselves to achieve a strangeness that is decipherable, but yet unnerving to look at. Unlike the contorted figures of Kertesz and the solarised nudes of Man Ray, Brandt is able to embellish his image with a narrative of dark interiors suggesting a more cerebral event, and his own creative explorations were surely influenced by his time spent assisting Man Ray in 1929.

In this particular image Brandt creates a feeling of separation by distinguishing each element present in the room. Through clever use of shadow, combined with the delicate textures of the creased sheets and the model's knotted hair, parallels can be drawn between her own shape and the shapes within the room, tying the two realms together.

The Photographer

The celebrated photographer Bill Brandt was renowned for his uniquely British sensibilities, capturing on film many aspects of life in his mother country. Documenting the social aspects of London's East End early in his career, including a famous image taken for the *Picture Post* in 1938 of a young girl confidently strutting past a group of other children laughing joyously as she does 'The Lambeth Walk', was typical of Brandt's ability to capture the essence of Britain's character.

Brandt's ability to record the breadth of human experience with all its highs and lows, especially during the Second World War when he served as a photographer for the British Home Office, resulted in some of the most moving reportage images of the British spirit during the Blitz.

Brandt's visit to the North of England was largely influenced by his reading J. B. Priestley's *An English Journey*. The resulting work of his time there revealed the dramatic social contrasts of life in the villages of East Durham and deprived Tyneside towns.

Brandt's dark, brooding photographs of individuals and landscapes call upon a world of shadows, which were both ominous and revealing for their time, setting a standard that is still greatly revered.

Brassaï (Gyula Halász)
Lovers in a Café

Nationality: Hungarian, b.1899, Brasso (HUN), d.1984
Genre: Social Documentary/Portraiture
Date: 1932
Print: Silver Gelatin Print
Edition:
Price:
Size: 8 x 10 inches

The Photograph

Here we have what has become an archetypal view of Paris. Brassaï's thirst for the night-time haunts of Parisians led him into cafés, Metro stations, dark streets and alleys in order to document the reality of a city alive with characters, debauchery and mystery. His image of two lovers in a café looks almost too perfect to have been chanced upon; as if the couple were posing for the benefit of the clientele or quite simply for their own amusement.

This exquisite image of a romantic moment can be seen from numerous angles. The mirrors reflect the face of each person and this adds a sincere quality to the scene, which would not be present if the gentleman's face had not been visible. There is a story here that we are left to construct, and Brassaï was to become the ultimate witness for so many intimate scenes and personal histories. Due to the identifiable nature of the couple, it was not used in the now legendary photography book *Paris de Nuit*.

The Photographer

Brassaï's success as a documentary and portrait photographer is a result of a supremely curious eye and fearless approach to the unknown. Many of his images of night-time Paris in the 1930s were deemed too risqué for their time, and as such were not exhibited or published for decades.

Brassaï photographed sordid brothels and the women who worked in them in a non-judgemental fashion, rendering them as a source of fascination rather than one of repulsion. He was also a regular contributor to *Harper's Bazaar* for nearly thirty years from 1936. Later, in the 1950s, Brassaï's abstract graffiti series depicted the etched-out markings and pictures seen on walls throughout Paris. This series was both intriguing and humorous.

Brassaï's impact on the arts was not exclusively photographic. He made a film entitled *Tant Qu'il y Aura des Bêtes*, (1956), which was a Prizewinner at the ninth Cannes Film Festival. Brassaï also used his photographs to create stage sets for three ballets and a play. His work is timeless in its romantic, forthright style, securing his enigmatic appeal for many decades to come.

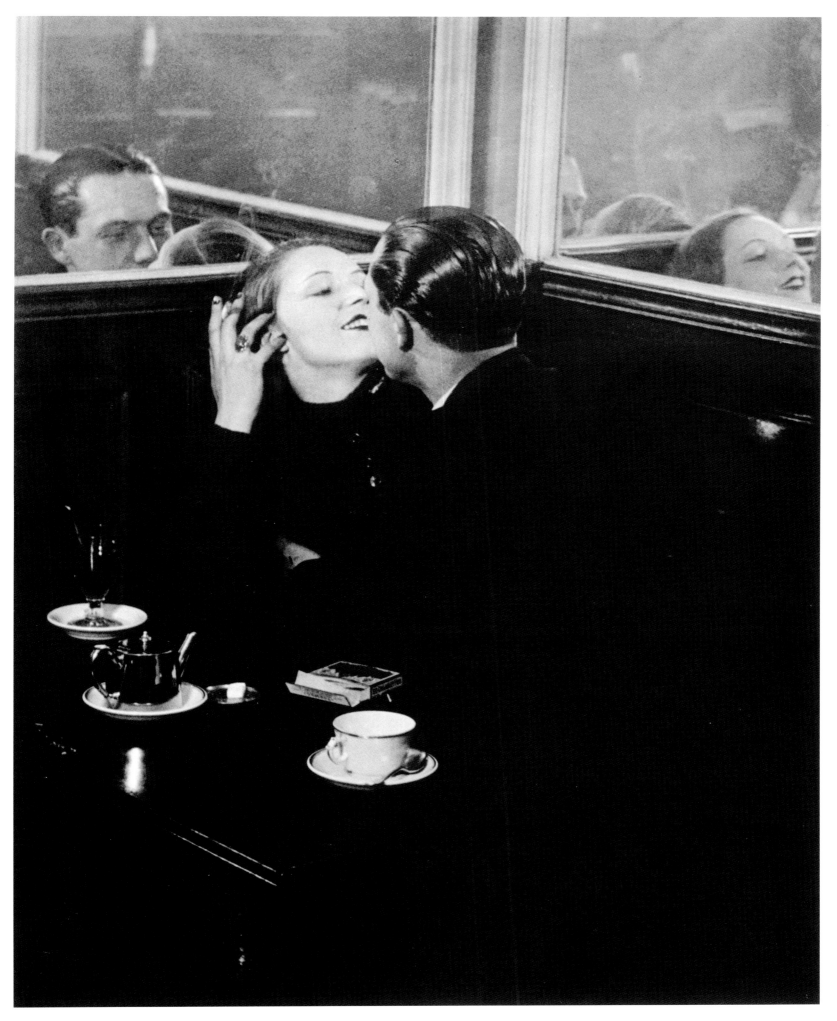

Adolphe Braun
Floral Study

Nationality: French, b.1811, Bresanç (FR), d.1877
Genre: Still Life
Date: c.1854
Print: Wet Collodion Negative Albumen Print
Edition:
Price: £8500/US$15,000
Size: 13 x 17¾ inches

The Photograph

Textile designer Aldolphe Braun was a relative newcomer to photography when he executed his collection of studies that were intended for 'artists using flowers in decorative motifs' during the mid-1850s. This magnificent, imaginative and technically adept collection was comprised of some 300 plates, and won a gold medal at the 1955 Exposition Universelle. Altering the lighting conditions of his still-life compositions allowed Braun to produce a veritable cornucopia of effects, from dramatic high-contrast images to those with delicate subtle nuances. These not only assisted designers, but also demonstrated the possibilities that still-life photography had to offer.

The wreath pictured here has a striking array of light and shadow; the dark foliage provides an enhancing effect to the flowers, which positively leap forward from the print. Braun's combination of both fragile and robust specimens allows each floral motif to shine. By choosing flowers of such differing shapes and sizes Braun also presents a clear sense of scale without compromising the aesthetic beauty of the picture.

The Photographer

Highly acclaimed for his floral studies, which were tremendously popular in the French Second Empire (1852–70), Braun furthered his interest in photography by establishing a studio at Dornach in Alsace. He employed a large team of photographers and concentrated on commercial European landscape views. His studio became hugely successful and was one of the largest suppliers of topographical views of popular destinations and tourist routes, especially in Switzerland. These images varied from large-format panoramas to stereoscopic prints. By 1869 Braun's studio was one of only two photographic firms invited to photograph the opening of the Suez Canal in Egypt.

During the mid-nineteenth century, the accurate recording of works of art in France became an important enterprise for many museums and Braun's studio was quick to capitalise on this. His firm held an exclusive thirty-year contract with the Musée du Louvre to photograph their art objects.

Braun's contribution to the appreciation of commercial photography is absolutely fundamental and is, as it should be, still rightly revered today.

Julia Margaret Cameron
Sir John Herschel

Nationality: British, b.1815 Calcutta (IN), d.1879
Genre: Portraiture
Date: 1867
Print: Wet Collodion Negative Albumen Silver Print
Edition:
Price: £68,500/US$120,000
Size: 14 x 11 inches

The Photograph
Sir John Herschel had been awarded a knighthood for his significant scientific achievements by the time Cameron met him in Cape Town, where he and his family resided from late 1833. Herschel was often described as a private individual, who was difficult to get to know. However, this was probably an attraction for Cameron who often found such characters fascinating.

Herschel himself had made a great contribution to photography: in fact he coined the term 'photography' and discovered that hyposulphite of soda (hypo) would 'fix' silver halides. He informed both Talbot and Daguerre that his discovery would fix camera pictures and so make them more permanent, but the mode of fixing an image with light-sensitive salts was plagued by the fact that once they reacted to light it was not possible to stop the process. Talbot and Daguerre both included this in their patents. Hershel should also be credited with coining the terms 'positive' and 'negative' as well as discovering 'hypo'.

As one of Cameron's first supporters and advisor, Hershel's keen interest in photography led to him informing her of all new significant technical developments. Here we have a sensitive portrait that conveys the warmth and respect that Cameron felt for this remarkable man.

The Photographer
Julia Margaret Cameron's status as a pioneer of portrait photography is absolute. In the Victorian era, her attitude was as complex and challenging as her work.

She produced photographs of outstanding beauty using models who were often members of her family or her friends, as well as portraits of significant creative figures of the nineteenth century. In many cases, Cameron's photographs are the only surviving images of these 'celebrities'.

By using shallow-focus photography, the aesthetic presided over the unambiguous imagery available to her in the traditions of commercial portraiture. This technique resulted in some of the most dreamlike, intense and sensual portraiture of all time. Cameron created physiological portrayals of highly emotive historical and literary scenes, where characters such as Ophelia, Sappho, King Arthur and Merlin came to life before the lens. Cameron's ability to bring forth the essence of a character through concentrated light, facial expression and gesture provided a formidable strength and longevity to her work.

William Christenberry
Still Life with Okra and Peas, Pickens County, Alabama, 1984

Nationality: American, b.1936, Tuscaloosa, AL (USA)
Genre: Still Life
Date: 1984
Print: Ektacolor Print
Edition:
Price:
Size: 8 x 10 inches

The Photograph

The luminous colour used by Christenberry intentionally harks back to his memories of childhood summers spent in Hale County, Alabama. The nostalgic approach renders a somewhat romantic view of a less-than-luxurious scene and it is hard not to be drawn into this quiet, almost abstract setting. The linear planes and lines in the image, punctuated by rectangular shapes, are visually and compositionally reminiscent of the De Stijl movement. In this image, objects 'interrupt' the structure of the vertical and horizontal lines of the architecture, adding expressive elements. It is somewhat telling that Christenberry studied under the abstract expressionist, Melville Price.

Encouraged by the light coming from the right, the depth of field is revealed by the jagged porch floor planks, leading the eye back to the wall of the house. Each line is slightly off kilter, which again emphasises the awkwardness of the structure pictured and the homely nature of Christenberry's work. As is the case in many of his photographs, what initially appears to be a very simple image, in this example, of a porch, is suddenly imbued with aesthetic delicacies and warmth.

The Photographer

This American photographer, artist and teacher has become internationally known for his interpretation of the American South through photography, painting, sculpture, collage and drawing. The biographical and mystical nature of his work examines details of his native home: from architectural and landscape studies, to replica, miniature sculptures of buildings he has also photographed. Christenberry is drawn to the worn weather-beaten facades of abandoned family homes, shops, churches, graveyards and signs. Visually synonymous with the Deep South, gourd trees (dried, hollowed shells of fruit that are hung to house purple martins) are another recurring subject for Christenberry. His particular attention to the family environment delivers a deeply personal feel to his work.

Originally using a Kodak 127mm Brownie Holiday camera that was given to him as a child, Christenberry's scope was limited. Discovery of *Now Let Us Praise Famous Men*, by James Agee and illustrated with photographs by Walker Evans, made a deep impression on Christenberry and Agee's experiences of living with the extremely poor families of Hale County struck an empathic chord.

In 1973, Walker Evans made his first visit to Hale County since 1936 and he and Christenberry spent four days photographing the town. By 1977, Christenberry began using an 8 x 10-inch Deardorf view camera and produced some of his best-known work. His artistic documentation of the Deep South is a poignant and affectionate examination of a past long since left at the mercy of the elements, yet still retains some vital, innate magic.

Larry Clark
Untitled (From the 'Tulsa' Series)

Nationality: American, b.1943, Tulsa, OK (USA)
Genre: Social Documentary
Date: 1971
Print: Gelatin Silver Print
Edition: 25
Price:
Size: 14 x 11 inches

The Photograph
Taken from his now notorious book *Tulsa*, Larry Clark's biting immediacy is plain. He has shocked many by his honest portrayal of life growing up in Tulsa, Oklahoma, and his candid statement at the beginning of the book is as hard hitting as the photography within it:

'i was born in Tulsa Oklahoma in 1943. when i was sixteen i started shooting amphetamine. i shot with my friends everyday for three years and then left town but i've gone back through the years. once the needle goes in it never comes out.' [sic] L.C.

Bearing arms before the Stars and Stripes brutally reflects a hollow world of self-destruction. The American dream is stripped of its romance through the eyes of the dispossessed. Kids occupy barren rooms as cold light pours through the windows, revealing a cold, hard world.

The Photographer
Larry Clark's world of speed freaks, teenage junkies, death, sex, abuse, violence and resignation captures a way of life that shocked the American press with its vivid frankness. Needles lie on floors and in children's arms as they laugh, high and vacant in empty rooms. His work is not for the faint-hearted. Blood, genitals, guns and death pervade the lives of these youths whose crumbling humanity is laid bare.

Clark's work in New York, photographing the subculture of adolescent boys surviving as hustlers and dope dealers, is equally disturbing. However, his methodology reflects an attraction, even an involvement, with the fringes of society rather than a detached photojournalistic approach to a subject. While some may find his work abject, this keeps Clarke's imagery raw and involved without patronising those whose lives he depicts.

Gregory Crewdson
Untitled

Nationality: American, b.1962, Brooklyn
(NY) USA
Genre: Surrealism/Fine Art
Date: 2001
Print: Digital C-type Print
Edition: 10
Price:
Size: 50 x 60 inches

The Photograph
Gregory Crewdson's domestic Ophelia
subverts the feral wildness of Sir John
Everett Millais's painting of the same
subject. Within this image, Crewdson
reinterprets her as a suburban woman
floating in her living room.

In Shakespeare's *Hamlet*, Ophelia was
driven mad by the killing of her father,
Polonius. Her death by drowning – only
referred to in conversation in the play – is
said to have occurred after she fell into
the river while picking flowers. It is
assumed however, that she committed
suicide, although Shakespeare does not
disclose this fact. Millais's painting is a
masterpiece of delicate floral symbolism,
which Crewdson cleverly reinvents here
with his surreal contemporary
manifestation of the housebound
heroine. With dreamlike theatricality,
Crewdson updates the image with the all
the sensibility of Freudian psychoanalysis.

The three windows in the photograph
invite a heavenly glow, which is enhanced
by the trio of windows in the door. The
light picks out the three stairs that lead to
the water's edge, and highlights the
carefully discarded slippers and robe,
which suggest the subject's voluntary
collusion in her uncertain predicament.
Three indistinct portraits stare out from
the wall, which mirror the stepped
windows in the door. The warm glow of
the room does not hide the drabness of
the décor, but instead enhances the cold
tones of the woman's body and pure
white cotton slip. We are left to establish
the significance of such deliberate and
intriguing composition for ourselves.

The Photographer
Gregory Crewdson's world is epic,
cinematic and strange. His approach
to photography is typified by an
amalgamation of new technology and
an obvious respect for older mediums
in the artistic arena. Crewdson's images
almost always contain a connection with
1950s cinema and its portrayal of the
aspirational suburban dream; where
housewives are perfect and the apple
pie and picket fence trappings of
respectability are maintained at all times.
Crewdson blends these influences skilfully
and respectfully, referencing both classical
painting and literature alongside Cold
War science fiction, which creates an
unnerving and unsettling world of images
that are often oblique, yet somehow
convincing. Crewsdon's interest in the
dark side of suburban life, the source of
much of his imagery, is doubtlessly
influenced by his father, a psychoanalyst
who conducted consultations with his
patients at home.

Under Crewdson's lens, the ultra normal
is somehow transformed into the
supernatural. Storm drains will glow with
warm yellow light, flowering stalks can
grow up to the sky and people stand on
a street where a school bus lies on its
side, but appear eerily disconnected.
Almost paradoxically, Crewsdon stages
these imagined scenes to show us that
they are in fact real. The psychological
element of separation within society is
taken to the extreme and choreographed
in graphic detail. The dark underpinnings
of fairytales come forth to show ever-
present dysfunction in daily life and in
our dreams.

Imogen Cunningham
Phoenix Recumbent

Nationality: American, b.1883, Portland, OR (USA), d.1976
Genre: Surrealism/Fine Art
Date: 1968
Print: Selenium-toned Fibre-based Silver Bromide
Edition:
Price: £700/US$1200
Size: 9 x 7 inches

The Photograph
This beautiful example of Imogen Cunningham's work demonstrates her skill for breathtaking simplicity, a characteristic often favoured by Group f.64, of which she was a founder member.

With sharp focus placed on the model's blonde tresses, we are distracted from her nude body to enjoy the textures in the photograph. The coarse weave of the fabric beneath her highlights the softness of her hair. Cunningham's celebration of the female form is well known; she celebrates femininity and sensuality through her lightness of touch, which radiates her nudes with intimacy and confidence. In this photograph, through careful composition, the model remains natural despite Cunningham's deliberate arrangement. The image's title suggests horizontal perfection, which is realised in the photograph.

The Photographer
First picking up a camera in 1901, Imogen Cunningham's career was a long and impressive one. She worked in the studio of Edward Curtis for two years between 1907 and 1909.

Her rejection of pictorialism in favour of a more abstract approach to photography proved a great asset to the medium. Cunningham produced a series of close-up native plant forms and also photographed pregnant nudes, both of which served to explore the subject of fertility. Cunningham remained purist in her approach to photography and often depicted sharp, focused details of modern architecture, utilising light with outstanding results.

Throughout her long and illustrious career Cunningham's work remained fresh and vital, earning her a reputation as a pioneer of modern photography.

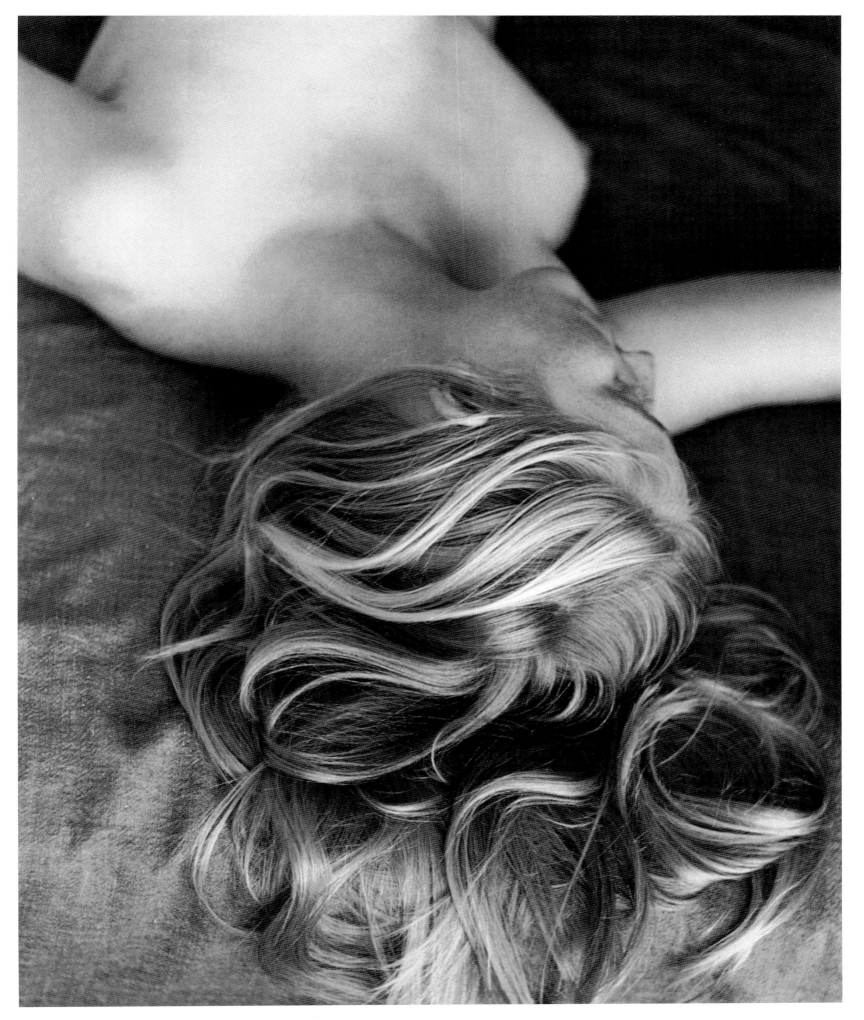

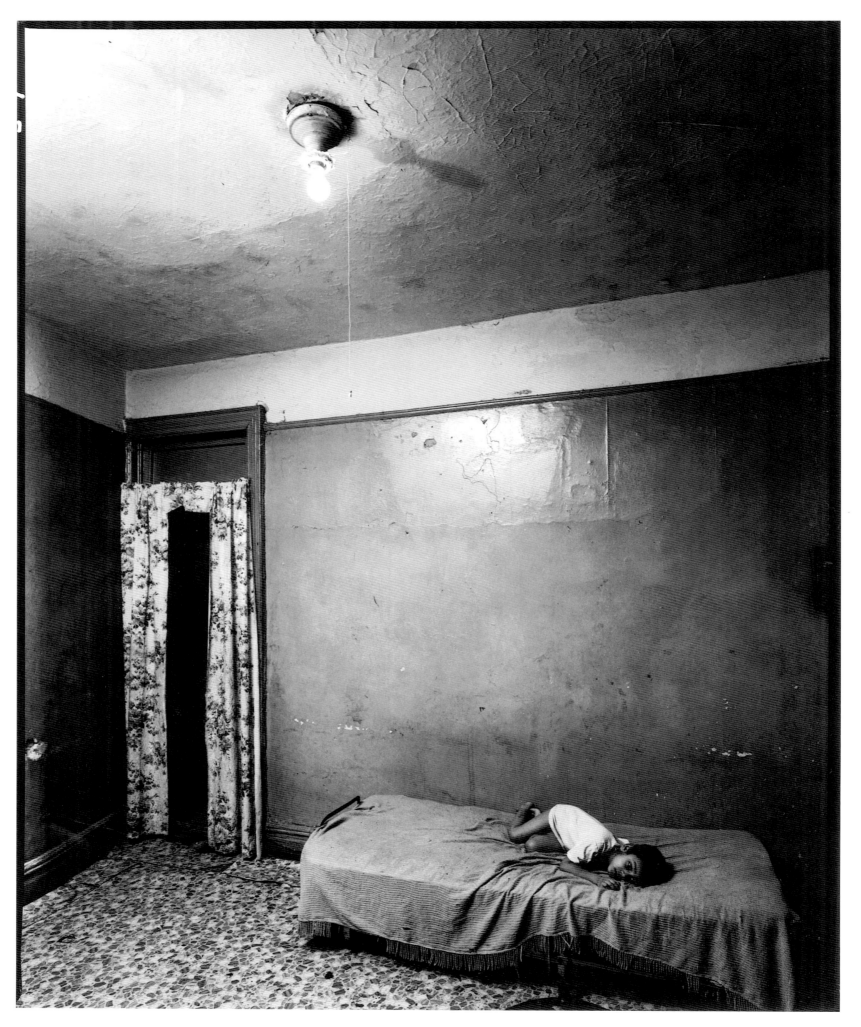

Bruce Davidson
East 100th Street, Spanish Harlem

Nationality: American, b.1933,
Oak Park, IL (USA)
Genre: Social Documentary/Portraiture
Date: 1966
Print: Gelatin Silver Print
Edition:
Price: £1100/US$2000
Size: 11 x 14 inches

The Photograph
For a two-year period during the 1960s, Davidson returned day after day to photograph this notorious East Harlem slum. In this time, Davidson himself became an honorary resident, searching out the hidden corners of the community and standing on street corners asking permission to photograph apartments and families, shopkeepers and transients. Despite the stark trappings of urban neglect that frame his portraits of the East 100th Street residents, Davidson's images never stoop to patronise, romanticise or demonise the inhabitants of the ruined streets. He instead lets his subjects inform their own compositions, allowing the participants to vicariously express their personal aspirations, their self-image, their hopes and fears through his images.

Ultimately, this work is concerned with the demystification of the ghetto. Davidson presents a visually eloquent reminder that what is deemed an uninhabitable and threatening slum by some is in fact a home to others. This image, which is one of a larger body of work, is not merely a chronicle of 1960s Harlem, but also a fitting tribute to the universal qualities of humanity and dignity implicit in us all.

The Photographer
Davidson was a member of the Magnum Photographic Agency before he was thirty, and his work is synonymous with powerful and thought-provoking imagery. His documentary photo essays and portraits include a six-year project entitled 'Subway', which emerged from the many journeys taken as he rode the subway to the Lower East Side and Coney Island – a location that had provided stimuli for his work in the past. Within it a gamut of human experience is portrayed amidst a glorious technicolour backdrop of graffiti; subversive decorative murals that became a phenomenon in the early 1980s. Despite very restrictive conditions, Davidson produced striking images that displayed a magnificent use of available light, which created photographs reminiscent of Renaissance portraiture. Unlike the subway portraits of Walker Evans, the romantic element of Davidson's work is less permeable but ever present. His love of the city and celebration of the many different people within it has become a signature of Davidson's work. This remarkable photographer rarely misses the visual intricacies we take for granted every day.

André-Adolphe-Eugène Disdéri
Portraits of M. Gray

Nationality: French, b.1819, Paris (FRA), d.1889
Genre: Portraiture
Date: 1860
Print: Wet Collodion Negative Albumen Print (Uncut Carte de Visite Sheet)
Edition:
Price: £1200/US$2000
Size: 8 x 9 inches

The Photograph
This wonderful carte de visite is a typical example of Disdéri at his very best. Here we are treated to a proud man dressed in full tartan, the uncut sheet presenting us with a wonderful sequence of four poses that explores the character of the sitter far more than an image taken in isolation could hope to. The two frames devoted to each pose suggest that Disdéri had the intention of splitting the sheet into two sets.

With a highly decorated pillar and cloth backdrop, the cultural stature of the subject is emphasised to the full. The second pose is jaunty and more playful, while a third formal profile shot lends itself more to the classical references of the props used. Utilising a more domestic prop and casual pose, the final two images present a more relaxed facet of the man, relieved of his sword and cap. Despite its anonymous nature, there is no doubt that this Disdéri carte de visite is a pleasure to view.

The Photographer
Parisian photographer André-Adolphe-Eugène Disdéri became famous for his cartes de visite, a production technique that he patented in 1854. He worked in a number of genres, including landscapes, war reportage, architectural interiors and narrative tableaux.

Cartes de visite allowed the production of up to ten images on a glass plate, which could be exposed together or one at a time. A former daguerreotypist in Brest, the vast success of Disdéri's invention propelled his career and allowed him to open a second studio in Paris and subsequent studios in London and Madrid. This was a revelation for the photographic industry.

Cards could be purchased at a relatively low cost and distributed among friends and loved ones. By affixing the portrait to a card with his studio name on the reverse, Disdéri's implicit association with the technique was assured. It is even said that Napoleon III had a portrait made at Disdéri's studio in Paris while on his way to Italy. However the attractiveness of the carte de visite format, which sold in their thousands at the height of their popularity, diminished as the larger cabinet cards were introduced in 1866.

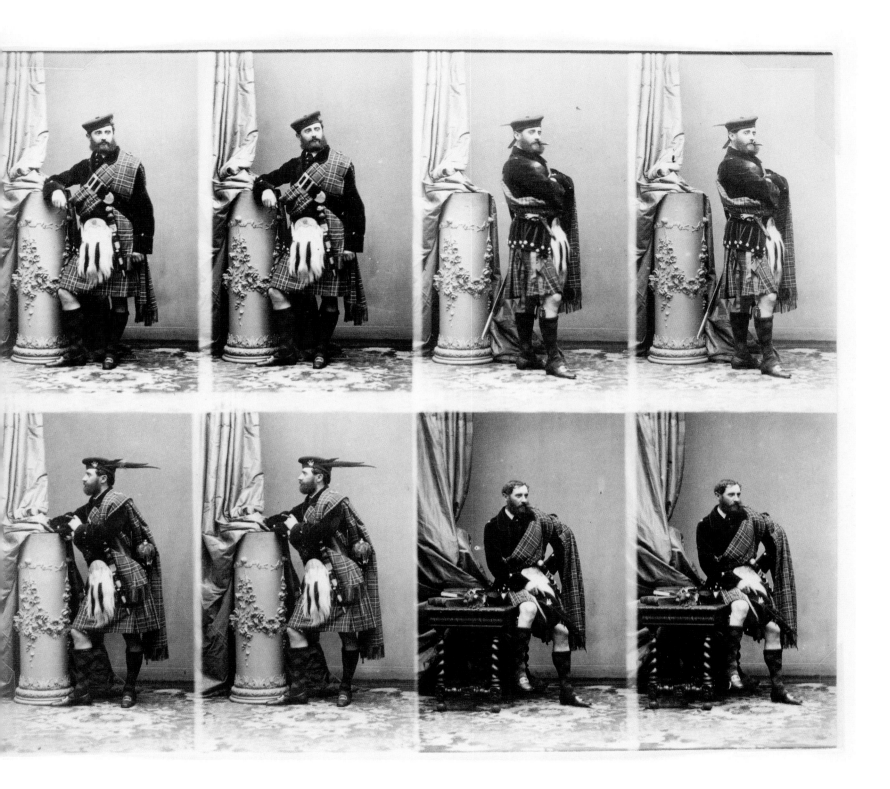

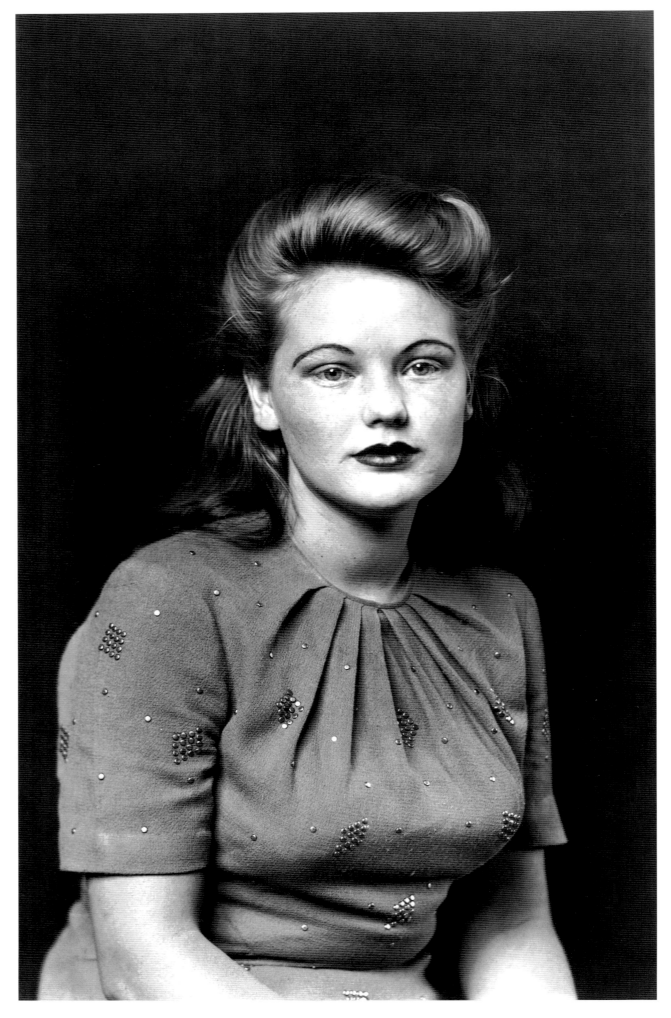

Mike Disfarmer
Bonnie Dell Gardner

Nationality: American, b.1884, IN (USA), d.1959
Genre: Portraiture/Social Documentary
Date: 1943
Print: Gelatin Silver Print
Edition: 75
Price: £500/US$800
Size: 11½ x 7 inches

The Photograph

This moving photograph of Bonnie Dell Gardner is a typical Disfarmer studio portrait. His sitter, a local girl from the small town Heber Springs in Arkansas, wearing make up and a smart dress, and with coiffed hair, appears at ease, comfortably and respectably posed. In front of a plain backdrop, her piercing eyes are staring straight into the camera lens, and it is only her attire that reveals the era in which this picture was taken.

The crisp quality of the print conveys the texture of her hair, skin and clothes to such a detailed degree, it is hard not to be intrigued by Bonnie. An image such as this unquestionably warrants the fascination that followed the re-discovery of Disfarmer's work in 1959 by Joe Allbright, an estate agent who had acquired the images when he purchased the contents of Disfarmer's studio following the photographer's death in the same year.

The Photographer

As a prolific commercial photographer, many of Disfarmer's images can still be found in the photo albums of Heber Springs's residents. His body of work represents an incredible historical study and a considerable artistic achievement.

Disfarmer never made enlargements and each of his photographs is presented as a contact print, adding to their intimate, private and personal qualities. His insistence on using glass plates, even when sheet film was readily available, gives clues to the unique character of this man and his work. Disfarmer's reluctance to employ props or elaborate backdrops further typifies his instantly recognisable and strikingly simple style.

The photographs taken in Disfarmer's Main Street studio provide a societal and historical record of Heber Springs. Disfarmer's portraits of the town's residents are characterised by an uneasy, yet arresting, quality that is reminiscent of the portraiture of Diane Arbus and August Sander.

Joan Fontcuberta
Centaurus Neardentalensis, 'Fauna', Barcelona

Nationality: Spanish, b.1955, Barcelona (SP)
Genre: Fine Art/Conceptual
Date: 1988
Print: Selenium-toned Silver Gelatin Print
Edition: 5
Price: £2500/US$4300
Size: 20 x 16 inches

The Photograph
In this image Fontcuberta stretches the connection between photography and truth with verve. Fontcuberta and Pere Formiguer's 'Fauna' series consists of an 'archive' of impossible, yet probable animals, hybrids and meta creatures. The collector of the archive is the esteemed Dr. Ameisenhaufen, the alter ego of the photographers. This image of the professor and the centaurus in a friendly pose is persuasively enhanced by the surrounds and further 'validated' as a found document by artificially aging the work. By giving his images the appearance of scientific credentials including titles that incorporate pseudo species names, Fontcuberta explores the assumed trust of the photograph as hard evidence. Although humorous and fantastical, the 'Fauna' series is reminiscent of those photographs found in *National Geographic*. Fontcuberta even published a convincing book of his hoaxes mimicking the famous journal.

We are entering the world of the unconscious with open eyes and are no less fascinated by Fontcuberta's constructs than if they were real.

The Photographer
The surreal, explosive imaginings of Joan Fontcuberta's photography do not merely exude strangeness, but positively revel in it. The bizarre subjects and creations of his photographic world evoke a sense of humour and childlike fascination with the immeasurable possibilities that the medium has to offer. Fontcuberta has a talent for creative juxtaposition that delivers surreal perspectives in order to construct alternative realities. His is a world where Braille text can become landscape, blood droplets on glass plates are used to make prints (aptly named 'haemograms'), and constructing a photograph with objet trouvés produces dreamlike scenes of partial realities.

Surely the only way to truly access Fontcuberta's work is to simply look at it, and let your own imagination do the rest.

Lee Friedlander
Mechanics' Monument, San Francisco, CA

Nationality: American, b.1934, Aberdeen, WA (USA)
Genre: Landscape
Date: 1972
Print: Gelatin Silver Print
Edition: 5
Price: a) £5750/US$10,000 (Vintage Print) b) £2400/US$4200 (Modern Print)
Size: 11 x 14 inches

The Photograph
Monuments are supposed have both a permanence and bear resonance to something or someone that is not to be forgotten.

In the USA, as in most countries, thousands of public monuments have been erected with the intention of their inducing remembrance and respect. However as the architectural and economic growth of these sites, and their surrounding areas, has changed dramatically over the years, so too has the dominance and reverence paid to the monuments in them. Some remain as iconic symbols of the American dream, yet some have been dwarfed by the society that encroaches upon or retreats from their location. Friedlander travelled back and forth across the United States for more than ten years recording this phenomenon. Here he illustrates the development of a site housing the Mechanics' Monument in San Francisco. The barrage of information in the photograph works as a perfect metaphor for the construction site that invades the monument's space. Two men have turned their backs to the monument and the apt position of the car in the foreground furthers the suggestion of an increasingly affluent and advanced society, but notably one that still relies upon the product of human toil, often forgotten in our technological age.

The Photographer
Friedlander's significance to American photography cannot be underestimated. His influence is paramount to the genre for several reasons, not least of which is the sheer volume of work he has produced, over a period of many years, documenting the less obvious subjects associated with America. His images are often subtle, witty and reflective. One has to absorb a Friedlander photograph, not just look at it. His visual language has to be 'read' and 'interpreted' by the viewer. His images do not appear at first to be things of beauty, but of curiosity and study, and intrigue plays a large part when looking at his work. Whether the aesthetic is minimal (the stems of flowers in a vase), or dense (a shop front with numerous reflections), his intelligence shines through. Observe slowly and look, long and hard, at as much as you can.

Paul Fusco
RFK Funeral Train

Nationality: American, b.1930, Leominster, MA (USA)
Genre: Documentary
Date: 1968
Print: Inkjet Colour Print
Edition:
Price:
Size: 11 x 14 inches

The Photograph
Five years after the tragic assassination of John F. Kennedy, Bobby Kennedy emerged to revive the politics and policies that his brother's government had not had time to establish. However, on 6 June 1968, while on the presidential campaign trail, Bobby was fatally shot, just minutes after he had won the California primary.

From the funeral train, Paul Fusco photographed and documented the journey's route from New York to Washington. The resulting pictures are a moving testament not only to Bobby

Kennedy, but also to the people of America, to whom he had given so much hope. Kennedy's assassination cruelly extinguished hopes and dreams of empowerment among America's underprivileged, leaving a painful scar that was felt by many.

Crowds line the station platform and looking into their faces we are confronted with a sheer wave of human emotion for a great man. This work's importance is not only historical, but is also an empathic confirmation of the unity of these ordinary citizens saying goodbye to an extraordinary man.

The Photographer
Paul Fusco's career in documentary photography began following his stint as a photographer in the US Army Corps in Korea, between 1951 and 1953. Studying photojournalism after the war, Fusco eventually became a staff photographer at *LOOK* Magazine and remained there until

1971. Issues of social hardship and injustice were a common focus of his work. Predominantly in the USA, but also in other parts of the world, Fusco photographed the lives of the oppressed and socially excluded. In America he recorded the lives of ordinary people, from runaway youths and Hispanic ghetto life in New York to social issues concerning farming, Indian reservations and migrant labour.

His work further afield has covered the legacy of Chernobyl, where Fusco photographed those suffering devastating health problems as a result of accidental exposure to radiation.

As a member of the prestigious Magnum Photographic Agency since 1974, and in the traditions of a great documentary photographer, Fusco still seeks out social injustice and exposes the truth for those unable to do it for themselves.

Adam Fuss
From the 'My Ghost' Series

Nationality: British, b.1961, London (UK)
Genre: Fine Art
Date: 2000
Print: Daguerreotype
Edition: None
Price: £2800–£5100/US$5000–$9000
Size: 11 x 14 inches

The Photograph

Notwithstanding the slightly unnerving nature of the dead swan, Fuss has created an entrancing mythical image by using the daguerreotype process; a technical backwards glance that is prevalent throughout much of his work. The image's intense blue may be equally suggestive of the swan's past, signifying the water it once swam in, perhaps.

The motif of a bird plays a recurring part in Fuss's work, as memories of his childhood are revisited. Aged only three and a half, he took a photograph of his nanny, who was pregnant at the time, holding out her hand as a hungry bird fluttered towards it. The image shown here can thus be interpreted as a direct reference to his personal history, and is one that is rich in symbolism. The swan is symbolic in myths, fairytales and folklore that are concerned with metamorphosis. Fuss encapsulates the polar opposites often prevalent in these tales by picturing this swan's lifeless carcass with its beautiful wings outstretched proudly, allowing the close examination of magnificent feathers; as such it is a symbol of both life and death.

The Photographer

A sensitively subversive photographer, Adam Fuss has had a fascination with the dualities of life and death, beauty and horror and memory and loss. Objects that he photographs reference these themes with delicate accuracy. For example, dead butterflies dance across the paper due to their placement and christening gowns become transparent apparitions.

Fuss takes the viewer on a journey through fairytales, revelling in their darker undertones; into a world where the entrails of a rabbit are graphically altered to become colourful patterns bringing rebirth. Fuss is not afraid to explore the inner workings of his childhood memories and fascinations in order to allow us to explore our own, and enjoy the textural detail that comes with looking closely at the smaller things in life.

Stephen Gill
From the 'Hackney Wick' Series

Nationality: British, b.1971, Bristol (UK)
Genre: Snapshot
Date: 2004
Print: C-type Print
Edition: 10
Price: £1000/US$1750
Size: 16¼ x 20⅜ inches

The Photograph

The snapshot aesthetic is the perfect genre for this striking, yet amusing, photograph, which was taken at Hackney Wick market in East London. Gill purchased a Bakelite camera at the market for only fifty pence in January 2003 and embarked upon his Hackney Wick project, which was completed in August 2005. Gill's Hackney Wick project began before the site had been thrust into the spotlight as a potential venue for the 2012 Olympic Games.

The series has become a fitting and honest reminder of the vibrant, often-chaotic, bustling market, which, although it wasn't glamorous, was certainly a popular and successful attraction for the local community. All the market's qualities are visible in this image. The skirt emerges amidst an untidy array of clutter, and we can see Gill's shadow beneath its bright orange fabric, which glistens in the sun. The skirt's folds are reminiscent of the drapery one might find in a pre-Raphaelite painting, and serve to seduce the viewer's eye.

The Photographer

The themes in Stephen Gill's work derive from his own personal interests. Often quirky and with a knowingly wry sense of humour, he celebrates the rudiments of daily life with verve. In one series Gill photographed the back of advertising billboards (their titles reveal the contents on the front of each board); reminiscent of Friedlander's approach to his subjects, Gill provides a dialogue that at first may appear banal, but ultimately engages.

Interest in the unseen, discarded and ignored are recurring concerns for Gill who can transform the mundane through his acute use of composition. He focuses on the quiet moments of a train journey, the puzzled faces of tourists trying to navigate their way around London, and men and women working in public places wearing fluorescent safety jackets, passing unnoticed despite their luminous attire, and records the impermanent for us to savour a little longer. When Gill photographs these things he raises their status. In one series, taken in Russia, redundant cigarette butts, laced with a spectrum of red and pink lipstick shades, become delicate porcelain-like forms when laid upon a crisp white surface. Gill's watchful eye can teach us to slow down and pay more attention to those things we so often take for granted.

Fay Godwin
From the 'Lings' Secret Lives' Series

Nationality: British, b.1931,
Berlin (GER), d.2005
Genre: Landscape
Date: 1993/4
Print: C-type Print
Edition:
Price: £600/US$1000
Size: 12 x 16 inches

The Photograph
Here, glass intertwines with nature to produce a remarkably intimate glimpse of an otherwise forgotten corner of an unkempt garden. Godwin conveys these places of discovery and magic through subtle composition. We can imagine a child encountering the garden in much the same way, finding excitement in the minute intricacies emerging in the space. The delicate nature in which the light falls on each object captures elegant moments of rapturous colour. Within these fragile juxtapositions the romantic and intimate reign superior, proving that human interaction with the land needn't be negative and can be found in the most unlikely places.

The Photographer
One of the foremost contributors to contemporary British landscape photography, Fay Godwin had the ability to capture her fascination with the land in every possible scale, from vast coastlines to intimate gardens (most notably Derek Jarman's in Dungeness, Kent). Although Godwin is known predominantly for her black-and-white photography, she also worked in colour, producing beautiful imagery with equal verve. Her interest in the landscape lay beyond the purely aesthetic, as Godwin revelled in the tactile, spiritual and sometimes humorous qualities of the British countryside. Concerned with local conservation, and the economic and environmental issues raised by the communities of each area that she photographed, Godwin often asserted a forceful argument through her imagery, a quality ignored by many other landscape photographers.

Milton H. Greene
Marilyn in the Pool, Connecticut

Nationality: American, b.1922,
New York, NY (USA), d.1985
Genre: Portraiture
Date: 1955
Print: Archival Colour Inkjet
Edition: 500
Price: £430/US$750.
Size: 18 x 22 inches

The Photograph
This rare glimpse of the Hollywood icon
Marilyn Monroe lays bare a natural and
carefree side of her character.

Milton Greene documented Monroe on
many of her films, including *Bus Stop* and
The Prince and The Showgirl, as well as in
numerous studio sittings. In Greene's
'Ballerina' series, which was taken in
September 1954 at his studio in
Lexington Avenue, New York, Monroe
wore an ill-fitting, white crinoline dress,
but still displayed her ease with Greene
and the camera alike.

In this image the familiar coiffed hair, red
lipstick and heavy lashes are absent. We
are exposed to a healthy, freckled Marilyn
playing in a swimming pool. This candid
close-up of such an icon is one of a
delightful series taken during a single
afternoon in Richard Rodger's pool in
Connecticut. The absence of artifice gives
the illusion of immediate access to the
'inaccessible'. The obvious rapport
between Monroe and Greene is no better
displayed than in this disarming portrait.

The Photographer
This forward-thinking photographer
abandoned his early commercial studio
work – photographing everything from
household items to cars and underwear – in
favour of a more personal approach, and
became a fashion photographer for Macy's
department store.

This charming man became a formidable
photographer in his own right and shot
many stories for *Life* magazine that
included an array of stars such as Cary
Grant, Marlene Dietrich and Audrey
Hepburn. Greene's creative use of props
always ensured signature images of style,
quality and longevity. Greene's
communicative skill with his sitters
ultimately procured their individuality,
resulting in some of the most satisfying
portraits of his time.

Andreas Gursky
99 Cent

Nationality: German, b.1955,
Leipzig (GER)
Genre: Architectural Interior
Date: 1999
Print: C-type Print
Edition:
Price:
Size: 81½ x 132⅝ inches

The Photograph

This incredible, dense plethora of items displays the characteristically captivating force of Andreas Gursky's work. His attention to detail is displayed richly in this 99 cent discount store, an image that could well have been deemed cheap in all other respects. The bombardment of choice for our eyes signifies Gursky's dry reflection on the world we live in. By aggrandising the scene in terms of scale, he renders each and every bright colour of all the available merchandise. By including the reflection above, the viewer is engulfed with information and the ordinary becomes epic. Despite the cold and clinical approach to his subject, Gursky has the propensity to confront scenes that we may have come across countless times, but through careful planning and foresight delivers them in a way we never knew how.

The Photographer

Gursky is another success story of the Düsseldorf Academy of Arts, and his work sells at record-breaking prices. Gursky's work is big, in every way: size, style and popularity. Not just concerned with dry representation, Gursky takes inspiration from industrial sites, stock exchanges, public arenas and hotels; he does not critique these places of commerce, but stands at a distance to observe. The resulting work creates a deep inspection of the subject without interference, and his pictures retain enormous detail despite the visual distance from the subject. Even in constructed images where Gursky has arranged the scene, an emotional detachment is observed. However his imagery remains transfixing throughout.

Todd Hido
Untitled 1975–A From the 'House Hunting' Series

Nationality: American, b.1968, Kent, OH (USA)
Genre: Landscape
Date: 1996
Print: Chromogenic Print
Edition: 5
Price: £2600/US$4500
Size: 48 x 38 inches

The Photograph
Our eyes initially sweep across this colour, night-time shot before being brought into focus by the hyper-defined quality of the print, presenting a contemporary feel that is contrary to the vague timelessness of the era it depicts. The eerie nature of this image comes not only from its atmospheric qualities but also from its anonymity. Far and away from the urban chaos, but not quite in the wilderness, there are very few clues as to the whereabouts of this place. We can see it is probably somewhere in America and that the glowing light from inside suggests that the house is inhabited, yet the light itself is dramatic, appearing somewhat alien and artificial. Hido's talent resides in his ability to strike up memories. He taps into our juvenile fear of the spooky old abandoned house that was rumoured to be haunted and allows us to be seduced by our curiosity and imagination.

The Photographer
Todd Hido's photography explores the suburban traditions of sameness; he exploits the uncomfortable notion of conformity. His landscapes look real, yet are jarringly unnatural. Hido's images are full of contradictions: houses look inhabited and abandoned at the same time. From the exteriors windows glow in warm tones, but interiors are barren, save for one chair or perhaps a creased and unmade bed.

Without becoming clichéd Hido enters the realms of film noir in super-real full colour. Despite the augur of menace, objects such as houses, trees, cars and telegraph poles exude beauty and retain mystery.

Lewis W. Hine
Icarus, High Up on Empire State

Nationality: American, b.1874, Oshkosh, WI (USA), d.1940
Genre: Architecture/Social Documentary
Date: 1931
Print: Gelatin on Diacetate Film
Edition:
Price:
Size: 5 x 4 inches

The Photograph
This young Empire State Building worker, Hine's Icarus, soars high above New York City. The image's association with the doomed fate of the mythical Icarus reflects Hine's concerns with the providence of the working classes. The strength and bravery of this man is illustrated in an iconic composition.

Hine's series of Empire State images remain popular today and were initially published in the *New York Evening Post*. These photographs imbued a dignity and drama to the lives of the labourers whose work in industry helped to build the foundations of America's status in the world to this very day.

The Photographer
As a proponent of America's progressive movement during the 1890s, Hine's photography played a great part in the reformers' campaigns to change legislation to aid the plight of the underprivileged working classes. Hine's own experience of numerous unskilled jobs gave him the empathic vision needed to photographically deliver the progressive message about the social injustices rife across the country through the popular press. Hine even coined the phrase 'social photography', to describe the nature and purpose of his work.

The cumbersome plate camera he used meant that a certain amount of co-operation was needed from his subjects, which had its advantages compositionally. Alongside Hine's prolific images he wrote extensive captions, which also serve as a great historical relevance. His images of factories, farms and social divides, as well as the Empire State's working-class heroes, remain poignant today.

Candida Höfer
Palacio Real Madrid I

Nationality: German, b.1944, Eberswalde (GER)
Genre: Architecture
Date: 2000
Print: C-type Print
Edition:
Price:
Size: 60 x 60 inches

The Photograph

Höfer's diagonal gaze invites the viewer into this luxurious dining hall, replete with ornate chandeliers and wall mouldings. The formality of the space is amplified by the absence of any occupants. Emptiness always arouses curiosity and here it presents an invitation to look at each and every detail within the room. This photograph is also reminiscent of a set, perhaps awaiting a cast of serving staff to lay the table and lead guests to their seats. Höfer's keen eye has managed to create an air of expectancy in an otherwise stuffy ceremonial space.

The Photographer

Addressing the notion of public space, Candida Höfer usually presents her chosen environments without anyone in attendance. Again, the influence of her teacher Bernd Becher at the Düsseldorf Academy of Arts is evident in Höfer's virtually puritanical approach to her subjects. Her immense technical clarity, coupled with an erudite use of colour, amplifies the impact of each image.

Through such theatrical staging, Höfer's museums, libraries, zoos, concert halls and even smaller spaces – such as the corner of a hotel bathroom – remain grandiose in scale, with an intriguing simplicity and sometimes decadent quality. She creates a platform within that space for the viewer to project into. Although the vantage point seems watchful, we are drawn into the image as if Höfer were never there. We become the 'public', experiencing the scene as if we were the first to enter the room and able to inspect our surroundings before anyone else.

John 'Hoppy' Hopkins
Thelonious Monk's Hands

Nationality: British, b.1937,
Slough (UK)
Genre: Portraiture
Date: 1966
Print: Iris (Giclee) Print
Edition: 25
Price: £600/US$1000
Size: 20 x13⅞ inches

The Photograph
This portrait typifies Hoppy at his best. Using available light, Hoppy captures Thelonious Monk through the depiction of the tools of his trade with those magic hands gliding over the keys, doing what they do best.

Photographing jazz musicians enabled Hopkins to indulge in his great passion for the genre. Dexter Gordon, Duke Ellington and Louis Armstrong are among the icons he has photographed. We can almost 'hear' the music being played due to the skilful joy of this photograph.

The Photographer
Hoppy's interest in photography developed after he received a graduation gift of a camera. He abandoned his promising career as a nuclear physicist and, combining his love of music and photography, began freelancing for various publications including *The Sunday Times*, *Melody Maker*, *Peace News* and *Jazz Journal*.

Arriving in London in 1960 paved the way to a long and illustrious profession photographing future icons of the music world at a time of great social change and diversity. Hoppy photographed The Beatles, The Rolling Stones and Marianne Faithfull, in their prime and revealing their personalities to the full. His naturalistic, spontaneous approach sets him apart from many studio photographers of the time.

However, his work was not just confined to the glamorous world of rock and roll. He also worked as a photojournalist, exploring the dark underworld of 1960s London. Bikers, prostitutes, tattoo parlours and fetishists were all portrayed. The subversive counter cultures of the day and psychedelic scene were all subjects of fascination for him. Iconic figures such as Allen Ginsberg, Malcolm X and Martin Luther King permeated the lives of many and 'Hoppy' was there to document it. The result is a body of work, which truly captures the 1960s in all its darkness and splendour.

Frank Horvat
Yvette in the Dressing Room

Nationality: Italian, b.1928, Abbazia (ITL)
Genre: Social Documentary/Portraiture
Date: 1956
Print: Gelatin Silver Print
Edition: 30
Price: £2300/US$4000
Size: 12 x 16 inches

The Photograph

Where this image is taken seems to be of little importance. By omitting the location of the dressing room we are unable to make assumptions as to Yvette's circumstances, though it would be logical to assume she is preparing to go on stage. The most striking element of this image is Yvette's piercing and confident gaze, looking at herself as if Horvat simply was not there. This private moment does not feel voyeuristic, because she appears perfectly comfortable with her body. As the light brushes across her breasts and highlights her left eye we are reminded of the power of 'female' gaze and all its associations. The table is strewn with make up, which is calculatedly out of focus in order to lead our eyes to hers. The combination of textures in the room and the lines of her body balance each other out perfectly, placing the viewer quietly in the room without intrusion.

The Photographer

Frank Horvat's talent for versatility has ensured his longevity in the photographic world. He has worked in almost every genre from fashion, nature, portraiture, documentary and cityscapes, deftly using new advances in technology to his advantage. Horvat creates tremendously atmospheric depictions with his signature use of light, which dances across his work time and time again. His extensive travels have taken him all over the world, photographing the everyday and the elite at work and play. He was persuaded to exchange his Rollei for a Leica by Henri Cartier-Bresson, who pointed out that his eyes were not on his belly so why should he photograph using it. The Leica enabled a more direct and instant type of photography. Horvat's work appeared in the seminal 'Family of Man' exhibition and he has been a member of the Magnum Photographic Agency, and American news agency Black Star, in addition to freelance work for *Paris Match*, *Picture Post*, *Life*, *Harper's Bazaar* and *Vogue* to name but a few.

Eikoh Hosoe
Ordeal By Roses, ('Barakei') No. 32

Nationality: Japanese, b.1933, Yamagata (JAP)
Genre: Portraiture/Fine Art
Date: 1962
Print: Gelatin Silver Print
Edition: Open Edition
Price: a) £1350/US$2500;
b) £2600/US$4500
Size: a) 11 x 14 inches; b) 20 x 24 inches

The Photograph
This photograph of celebrated author Yukio Mishima formed part of Hosoe's Barakei series. Translated literally, 'bara' means rose and 'kei' means punishment.

By all accounts the sittings were intense and the results no less so. Here, Mishima holds a rose to his nose, staring intently at the photographer and displaying a fierce determination of spirit rather than a representative likeness. With strong lighting and high-contrasting shadow, the portrait is broken into positive and negative spaces accentuating the authority of the image. Life, pain, punishment, flesh, birth and death are ever present, perhaps precluding Mishima's own internal conflict that was to culminate in his shocking suicide; he committed hara-kiri at the Japanese Self-Defence Headquarters in 1970.

The notion of the tortured warrior, torn between ancient Japanese traditions and modern Western influences, was explored through Hosoe's lens. This artistic collaboration has become a fitting epitaph to Yukio Mishima, a great creative soul of his time.

The Photographer
Eikoh Hosoe is well respected for his combination of great technical expertise and artistic beauty, which is coupled with an undeniable sense of humour. Hosoe's work reflects his early immersion in Shintoism and Buddhism, with the presence of ritual and wit in aesthetic harmony, which produces images of great quiet drama. His extensive nude studies are often somewhat surreal: for example naked women might hold sunflowers that obscure their faces, and part-solarised images are not uncommon. These strange constructed realities play with movement and space to intriguing effect. We accept them instantly and revel in the autonomy of Hosoe's imagination.

Michael Kenna
Fierce Wind, Shakushi, Honshu, Japan

Nationality: British, b.1953, Widnes (UK)
Genre: Fine Art/Landscape
Date: 2002
Print: Sepia-toned Silver Gelatin Print
Edition: 45
Price: £2900/US$5000
Size: 7¾ x 7¾ inches

The Photograph
This truly beautiful image is so textured that it could be mistaken for a painting or etching. The delicate nature of the photograph is recognisable to anyone familiar with Michael Kenna's work. His ability to capture the spiritual side of the landscape has become a signature of his images. It is impossible not to be affected by this image. Its title, 'Fierce Wind', conveys more than just descriptive information. Use of the word 'fierce' encapsulates the emotive effect of this composition as well. The movement gives life to an uncomplicated scene, thus enhancing the drama that Kenna witnesses with his camera. Kenna's choice of photographing the commonplace, but still delivering a sense of wonderment, is beautifully interpreted here with his choice of location. The poetic and entrancing themes in this image draw our attention to the delight that can be found in the smallest of details in all landscapes if we just take the time to look.

The Photographer
The key to Michael Kenna's success is his sensitive handling of the photographic medium. He has unapologetically found beauty in the smallest of forms and the largest of landscapes. The intimate details of life are all ripe for his camera. The visual absence of people in his work allow the viewer to enjoy a private experience when looking at his photographs. From series picturing tiny objects including keys, toys and small objects of curiosity, reminding us of Alice's Adventures in Wonderland, to Kenna's great vistas of Easter Island, all capture a sense of his childlike awe of the world around us.

Kenna is particularly known for his night photography, which again leads the viewer around the world with fresh eyes. His work is meditative and contemplative, giving a timeless quality to each space he photographs.

Dorothea Lange
Migrant Mother, Nipomo, California

Nationality: American, b.1895,
Hoboken, NJ (USA), d.1965
Genre: Social Documentary/Portraiture
Date: 1936
Print: Gelatin Silver Print
Edition:
Price:
Size: 13⁷⁄₁₆ x 10⁹⁄₁₆ inches

The Photograph
Probably one of the most famous
documentary photographs ever taken,
'Migrant Mother' encapsulates the
desperation of migrating families during
the American depression of the 1930s.
This homeless family had been surviving
on birds that the children caught and
frozen vegetables taken from nearby
fields. We feel the severity of their plight
through the lines etched in the mother's
face – a woman seemingly aged beyond
her 32 years. Her children press themselves
against her with their faces hidden, a
gesture that speaks volumes. She stares
into the middle distance, avoiding the
gaze of the camera, as if lost in
contemplation of an uncertain future.

In Lange's retouched version of the image,
the thumb grasping the tent flap in the
foreground was erased as it interfered
with the composition. This raised
questions and generated criticism as to the
validity and truthfulness of the image as a
documentary photograph. This controversy
was perhaps to be expected, as 'Migrant
Mother' was presented as a very direct
social statement, with an unambiguous
moral purpose, yet the thumb's omission is
quite inoffensive.
Without it in the foreground the eye is
drawn straight to the centre of the image,
and it is understandable why Lange chose
to erase it in the retouched version.

The Photographer
Dorothea Lange's formidable canon of
work plants her firmly amongst the
greatest documentary photographers. Her
exposure of the contradictory nature of a
polarised American society during the
1930s, 1940s and 1950s was a personal
mission. Lange is probably best
remembered for the work she produced
for the Farm Security Agency during the
Great Depression. Struggling to survive,
migrants travelled cross-country in a
desperate bid to find work, all in the
shadow of billboards advertising
America's wealth and prosperity. Lange
sought to bring attention to the plight of
these dispossessed people, yet her
portraits also manifest the pride and
resilience of people left with little hope
and rejected by society.

Racism was another theme prevalent in
Lange's work. During the Second World
War, the ill-treatment of Japanese-born
immigrants appalled Lange. Chosen by
the War Relocation Authority (WRA) to
document the registration of Japanese
Americans, Lange used this opportunity
to reveal the cruelty and ignorance of the
WRA itself through her photographs.

It should also be noted that Lange's
commitment to photographing the poor
and oppressed was not exclusively
executed through portraiture. She
captured many views of buildings
facades, such as an abandoned tenant
cabin or the Rex theatre in Mississippi,
which carried the public notice that it
was 'for colored people', which also served
Lange's personal political objectives. The
same objectives and her commitment to
them ensures that Lange's work still
resonates today.

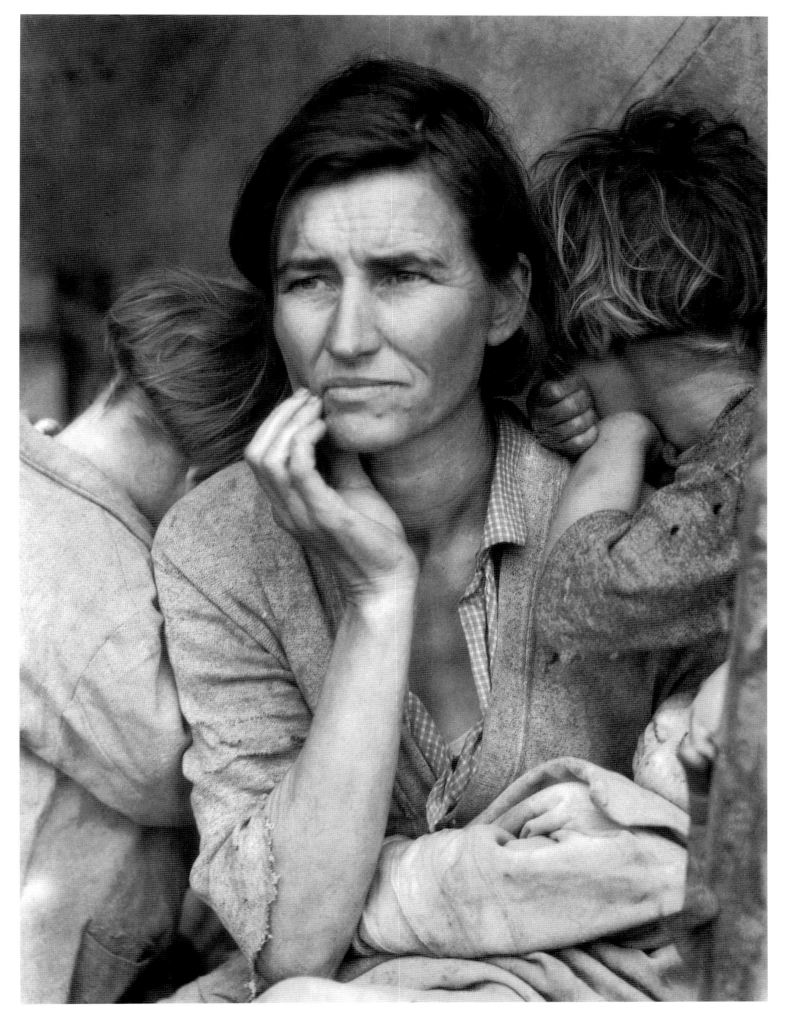

Gustave Le Gray
Landscape Study, Fontainebleau

Nationality: French, b.1820,
Villiers-le-Bel (FR), d.1882
Genre: Landscape
Date: 1852
Print: Wax-paper Negative Albumen Print
Edition:
Price: £52,000/US$90,000
Size: 8 x 10¾ inches

The Photograph
Le Gray made numerous studies in Fontainebleau. In this scene the true beauty of the trees is beautifully rendered, striking a sharp contrast between the foliage and the sky. Le Gray's skill with wax-paper negatives enabled him to exhibit incredible detail. The delicacies of the branches and texture of the leaves catching the light are distinctly clear against the highlighted trunk of the central tree. Sharp intense contrasts, teamed with a lightness of touch, deliver a truly restful and contemplative image.

The Photographer
Although famous in his day, Le Gray was commercially unsuccessful, which resulted in his exile in Cairo, Egypt – abandoning his wife and two surviving sons – in order to escape his creditors. He remained in Cairo and worked as a drawing instructor, but still produced photographs and drawings, some of which were exhibited in the Egyptian section at the 1867 Exposition Universelle held in Paris.

Le Gray's work stands as a benchmark in the historical development of photography, both technically and aesthetically. Le Gray's invention of the wax-paper negative and work with wet-collodion negative processes achieved remarkable results; his studies of clouds and seascapes retain their enchanting admiration of nature's phenomenal beauty and splendour.

In 1851, alongside Le Secq and Negre, Le Gray founded the Société Héliographique, which championed some of the earliest photographic developments. Le Gray should be best known for his commitment to the worth of the photographic image, not just as a recording device, but also as an art form in its own right. Le Gray's architectural compositions and landscape studies of France and Egypt remain exceptional in their artistry.

Helen Levitt
New York

Nationality: American, b.1918,
New York, NY (USA)
Genre: Social Documentary
Date: c.1940
Print: Gelatin Silver Print
Edition:
Price: £1700/US$3000
Size: 11 x 14 inches

The Photograph

The life of a street in New York can deliver many things. In Helen Levitt's world, the front steps of a building can become a stage upon which one can watch the extraordinary elements of everyday life being played out in full public view. The players here are three young children 'acting' in their own fantasy; attired in somewhat unnerving masks they appear completely unaware of Levitt's presence. Children were a constant source of fascination for Levitt. She was herself a very private person and it is perhaps her quiet, unobtrusive method, using a small Leica camera, which allowed her to observe and enter the world of the street without attracting attention. This image is reminiscent of a Diane Arbus's series (also untitled) taken between 1969 and 1971, which depicts residents of a mental-health institution playing in masks. These images presented an 'adult' notion of play and, as with Levitt's image here, the concept of innocence is challenged and even compromised by the sinister nature of the masks.

The Photographer

Mostly taken in ethnic and working-class neighbourhoods, where urban life was most vibrant, Levitt's work retains a mysterious quality much revered by many photographers today. Children at play were central to her work. The transitory immature chalk drawings and messages, given permanence by Levitt's camera, on pavements, steps, walls and nooks and crannies of the street, provided ample social anthropology for Levitt to record. Her poetic eye would respectfully photograph them with the reverence they deserved. This gentle graffiti is sometimes predictable and sometimes hilarious but always beguiling. A fine example is the chalked message 'BUTTON TO SECRET PASSAGE PRESS' [sic] alongside a drawing of a doorbell.

Having photographed in black and white her whole professional career, Levitt embarked on colour photography as a result of two Guggenheim Fellowship grants in 1959 and 1960. Due to a burglary in 1970 in which the new colour work was stolen, Levitt had to begin work on the project all over again. The new images were shown as a continuous slide projection of more than 100 photographs, including the eight surviving images from the 1959–60 series, at New York's Museum of Modern Art in 1974. This was a pioneering method of displaying colour photography and in these images her keen eye for the daily marvels in the world shone through.

Steve McCurry
Afghan Girl

Nationality: American, b.1950,
Philadelphia, PA (USA)
Genre: Social Documentary/Portraiture
Date: 1985
Print: Dye Transfer Print
Edition:
Price:
Size: 19¾ x 16 inches

The Photograph
Since it appeared on the cover of
National Geographic in June 1985, this
iconic image of a young girl in Pakistan
has become McCurry's most famous
photograph to date. While 12-year-old
Sharbat Gula's bright eyes stare directly
into the camera – momentarily drawing
attention away from the rest of the image
– her worn, saffron-coloured shawl bears
numerous holes, providing a subtle clue
as to the reality of her fragile situation.

McCurry's portraiture draws its power
from his direct approach and keen sense
of colour. We are immediately presented
with the exotic and the beautiful, yet
equally confronted with social
commentary and concern. Sharbat's
plight is humanised through her intense
eyes, drawing us into a story that is as
poignant and compelling as the image
itself. Sharbat's parents had been killed in
an air strike on their village and she
became one of millions who fled
Afghanistan during the Soviet invasion.
McCurry found Sharbat at the Nasir Bagh
refugee camp in Pakistan and captured
this now historic image after shooting
only a few frames.

Seventeen years after the photograph
was taken, McCurry found Sharbat again.
Her skin was weathered and worn yet
McCurry said that she was still as striking
as she was the first time they met. The
photograph resulting from this reunion is a
haunting and stark reminder of both the
brutality and bravery prevalent in humanity
throughout the world.

The Photographer
A member of Magnum Photographic
Agency since 1986, McCurry's work has
become instantly recognisable through
his colourful and vibrant depictions of
humanity throughout the world.
Disguised in native garb, McCurry crossed
the Pakistan border into rebel-controlled
Afghanistan just before the Russian
invasion. When he left, he did so with
rolls of film sewn into his clothes. As a
result of his subterfuge, McCurry was
able to publish some of the first pictures
of the conflict there. Winning four first
prizes in the World Press Photo Contest
and Magazine Photographer of the Year
in the same year established McCurry's
position as one of the foremost
documentary photographers in the world.

His extraordinary photographs from
numerous war-torn destinations include
coverage of the Gulf War and the Iran-
Iraq War as well as conflicts in Cambodia,
Beirut and the Philippines. Each body of
work captures the struggle and conflict
with a humanitarian approach, despite
the tension of the situation he may be
witnessing through the lens. McCurry
communicates the stories of individuals by
patiently observing and revealing their
experiences, despite the cultural and
language barriers he encounters.

McCurry's work in the temples of Angkor
Wat in Cambodia notably displays his ability
to capture the unknown. The empathy and
compassion evident in his work has earned
his place amongst the finest photographers
of his time.

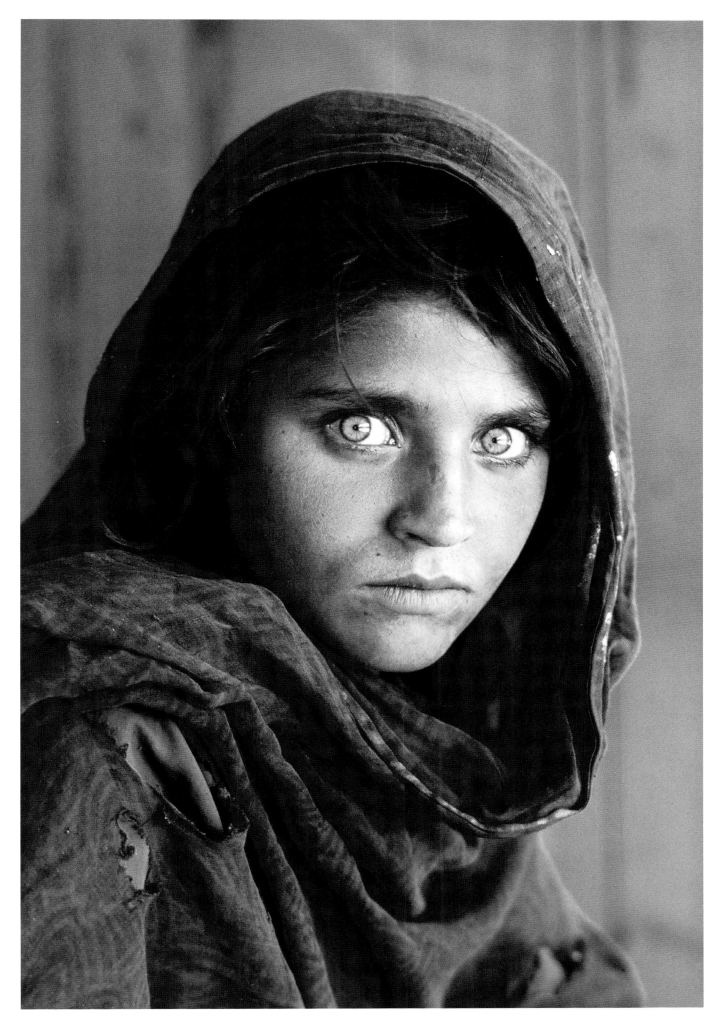

Richard Misrach
Shrapnel, Bomb and Bus

Nationality: American, b.1949,
Los Angeles, CA (USA).
Genre: Landscape
Date: 1987
Print: C-type Print
Edition: a) 25; b) 7; c)3
Price: a) £1700/US$3000;
b) £3700/US$6500; c) £5450/US$9500
Size: a) 20 x 24 inches;
b) 30 x 37 inches; c) 40 x 50 inches

The Photograph
In 1952 the US Navy named this area of the Nevada desert 'Bravo 20', and began using it as a testing ground for explosives. However, as this was publicly owned, and sacred land for the Northern Paiute Indians, the US Navy was using it illegally.

Misrach became deeply involved with this cause and local residents assisted him in documenting the history of the site and gaining access to the highly polluted land in order to photograph the results of years of tests carried out on it. In this photograph, the beauty of the Nevada desert is unavoidable, yet the stark contrast of devastation is visible everywhere: a school bus, which was once used as a target, sits in the distance empty and abandoned, and an unexploded bomb emerges from a ground littered with shrapnel.

The distance of the bus might be construed as an attempt to show the belittling of humanity in the face of such weapons, and as such educates with awe-inspiring aestheticism.

The Photographer
Richard Misrach's work reaches beyond picturesque ideals and could be described as 'investigative' landscape photography, for each series has a tale to tell, whether it be political, environmental or otherwise.

Misrach's more abstract views of the sky display an almost scientific level of attention to detail, and each carry the location, date, and a description of the celestial image or phenomenon on display. His comprehensive approach builds a jigsaw of information that not only informs but also delivers the aesthetic beauty of the landscape.

Closer to home, Misrach took over 700 pictures of the view overlooking the Golden Gate Bridge from the porch of his house in Berkeley Hills. Taken both during the day and at night, the history of the region is also considered in these images; however, characteristically, the weather pervades to mask and overwhelm with wonderful results.

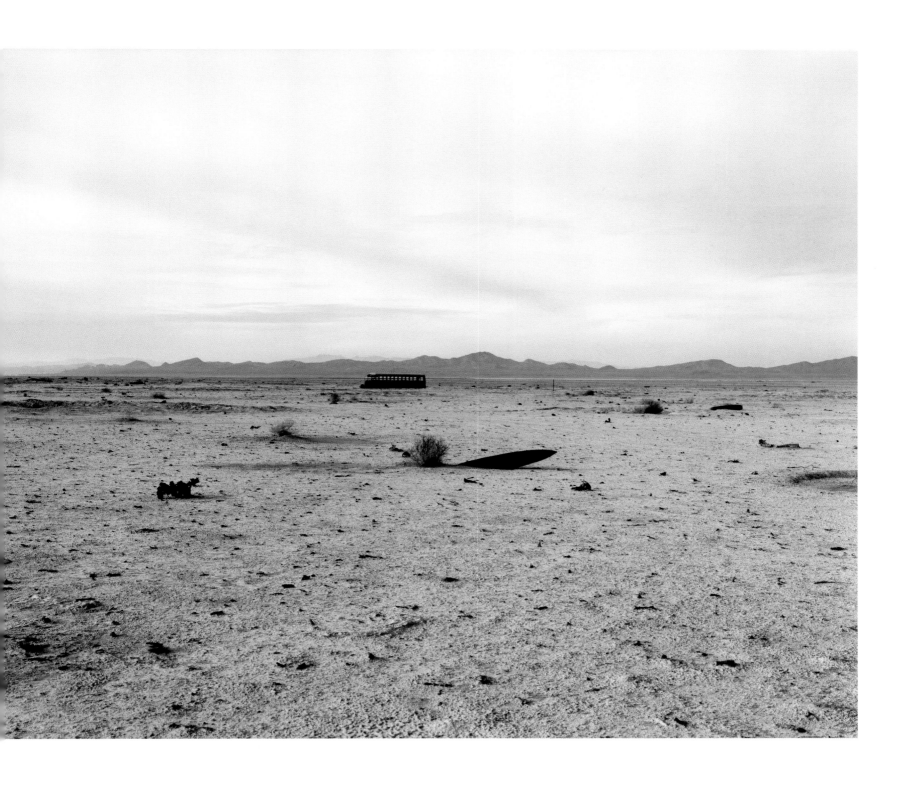

Daido Moriyama
National Highway 1 at Dawn (Asahi-cho, Kuwana City, Mie Prefecture), 1968

Nationality: Japanese, b.1938, Ikeda City (JAP)
Genre: Snapshot/Landscape
Date: 1968
Print: Vintage Silver Print
Edition:
Price:
Size: a) 6 x 8½ inches; b) 10 x 12 inches

The Photograph
The weight of this lorry bears down on the eye as a result of Moriyama's decision to photograph it from such a low angle. The stature of the tyre is rendered mammoth with imposing results. Splashes of dirt, lime or paint expressively patterns the otherwise ordinary rubber, and is reminiscent of an abstract expressionist painting. Three planes and textures fall diagonally from the bottom left to the top right of the photograph. The hard, pale tones of the road in the foreground juxtaposed against the soft mid-tones and textural patterns of the wheels provide another hard contrast with the background, which fades to blackness. Elements of a journey are all present in this picture by including the road and a sense of movement is represented by the tyres. Moriyama was travelling across the country himself around this time and seems to have encapsulated his feelings for stepping into the unknown in this one bold mesmerising picture.

The Photographer
Daido Moriyama's work evokes the sometimes predatory context of the photographer capturing a subject through keen pursuit. His snapshot aesthetic only intensifies this, while the high-contrast style maximises the technical brilliance of the work, adding another visual dynamic.

Among his early work, 'The Theatre of Japan' series featured portraits of actors whose facial characteristics were highlighted by strong light sources, a technique he also employed on still-life objects such as hats, television screens and dusty beer bottles. Moriyama's approach to his subjects imbues his work with other qualities, for example, use of intentional blurring or taking pictures through car windscreens while on the move transforms fleeting moments of everyday life. The results are sometimes eerie and often thought-provoking due to Moriyama's inimitable vision.

Nadar (Gaspard-Félix Tournachon)
Jules Janin

Nationality: French, b.1820, Paris (FR), d.1910
Genre: Portraiture
Date: c.1857
Print: Wet Collodion Negative Coated Salt Print
Edition:
Price: £8600/US$15,000
Size: 9⅞ x 7½ inches

The Photograph

At first glance, this image of theatre critic Jules Janin appears to be a simple and straightforward portrait. However, on closer inspection it allows us an insight into the character of both the sitter and the photographer.

As with most critics, Janin had plenty of enemies as a result of his inconsistent and occasionally disingenuous opinions, and this inconsistency was also characteristic of his relationship with Nadar. In this portrait, Nadar apparently introduces a sly critique of his subject; placing Janin's rotund figure in such a way that we are unable to see what he is sitting on and taking the photograph from a subtly unflattering angle that emphasises the strain upon his sitter's waistcoat and trousers, a result of his ample girth. It would appear that Nadar's relationship with Janin is enshrined in this particular composition.

Working as a caricaturist and with an interest in phrenology, Nadar's talents were put to full use here, providing a photographic glimpse into his sitter's real personality, in a manner that demonstrates the reasons for his enduring appeal.

The Photographer

Nadar's character as a left-wing, subversive and vital tour de force of the photographic world is what fuels fascination with his work. Nadar's interest in a photographic career began following a suggestion made by his brother Adrien, who was a portrait photographer with his own studio. Nadar initially collaborated with his brother until Adrien tried to adopt the same name, which resulted in the first of a series of fraternal legal actions. Nadar's talent, however, far surpassed that of his brother, as his later success would prove.

Fortunately counting some of the most influential personalities of the bohemian set amongst his closest friends surely aided Nadar's career. He was certainly well placed, as Paris in the mid 1800s – with the romantic and realist movements in full swing – was a hotbed of artistic excellence. Nadar's style typically involved simple neutral backgrounds and he refrained from using props in order to emphasise the sitter without excessive formality. This often fills his work with a timeless quality. He mainly photographed writers and artists, among them actress Sarah Bernhardt, humanitarian Victor Hugo and poet Charles Baudelaire. However, Nadar's other interests in science and medicine also placed him among the first photographers to use the medium for the scientific community. Nadar's work is notable due to his dualistic ability to absorb the creative and philosophical nature of the time, while enthusiastically embracing the latest technical developments. His studies of the Paris sewer system and aerial photographs of the city, for instance, display a love of technology and the empirical, yet retain respect for the romantic unknown.

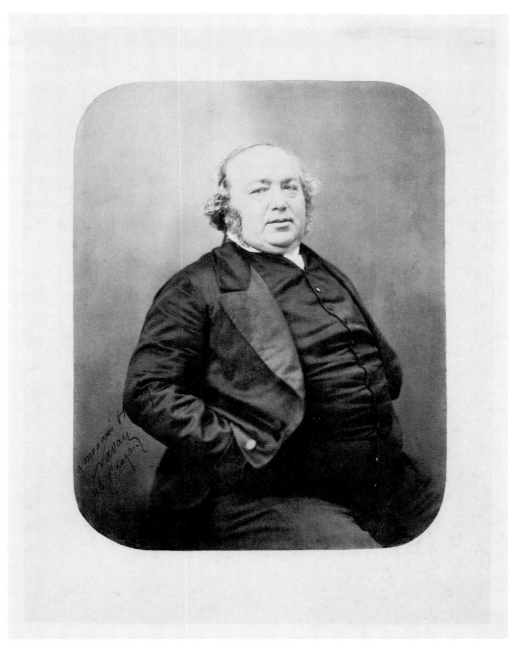

Simon Norfolk
Government Building Close to the Former Presidential Palace, Darulaman, Afghanistan

Nationality: British, b.1963, Lagos (NG)
Genre: Landscape/Social Documentary
Date: 2002
Print: C-type Print
Edition: 10
Price: a) £4000/US$7,000;
b) £7000/US$13,000
Size: a) 40 x 50 inches; b) 24 x 30 inches

The Photograph
Despite the physical damage to this government building, which was destroyed in the early 1990s as a result of fighting between Rabbani and the Hazaras, it still retains a sense of its former grandeur. Layer upon layer of history is contained within this image.

Norfolk has positioned his camera directly in front of the building, allowing us to imagine walking along the rubble-strewn path leading to what was once the front entrance. Norfolk's unavoidable retrospection is more akin to painting than photography; the deep, clear blue sky forming a backdrop against the battle scars of the ruin illustrate two opposing, yet equally fascinating, aesthetics.

An erudite use of historical references inform this work, allowing us instant recognition of the beauty he presents, and forcing us to question the outcomes of war.

The Photographer
Originally a photojournalist, Norfolk worked for numerous left-wing publications, but in 1994 he dedicated his photography solely to landscapes, albeit with a sharply political slant. He spent four years photographing sites of genocide across the globe. The work culminated in the publication of *For Most of It I Have No Words*, the title of which was taken from one of Edward R. Murrow's reports about Buchenwald.

Norfolk's photographs explored the need to remember the atrocity of genocide as the passing of time erodes, not only the human costs, but also the topographical ones. Events in Rwanda, Cambodia, Vietnam, Auschwitz, Dresden, Ukraine, Armenia and Namibia all carry horrific sorrows, whether worn on the surface or etched deep in the mind. Norfolk's is landscape photography with an ulterior motive.

Martin Parr
Bonchurch, From the 'Think of England' Series

Nationality: British, b.1952, Epsom (UK)
Genre: Still Life
Date: 1995–99
Print: C-type Print
Edition:
Price:
Size: Various

The Photograph

Here we have a less than fabulous tombola prize, not a particularly coveted one, yet proudly presented upon an embossed, floral, plastic tablecloth with its elusive winning number attached.

It is hard not to smile at this scene, a comic still life that may bring back fond memories for many. The school fair or church fete is simply not complete without a raffle and the pitiful prizes that are usually donated to it. Some useful or valuable items may occasionally find their way on to the prize table, yet most raffle winners will happily come away with objects that they would never have purchased themselves.

Parr knowingly isolates the cheerfully banal and embarrassingly familiar without offending or sneering, and thus presents us with a touchingly nostalgic, common memory. By embracing the absurd, Parr has created a charming and colourful reminder of the traditions so customary in villages and towns across the British Isles, encouraging us to respect and embrace our own peculiarities and quirks.

The Photographer

Observing the idiosyncrasy of the Great British public is what Martin Parr does best. His ability to consistently draw both delight and fresh insight from the ordinary and the everyday is compelling.

With an extensive portfolio, Parr has recorded the phenomenon of the aspirational middle classes, the working classes and a spectrum of aesthetic and obsessive trends. Famous for his bright, often garish, colour photography, Parr has effectively captured and exposed the quaint, often eccentric and always quintessentially British elements of a nation with his tongue planted firmly in his cheek. The images he takes are not patronising or parodied, but are a social documentary with warm and affectionate observations of a quirky nation.

Among Parr's gallery of bored suburban couples, mock Tudor semi-detached houses and Brits abroad with lobster-red tans, he manages to explore serious social issues with his deceptively broad and comical images. Most importantly, he never stoops to judge but simply records and sometimes celebrates. This celebration has ensured a prolific career and a place in the hearts of many who enjoy his photography.

Man Ray (Emmanuel Radnitzky)
Larmes (Tears)

Nationality: American, b.1890, Philadelphia, PA, (USA), d.1976
Genre: Surrealist/Portraiture
Date: 1930–32
Print: Gelatin Silver Print
Edition:
Price:
Size: 9 x 11⅞ inches

The Photograph
Probably Man Ray's most famous image, this surrealist classic succeeds on many levels, not least aesthetically and conceptually. Aesthetically her eyes, the windows of the soul, are gazing heavenwards, her long eyelashes are perfectly coiffed and her sorrowful eyebrows are reminiscent of silent movie goddesses: pleading, hopeful and fine. The glass beads 'perform' their role of tears, catching the light coming from the left to emphasise the contours of the spheres as well as the model's features. We are instantly aware that these are imitation tears, but understand the part they have to play in this composition, frozen theatrically in place, illustrating Man Ray's surrealist sensibilities.

The Photographer
Trained as a painter and sculptor, Man Ray's interest in photography began in 1915 after discovering the 291 Gallery, which was founded by Alfred Stieglitz. Man Ray's accomplished and pioneering career in a variety of media demonstrates his innovative approach to the arts. Using collage, found objects, sculpture, painting and film he embraced the Dadaist and cubist movements with verve and influence.

The Parisian avant-garde was quick to welcome Man Ray into the fold, shortly after his arrival in Paris in 1921, and he successfully turned his hand to fashion photography. At his studio, Man Ray also photographed artists, musicians and poets, including Constantin Brancusi, Henri Matisse, Pablo Picasso, Gertrude Stein, James Joyce and Igor Stravinsky.

Man Ray's penchant for experimentation led to his exploration of photograms in the early 1920s and the development of his own interpretation of them: rayographs. As a result of an error in the darkroom by his then assistant Lee Miller (who later achieved status as an outstanding photographer in her own right) a developing negative was exposed to light, which led to their discovery of 'solarisation', a technique that Man Ray would become renowned for.

Man Ray is rightly recognised as one of the twentieth century's great artists. The writer and fellow surrealist Jean Cocteau, probably best described his talent for the medium, declaring Man Ray to be 'the poet of the darkroom'.

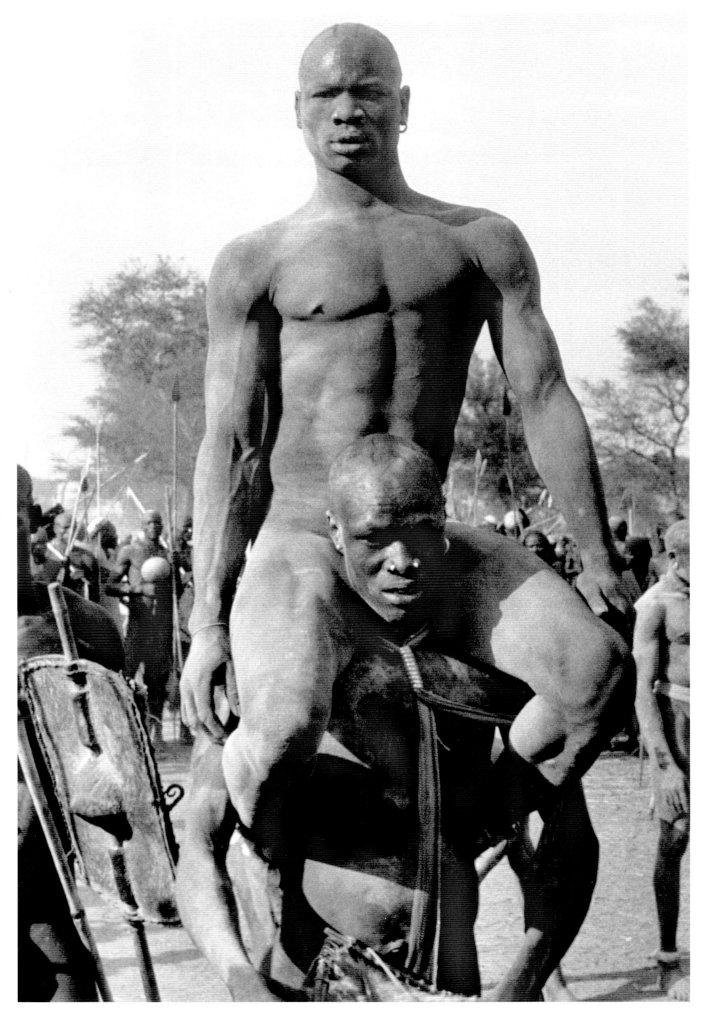

George Rodger
Korongo Nuba Wrestling Match, Kordofan, Southern Sudan

Nationality: British, b.1908, Hale (UK), d.1995
Genre: Social Documentary/Portraiture
Date: 1949
Print: Gelatin Silver Print
Edition:
Price:
Size: 13½ x 8⅜ inches

The Photograph
George Rodger's extensive document of the Nubas in Sudan was captured in just three weeks during 1949 and the images first appeared in *National Geographic* in 1951.

This short time period did not, however, hinder the spectacular understanding of their culture that Rodger was able to capture in his extraordinary photographs. A humanitarian approach to his subject culminates in respectful imagery of a tribe far removed from other cultural influences. Rodger kept a journal of his time there and found the tribe extraordinarily friendly in spite of their remote existence. The Korongo Nuba wrestling champion in this picture is carried upon the shoulders of his defeated foe. Sadly, when Sudan was declared a newly independent Islamic state the contests were outlawed, and the Nubas were compelled to cover up their bodies, thus changing their traditions and culture forever.

The Photographer
One of the founders of the Magnum Photographic Agency, George Rodger's humanitarian response to his subjects secured his place in the documentary canon. *Life* magazine appointed him as their war correspondent after seeing his pictures of the London Blitz. Rodger's work took him all over the world, covering the referendum activities in French West Africa, the war fronts in Eritrea, the Western Desert and Abyssinia, Iran, North Africa, Burma and Italy, which was where he met his fellow Magnum founder Robert Capa.

Working for both *Life* and *Time* magazines, Rodger was the first photographer to enter the infamous Bergan-Belsen concentration camp in April 1945, and witness the German surrender at Luneberg in May of the same year. This experience affected him greatly and shaped his photographic path in the future; he made the decision to end his career as a war photographer.

Rodger's later work in Africa saw him photographing wildlife, the Nubas of Sudan and the Masai of Kenya. The latter allowed him to become the first white man to witness the Masai's moran circumcision rituals, and his photographs of it became his most famous images to date. Rodger created a revelatory body of work that both informs and inspires without patronising. His lack of artifice and commitment to his subjects stands as a testament to a great humanist and photographic talent.

August Sander
Beggar, 1930

Nationality: German, b.1876, Herdorf (GER), d.1964
Genre: Portraiture
Date: 1930
Print: Gelatin Silver Print
Edition:
Price:
Size:

The Photograph

Despite her timid expression, this arresting depiction of a beggar reflects Sander's commanding and frank portrayal of his subjects. He did not aim to flatter, but to mirror every detail before the lens. We cannot help examining her clothing and posture as she stands in the doorway. We are left asking the questions as to what circumstances led to her predicament at that time. Yet these questions only arise from the image's title, as there is no attempt to convey pity or rejection of her presence in this photograph. Implications as to her character are only those that she chooses to show or conceal.

The Photographer

Photographing subjects across the range of the social spectrum, Sander's life-long project, entitled 'Man of the Twentieth Century', assembled a portrait of the people of Germany. Spanning from the years of the Kaisers right through to the early period of the German Federal Republic, Sander adopted a democratic approach to documenting the world as he saw it. The Nazi regime suppressed the work due to Sander's truthful representation of those Germans that did not fit the Aryan ideal.

Sander's subjects, whether they are peasants, artists, circus people or members of the village band, give the impression of self-representation through the directness of their poses, as people often stood in quite a formal manner. However, there are moments of impromptu joy, as can be seen in Sander's 1929 image of two young boxers neatly standing side by side, one beaming proudly, demonstrating an informality quality that was quite rare in portraiture of the time.

Despite the quashing of his project by the dictatorial might of Hitler's state, the collection of almost 600 photographs in 'Man of the Twentieth Century' remains one of our most telling summations of a time and place that history should never forget.

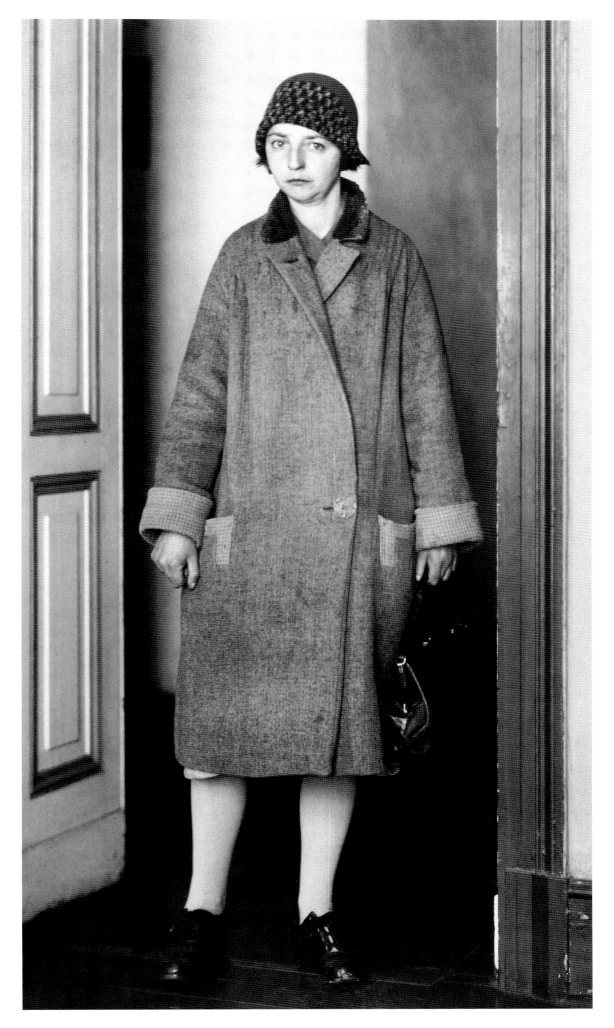

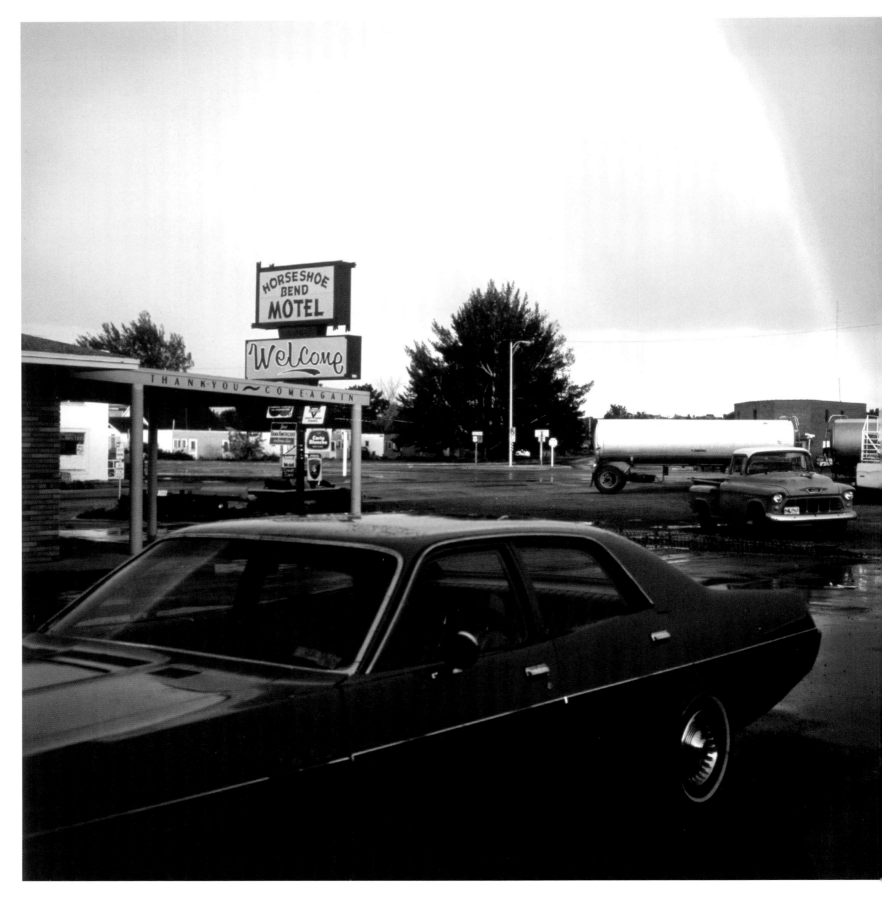

Stephen Shore
Horseshoe Bend Motel, Lovell, Wyoming, July 16, 1973

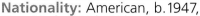

Nationality: American, b.1947, New York, NY (USA)
Genre: Landscape
Date: 1973
Print: C-type Print
Edition:
Price:
Size: 20 x 24 inches

The Photograph

The desolate parking lot of the Horseshoe Bend Motel seems an unlikely place to take a photograph. With the drivers of the gas tanker, two pick-up trucks and the green car in the foreground all absent from their vehicles, we are left only to imagine what is out of shot. Maybe a diner or a gas station? Have the owners been waiting for the rain to clear?

The natural beauty of an opportune rainbow, creating a bend of its own in the sky, illustrates the contrasts and distance between the manmade landscape and the retreating natural environment that still has the ability to surprise, in even the most bland of locations.

The Photographer

Stephen Shore's photographs are instantly recognisable: he has a way of using colour that gives an authorship to his work. Outdoor scenes often have bold but powdery pastel tones that lend the hard lines of cars, telegraph wires and buildings a romantic quality.

Shore's work concerns itself with observation and composition, and his images are truly American in their aesthetic, harking back to the 1950s and the colours associated with the era – even though his most famous imagery was taken during the 1970s and 1980s.

Along with many other landscape photographers in Europe and the USA from the 1970s onwards, Shore's work was described as new topography as it focused on documenting every aspect of the landscape as found. No human encroachment was to be altered for aesthetic purposes. This almost forensic approach allows the viewer to inspect the photograph and come to his or her own conclusions. Shore's geographic approach to all his subject matter, including occasional interiors and portraits, supplies a sense of place without judgement. He leaves us to enjoy the landscape for what it is and draw our own conclusions.

Frederick Sommer
Cut Paper

Nationality: American, b.1905, Angri
(IT), d.1999
Genre: Still Life/Fine Art
Date: 1977
Print: Gelatin Silver Print
Edition:
Price:
Size: 9⅝ x 7⅜ inches

The Photograph
Sommer's degree in landscape
architecture imbues his sense of
dimension and space, and this, along
with a delicate touch, results in the
gloriously palpable imagery that we
see here. His fine-art approach to
photography gives his work a tactile
component that is more commonly found
in sculpture, drawing and collage. His
artistic career spanned all of these
disciplines, each informing his way of
seeing and practising his art.

The close relationships between the
physical space, the composition and the
light that falls upon the cut paper are so
multi-faceted that it is hard to
comprehend the scale or distance
between the paper and the surface
behind it. This gives the photograph a
further surreal visual advantage. The
appreciation of both the cubists (shown
in the structure of the lines), and the
surrealists (shown in Sommer's anarchistic
approach that allows the deconstruction
of the carefully cut lines as they collapse
once lifted), is clearly evident here.

The Photographer
Frederick Sommer's methodology involved
working in a medium or with a process
that interested him, which subsequently
gave his portfolio tremendous breadth
and ultimately gave him a sound
understanding of many genres and visual
styles across the photographic spectrum.
Found objects and animal parts placed on
different surfaces presented a fascinating
yet disturbing surreal aesthetic, and his
landscape photography cast aside
compositional norms. Sommer avoided
horizon lines, sky or other obvious
contours present in the landscape, thus
confusing, yet unifying, scale and
producing images that at first glance
could be read in abstract terms. This
allowed the textures and juxtaposition of
objects, plants or trees to be considered
in great or little detail without the
constraints of a formal structure.

Away from the genre of landscape,
Sommer's subjects included occasional
portraits and cut-paper drawings on foil
or *cliché-verre* (cameraless images of
smoke or paint on glass or cellophane), and
all were approached with his inimitable
style. Sommer's careful constructions all had
one thing in common: they saw beyond the
realms of reality and stretched the
possibilities of the medium to produce a
sublimely fascinating body of work.

Chris Steele-Perkins
Playing Bushkashi

Nationality: British, b.1947,
Rangoon, (BUR)
Genre: Social Documentary
Date: 1995
Print: C-type Print
Edition:
Price:
Size: Various

The Photograph
This extraordinary photograph captures the energy exerted by horse, rider and spectator alike during a bushkashi game in Afghanistan. By including the surrounding crowd and omnipresent landscape, Steele-Perkins encapsulates the exhilaration surrounding the game. The image's focal point, the horse (not its rider), mouth agape and rearing up, is placed centrally in the frame with its head almost level with the mountains behind. This placement raises the stature of the horse alongside that of the beautiful landscape to create awe-inspiring results. Steele-Perkins's depiction of the Taliban remains strong without resorting to obvious social stereotypes.

The contrasting colour of the vibrant blue sky and other static elements in the picture emphasise the reality of the event. The signature style of many of Steele-Perkins's documentary photographs is due to his ability to successfully couple both action and colour in even the most testing situations.

The Photographer
Chris Steele-Perkins's industrious career to date has placed his work among that of the most recognisable documentary photographers in the world. He has produced many monographs, each focusing on a particular body of work. Among these are 'The Pleasure Principle', which profiled Britain in the 1980s and 'The Teds', an exploration of the teddyboy in the 1970s.

Steele-Perkins's wry sense of humour is evident in many of his images, as is his skill to look beyond the obvious in order to reveal the surprising.

Alfred Stieglitz
Spring Showers

Nationality: American, b.1864,
Hoboken, NJ (USA), d.1946
Genre: Fine Art/Landscape
Date: 1911
Print: Photogravure
Edition:
Price: £31,500/US$55,000
Size: 12 x 5⅛ inches

The Photograph

The rain-drenched streets of New York create a wonderful atmosphere for Stieglitz to affirm his pictorial style in this timeless work. Stieglitz's skilled composition, which is aided by the elongated dimension of the image, guides the eye up and down the image to gradually bring into focus all of its detail. His painterly approach to the scene successfully combines a soft-focused, somewhat diluted background, which is reminiscent of an impressionist style, with an almost Japanese aesthetic provided by the dark skeletal shape of the tree. The only figure that can be distinguished is a road sweeper, moving towards the more populous murky distance. Taken in a negative context this could be seen as a truly dismal day in New York, but through Stieglitz's gaze it is transformed poetically into a diametrically handsome picture.

The Photographer

Acquiring some 650 works by leading pictorialists (most of which were subsequently given to the Metropolitan Museum of Modern Art), Alfred Stieglitz secured his movement's place in photographic history. His keen faith in the potential of photography as a fine-art practice proved to be a prescient one. With confident devotion to representing a given subject through inspired techniques and compositions, Stieglitz's work can take you to a dreamlike reality where textures are heightened and boundaries are blurred with magnificent effect. Stieglitz's photographs display his love of portraiture, tableaux and the landscape, and whether or not he is depicting a scene or person in the distance or close up, they always remain intimate and contemplative. His images are so aesthetically comparable to painting and etching that to glance at them is to ignore them completely. Surely the only way to observe his work is unhurriedly and quietly.

Joseph Szabo
Priscilla

Nationality: American, b.1944, Toledo, OH (USA)
Genre: Social Documentary/Portraiture
Date: 1969
Print: Gelatin Silver Print
Edition:
Price: £1700/US$3,000
Size: 8⅛ x 12 inches

The Photograph
This photograph could have been taken yesterday; that it was taken in 1969 is of no consequence. The fact that this picture was been used on the album cover of grunge band Dinosaur Jr's 'Green Mind' as late as 1991 displays its timeless universal connections to the teenage experience.

Szabo's direct style of portraiture does not shock, but instead examines its subjects in a very matter of fact manner. Priscilla's age is not disclosed, although her appearance is closer to that of a child than a formative adult. This duly deems the image more striking but it is not threatening. We feel a correlation to her thoughtful or perhaps hardened expression. Without allowing himself to appear judgemental Szabo's photograph presents an insightful aspect of youth, which is both thought provoking and somewhat beautiful too.

The Photographer
Documenting his teenage students, while teaching at Malverne High School in Long Island during the 1970s and 1980s, resulted in a body of work that has fascinated many American and British fashion photographers. The importance and necessity of make up, clothes, cigarettes and cars are observed through Szabo's forthright approach, without appearing exploitative.

His first book, *Almost Grown*, featured 25 poems written by teenagers in Alan Ziegler's writing workshops, and included 90 of Szabo's photographs. The poets were asked to interpret the pictures as if they were their own and the collaboration revealed a truthful understanding of the young poets' views of the photographic subjects, which were revelatory, romantic and funny.

Szabo's approach to emergent teenage sexuality is not avoided, but dealt with respectfully, providing a dialogue that is devoid of ulterior motives or hidden agendas. The results are poignant moments, possibly familiar to those of us who remember the strange and difficult transition from childhood to adulthood. The experiences may change over time, but the sentiment in Szabo's work shows that some things never change.

William Henry Fox Talbot
Study of Lace

Nationality: British, b.1800, Melbury, (UK), d.1877
Genre: Fine Art/Still Life
Date: 1844
Print: Calotype Negative Salted Paper Print
Edition:
Price: £17,200/US$30,000
Size: 9 x 7¼ inches

The Photograph
This fine example of one of Talbot's calotypes, which are also referred to as 'talbotypes' as a result of his patenting the production process in 1841, illustrates the incredible detail he was able to capture using this method. This early demonstration of the power of representation that photography pioneered is a beautiful one, with every stitch in the lace near-perfectly rendered. Talbot's decision to make a positive print from a negative photogram, without using a camera, gives the image a more accurate and detailed quality. Although small and unassuming, the subject is no less dramatic than Talbot's more ambitious studies. Rather than act as a straightforward technical demonstration, the tactile nature of this deceptively simple, yet complex, image gives it an intimacy that is bewitching.

The enduring appeal of Talbot's work is no surprise considering the resounding quality of his images, which still stands up alongside those of any contemporary photographer today.

The Photographer
Describing the importance of William Henry Fox Talbot in a few short paragraphs is impossible. His influence on the photographic oeuvre was immense, from his technical contribution, and his personal artistry, to his advancement of the photographic medium as a whole. In terms of composition and demonstrating the potential of the photographic process, Talbot's contribution was vital to further the appreciation of the photograph as an art form, and not merely a form of representation.

Talbot's work ranged from portraits, still lives, cityscapes, landscapes, photograms and genre studies, and his versatility was equalled only by his enthusiasm for the medium. *The Pencil of Nature* was acknowledged as the first significant book to be published and illustrated with original photographs. It was published in six fascicles, over a two-year period and contained 24 plates. Talbot's second book, *Sun Pictures of Scotland*, became the first book purely composed of images.

Talbot also took many pictures of scenes in and around his home; Laycock Abbey, and of notable aspects of British heritage including the construction of Nelson's Column in Trafalgar Square. His depictions of nineteenth-century life are an invaluable glimpse into the past.

Captain Linnaeus Tripe
Rangoon. View Near the Lake

Nationality: British, b.1822,
Devonport (UK), d.1902
Genre: Landscape
Date: 1855
Print: Wax-paper Negative Salted
Paper Print
Edition:
Price: £42,750/US$75,000
Size: 10⅟₁₆ x 13⅜ inches

The Photograph

Captain Linnaeus Tripe was the official photographer for the military expedition of little known areas of Burma (now Myanmar) following the end of the Anglo-Burmese war in 1853. Exchanging his weapons for the camera, Tripe took the very first photographs of the country. In this image we are presented with a wooded path that leads toward distant temples. Tripe captures a sense of wonderment, the open foreground dotted with flora leading the eye upwards to its first glimpse of the distant and exotic architecture emerging from the horizon. Tripe's familiarity with the landscape is evident in this assured composition, which places the architecture in the context of the landscape as if it was simply an organic extension of the environment.

The Photographer

Linnaeus Tripe's impressive portfolio boasts some of the most absorbing early landscape photographs. Released in 1857, his topographic studies of forts, temples and architectural facades resulted in some 300 published views of Burma.

Tripe produced many albums during his career, one of which used a binocular camera to produce stereoscopic views.

This particular work, 'Stereographs of Trichinopoly, Madura, Tanjore and Other Places in the Neighbourhood' consisted of 70 photographs.

In the late 1860s, Tripe produced images of Burmese vegetation that were aimed at a more commercial market. These photographs were made using the collodion process, a new development of the time that allowed greater detail and delicacy of tone than the calotype process.

Tripe's portrayals of the Indian subcontinent are important historical records, but his compositional skill, seen particularly in his treatment of architecture, and through his thoughtful use of natural light, ensured that his works would retain a significant place in the history of photography.

Weegee (born as Usher, later Arthur H. Fellig)
Cop Killer

Nationality: American, b.1899, Zloczow, (GAI, AUT, now UKR), d.1968
Genre: Photojournalism
Date: 1941
Print: Gelatin Silver Print
Edition:
Price:
Size: 13¼ x 10⁹⁄₁₆ inches

The Photograph
This extraordinary shot of a man accused of murdering a businessman and a policeman in 1941 displays the dark side of the New York underworld. A progressive evening newspaper, *PM*, employed Weegee at the time, and he supplied the story along with the photograph. The image is striking for many reasons, not least the battered appearance of the accused.

Here we see the uncooperative and manacled Anthony Esposito being held firmly by his coat lapel and arm in order to keep him upright for the photograph. The officers turned away from the camera draw attention to the gunman, improving the drama of the composition. However, this was not as a result of Weegee's choice, but on the insistence of the two detectives, who were adamant that neither their faces or names should appear in the newspapers.

The Photographer
In the period following America's Great Depression, Weegee took some telling images of New York City, many of which still provide inspiration for photographers and film-makers today.

Plagued by crime, prostitution and poverty, New York City was a breeding ground for some of the darkest of crimes found in America. Weegee himself grew up in the Jewish ghetto on the Lower East Side of the city, and from an early age was obsessed with photography. His incredible pictures were expertly captured, often before the police arrived at the scene, thanks to a police radio in his car and good contacts with the Manhattan Police Headquarters. Horrific crimes, mob violence, gangster wars and, by stark contrast, society photographs all formed part of his extensive portfolio. Weegee became renowned and even stamped his tabloid press photographs 'Weegee the Famous'. He left nothing to chance and armed himself not only with his camera, but also packed a typewriter, cigars, film, flashbulbs and spare shoes in the trunk of his Chevrolet. Weegee's style was punchy, direct and graphic. Using artificial light to heighten the drama and contrast of his imagery he achieved superb aesthetic intensity. He published *Naked City* in 1945, and it became a bestseller overnight (and later inspired a film of the same name that won an Academy Award).

Weegee's work tells the story of life on both sides of the social spectrum. His images taken in the clubs and bars of the Bowery, infrared pictures taken inside movie theatres and his later kaleidoscope photographs distorting the rich, famous and unknown alike are shining examples of tabloid photojournalism at its very best. Weegee's brutal, fierce and bizarre work pushed boundaries and set the pace for the future of photojournalism.

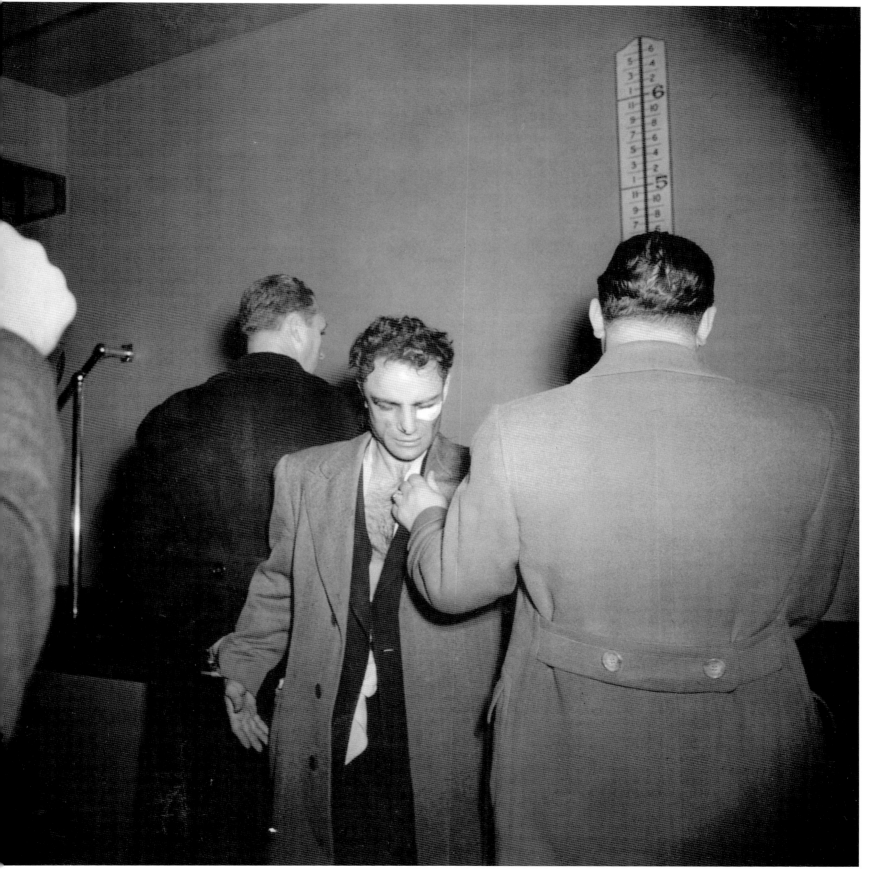

William Wegman
Evolution of a Bottle in Space V

Nationality: American, b.1943, Holyoke, MA (USA)
Genre: Fine Art
Date: 1999
Print: Colour Polaroid
Edition:
Price: £4200/US$7500
Size: 24 x 20 inches

The Photograph

Combining humour, fashion pastiche and his beloved dog Fay Ray, Wegman has created a multifaceted dialogue with the viewer. Here we see Fay Ray sporting a very expressive and sculptural Issey Miyake garment. Within this composition, Wegman has created his own still life and identified it as a 'Bottle in Space'. The 'evolution' has quite literally 'evolved' from the re-identification of the form and its naming by the artist. Reinterpretation of art is a common practice, yet Wegman has paid homage to a clothes designer here through a reappraisal of the garment's use to that of an outfit for his dog. Just as fine-art painters concentrated on the texture and representation of fine fabrics to display wealth and prosperity in the past, Wegman has done so photographically, and not without a wry smile. Fay Ray peers over the pleated fabric with a somewhat bored, yet almost coy look, comparing favourably to many a model in the glossy pages of *Elle* or *Vogue*.

The Photographer

William Wegman's Weimaraners are more famous than the average pets. He has photographed generations of his much-loved dogs to such an extent that his work is instantly recognisable via its canine incorporation.

Full of humour and with clear adoration for these docile characters that are dressed, posed and placed into position, he create scenes and images which have delighted many over the years. By constructing scenes, his pictures operate on a thematic level rather than a technical one. Wegman works in various mediums, including drawing, painting and film. Working across a range of media, with an expanding cast of sitters and through skilful artistry, Wegman has placed himself in a photographic oeuvre of his own.

Bob Willoughby
Dustin Hoffman & Ann Bancroft
– 'The Graduate'

Nationality: American, b.1927,
Los Angeles, LA (USA)
Genre: Portraiture
Date: 1967
Print: Gelatin Silver Print
Edition: 200
Price: $850/US$1500
Size: 12 x 16 inches

The Photograph

Willoughby took this image as a potential promotional shot for *The Graduate* (1967). Dustin Hoffman stands limply, jacket in hand, at the far end of a space that goes nowhere. Hoffman's character's meek and nervous demeanour in the film is reflected beautifully here as he recedes in the metaphoric shadow of Ann Bancroft's character. The sharp contrast of Bancroft, seen confidently nursing a cigarette in her bejewelled and manicured left hand and resting her right hand on her hip, illustrates her character's power and control. The obvious exchange of roles, freedom and confinement are all displayed to iconic effect. The contrast between Hoffman's white shirt, which blends into the background, and Bancroft's imposing leopard-fur coat, prominent in the foreground and its pattern pointing to her illuminated features, completes the dynamism of her role. Willoughby's ability to capture each persona so eloquently provides a succinct visual synopsis for the film in a single photograph.

The Photographer

Willoughby's prolific career – incorporating fashion, portraiture and music photography, as well as his signature work of the stage and screen – is as varied as his subjects. His music photography spans more than 50 album covers, including those for the Dave Brubeck Quartet, and Willoughby has also had the enviable honour of photographing jazz greats such as Chet Baker and Gerry Mulligan.

The stage plays a large part in Willoughby's work. By utilising sets and surroundings he is able to capture an essence of the soul of his sitters, combining composition, light and obvious ease with his subject to bring out their very nature in a way only few photographers can. This talent is apparent in all his portraiture, both black and white and colour, even with the most famous actors, directors and personalities. This most compassionate photographer allows us to glimpse into their world and witness the nuances of their character through his meticulous and thoughtful photography.

Garry Winogrand
White Sands National Monument, New Mexico

Nationality: American, b.1928,
New York NY (USA), d.1984
Genre: Social Documentary
Date: 1964
Print: Gelatin Silver Print
Edition: Non-editioned
Price: £4500/US$8000
Size: 11 x 14 inches

The Photograph
Winogrand left New York in 1964, for four months, to travel across America and experience, and photograph, the prevailing mood of the ordinary American. The result was a truly unforgettable series of works, palpably absorbing the country through his watchful eyes. The ordinary became aesthetically decisive and striking in his hands, and this image is no exception.

The shade in this composition expertly delivers sharp tonal contrasts to inform two very separate actions. As the girl walks to the left of frame the detailing on her dress is enhanced by the darker tones, which emphasise the strain on the lace and give her form a greater presence. Although her pace is casual, the folds of her dress further the perception of movement, accentuated again by the image's tonal contrast. However, the two women scrambling up the sands in the background appear motionless in the white light, which flattens out their figures and deceptively renders their efforts as being nonchalant.

The Photographer
Chiefly known for his street photography in the 1960s, Gary Winogrand has influenced the path of American photography through his impeccable imagery. Predominantly photographing in his native New York, Winogrand studied under Alexy Brodovich, whose intuitional approach embraced the traditions of capturing the 'decisive moment', pioneered by Henri Cartier-Bresson.

Skilled in both black-and-white and colour photography, Winogrand's momentum in the 1960s still forms a solid interpretation of the vitality of the human spirit today. His masterful use of 35mm photography and available light brought a visceral and intense prolific body of work. Some of his best work was as a result of his sharp observations of passers-by. Winogrand was able to pick out people of interest as they move towards him on the pavement resulting in arresting spontaneous moments. His legacy has inspired many photojournalists to find the remarkable in all aspects of public life.

Joel-Peter Witkin
Portrait of a Dwarf

Nationality: American, b.1939, Brooklyn, NY (USA)
Genre: Portraiture/Surrealism
Date: 1987
Print: Toned Gelatin Silver Print
Edition: a) 15; b) 3
Price: a) £2000/US$3500; b) £5700/US$10,000
Size: a) 16 x 20 inches; b) 28 x 36 inches

The Photograph

The striking images created by Witkin are uncomfortable to look at. This work is no exception, as the subject matter of the unfamiliar is 'displayed' as an oddity specifically to be stared at. It is equally fascinating and repulsive, and the photograph recalls the carnival freak show. Witkin's fascination with the fringes of society is somewhat comparable to Diane Arbus's interest in the unknown, but Witkin explores with a more layered approach.

By employing a combination printing technique, Witkin is able to 'smash' a hole in the face of the bust. This gap is echoed by that in the 'horse' on the left. To further intensify the diminutive stature of Witkin's primary subject, a seven-foot man stands to her right and her clothing is disproportionate, which deliberately amplifies her build. Clothed in a wedding veil and mask (Witkin bought these himself), the notion of childhood and dressing up is slyly introduced, yet her gaze through the mask pierces this flicker of innocence and re-introduces the sinister.

Witkin combines his compositional elements with a painterly, scratchy surface, which gives the picture an aged look. We are left to revel in his contradictory carnivalesque and construct our own tales amidst the chaos he presents.

The Photographer

Fantasy, mystery, alchemy, fairytale and horror could all be used to describe Witkin's work. He merges real life with spectacle and mysticism to fuse together thoroughly disturbing elements of life and death.

Props and references to art history play a large part in his theatrical and often nightmarish images. Witkin's sitters frequently share extreme physical characteristics: they may be contortionists, pre- or post-op transsexuals, or may suffer from obesity or anorexia. Witkin's use of cadavers pushes his aesthetic from the bizarre to the grotesque.

Madame Yevonde
Persephone from the 'Goddesses' Series

Nationality: British, b.1893, London (UK), d.1975
Genre: Portraiture
Date: 1935
Print: Dye Transfer Print
Edition:
Price: £1000/$US1750
Size: 12¼ x 16½ inches

The Photograph
Persephone is the goddess of the underworld in Greek mythology, the daughter of Zeus and Demeter. Persephone was such a beautiful young woman that everyone loved her; even Hades, the king of the underworld, wanted her for himself. One day, when Persephone was collecting flowers, the earth suddenly opened and Hades abducted her.

Broken-hearted, Demeter, the goddess of the harvest, wandered the earth looking for her daughter until Helios revealed what had happened. Demeter was so angry that she withdrew herself in loneliness, and the earth ceased to be fertile. Zeus sent Hermes down to Hades to make him release Persephone. Hades grudgingly agreed, but before she went back he gave Persephone a pomegranate. When she later ate it, it bound her to the underworld forever and she had to stay there one-third of the year. The other months she stayed with her mother. When Persephone was with Hades, Demeter refused to let anything grow and winter began.

Yevonde's portrayal of Mrs Longdon as Persephone subtly fuses mythological elements and photographic composition. Mrs Longdon's face is illuminated as it shines amid the darkness, her eyes are cast upwards, she is clothed in dark garments and set against a black background, all of which creates the illusion of Persephone in the underworld.

Persephone's myth is one that is symbolic of the budding and dying of nature and Yevonde pictorially represents this through the flowers in Mrs Longdon's hair.

The vibrant vivex tri-colour separation process used is perfect for enhancing this other-worldly depiction as the black projects the colour forwards. By lighting the head from behind, Yevonde also creates a slight halo effect around Mrs Longdon's hair, which softens an otherwise solid form and allows her subject to float ephemerally in the dark.

The Photographer
Madame Yevonde's career spanned many genres, from portraiture and still-life studies, to advertisements, tattoo studies and fashion.

Even as a society photographer, she explored women's' sexuality using metaphorical props that alluded to myth and fantasy. Butterflies, scorpions and busts were all reinterpreted and integrated in rich layered scenes. Yevonde's cover shots for journals such as *Harper's Bazaar* and *Vogue* benefited from her insightful and vivid imagination. Notably, Yevonde was commissioned by *Fortune* magazine to provide four shots of artists and craftsmen at work on the sumptuous interior of the RMS *Queen Mary* for a feature they were preparing. Over a period of several days, Yevonde took no fewer than forty-six shots, twelve of which she submitted to the editor to choose from. He was so delighted with the results that all twelve were reproduced in the magazine.

Madam Yevonde's membership of the Professional Photographers Association, and her becoming the first woman invited to speak to its members, is a testament to her pioneering attitude to photography. As a result her images remain as exuberant today as when they were taken.

Chapter Three
Structuring Your Collection

Deciding what sort of images you wish to collect may initially appear to be a rather simplistic consideration, but there are many different ways in which a collection can be approached, and it is advisable to firmly establish what type of collection is best suited to your interests before purchasing your first piece.

Approaches to Curating

The casual buyer of artwork is often characterised by his or her sporadic purchases, and these are often based on the premise that a particular piece holds an immediate appeal. While it is tempting, and entirely valid, for the fledgling collector to adopt a similarly random and scattershot approach to collecting, it is a better idea to instead carefully plan a photographic collection so that the result is structured and coherent, with the emphasis placed on a unifying theme, purpose or subject. Establishing a historical, thematic, biographical or stylistic collection provides the focus and discipline to inform your choices from an early stage, and by doing so impulse buying is avoided, allowing each progressive purchase to complement and contribute towards the shaping of a personal, distinctive and unique collection.

This sort of approach to curating is recommended for a number of reasons. The images in a collection, when displayed together, represent a total aesthetic statement. When works are in close proximity to one another, they are viewed as a whole and should be sympathetic with one another. Keeping a coherent thread running through a collection allows the visual harmony to be more easily maintained, with each new acquisition forming a considered part of a complete and ever-growing entity. These considerations are not intended to limit your collection, but will simply make it much easier to curate in either a domestic or commercial environment. As recurrent themes and subjects may often overlap and/or form sub-groupings, these branches of interest keep the accumulation of new work more of an organic process. By stimulating a cohesive expansion of individual interests within certain set parameters, you can produce quite dynamic results, and you may well be surprised by the direction your collection takes as it grows.

Setting yourself collecting parameters does not restrict your collection, but instead allows it to blossom. As your collection grows it will naturally evolve and you should be unafraid of shifting the focus over time. One collector I know, who solely collected black-and-white images, came to be so enamoured with a particular colour image that he altered his entire collection to accommodate this single work. The piece had a striking red theme that, once purchased, inspired a dedicated 'red room' of works only keyed to the colour, forming a new and unexpected facet to his portfolio. A collection should be considered as a dynamic living thing and as such it should naturally reflect your own changing tastes.

The uniqueness and specificity of the choices made by the collector actually have the potential to shape a more valuable body of work, not only in personal and historical terms but also in financial worth. For example, by collecting work that is exclusively from your country of origin, or concerned with a particular event in history, your collection may become an investment for future generations to keep and expand upon, with interest in it lying far beyond the photographic sphere.

As part of a focused collection, shared subjects, aesthetics and themes resonate more powerfully. The commonality doesn't have to be immediately obvious, but it must be consistent. A more specialised collection will still generate many exciting juxtapositions when displayed together. As an example, consider the surreal influences prevalent in the 1930s, which pervade anonymous images made by amateurs and professionals alike. Surrealism was present not only in the fine-art end of the market but also filtered down through the media and even into everyday depictions as photography became increasingly accessible to the masses.

Always consider your collection from the perspective of a viewing audience. As a collector, you have the capacity to curate something that you can share and enjoy with others. It is the duty of a collector not to keep a passive record, but to influence future enthusiasts. With a keen eye and careful research there are numerous possibilities for the future of photography, and these can be directly influenced by the decisions made by today's collectors.

This chapter outlines some examples of popular and commonly used types and themes of collections for you to consider. These examples are by no means finite, but provide a suggested guide that can be further developed upon as your purchases form a collection. This chapter is intended as a guiding hand to demonstrate the advantages of clarifying your outlook when deciding on future purchases, in order to enhance the pleasure to be gained from building a photographic collection.

'Song of Sentient Beings #1617', 1995.
Bill Jacobson
With a delicate aesthetic, Jacobson's androgynous and ambiguous nude remains emotive, but this stems from what it hides rather than what it discloses. The 30 x 36 inch silver gelatin print is one of a series of works exploring desire, loss and their relationship with the AIDS epidemic. Subtle suggestions of the human as a vulnerable and beautiful entity, from cradle to grave, enrich the ghostly quality of this work further still. By placing the figure in a fetal position and enveloping it in darkness, its appearance is very womb-like. Regardless of its mournful tones, the poetic fluidity of Jacobson's visual language transpires the obvious to register a beguiling composition upon which to reflect.

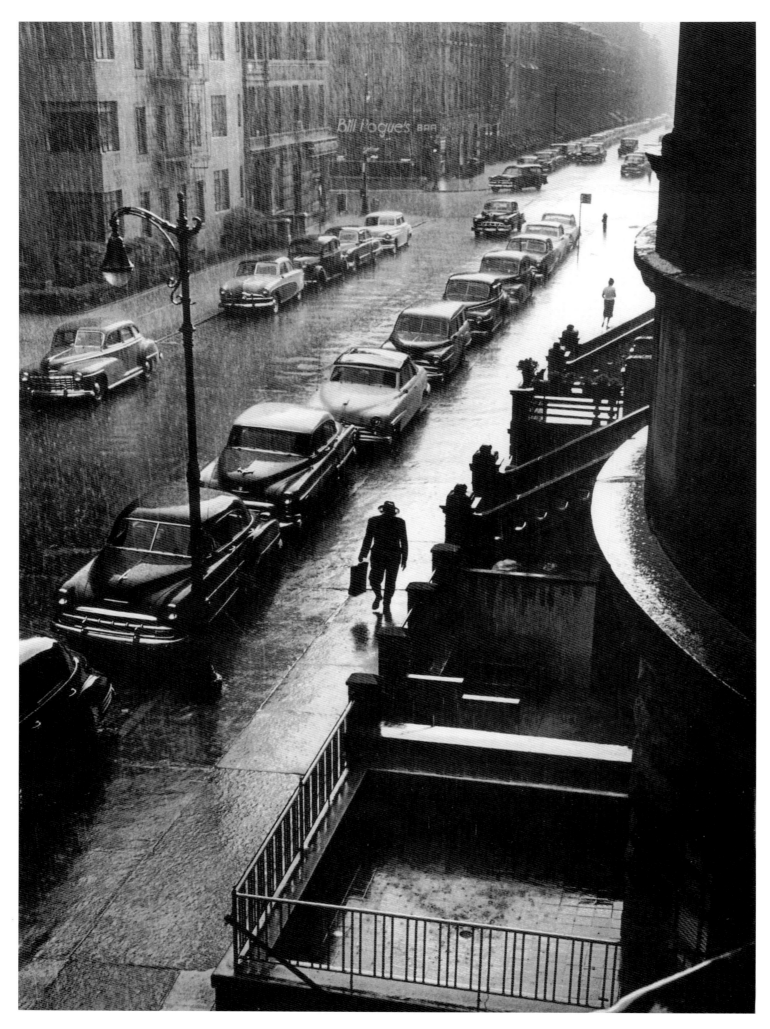

Biographical Collections

The most unambiguous collection is composed of the work of a single photographer, as this provides a straightforward and easy vernacular in which to structure the works. A biographical collection has the advantage of creating a body of work that will, by definition, often consist of images that are visually sympathetic to one another.

Investing in a single photographer may well be a financial gamble as the popularity of photographers and the value of their images, both past and present, can shift dramatically from year to year. Pioneering, well-known and established photographers offer the most financial security; however, acquiring images of this calibre requires the highest initial investment as these sort of works are more familiar to a broader audience and exhibited on a more frequent basis, thus acquiring a much larger price tag. Aside from the high cost, collecting such 'master' works may also be a slower process due to the relative rarity of such images reaching the market, and also lacks much of the excitement that can be gained from discovering a new image by a more obscure or emerging photographer. If you are restricting yourself to forming a biographical collection of a grand master then ensure you choose your photographer wisely. The added advantage of collecting the work of Henri Cartier-Bresson, for example, is not only that it is an assured investment, but also, due to his prolific output during his long career, that it still provides an opportunity to introduce a personal level of authorship to a collection of his works.

Conversely, a collection of work by a little-known or new photographer may enable a larger collection to be built on a more modest budget, with the small possibility that the images within it will increase in value over a relatively short period of time. However, there is also the greater likelihood that your chosen photographer may well languish in obscurity. Remember that your choice of a relative unknown will be less likely informed by notions of investment, and more by your personal attraction to the work. As a collector, you have the power to give your patronage to those images that you feel deserve to be more widely seen. Whether you concur with the philosophy behind the work or whether you simply appreciate the aesthetics of a certain photographer, you are directly supporting the development of that artist. The initial success of a photographer and the value of his or her work will be relative to his or her rising profile. Collecting a single photographer's images will stimulate interest in his or her work, which directly affects the success and value of it.

Following the professional development of a photographer can be immensely satisfying, and your support and investment can pay dividends as his or her career unfolds. In the case of contemporary photographers, it is worth taking into consideration the fact that the photographic community will be aware of up-and-coming names to watch out for. You may often find that certain photographers already have a keen and committed following among collectors, and any recommendations that appeal to you should be investigated fully, as the larger the level of interest and base of support, the more likely that photographer is to succeed! As a rule, popular and expensive photographers provide greater security, but can result in smaller returns on the initial investment when the time comes to sell, whereas lesser-known photographers have a greater risk of loss, but also have the room for faster growth within the market over a shorter period of time.

Aside from financial considerations, a biographical collection is a fine method with which to amass a series of photographs that have a particular theme or interest in the broader sense. The career of a photographer can represent a summary of the time and place he or she is or was working in, and very often the photographer will become extremely well known for a particular body of work that typifies a particular moment. A key component of photographic history may well spill over in association with a key moment in social history. This was certainly the case for Robert Frank's 'The Americans', a series that not only holds an important place within the genre, but also within the history of the United States. Whenever and wherever there are social and cultural shifts, pop-culture phenomena or historical upheavals and conflicts, photographers are attracted. This eagerness to observe, comment and inform often means that some photographers become celebrities through their involvement and association with their subject, as much as through their work itself.

'Man in Rain, NYC', 1952. Ruth Orkin
Ruth Orkin often used the view from the window of her apartment as the subject of her photographs. Here, on the street below, a man walks in the rain, his direction complementing the cars that are parked facing the same way on either side of the street. The strong contrast between light and dark, splitting the scene diagonally from the bottom left to the top right, gives weight to the image, and a single dark figure placed in the centre of the composition fixes our gaze directly upon him. As the only elements moving are the rain and the figure, the solidity of everything else is accented beautifully.

WOODBURY &Co. W. P. DANDO. F.Z.S.

Historical Collections

A historical collection consists of work from a single era, whose value is determined not only by its composition, but also in its capacity as a historical record. You may simply wish to collect work of a specific era that holds a particular interest and personal fascination, such as images taken during the Second World War or the Great Depression. This type of collection can encompass a large and varied range of photographers, but is likely to prompt your focus towards a specific aesthetic. A historical collection does not necessarily have to be composed of reportage or documentary photographs, as a period can be represented in many and abstract ways.

Collecting work from a single era allows the scope to specialise in particular styles, which may be prevalent at the time or emphasise influences from other artistic genres and movements of the day. For example, the modernist movement influenced photography in many ways, and similarly trends in painting, film, sculpture and even architecture have all had an impact on photographers' approach to their media.

By definition a historical collection of this nature differs from a broader stylistic collection, as it will only focus on a specific period. Over time the influence of a movement such as modernism will still exist, to a greater or lesser extent; however, a collection composed of those images made at the height of a movement's popularity will have the advantage of historical context that later collected work does not.

While it is true that trends are fickle, and that certain eras often hold greater interest than others, there is a strong and consistent market interest in historical collections, both from other photographic collectors and historians. As with every other type of collection, photographs of popular subjects often command higher prices, but by opting for these in the parameters of a historical canon you will also benefit from a greater availability of specialist images and support.

While a historical collection is often primarily defined by the subject of the print (the prints themselves may well have been made at a later date), you may also wish to consider building a vintage collection. A collection of this nature consists of prints actually made at the time the photograph was taken and is therefore often seen to more fully embody the period in question, as seen in the eyes of the artist. As most editions are not printed in their entirety at the time they are made, a vintage collection is more sought after for its rarity and is priced accordingly.

The authorship of the production of a work, either by the photographer, or the photographer overseeing the printing of his or her work by an assistant, will also favourably affect the value of a vintage print, as this is seen as bringing the 'hand of the artist' even closer to the work. Vintage prints display a richness, which becomes clearly apparent when they are viewed alongside 'serial' prints (those made years later), due to characteristics of the printing techniques and the type of printing paper used.

There are instances, however, when the availability and demand of work is such that it is necessary to produce further prints from earlier negatives at a much later date. The posthumous print, made by a relative, photographer, technician or publisher, can be a valid necessity due to its historical importance. For example, there has been increasing demand for the work of female photographer Lee Miller, one of the first accredited female photographers to photograph combat during the Second World War and whose insightful work before, during and after the conflict has become more appreciated in the time following her death in 1977. As a result, there has been an increase in the production of posthumous prints of her work. The importance and integrity of this work is retained by the strict control of the Lee Miller Foundation, who maintain the value of the work by limiting edition numbers and keeping production standards high. Miller's negatives are printed by photographic printer Carole Callow and then authenticated with a stamp signed by Miller's son, Antony Penrose, and accompanied by an official copyright mark. Penrose personally oversees the production of the work to ensure that his mother's intentions and legacy are preserved. Prints of this nature can be an integral part of a historical collection, especially in those instances where there is a scarcity of original material on the market to fill the gaps in an otherwise comprehensive collection.

'Chimpanzee, Regent's Park Zoo, London', c.1890. W. P. Dando
Dando's early wildlife studies are collected by historical and scientific photographic collectors alike, and are renowned for their accurate depictions of animals in captivity, some of which are endangered today. Here Dando has captured the anthropomorphic qualities of a chimpanzee that looks quite at ease in his seated 'portrait'.

The difficulty of keeping animals still in order to photograph them is a common problem and successful portrayals such as these are a joy to look at, both compositionally and technically. It is also noteworthy that the delicate tones achieved by the carbon printing process are suited perfectly to reproducing the texture of the chimpanzee's hair.

Technical Collections

Collecting a specific type of print requires a high level of relevant technical knowledge. The construction of a technical collection is very much a connoisseur's approach to collecting and often a large investment is needed in order to ensure that the very best examples are secured.

Photographs produced using nineteenth-century production methods are highly favoured, as these were often one-of-a-kind works created without a negative. A daguerreotype (whereby the image is created on a copper plate) is the finest of these processes and as such will fetch the highest market price in this field. Ambrotypes (whereby the image is created on a glass plate) sit in the mid-range bracket, and tintypes (whereby the image is produced on a tin plate) were the cheapest to produce and are therefore the least expensive 'type' to acquire.

Daguerreotype, ambrotypes and tintypes were all made by placing physical items within the camera (as opposed to a negative from which copies could be made), and produce a reverse image (unlike a paper print). As such they possess a unique quality: these items are rare and desirable and good examples fetch high prices. As the exposure needed to create these 'types' was between 60 and 90 seconds the chance of movement during this time was greater. Therefore crisp, blur-free examples are highly valued and more difficult subjects to capture, such as animals, children or the natural world are particularly desirable. Equally those of historically significant events, people and photographers usually fetch high prices.

It is a familiar irony that the factors which contributed to the obsolescence of the daguerreotype, namely its long exposure time and the fact that it was a positive-only process allowing no reproduction of the photograph, are the same factors that now stimulate contemporary collectable interest and increase the value of them. The highest price paid for a photograph at auction to date was for a daguerreotype: Joseph-Philibert Girault de Prangey's 'Athènes, 1842'.

There is equal interest in the printing processes spawned by William Henry Fox Talbot's invention of the salt-paper print, which was itself considered a groundbreaking development. These multiples form the second highly collectable technical type of print and, as well as salt, include albumen and platinum prints as well as those produced using other sensitising materials.

The nineteenth-century exploration of the world via photography brought forth the recording of many sites of beauty and cultural interest, examples of which are rightly coveted by many collectors. The finest portray the wonder of the world with devastating accuracy and beauty, and early works by photographers such as Bisson Frères, Timothy H. O'Sullivan, Felice Beato, Francis Frith, Maxine Du Camp and Samuel Bourne remain as cornerstones of early photographic exploration and are highly collectable as a result.

At the upper end of the paper-prints market sit the masters of nineteenth-century photography. Good albumen prints by Julia Margaret Cameron, for example, range from £5700/US$10,000 to £45,700/US$80,000. This price is indicative of the growing popularity of photography, as only a few decades ago the price of her work was approximately twenty times less. Cameron's position in society enabled her to photograph the great artists and writers of the day such as Lord Tennyson, which of course adds to the prestige and desirability of her work.

It is however, possible to undertake a technical collection on a more modest budget. Other extremely popular paper-print collections worth considering for both large and small investors are cartes de visite and stereographs, whose prices vary considerably despite their mass production during the nineteenth century. Their abundance means that there is a wide and affordable range of examples on the market, but rarer images will of course command higher prices. Photographs of both the unknown and the famous were featured in this format, as well as images of historic events, city scenes and wildlife. As with all nineteenth-century works, the rarity, authorship and subject of cartes de visite all affect their price. Similarly, stereoscopic images of often comparable subjects are also attractive to collectors, along with the stereoscopes required to view and appreciate the work's three-dimensional effect. These are often found through specialist dealers at a variety of prices dependent upon their quality and rarity, with both plain and highly-decorative examples available.

High quality reproductions in photographically illustrated books of the nineteenth century, many of which often contained paper prints such as calotypes, woodburytypes and photogravures, are also collectables worth considering. Although not as refined as other paper prints mentioned here, they still retain value within the context of a collection.

When buying illustrated books it is advisable to closely inspect all pages, especially the title pages (which are sometimes absent), and the binding. Unfortunately wear and tear is often unavoidable and copies of famous imprints do exist with variable print quality. If possible, try and compare one copy of the book to another. As ever, rarity and quality guides the price: classic works such as William Henry Fox Talbot's Pencil of Nature or Peter Henry Emerson's Life and Landscape on the Norfolk Broads sell for vast amounts.

'La Côte', c.1841. Bisson Frères
This is a rare image of supreme quality. Due to the exposure time required, daguerreotypes of animals are highly valued as the likelihood of the animal holding still long enough to record the image is rather slim. Assisted by a sharply focused foreground, this fine example has little sign of movement and retains a beautiful clarity that wholly displays the equine physique and markings to full effect. Taught daguerreotypy by Daguerre himself, the Bisson Frères are mostly known for their spectacular, large-scale scenic images of the Alps and architectural subjects. Increasing demand for portraiture put them out of business by 1864, a fact that enhances the rarity of an image such as this.

Below: 'Siren XXXV'. David Parker
On an epic scale – some are six feet wide – the grandeur of David Parker's photographs ably captures the wonder of the world as seen through the eyes of one of the great landscape photographers. The composition is imbued with symbolic and mythological presence, both in visual terms and in terms of process.

This toned silver gelatin print was taken with a custom-built panoramic camera that used military reconnaissance film, and was printed with traditional techniques and materials. The sepia/selenium-toned image invests a sense of history to the work. which does not fail to impress.

Although not original prints, photogravures by the photo-secessionists, which were often showcased in the seminal *Camera Work,* are also extremely collectable. To own a photogravure of a master photographer is within easier reach for most, as often there are a greater number available (up to 1000 per edition approximately).

Before you embark on a technical collection, you must be aware of the added difficulties in managing and maintaining vintage works. Daguerreotypes require specialist storage and low light, and many other types of prints require carefully monitored conditions to maintain their condition. Prior to purchasing, a keen eye is needed to look at the condition of the print and you should be prepared to research authenticity thoroughly. This can require a lot of specialist knowledge, as documentation for provenance is rarely available, and this is where a reputable dealer can prove to be invaluable.

A good technical collection should reflect fine examples of extraordinary quality. Although many technical collectors focus on examples of the nineteenth century, the twentieth-century masters of photography are also collectable. Superbly printed masterworks by Alfred Stieglitz, Edward Steichen, Paul Strand, Edward Weston and Ansel Adams have secured their highly-valued place in the market and are prized among serious collectors, as too are works by contemporary photographers such as William Eggleston, who is renowned for his richly coloured iris prints. The quality of work available and the progressive and consistent development of fine-printing techniques results in a wealth of choice for the technical collector.

Left: Daguerre built on the work of Niepce to perfect his daguerreotype – a highly polished copper plate that was coated with a thin emulsion of silver. The image surface is extremely fragile and each unique plate was protected by glass in often elaborately decorated sealed cases.

Centre: Ambrotypes, or collodian positives, are superficially similar to and easily confused with daguerreotypes, though the process is quite different. When backed with black lacquer or paper an under-developed collodian glass plate negative appears as a positive, which is then encased to protect the unique image.

Right: The tintype (or ferrotype) is produced in a similar way to the ambrotype, but using a thin sheet of enamelled tinplate as the base support instead of glass, which gives a chocolate-brown tone. Tintypes were popular with street photographers until the beginning of the twentieth century and are often very simply mounted into paper sleeves or pressed metal mats.

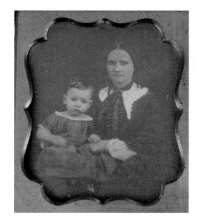 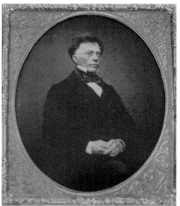 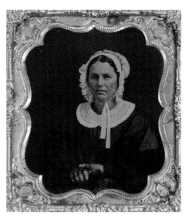

Thematic Collections

A single genre of photography may be defined as consisting of those images with a shared theme or a style. Both thematic and stylistic collections are commonly housed under the term 'genre' collections, but in actual fact each has separate and distinct concerns and so are best considered individually.

A thematic collection consists of work that has a unifying subject, such as a particular person, item or location. Popular subjects include particular film stars or musicians, wildlife or images of a specific city. As with a historical collection, a thematic collection may also be of great interest to enthusiasts beyond the realm of photography. The Beatles, for example, have a long established network of collectors who rabidly devour any associated memorabilia, including photographs of the band.

While it is possible to pursue any consistent theme, there are a number of established thematic conventions that prove popular with collectors of photography. You should be familiar with these as they will already have a vibrant recognised market and a network of associated specialist galleries, publications and enthusiasts.

Each of the following six themes are a great starting point for the collector, as they are broad and flexible, and so allow for the further, more detailed categorisation to be made when choosing the thread with which to bind your collection together.

Documentary Photography and Photojournalism

Finding its origins in the recording and reportage of news and significant events, photojournalism produces images that have a purpose beyond their aesthetic value. It is the photography of bearing witness and recording war, poverty, social injustice, politics, disasters and all the elements of our world and the human condition.

The inherent themes of social documentary and photojournalism may seem an unlikely collectors' choice. However, just as historical collections reflect a photographical record of important events and significant people over the years, great documentary photographers and photojournalists have become favoured for the artistry in their work as well as its subjective and historical significance. The fact that the role of a photojournalist is assumed to be impartial and factual, to inform and perceive the truth of a situation, usually without interference, staging or posing, seems to be at odds with the idea of producing an image as an art object, yet each photojournalist has his or her own style that can be instantly recognisable and convey artistic authorship of the image. The aesthetic he or she creates is appealing to many with an appreciation for photography beyond the strict fine-art parameters, and the subject matter often only adds to further enhance its impact.

On many occasions the subjects undertaken by great photojournalists are personally led or instigated and the photographers themselves become a key point of interest to the collector. The great photojournalist Robert Capa is as famous for his personal life as his work, and this is therefore part of the commodification of the value his images hold. The impact made by many photojournalists is indicative of their conviction to produce quality imagery that reaches above and beyond the recording of events and a duty borne of the necessity to disseminate their information as widely as possible. Key twentieth1-1century documentary photographers associated with the prestigious Magnum Photographic Agency include photojournalists such as Eve Arnold, Martine Franck, Philip Jones Griffiths, Inge Morath and Chris Steele-Perkins; all are unified in their pursuit of photographic excellence and deeply respected for their contribution to photography.

'Mrs Msweli', 1997. Jillian Edelstein
In this powerful and moving photograph, taken during the truth and reconciliation hearings in South Africa, Edelstein sensitively portrays Mrs Josephine Msweli standing in Sappi Gum Tree Forest, on the spot where her son was murdered in 1992. The visual mixture of strength and grief in this photograph is depicted through Mrs Msweli's face and her sure stance is reminiscent of August Sander's portraits. She presents herself willingly to the camera, almost as an act of defiance towards those who killed her child.

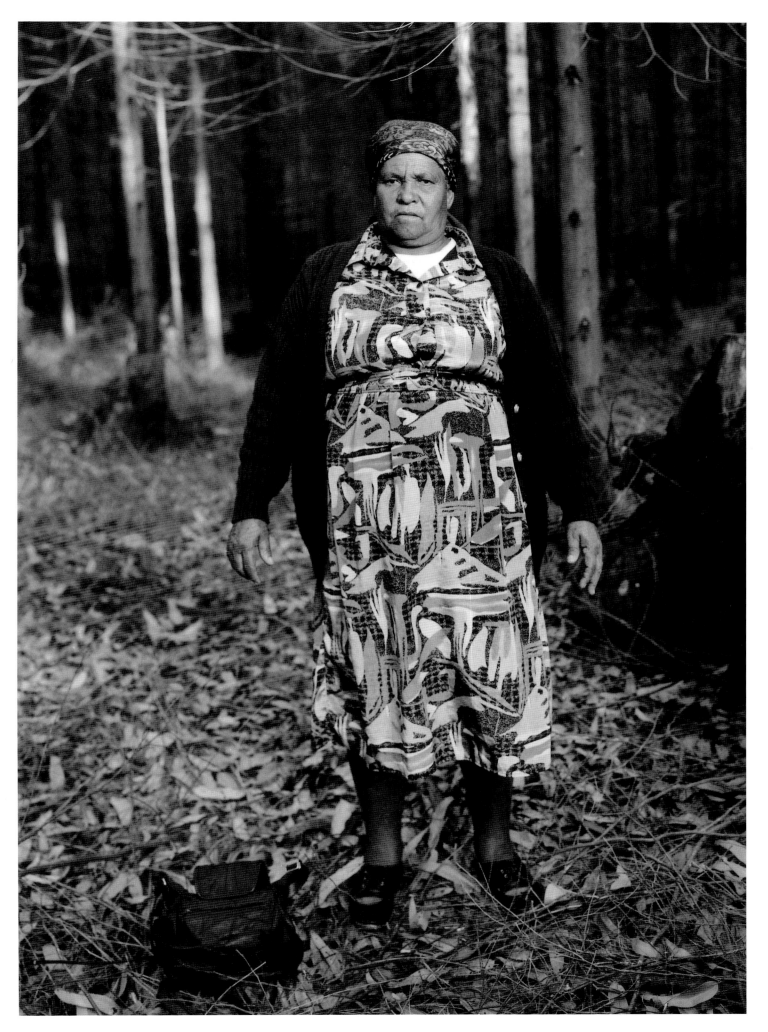

Fashion Photography

In its most basic form, the fashion photograph is an illustrative image intended to sell clothing and accessories for top designers. However, interest in the photographers, their aesthetics and their subjects has established fashion photography as a highly collectable genre in itself. Fashion photography often filters through into other genres (most frequently portraiture), and by its very nature records a popular visual language, which in retrospect imbues the work with rich layers of nostalgia.

Interest in fashion photography has accelerated at a startling rate in recent times, with photographers such as David LaChappelle, Guy Bourdin and Helmut Newton transcending limited categorisations and taking their work to new heights. With bold visual statements, unique aesthetic visions, subversive compositions and the fusion of other artistic influences, great fashion photography is now, quite justifiably, seen as a fine-art form and holds great appeal for collectors. The photographer's status within the fashion industry and the sometimes iconic people they photograph are a winning combination. Within an industry that embraces notoriety, these photographers are in a position to experiment in a way that many other artists could only ever dream of. The public's desire to view the work in new environments, outside the pages of glossy magazines and confines of galleries, has further fuelled an appetite for beautiful, glamorous and striking imagery.

Strong, bold statements made by great fashion photographers have regularly transcended their original advertising remit to become newsworthy items themselves. The industry has assisted the blurring of the lines that once defined the genre by investing beyond the confines of selling accessories and clothing to selling utopias of style and creativity. Such photography has propelled the phenomenon of the supermodel, from Twiggy in the 1960s to the likes of Kate Moss and Gisele Bundchen today. The clotheshorse has been transformed into a thoroughbred, making superstars of both the model and the photographer. One such photographer is Mario Testino, who has become a global brand with a massive audience and an enviable client list. Indeed, it is the cult of celebrity that, in part, attracts such acclaim. Testino's work is now exhibited all over the world, complete with the associated glamour and excitement expected of the fashion industry. The care and attention taken with ever-more adventurous and ambitious photographic practice to promote fashion in ways unimaginable in the time of William Klein's innovative fashion photography of the 1950s sees photographers utilising trends and ideas from many other genres successfully to become worthy of sitting alongside them.

Numerous photographers, who would not traditionally describe themselves as working within 'fashion', have incorporated the genre within their portfolio, bringing respectability and greater kudos to it. Sound investments include famous, iconic, groundbreaking and celebrity-orientated imagery by well-known photographers such as David Bailey, John French and Bruce Weber, as well as historically recognisable eras, classic moments and trends in fashion.

'Charles Jourdan – Spring 1968'.
Guy Bourdin
It is Bourdin's very individual take on fashion photography that places him firmly in the top bracket of collectable fashion photographers. This is encapsulated in this surreal interpretation of an otherwise unremarkable shoe. By allowing a single, enormous, bright yellow woman's sandal to literally 'dominate' the male footwear, also placed outside each doorway in the corridor, Bourdin creates a rather comic take on the persuasive female presence. His ability to transcend the dry remit of purely displaying an accessory, garment or object, while retaining elegance, style, wry humour and impeccable use of light and colour has earned him the reputation as one of the world's greatest fashion photographers.

Landscape Photography

Landscape photography encompasses all the elements of our external environments, both natural and manmade. The subjects of interest to collectors cover the whole gamut of landscape-photography themes, ranging from pastoral, architectural and urban locations, and may also include people as an integral part of that locality.

With its origins in painting, the traditional perception of the landscape, and our interaction with it, has changed dramatically over the last century. The medium of photography reflects this change, as arguably more representative imagery can be produced with the camera than with the brush, with the notable exception of the pictorialist movement, which aimed to retain the qualities and temperament of more traditional art forms.

Contemporary photographers have further explored the landscape specifically to expand upon the way that we view the world around us. They do this by questioning traditional methods of depiction and including those environments that are conventionally seen to be unworthy of interpretation. Consider work such as Ed Ruscha's conceptual 'Thirty-four Parking Lots in Los Angeles' or Joel Sternfeld's 'The Highline' series as examples of how broad the definition of landscape could be. Photographs reflecting this shift have great appeal to collectors as they present a pictorial reflection of art's transformation into postmodernism by the fetishisation of the recent.

Conventional landscapes, however, retain equal standing within the collecting world. A great landscape photograph can take you to a time, place, era or simply provide a compelling visual aesthetic. Consider, for example, the masters of the genre such as Eadweard Muybridge, Carlton E. Watkins and Ansel Adams. Landscapes are personally and emotionally engaging, and as such are consistently very popular with collectors. With so many images to choose from, this is an extremely rewarding genre to collect.

Above: 'Looking East on 30th Street on a Monday Morning in May 2000'

Below: 'A View Towards the Empire State Building, November 2000'

Images from 'The Highline' Series, 2000. Joel Sternfeld

Sternfeld's outstanding and socially conscious photographs command a great deal of attention from collectors as they often capture the broad scope of the landscape and place strong emphasis on our position within it. This series explores an overgrown viaduct, which stretches 1½ miles from 34th Street to Gansevoort Street in Manhattan. Sternfeld's photographs reveal a hidden oasis above the busy streets below, and we see the tracks of the derelict railway overgrown with thriving greenery, a precarious new ecosystem born of neglect. It is at once an urgent call for preservation of such forgotten spaces and a rich metaphor for the invention of nature and the ephemeral position of urban progress.

'Looking South on a May Evening (the Starrett-Lehigh Building), May 2000'

Nude Photography

In photographic terms, the nude represents a study of the human form. Classically the model would be posed; however, candid shots of the naked body also fall into this genre. Erotic photography is also affiliated with the nude genre, and this often comprises images of the human form that are specifically designed to titillate and arouse. While the term 'erotic' may have tabloid connotations nowadays, it has remained popular throughout the development of the medium and early examples are highly sought after.

During the nineteenth century many nude photographers strategically covered their models with props and exotic embellishments in order to distinguish their images from explicit erotic photography, which often fell short of the decency standards of the day.

Many photographers have explored the genre as part of their practice and there are numerous works by famous artists that have interpreted the nude in very distinctive ways. Compare André Kertész's distorted nudes, Robert Mapplethorpe's homoerotic imagery and his photographs of the female bodybuilder Lisa Lyon, and Edward Weston's purist approach to the human form to see just how wide the scope of this genre really is. The great variety of exposition regarding the nude allows for further interpretation and display for many collectors.

Left: 'Orientalist Study', c.1853.
Julien Vallou de Villeneuve
Removing the nude from the reality of the
present, using mythical or exotic depictions,
allowed Vallou de Villeneuve to make numerous
studies between 1851 and 1855. Issues of moral
ambiguity aside, Vallou de Villeneuve created
some of the most enchanting tableaux via his
use of props, in this case recruiting an array of
patterned fabrics to add interest to the
otherwise unimaginative pose. Her beads part
either side of her left nipple, providing a
tantalisingly ripe focal point of this early,
relatively chaste, nude study.

'Below: 'Les Berlinglots', 1954–58.
Fernand Fonssagrives
One of the hidden gems of twentieth-century
photography, the work of Fernand Fonssagrives
notably displays a fusion of the early influences
in his life. Consider the sculptural contouring
lines created by the dots of light on the model's
body in this photograph, accentuating
Fonssagrives's skilful perception of form. As his
first career was that of a dancer, Fonssagrives's
understanding of the beauty of the human
form was evident in all of his work. By
abstracting the human body, through relatively
simple techniques, Fonssagrives was able to

create truly absorbing photographs.
Fonssagrives actively encouraged his models to
express themselves in front of the camera in
order to harness their own creative energy, and
this image is a magnificently successful example
of just that.

Portraiture

Portraiture encompasses images of the famous and anonymous alike, and has a universal appeal as a collectable genre. A good portrait should reveal the character of the sitter through its composition. Early photographic portraits were initially restricted to those who could afford it. However, with the growth and increased accessibility of photography, portraiture was brought into peoples' homes and everyday lives and the general public was invited to witness every level of existence in ways that were previously unimaginable.

Snapshot collections often contain anonymous images from a variety of lifestyles, and the choices made by the photographer, whether professional or amateur, divulge the social landscape through elements of style, clothing, expression or location in an extremely personal way; as the awareness of being photographed allows the sitter some element of control over their portrayal. August Sander's 'Young Farmers in their Sunday Best' remains one of the most famous portrait photographs in history. Sander's decision to allow his subjects to pose themselves gave his photographs such depth and honesty that they retain great collectable interest today.

Still-Life Photography

Bringing life to that which is static, while appreciating light and form, is key to a successful still-life photograph. Most commonly a still life consists of objects that a photographer has either found or arranged. They must stimulate interest through their form, texture or arrangement to convey a study or interpretation that may be symbolic of a subject, person or event, or may be a purely sensualist deconstruction of the media itself.

Historically, the ability to represent objects truthfully through photography allowed museums to photograph their collections without painstaking and time-consuming rendering by an artist. Some of the greatest still-life images allow the viewer to enjoy the object pictured as much as, if not more than, if it were present. As a tool for many artists to develop their skills, still life is a flexible way of creating a composition in its purest terms. It is an exercise in composition and representation that has fascinated artists long before the dawn of photography.

The appreciation of particular objects, such as flowers, could form a theme within a still-life collection. The simplicity and beauty displayed in Baron Adolphe de Meyer's 'Still Life', a photogravure that was taken in 1907 and appeared in *Camera Work* in 1908 (issue 24), remains a prime example of a successful still-life image.

Left: 'James Dean – Times Square', 1955. Dennis Stock

This image is one of a handful of definitive portraits of James Dean. Stock captured Dean's personality using the then unconventional backdrop of a rainy day in New York City. Stock actually photographed Dean extensively between 1957 and 1960 and was quite familiar with his subject: a man who was well versed in the art of his own representation. The charm of this picture is not only in Stock's formal compositional choices, but also in the humour within the photograph. There is superb visual wit here: in Dean's comical expression as he walks in the pouring rain with a redundant cigarette in his mouth, and particularly within the glimpse of the cinema in the background, which is screening *20,000 Leagues Under The Sea*. We are given the rain, the man and a movie in one image, all well worth watching.

Right: 'Têtes par Jean Goujon', 1854. Henri Le Secq

Le Secq's image reveals the innate charm of the object in this early still-life photograph. Le Secq was a painting student at the studio of Paul Delaroche in Paris, and often photographed objects to use as studies for paintings. Among his broad photographic oeuvre, Le Secq made other purely photographic still-life studies, utilising his understanding of light and form as beautifully as we see here.

Stylistic Collections

As the name suggests, a stylistic collection contains the work of a particular photographic school or style. A school or style of photography can be broadly summarised as a specific movement, often within a particular epoch, which is comprised of a close community of artists working towards a shared agenda. It is a little harder for the novice collector to identify those images that are associated with specific schools or styles, and may require the undertaking of more background research concerning the specific working history of a particular image's photographer.

By definition, a photographic movement usually has an ideology, methodology or style that its subscribers adhere to in order to distinguish itself from other groups. For example, new vision photographers, such as Moholy-Nagy, broke away from the doctrine of old vision photography and rejected pictorialism in favour of the snapshot aesthetic and no-viewfinder style. In some cases, such as Ansel Adams's Group f.64, the artists worked in accordance with stylistic guidelines that were printed in a manifesto.

Assembling a stylistic collection is essentially very similar to collecting works from a certain era or period, as styles and schools are often easily chronologically identified. Examples of many of these have already been discussed, but might also include photographic images associated with broader movements using other artistic mediums (such as architecture, painting and sculpture): Dadaism and the work of the Bauhaus are prime examples of these.

The significance of many movements that have been solely photographic and/or part of a particular epoch is often identified by key artists whose overall collectability is heightened by their reputation. To have good examples from key photographers within a stylistic collection will ensure a fine and sound investment and is worth pursuing. However, within the stylistic gamut, a proliferation of images and print types are available. Aim to find the finest examples available, as many different outlets may carry the same image to varying degrees of quality, price and type.

'Lillian Gish as Ophelia', 1936. **Edward Steichen** This sublime image by Steichen, co-founder of the Photo-Secession Group, depicts the famous silent movie actress Lillian Gish as Ophelia.

Gish was playing the role in Gielgud's 1936 production of Hamlet on Broadway at the time. The tableau casts Gish as the eponymous heroine draped within the foliage; her melancholy stare downward serves to further the drama of the scene.

Contemporary Inventions

Reducing the body of collectable photography to a simplistic, singular categorisation is often impracticable, simply because there are so many crossover genres to contend with. Many images fall into more than one category and all art, by its very nature, is subjective, not only for the photographer, but so too is the interpretation of the person viewing the work. Some images may span a variety of techniques and themes as well and therefore a single photograph can mean different things to different people.

Similarly, in a medium as new and dynamic as photography, which is constantly evolving and often at the forefront of the wider manifestations of modern art, you may find photographers whose images are hard to categorise at all. New genres are both launched and abandoned with alarming frequency: trends such as heroin chic, for example, swiftly came and went in the 1990s; without substance or association with recognisable concerns, its time in the spotlight was inevitably limited.

In order to accommodate the fickle tides of fashionable tastes in the fine arts, we should bear in mind that conceptual amalgams and pictorial imaginings are not all fleeting. The work of photographers such as Gregory Crewdson and Robert ParkeHarrison are perfect examples of contemporary inventions that stand the test of time, due to their considered and informed approach to the medium.

'Flying Lesson', 2000. Robert ParkeHarrison
ParkeHarrison uses visual aesthetics from the past to convey his conceptual and mystical visions. Created via the technology of today, otherworldly narratives unfold. Here, a dreamlike and surreal scene is played out as birds on strings teach a man how to fly. The poetic grace of the birds, each restricted by cage or ties, reflect the man's own inability to escape the ground. Reminiscent of the great pictorialists, ParkeHarrison conjures a reality ever present in art but somehow solidified and made *real* through the medium of photography.

Chapter Four
Practical Advice on Building a Photographic Collection

With the right tools at your disposal you can embark on the road to collecting with confidence. In order to build and maintain a successful collection, one must consider the practicalities of acquiring photography. Knowing how to find what you are looking for, where and how to purchase work, and how to inspect it and fully understand common practice within the field are all essential for the photography collector. The factors that affect the value of photography are both physical and intellectual. With the right guidance and care you can be swiftly on your way to owning the photography that might otherwise seem unobtainable.

Practical Concerns

Once you have decided how you wish to structure and approach your collection, and feel confident that you have acquired sufficient knowledge about your chosen work, photographer or genre, you should address the practical concerns of collecting. The first and foremost consideration is financial, but with enough research most collections can be established to suit your means. Setting an initial budget is essential and sticking to it paramount; you can accumulate work you adore without spending the earth. The ultimate goal is to collect work that speaks to you both emotionally and intellectually. Doing this within limits serves to discipline your choices, therefore making every purchase count. Set yourself a band of flexibility, ranging from what you would like to spend and, under exceptional circumstances, how far you can stretch beyond it. Do not exceed your upper limit as this could hamper your next acquisition, and possibly deny you the purchase of a lifetime. Take framing into account and possibly transportation and insurance, which will also add to your overall expenditure.

Regardless of the type or size of your intended collection, it is vital to keep in mind that collecting photography is a specialist area and there are a number of practical considerations that are quite unique to this medium. These considerations range from understanding the way in which prints are editioned, valued and presented, to the actual process of buying work from galleries and dealers or storing and caring for your prints. The amount of technical information you will be required to absorb may at first seem daunting, but the key points covered in this chapter will soon furnish you with a basic understanding and give you the confidence to explore these skills further. While you may well be itching to launch yourself from the starting blocks, you will see that much of this practical information should be considered beforehand.

However, it must be noted that in this broad outline of collecting fundamentals, you may well find that certain areas of expertise are not entirely applicable to you. This is to be expected and is not a cause for concern. For instance, a collector of vintage prints may well have no need to develop an intricate understanding of digital photographic processes and vice versa. Conversely, if you intend to build a particularly specialist collection it is recommended that you source specific literature and advice to supplement this guide. Many specialist books are available, covering a huge range of photographic subjects in great depth. You should also, of course, familiarise yourself with the classic or seminal monographs that are relevant to your chosen collection. These may include publications such as Steichen's *Camerawork*, Eggleston's *William Eggleston's Guide*, Frank's *The Americans* or Weegee's *Naked New York*.

It is also worth mentioning that monographs are not only an inexpensive starting point for research, but can also be a collection form. With the advent of tritone and quadtone printing, the quality of some illustrative plates has improved phenomenally, and the frequent editioning of books by key photographers often makes them a good investment. Occasionally limited edition monographs are released that contain a print, and these are collectables also worth considering. The smaller the edition number and the status of the photographer are the two crucial factors that can determine how valuable a monograph and/or accompanying print may be in the future.

'Railway Tracks', c.1855. Edouard Baldus
In 1855, Baldus produced an album of fifty plates on the subject of the northern French railway (Chemin de Fer du Nord). It is notable that after this date, he increasingly used collodion glass negatives. In this particular example, observe the shrewd positioning of the camera at a diagonal angle, allowing Baldus to record the railway in relation to the lie of the land and its adjacency to the buildings on the left. The result is a most pleasing composition in which the eye is led down the railway track and simultaneously invited to inspect the nearby architecture.

Purchasing a Print

There are a number of key outlets or vendors through which photography can be commonly purchased, and each has their own particular conventions and considerations. Such outlets may include galleries, auction houses, photography fairs or private dealers. A successful collector, or at least an economically shrewd one, should consider all the available outlets and not just stick to a single method of purchase. There are universal considerations that apply to collectors purchasing work from any outlet. As with all collecting, the key to successful acquisition relies on a calm, measured and methodical approach. The simple, golden rule for any collector is to never rush into a purchase.

Primarily, you should learn as much as you can about the sort of photography you are interested in. Doing your homework beforehand to broaden your knowledge of a particular photographer or period will put you at an advantage when approaching dealers; if you are more knowledgeable then you will command more respect. Provisional window-shopping can be of great help and making regular visits to photographic exhibitions is invaluable. Viewing a particular work close up is always beneficial and the information that accompanies work in a photographic exhibition often provides a shortcut to researching a photographer or genre of interest. Photographic exhibitions also provide a good opportunity for you to look at the methods of display and familiarise yourself with aspects of curation, framing and mounting.

Pre-emptive study should not be confined to the past. It is equally important that you are mindful of relevant current trends in photography. Even if you only intend to build a very modest photographic collection, it is vital to stay up-to-date with new developments in such a dynamic medium. The best way of doing this is to be aware of newly released monographs and to immerse yourself in the current photographic climate through pertinent journals and periodicals (see listings in the Appendix). Pay particular attention to reviews of photographic shows by respected critics, as these are useful when judging rising talent or the past work of a photographer that appeals to your taste.

Observe new developments carefully and, over time, you will find that many come and go quickly and it takes a while for a genre or trend to establish itself firmly in the photographic canon. Contemporary appraisals will often signpost the value of a style in years to come, but many photographers quickly fall in and out of fashion as aesthetic tastes change. There will be numerous fads, each with relatively short life spans, to contend with along the way so keep a long-term perspective and try to beware of hype. Remember that photography is, for many, a commercial industry and media coverage of a particular photographer may not always be a fair representation of his or her true status.

Research Resources at The Howard Greenberg Gallery, New York

To avoid falling prey to any unscrupulous dealers, it can also be a good idea to research the reputation of the vendor you wish to purchase work from. This may seem overly cautious, but it makes sense if you intend on making a particularly large purchase. You are unlikely to buy an expensive household item on impulse for instance, so why take the risk with a photograph? If there is a print you are interested in, make several visits to the vendor and get a feel for how they do business. Observe their efficiency, knowledge and quality of service and find out how long they have been in business. Although it continues to grow, the photographic community is a fairly close-knit one, so talk to other collectors and dealers to get a feel for the reputation of your potential supplier.

Once you are confident in your choice of vendor, you should ensure that you have an opportunity to properly and closely inspect your prospective purchase prior to any final agreement. If the work is being purchased through a catalogue, it is incredibly important to do this as a description or a reproduction of the image is never fully representative of the true condition of the print and overall quality of the photograph. Even in a gallery where work is exhibited, the actual print you are purchasing may well be one of an edition that is in storage or, in some cases, still to be printed. In all good outlets, the vendor will be happy to allow you to view the actual print beforehand. If possible, it often helps to spend time alone with a potential purchase as this gives you the chance to fully absorb its initial appeal. You should also inspect the work with the dealer and remember to ask questions. A good dealer will be frank and happy to answer your queries; after all it is in their interest to keep you as a client.

It is also preferable to check the details of the history and provenance of an image. A gallery will usually deal with a photographer directly or with the estate of a photographer, and so should be able to supply provenance and historical details. Auction houses should state in advance what provenance is to be provided with the photograph. Work from other outlets may bear a stamp, a signature or a document from a previous owner explaining where it was obtained.

Finally, always be wary of bargains. If something seems a little too good to be true then it probably is! In particular, be very mindful of the Internet as a means of purchasing expensive work as you are often only able to view the work 'virtually'.

If this all seems a little sterile, remember that a dynamic collection should be an ongoing venture. If you are collecting photography, then naturally you will already have a love for the medium. The most rewarding discoveries may quite often come by chance.

Exhibition Space at The Howard Greenberg Gallery, New York

Commercial Galleries

A public gallery exhibits artwork for public viewing, while a commercial gallery exhibits work to be sold. Different photography galleries often specialise in specific eras or subjects and build up a regular clientele who have an interest in that speciality. Many fine-art galleries will also have photographic exhibitions from time to time.

It is good practice to identify galleries specialising in subjects that are of particular interest to you using listings, local phone directories, advertisements in journals, or via the Internet. Visiting dedicated galleries and looking at the types of exhibitions they have held in the past, as well as those they are currently holding, will help you to narrow down your points of enquiry, as you may sometimes find that a current exhibition does not fully reflect the flavour of a gallery's specialised field. Most galleries operate regular opening hours for you to visit, but in some cases you may be required to make an appointment before viewing. In addition to inspecting the exhibited work, an appointment may also allow you to view archives of undisplayed work.

Established galleries should offer extensive expertise and will be knowledgeable about additional or alternative photographers that you may not have been previously aware of. They may also recommend other dealers you may be interested in. Additionally, a gallery is a good environment to meet other collectors and browse work in an informal setting.

In general, gallery prices are fixed and there will be prints available for purchase at a wide range of prices, so don't be embarrassed to discuss your budget, even if it is limited. Of all outlets, purchasing photography from a reputable gallery offers the greatest degree of consumer security. As a rule, you will be expected to pay half the price of the print as a deposit and the balance on receipt of the work. Galleries often offer a framing service as an optional extra, which will be in addition to the purchase price, but be wary of this as it can prove to be a more expensive option than having your print framed independently.

Buying large quantities of prints can sometimes warrant a discount and it is also worth asking if there is also a price reduction for immediate payment. Many galleries will offer a range of payment options, including the opportunity to pay larger sums through a regular instalment plan.

Purchasing work from a gallery should be a stress-free process. If you are interested in a work, it can be best to take a day or two to make sure you are happy with your decision and possibly view the work again to be sure. Galleries are usually happy to reserve a piece for you whilst you decide. As a matter

of courtesy be true to your word when reserving a work and contact the gallery before, or on, the designated collection date to confirm your purchase. Forgetting a purchase or indulging in lengthy procrastination is frowned upon and can work against you in the event of future purchases. The relationship you establish with a dealer is essential and a respectful and courteous affiliation will bear fruit. A good client is always worth the extra mile and a dealer's connections can ensure that you are the first to hear about potential works of interest when they come onto the market.

Equally, establishing close ties with a gallery can be immensely beneficial. Building a rapport with members of staff so that they become familiar with your photographic tastes and interests can introduce you to other work that you may not otherwise have discovered. A good gallery will have staff that possess an extensive knowledge of photography as a whole, and not just those photographers whom the gallery represents. They should have an interest in the rest of your collection and may be of assistance in introducing you to other galleries, dealers and artists.

Trusting a gallery dealer is imperative. Never accept the 'hard sell', as this is unprofessional and a dealer guilty of this should be avoided. Equally, do not allow yourself to be vulnerable to

the over-hyping of new or unknown photographers. If you exercise caution and do a little research there are bargains to be found, but buying the work of relative unknowns can prove to be disastrous if care is not taken. This sort of purchase is best left to the more experienced collector or else undertaken with trusted guidance.

If there is a particular gallery that appeals to your aesthetic and subjective concerns, it is worth enquiring if they have a gallery membership programme. Becoming a gallery member often entitles you to previews of forthcoming exhibitions, talks, events and even special offers, which may be of interest.

Exhibition Space at The Michael Hoppen Gallery, London

Auction Houses

An auction house refers to any outlet in which items are purchased through a process of bidding. The major auction houses operate internationally and include globally recognised institutions such as Christie's or Sotheby's, but there are also a number of smaller, localised and independent auction houses.

The immediate attraction of buying work through an auction house is the price. Generally, a gallery sells work at a fixed price while the cost of work at auction represents the wholesale value, so it can be cheaper to purchase work at auction. However, while there are many opportunities to seize a bargain, there is also the chance of paying more than a piece is worth, particularly if bidding gets carried away, so caution is recommended. You should also be aware of hidden costs, such as taxes and buyers' premiums, which may considerably inflate the purchase price.

Auctions represent the driving force of the collectors' market. The value of a photographer's work will rise and fall according to the prices reached at auction, and auction house sales, and the prices reached within them act as a good barometer for measuring current trends and tastes within the market.

Specialist photographic auctions have been a permanent fixture since the 1970s and have grown in prominence ever since, with records broken regularly and prices continuing to rise. In 2003, 'The Athenian Temple of Olympian Zeus', a daguerreotype by French artist and explorer Joseph-Philibert Girault de Prangey, was sold at Christie's in London for £565,250/US$1,001,400. This was four times the image's estimate and set a new record for the highest price ever paid for a photograph at auction. Whilst this particular image represents a historical piece of great rarity and of much wider interest, its huge leap in listed and realised price is still of great relevance.

Perhaps even more significant was the 2002 sale of German photographer Andreas Gursky's 'Untitled V' for £432,750/US$766,833, again at Christie's in London. This set a record for the highest price paid for a contemporary photographer's work. Gursky had previously held the same record for his 'Montparnasse' (1994), which was sold in New York in 2001 for $600,000/£338,594. As a result, Gursky was listed as the eighteenth most expensive contemporary artist in 2003 (*Artprice*, June 2003). The fact that a photographer could be ranked so highly proved, beyond a shadow of a doubt, that photography had become an artistic force to be reckoned with.

Before the Auction

It is likely that most people will be familiar with the auction process, to a greater or lesser extent, but it is still worth doing a little research before bidding. Subscribing to auction-house catalogues is a very useful way to keep up-to-date with what is coming onto the market. The catalogue will include a range of details about each image for sale, such as its title, the type of print, the photographer, the dimensions, the lot number, the date it was taken, the date it was printed and an estimated price (or list price). You should also note whether or not the photograph has been signed and editioned, as well as the condition of the print, including whether or not it has been inspected out of its frame.

Catalogues are usually made available a month before the sale and a good catalogue will also contain a wealth of information about an image's history, provenance and technical

specifications. For this reason catalogues have actually become collectable items too.

Be aware that the stated list price in the catalogue is only an estimate based on the auction house assessment of what the work should sell for. Treat this price only as a rough guide, as you never know what will actually happen on the day. The conditions of sale are also stated in the catalogue, and these should be read carefully as they will outline and explain commission percentages and extra expenses, and warranties and insurance details. Works will also have an undisclosed reserve price, which is an agreed minimum amount that the work can sell for. Should work fail to reach the reserve price in auction, it will be retained by the seller. If this happens, then it may be possible to contact the seller privately (via the auction house) to negotiate a sale.

It is advisable to do some research into previous prices of works sold at auction by the photographer you are interested in and set yourself a strict budget accordingly. Sales prices are termed 'hammer prices' and are usually made available on the day following an auction. Comparing previous list prices with final hammer prices will allow you to estimate the interest and potential highest bid for a photographer. Although this not an exact science, having this information will ensure that you do not pay over the odds and are able to budget realistically.

Try to see the work in person before the auction. By their very nature, auction houses specialise in rare and unique items that are sold 'as seen', and even detailed catalogues can be deceptive or occasionally contain mistakes. Sold 'as seen' means that the auction house only guarantees the authorship of the

image and has no liability for any further problems you may have. Work is usually made available for viewing a couple of days before the auction, so take advantage of this if you can. Inspect the work you are interested in and look for creases, watermarks, or damage of any kind, and don't forget that examination of the reverse of the print is equally important should the work be unframed.

At the Auction

It is easy to get carried away in the excitement of a lively auction room, therefore setting your budget beforehand and sticking to your limit is essential. Similarly, the inexperienced collector can get carried away with the exciting atmosphere of an auction and make bad purchasing decisions; resist the temptation to impulse buy.

Attending an auction is also a good opportunity to talk to fellow collectors and pick up tips and advice from others in attendance. Perhaps familiarise yourself with the process by going to an auction and observing the way that it works. You will find this invaluable when there is a lot you wish to bid for in the future.

If you cannot attend an auction, an absentee bid can be made in advance by filling in a form from the catalogue. Once again, remember that this bid excludes the buyer's premium and taxes, so bear this in mind when deciding your maximum bid.

Photographic Auction Catalogue Covers from Sotheby's and Christie's

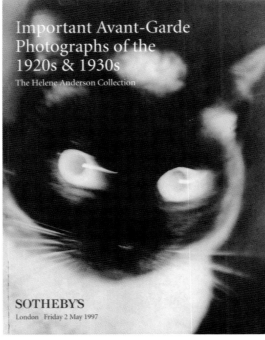

Photography Fairs

Major international photographic exhibitions such as Paris Photo, Photo-London and The Association of International Photography Art Dealers (AIPAD) in New York regularly attract exhibitors and visitors from all over the world and provide a great opportunity to see a wide variety of photography under one roof. The success of these major shows, and the revenues they attract, has resulted in an explosion of specialist photography fairs in the last decade. In addition to high profile international events, the buoyant market has propagated many smaller and increasingly specialised fairs where local dealers set up stalls alongside other collectors and photographers.

To the uninitiated, a photographic fair may seem a daunting prospect, but diving into the bustling throng of collectors and enthusiasts can be immensely rewarding. Larger events will issue the visitors with a catalogue or guide identifying the specialities of each of the exhibitors so you can plan your visit, but don't miss the opportunity to browse, as you may come across many new and wonderful discoveries simply by chance. Smaller fairs may be more chaotic, but digging through mixed up crates of prints searching for that elusive image can be an extremely rewarding and addictive experience. Gems can be found for a fraction of the price, but often at the cost of considerable legwork. Be sure to explore fully and get a feel for the range of items on offer, and visit a number of vendors before you make any purchases as you may find that a type of print which appears unique may prove to be ubiquitous.

Galleries are also represented at photography fairs and will offer the same professional level of service you would receive at their establishment. At smaller dealers' and collectors' stalls the provision of provenance may be difficult, but most good vendors will tell you how they came upon the work and usually have a very specialised range of wares, such as photographs from a particular period or genre.

Photography fairs are a great forum to discuss your collection on an informal basis with like-minded individuals. You will occasionally find collectors selling on their own acquisitions for one reason or another. Don't be afraid to talk to collectors and vendors and ask questions, as it is all part of the learning process.

Direct Outlets

Photographers

Emerging photographers may exhibit their work in a wide variety of alternative venues. These may include bars and restaurants, artist-run shows or university exhibitions. Such displays are often unattached to galleries or dealers, and you should contact the photographer directly in order to negotiate a sale. Visiting these alternative venues is a rewarding way to make new discoveries and also support fledgling artists. Major galleries and dealers regularly attend student exhibitions in the hope of discovering new talent, so these are an excellent opportunity for you to obtain a bargain from future master photographers at the beginning of their careers.

Other Collectors

As you become acquainted with other collectors in the photographic community, you may occasionally wish to acquire images directly from them. You may want a specific photograph in their collection, which they have expressed a desire to sell, or perhaps you wish to exchange work from your own collection. This process may begin with an informal request, but you should ensure that you approach such a purchase in the same manner as you would from any other outlet. Inspect the print and provenance, agree a price and the terms of sale beforehand and obtain a written receipt for your purchase.

Internet Purchases

Trading on the Internet is a relatively recent, but fast growing development. The Internet allows the collector easy and convenient access to a vast international market from the comfort of their own home. Prints can be purchased directly from galleries, online dealers or via auction websites. The main disadvantage of Internet purchasing is that more often than not you will be unable to inspect the condition of the print. For this reason, it is advisable to purchase only through reputable sellers and to avoid making large transactions.

Other Outlets

Collectable photography can also be found in a number of places: from flea markets to antique shops and a wealth of outlets in between. However, as ever, the buyer must beware: prints may be in poor condition, you may not be able to return images and there is usually no guarantee of provenance from these outlets, so more specialist knowledge can be needed. 'Found' photography, however, can be an incredibly satisfying way of building an interesting collection without incurring the outlay of acquiring established photographers' work.

Left: Paris Photo
Considered by many to be the world's premiere event for photography, Paris Photo is an international fair for nineteenth-century, modern and contemporary images.

Above: Internet Resources
Websites such as photocentral.org can prove to be an invaluable source of photographic information. Internet auction sites, such as behold.com, provide an alternative means of purchasing photographs.

The Value of a Print

It is important to develop an understanding of those factors that affect the value of a print, as this will allow you to not only estimate whether or not the marked price of an image you are interested in is fair, but also negotiate with more confidence, or set yourself an informed and realistic budgetary limit at auction.

If you are purchasing prints directly from smaller outlets, such as local photography fairs, it is likely that the marked price will err towards a more expensive estimate of value. At major photography fairs, however, the prices are usually identical to gallery prices and, with the exception of discounts for buying in bulk or immediate payment, are non-negotiable.

When discussing the value of a photograph, we must be mindful of the fact the concept of 'value' is an abstract one. A photographic print is largely of negligible innate value. The real value of a print is instead a reflection of the market interest in a photographer, a subject or a theme at any given time. As with any investment, the base value of a product merely reflects the average amount that the market is willing to pay at any moment in time. From year to year, this will fluctuate and your initial purchase cost offers no guarantee to the long-term value of the work.

The value of an individual print, measured by its desirability, is informed directly by a number of key interlinked factors, and consideration of these should enable you to broadly assess a print's reasonable financial worth.

Reputation
A photographer's reputation can increase the value of a print tremendously. Fame is not the only requirement, however, the quality of the work remains paramount and consistency is important. The success a photographer has earned may be related to critical acclaim and their subject matter also.

Size
Generally larger prints require more elaborate printing techniques and are therefore more expensive. However, this is not a hard and fast rule as many photographers do not print on a large scale and historical work is usually produced in a smaller format due to limitations of techniques and processes of the period.

Subject Matter
The popularity of certain subjects can affect the value of prints, by both unknown and high-profile photographers. For instance, Marilyn Monroe's iconic status provides collectors with a subject that has remained in fashion, and so of value, over the last fifty years. Historical prints, either from particular periods or significant events, are also of wide and continual interest. Do your research with historical prints, as some are anonymous, so provenance must be found by other methods, such as comparative work from the same time or even event.

Rarity
This factor can relate to a print's age, its historical value, its unusual subject matter or its limited availability. The work of a living photographer doesn't necessarily mean that it is less rare, as the number of prints in any given edition may be few. Similarly, the type of print may be one of only a few examples by a particular photographer or the photographic canon as a whole.

Condition
The physical condition of a single print will positively or adversely affect its value, but poor condition may be offset by rarity. In the case of daguerreotypes and other singular prints of extreme rarity and historical significance, the condition is of even less relevance to the value. Consider the 89 cracked, corroded and aggressively defaced glass plates of Bellocq's turn-of-the-century portraits of New Orleans prostitutes. The rarity of the plates and their exotic subject matter actually increased interest in the portraits. This intrigue raised the profile of the work following its rediscovery in the late 1950s, and catapulted the obscure Bellocq to a near-mythic fame.

Provenance
This is evidence of the history of a print, and is the proof that a particular photographer genuinely produced it. Any print without positive proof of authorship will be substantially reduced in value.

Quality
This refers to the quality of a photograph's printing process (in relation to other works by the same photographer), it is distinct from a print's condition. A photogravure, for example, is taken from an original negative, but is ultimately an ink reproduction and so is comparatively of lesser quality to, say, a platinum print.

Verso of a Robert Doisneau Photograph
Wetstamps are an identifying mark, usually placed on the verso of the print, which are used to assert authorship or copyright and can be useful in authenticating the provenance of an image. In this instance two wetstamps appear: firstly the distinctive stamp of the photographer Robert Doisneau and secondly that of the French agency Rapho, for whom Doisneau worked for most of his career.

'Auguste Rodin'. Alvin Langdon Coburn
The photogravure technique, developed from traditional etching processes, offered a superior photomechanical method of printing photographs in large editions. It was popular among the pictorialists, including Coburn and Steichen, who exploited the painterly effects and hallmark soft charcoal blacks and delicate whites. Coburn hand-printed his volume *Men of Mark* in 1913, using the inherent qualities of gravure to emphasise the personalities of his sitters.

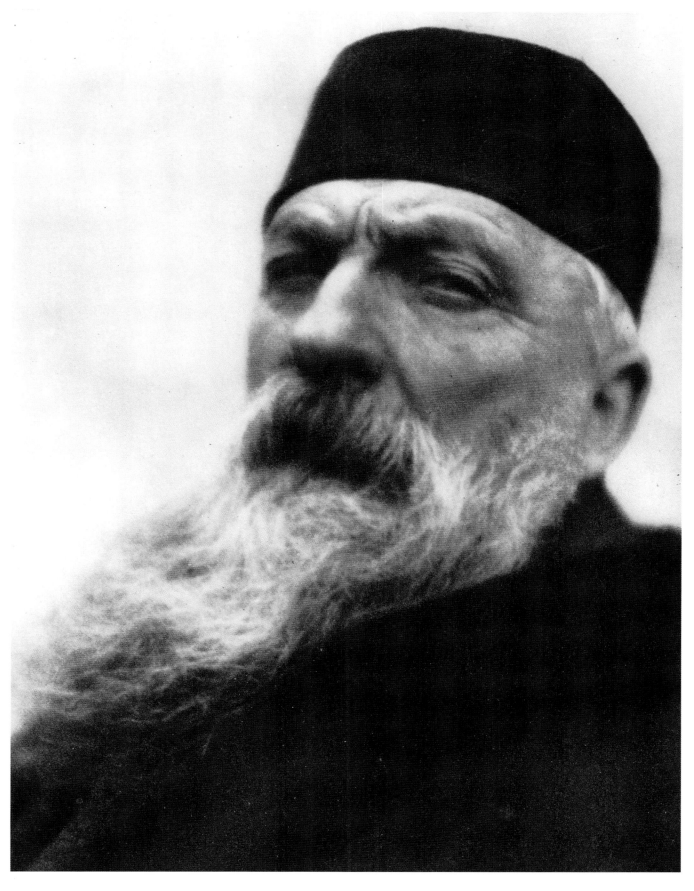

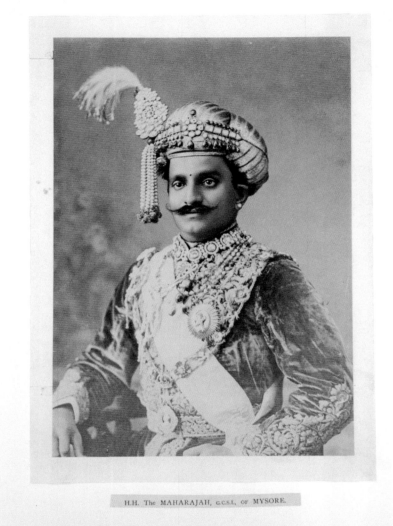

'Maharaja of Mysore'. Anon
Platinum prints or platinotypes are highly valued because of their subtle range of silvery greys and intense blacks, which in good examples can give the same effect as that of a fine lead-pencil drawing. As can be seen here they are not prone to fading like silver-based photographs. Platinum printing was popular until the outbreak of the First World War, when costs soared, but the medium has recently enjoyed a modest revival.

H.H. The MAHARAJAH, G.C.S.I., OF MYSORE.

Edition Numbering

In photographic terms, an edition is the number of prints made from a negative, which are usually numbered in accordance with production (1/20, 2/20 and so on). However, the whole edition does not have to be printed during the same period. The laborious process involved in producing a fine-art print often means that only a few images are printed at any one time. As a rule of thumb the fewer prints of a specific image that are in existence, the more valuable the photograph will be. The editioning of prints started in the 1970s and most prints preceding 1980 are not editioned.

Limited editions refer to a fixed number of prints that have been produced from a single negative and in a particular size and format. Although the negative is not destroyed afterwards, it is 'retired' to prevent further reproductions.

Modern, Vintage and Posthumous Prints

A 'modern' print is one that has been recently made from an earlier negative. For example, a print made from a thirty-year-old negative by a photographer in the present day would be classified as modern. Due to advances in photographic printing modern prints can be improved upon from those made at the time, which may have been damaged in some way due to their age.

If a photographer prints a photograph around the time the image was taken, it is classified as a vintage print. There remains some debate over the accepted time period within which the images must be taken and printed for it to be classified as 'vintage'. But vintage prints are commonly printed within a year of the photograph being taken, although contemporary vintage prints are often categorised as such if they are made within five years.

Beyond this, a print produced between five and ten years after it was taken is called a period print. A vintage print is usually more valuable than a period print, but both are prized by collectors as the artist's intentions for the work are more thoroughly expressed at the time the image is taken. The historical link to the time the photograph was taken and produced also adds value to the vintage print.

The guardians of an estate of a deceased photographer will sometimes commission posthumous (or estate) prints, which are produced from the photographer's original negatives. The guardians have the sole authority on the number of prints produced. Posthumous prints have a lesser value than vintage prints, but the controls over numbers produced ensures their relative value.

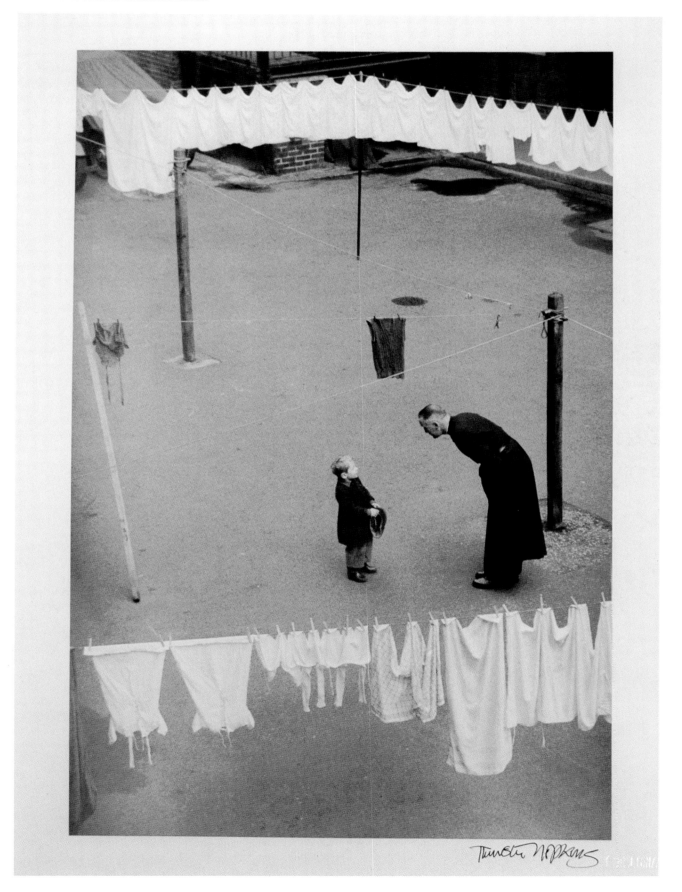

'Reverend Reindorp' 25th December 1954
Signed Print by Thurston Hopkins
Limited Edition: 2/5

**Below: 'Reverend Reindorp', 1954.
Thurston Hopkins**
Picture Post photographer Thurston Hopkins shot his famous photo-essay *A Man of Goodwill* in 1954. This modern, silver gelatin fibre-print from the original negative is significantly increased in value because it is signed by the photographer and also produced in a limited edition. Each print is signed on the front of the image so that the signature can also be displayed when matted and framed. The print also carries an embossed copyright mark, known as a blind stamp.

Inset: The reverse carries information written lightly by hand in soft pencil (so as not to damage the print) authenticating the number and edition numbering. All the necessary information, including title, author and date, is added to show the provenance of the photograph.

Managing a Collection

Once you have begun to acquire prints, you must consider the three key areas of collection management: inventory, appraisal and storage and display.

Inventory

There are a number of ways in which to organise your collection; usually these will vary in accordance with the size of it. For a very large archive then you should consider the way in which your work is classified for convenient record keeping.

A universal classification standard for huge collections and archives is the Gibbs-Smith method, which is a picture library classification system that attempts to cover every 'picturable' activity and topic imaginable. The works are first classified into one of four basic sections, which are each identified by a colour and a letter. 'P' (red) for personality, covers images of individuals. 'T' (green) for topography, includes images of places or territories. 'H' (blue) for historical, includes all material relating to historical events, and 'M' (black) for modern, concerns all material of a similar nature, produced since 1920.

Within the system, each image is marked on its reverse with the most appropriate letter and colour, along with other specific information including title, artist and so forth. The colour coding is very handy when browsing through prints as it is easy to see when items are out of place. For more specific classification, a grid accompanies the identifying letter that includes additional details, for example, for portraits, the name of the subject would be included. The images are then sub-classified using a range of convenient and flexible three-letter codes to identify specific topics, which ranges from ACC for accidents and disasters to ZOO for zoology. Some of these codes are very specific and others are very broad, but they have been designed to include every eventuality.

For a smaller collection, where most of your prints are on display, it is of course unnecessary for you keep an elaborate database or cumbersome filing system. You should, however, always ensure that you keep all documentation relating to your prints, including records of transactions, provenance and any maintenance that has been undertaken. As a minimum standard, your inventory should contain at least the following information:

- The title and size of each work
- The date of the work
- The purchase date of the work
- The actual (transaction or hammer) price of the work
- The type of print, and any special conditions of storage or display relating to it
- The condition of the print on last inspection; be sure to note any marks, scratches or unique imperfections
- The location of all documentation relating to the work

As your collection grows, you may be storing prints in a variety of locations. If this is the case, then you may also wish to keep a tracking log that identifies where and during what period a print has been stored. You should add a record whenever a print is moved from one location to another and what condition it was in at that time. The larger your collection, the more important it is to keep track of individual prints, and the more often the work is out of your hands, the more detail it is necessary to record.

Terry O'Neill's Test Shots
When setting up a shoot in the studio or on location, celebrity photographer Terry O'Neill uses Polaroid test shots to check lighting and composition. As an example of how not to organise images, these test shots were casually stored in a cardboard box in the studio. Although the Polaroids were in no order, curled, stuck together, and showing evidence of mould, they are a valuable record of the photographer's working methods. As such they have since been been properly recorded and filed.

The Gibbs-Smith Method

Everyone designs their own cataloguing system to suit the needs of their collection and as a collection grows it is increasingly important to be able to locate any image quickly and easily. Today computer catalogues make the job a whole lot easier and can cross reference large amounts of data and be sorted in numerous ways. In 1947 Charles Gibbs-Smith was commissioned by Edward Hulton to create a visual classification system for his growing picture library, which already contained several million images from Hulton's *Picture Post* Archive. Gibbs-Smith's solution was the HMPT system, so called because he divided the files into four main categories: historical, modern, personality and topographical. Each subject section was further broken down by a three-letter code that made image researching and filing fast and efficient. The system is extremely versatile and specific, whether looking for images of suffragettes or the Eton Wall Game.

Most archives adopted similar systems for filing their images, including Keystone Press, which is an international press agency whose main categories cover subjects, personalities, royalty, geography, sport and war, as this reflects the agency's subject strengths.

→ KEY SUB: **PICNICS – SCOUTS 1943**
← KEY SUB: **SCOUTS 1944 – ZOOS**

Appraisal

Regardless of the size and value of your collection, you should conduct a regular appraisal of your work. A full appraisal involves a complete evaluation of the work in your collection in which the inventory record of each print should be checked and updated, placing particular emphasis on the inspection and condition of the print and its value revisited and reassessed accordingly. This appraisal must be systematic and painstaking: a simple oversight in storage or display method may lead to costly damage in a surprisingly short space of time. If you are quick to notice any deteriorating quality, swift action can be taken and heartbreaking (or bankbreaking), damage can be avoided.

It is important to monitor the value of your collection as it too will be constantly changing. Your assessment of value can be based on your own estimate, although for a more accurate valuation you may wish to use a dealer or expert. For a valuable collection, a proper appraisal may well be necessary for insurance purposes. Homeowner and contents insurance is generally designed to cover household items with fixed values and often has low limits for collectable items. It is therefore advisable to purchase specialist collectables insurance so that you have more comprehensive and appropriate cover.

Storage and Display

A beginner will no doubt find the space to permanently display his or her entire collection and may question the logic of building a collection that cannot be shared and enjoyed on a daily basis. However, as you continue acquiring work, you may quickly find yourself running out of storage and display space. Prints covering every available surface will quickly become quite overbearing and unattractive, not to mention the increased risk of damage and deterioration. At this stage you may have to consider some form of storage, whether this be in dedicated drawers or at an appropriate facility. Quite simply, you will require a cool, dry, dust-free environment where the prints can be laid flat.

Drawers or cabinets should be correctly sized for your prints and made of a non-flammable and non-corrosive material such as stainless steel. It is advisable to avoid wooden furniture as chemicals in the wood could stain your print. Prints, slides and negatives can be vulnerable to all manner of chemicals migrating from a wide variety of materials so the best option is to purchase storage furniture specifically designed for the purpose.

Individual prints should be stored in sleeves before stacking in boxes. Once again, only purchase sleeves and boxes that are

specifically designed for storing prints. If you are using paper envelopes or sleeves with a seam, ensure that the seam is not in contact with the printed surface as the glue used to seal envelopes and seams can also leave marks. Sleeves and boxes should be changed periodically to ensure the prints stay in optimum condition.

In addition, it is worth investing in some acid-free mounts or matts, especially if you are handling your prints frequently. A mount is a backing sheet, usually made of card, upon which the print is affixed. The matt includes a frame, which is mounted over the front of the print. Both options provide a handling border, offer additional protection to the bare print and assist with framing.

Left and Far Left: Archival Storage
Collectors may sort collections by photographer, location or medium. However, in a commercial archive, prints are often stored by subject categories as this is the way they are usually requested. In contrast, accompanying negative collections are stored in chronological order by a unique number assigned when the photographs were taken. This information was logged in a daybook and cross-referenced with a subject catalogue index, which links each print to its corresponding negative.

Prints from *Daily Express* photographer Terry Fincher's award-winning series of American troops in Vietnam are filed under WAR/1968-74/VIETNAM/CAMP (USA) while the negatives and contact strips (shown far left), are filed together and each story is assigned a unique year and number, with frame numbers identifying each individual image. Every image has a corresponding electronic record (shown left), which can be accessed online.

Protecting Prints

Photographs are surprisingly delicate objects and are vulnerable to damage and deterioration from a wide range of external factors. However, each of these risks can be reduced or even eliminated with a little care and attention.

Handling Prints

Improper handling of prints is the most common cause of minor damage, but following a few simple rules will easily remedy this situation. Always wash your hands before handling a print as grease or moisture can leave unsightly fingerprints across its surface. In fact, you should try to avoid ever touching the surface of a print, and the best way to eliminate this risk altogether is to wear lint-free cotton gloves (usually available at most art shops) when handling your print.

Always ensure that you have a clean, flat, dust-free surface on which to lay your prints. Handle each print one at a time so you can pay full attention to it. Never lay prints on top of each other as this can damage the print underneath or transfer blemishes. An uneven surface may also mark or crease your print. Prints should be lifted carefully, either gripped by the mount (if the print has one), or from the edges, using both hands. Ensure that the back is supported from behind so that the print does not bend. Keeping work in archival sleeves limits this risk and the use of archival matts allows the work to remain rigid when it is picked up.

Finally, when inspecting your photograph closely, try not to breathe directly on to its surface as stray spots of saliva can also cause blemishes.

Frame Prints on Display

Prints on display should be framed with glass covering in order to protect against dust, minor accidents or spillages and general environmental damage. It is advisable to have your prints framed by a professional and reputable framer; galleries usually offer a framing service too. As a rule, the larger the print, the more expensive the framing.

Protect Prints in Storage

Unframed, stored prints should be separated by sheets of acid-free tissue paper, and ideally enclosed between hard-backed sheets of acid-free mounts or card, especially if they are to be viewed regularly.

Direct Sunlight

Never hang your prints in direct sunlight, even in areas where there is only occasional or partial exposure, as doing so will bleach your prints over time. Fluorescent lighting will also give off ultraviolet light and have the same effect on your prints. A useful way in which to minimise light damage is to periodically rotate the prints you have on display with those in storage. Even in a small collection, simply swapping images around will suffice. Avoiding direct sunlight is especially important for colour prints.

Exposure to Pollutants

You should avoid storing or displaying work in places where they will be exposed to any harmful pollutants, such as paint or exhaust fumes and any other kind of smoke. Similarly, refrain from hanging photographs in a kitchen or workshop environment where there will be suspended vapours in the air.

Handling Prints
Wearing clean, lint-free cotton gloves prevents the transfer of damaging dirt and oils from fingers on to the surface of the print. Handling the print at the margins avoids touching the delicate image area while supporting the print along opposite edges with both hands prevents creasing. Work surfaces should be clean and dust free, ideally covered with acid-free tissue or clean white paper.

Right: Faded Print
This photograph was taken from an album and fading is evident along its bottom and right-hand edges where light has penetrated the pages. All silver-based photographic images are light sensitive to some degree, especially nineteenth-century processes such as those used in the production of albumen prints. Ideally they should be stored in lightproof boxes or sleeves and only displayed at reduced light levels for short periods of time – if at all.

Below: Water Damaged Print
Water damage can be irreversible and even clean water can leave tidemarks and stains. Where prints are stored in albums, as here, there is also the likelihood that the prints will stick together and parts of the image will be lost when they are peeled apart. Because of this prints should be separated while wet and air-dried on blotters. However it is advisable to consult a conservator rather than attempt to separate valuable prints yourself.

Left: Brittle Acidic Board
Bottom Left: Close-up Detail
Albumen papers are very thin and prone to curling so the majority were mounted, often using board made from highly unstable wood-pulp products that contained lignin, volatile acids and peroxides.

Sometimes termed 'biscuit' board because of its tendency to crumble, the acidic board support discolours, becomes extremely brittle and starts to flake at the corners, taking the edges of the print with it.

Excessive Heat and Humidity

Do not hang or store your prints in places where they will be exposed to excessive humidity or heat, such as near radiators, in damp cellars or near heating pipes. Find a cool, dry place instead.

High humidity softens the gelatin of the binder and adversely affects the image quality, while low humidity shrinks the binder, resulting in curling or cracking of the print. High temperatures speed up the general deterioration of the print, which may lead to discolouration, fading or may cause the print to curl up. High temperatures and high levels of humidity may also result in mould, which is difficult to remove. Keep an eye out for any early signs of these symptoms so that you intervene before expensive and very difficult restoration of your print becomes necessary.

As a general rule, a temperature of around 15 degrees centigrade and a relative humidity of around 30–50 per cent is optimum. This is only a guideline: the important concern for home storage is that the temperature and humidity is kept in approximation to these figures and remains constant.

Acts of God

Always be wary of any unforeseen incidents that may harm your collection, from a burst pipe to a serious structural accident. Of course, you cannot foresee the unforeseen, but you can minimise the general risks to your prints. Use common sense when deciding where to hang or store work: consider areas that are vulnerable, check walls and ceilings for water damage or subsidence and identify locations that may be more at risk from fire or flood and site work accordingly.

Insects

When it comes to storing or displaying photography, insects can pose a threat. Certain insects can be attracted to photographic chemicals and may damage your prints in a number of ways, ranging from staining the surface to actually eating away at it! For this reason, check your frames and storage areas periodically for evidence of insect activity and regularly clean surfaces. Be sure to remove any visible specks from the inside of the frame (which may be eggs) and ensure that your frame is properly sealed. For serious infestations, you may wish to refer to a pest control service. If you are unfortunate enough to have rodent problems, be warned that they too will be partial to your prints. Good housekeeping is the best prevention.

Moving your Collection

Always consider the transport of your collection carefully when moving work. If possible, you should transport it yourself. If you are using a professional removal firm, ensure you brief those who will be responsible for your prints on the proper care and handling of the work, and point out any special conditions for the transportation of it. If possible, obtain an agreement to adhere to your conditions in writing. When packing works, remember to cushion each of your framed prints, and cover in a plastic wrap for waterproofing. Finally, box the prints (or cover with thick packing card), and clearly label the package.

Above: Sellotape Damage
Prints that have been creased or folded, especially at their corners, risk losing parts of the image. Pressure-sensitive tapes, such as Sellotape, should never be used to repair tears as, over time, the tape oxidises and turns brown, penetrating stains into the paper fibre and these stains are very difficult to remove. Conservation tape is now available that does not harm the print.

Right: Adhesive Damage
Animal glues have traditionally been used to mount prints. Over time the constituents of the adhesives deteriorate and leave yellow or brown stains that can migrate from the backboard right through to the front of the print. Only conservation hinges or corners should be used to mount prints. Alternatively they can be supported unmounted on thin acid-free card in an archival polyester sleeve.

Conservation

A typical photographic print is made up of three layered components, each of which is vulnerable to deterioration. The support layer is the material upon which the image is printed. Usually it will be some kind of photographic paper, but may also be a glass plate or plastic film. The binder layer is the emulsion that coats the printed surface of the support layer. Usually this is gelatin, but many other chemicals have been used throughout the history of photography. The final layer is composed of the chemical pigmentation that forms the visible image on the surface of the print, which will have been suspended in the binder layer, as a result of the developing process.

Different types of prints are composed of different chemical combinations and some are more susceptible to environmental conditions than others. As such your prints will deteriorate at different speeds and under different conditions. Ensure that you identify the type of print you have purchased and clarify any special conditions of display or storage that may be necessary.

If you identify causes of accelerated deterioration early enough, you should not need to restore your prints. Restoration is a costly process and carries risk of causing further damage. Do not try to restore your own prints unless you are fully confident in your knowledge and ability to do so.

Professional Conservation

Lenny Hanson is the conservator of Getty Images' archival collections in London. Photographic conservation is still a relatively new art and its techniques and processes are being developed and refined all the time. Lenny is one of an elite group of specialist photographic conservators in the UK, and one of only a handful of glass-plate specialists currently working in the area. Lenny's emphasis is on conservation rather than restoration; on halting deterioration and stabilising the image rather than using chemical processes to reverse or restore damage. Restoration processes can be irreversible and present future problems, and high-street vendors offering restoration services should be approached with caution.

Lenny works on a multitude of problematic photographic materials, across a range of print and negative formats, from the 1840s until the present day. As a trained paper conservator his work often extends to photographic albums, mounts and supports that can have inherent value in their own right. Alongside Lenny's routine work of cleaning and re-sleeving negatives and prints, his tasks and projects range enormously, from delicately removing a 150-year-old albumen print from an acid-laden backboard to floating the emulsion layer off a cockled diacetate cellulose negative and restoring it, as good as new, on to glass.

Lenny was asked to choose three of his most challenging projects and share the extensive skill and specialist knowledge required to restore a range of negatives, images and albums. The result provides a fascinating insight into the complex and painstaking world of photographic restoration.

Foxing Stains

This photograph (shown on the facing page) had been mounted so as to resemble an engraving. Its India-laid paper support (so-called because the paper was imported by the East India Company) has been dropped on to a platemark backboard, thus imitating traditional printing techniques. True to form, this backing paper shows evidence of foxing, which is seen in the form of small reddish-brown spots, a problem that is common to late eighteenth- and nineteenth-century papers. Foxing is thought to be caused by fungus reacting to impurities, most often iron particles, that were incorporated in the paper during its manufacture, and is also prevalent in conditions of high humidity. Eventually the rust-coloured spots will migrate from the paper to the photograph, causing irreversible staining.

Foxing marks on the paper can be treated by localised bleaching, using a cotton bud dipped into a weak solution of ammonium hydroxide and lightly applied to the problematic area. However this treatment is not suitable for photographs as the image area will also be bleached out so, if possible, action should be undertaken before the marks have transferred to the print.

An alternative treatment is to remove the print from its support. After doing so the print may be lightly dampened and the supporting papers removed using a scalpel. Extreme patience and caution must be exercised to ensure that the print is not ripped or gouged during the procedure and this work should always be left to a trained conservator. The support is usually completely destroyed as a result of this process so, before work begins, it is important to assess the value of the backboard and any annotation, such as original handwritten captions or wetstamps, for example, which add their own inherent value to the item as a whole. If proceeding, the unmounted print can then be stored on lightweight acid-free card in a polyester sleeve.

Right: This print has been mounted on India-laid paper that has subsequently been dropped into a platemark board support. Foxing is most evident as reddish-brown spots, but is also present, to a lesser degree, in the backboard, which shows signs of water staining too, and the resulting increased humidity will have accelerated the fungal growth. So far the print has remained unaffected, but over time the foxing will migrate to the print area.

Below: India-laid paper, often used for book illustrations and individual works of art, uses a thin layer of starch paste as the adhesive, producing quite a strong bond when passed though a press.

Water Damage

William England was the chief photographer for the London Stereoscopic Company (LSC), before pursuing his own career as an alpine photographer. England travelled extensively for the LSC throughout Ireland and France, and in 1859 he journeyed to the USA and Canada producing topographical views, which were to be produced as series of stereocards. Master sets of albumen contact prints from England's negatives were bound into photographic albums, and labelled with their title, location and number, and acted as the company's catalogues for England's work.

This particular album was one of a number that were unfortunately damaged in a later flood. The flood created water tidemarks on the album's pages, and caused them to stick together. The moisture also introduced warping of the cover boards and spine, which in turn served to deteriorate the linen cloth supports and the photographs. Left untreated in an environment of high humidity, the album would have suffered from mould growth and permanent insect damage.

After an initial assessment, a conservation report was produced that detailed the condition of the album and a proposal for the best form of conservation treatment. Firstly, excess water was absorbed and the humidity and temperature of the storage environment strictly controlled.

Lenny then froze a large number of the remaining albums so they could await further treatment (this is not recommended for glass plates). It was essential to protect these albums in waterproof enclosures before freezing. When they were removed from the freezer they were allowed to acclimatise at room temperature over several days before being unwrapped, in order to prevent damage from condensation and temperature fluctuations.

Secondly, the album's damaged covers were supported using weights until the album was completely dry. It was then flattened under significant weight. Conservation work could then begin on the album's pages, photographs, spine and cover boards.

Wheat-starch paste was used to repair tears in the prints and water stains were removed using a solution of water and industrial methylated spirit. The original album pages had been constructed from linen cloth, on to which each albumen contact print had been tipped by hand. A similar linen cloth was sourced and used to repair the margins of the pages, which not only helped to support and strengthen them, but also maintained the look and feel of the original album.

The spine was resewn, but in this particular instance the cover boards were too badly damaged to save and new acid-free boards covered in grey library buckram were attached. The original cover cloth, containing gilt-embossed title lettering, was preserved and mounted on to the new boards to retain the integrity of the volume. Finally a custom-built museum boxboard enclosure was commissioned to house the album, thus protecting it from any future damage.

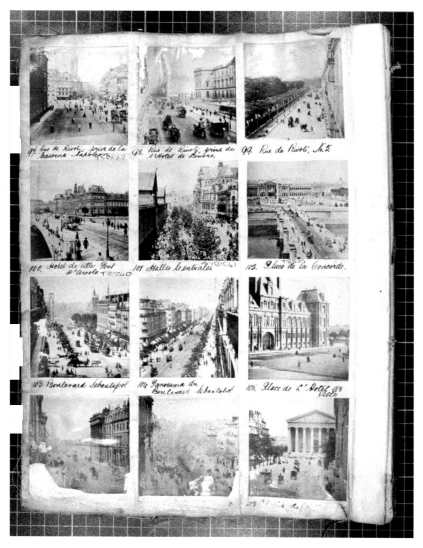

Left: The album as discovered: the flood damage created tidemarks and caused the album's pages to stick together. The moisture also introduced warping of the cover boards and spine, which served to deteriorate the linen cloth supports and photographs.

Top Left: Evidence of water tidemarks on the inside of the acidic cover board.

Top Centre: A close-up detail of the deteriorated albumen photograph, and its supporting linen page.

Top Right: A close-up detail of one of the stereoscopic images. Brown staining, tears and losses at its left-hand side are clearly visible.

Bottom Left: The binding structure clearly shows the warping pages (before conservation had begun).

Bottom Right: Each photograph had been numbered by hand with iron-gall ink. Inscriptions also detailed the landscape location. Some inscriptions on the bottom photographs were eroded by the water.

Below: The album after conservation. All the damaged pages were repaired using a similar linen cloth. The spine was resewn and new acid-free boards were attached and covered in library buckram cloth. To preserve the physical and chemical nature of the album, a boxboard enclosure was made to house it.

Preserving Photographic Emulsion

Lenny developed his own unique procedure for separating and preserving photographic emulsion from deteriorated cellulose acetate negatives.

Acetate film, commonly known as safety film, was introduced in the early 1930s as an intended replacement for highly flammable nitrate stock. Diacetate, and later, triacetate was in widespread use until the late 1950s, when it was replaced by more stable polyester-based stock. Although acetate does not have the health and safety problems associated with nitrate it is very sensitive to environmental changes. Fluctuations in temperature and humidity cause different elements of the negative to contract or expand at varying rates, producing channels and bubbles that seriously distort the image. Fumes of acetic acid are emitted as a by-product of the reticulation process, and any hint of a vinegar smell indicates that the process is well under way. Unfortunately, reticulation also speeds up degradation in surrounding negatives, so as soon as it is identified in a collection the offending negatives should be removed and stored separately until they can be treated. Lower temperatures can slow down reticulation's progress, but eventually untreated negatives will crumble and disintegrate altogether. Sadly most acetate negative collections suffer to some degree from reticulation and some archives have already been lost altogether.

This particular example demonstrates all the classic signs of reticulation. It is a negative image of Hollywood actress Lauren Bacall, which was taken in 1951 by the Baron (Stirling Henry Nahum).

To halt further deterioration of the negative, its edges were carefully trimmed to break the seal and allow penetration of the soaking agent. The negative was then left in a bath of solvent solution until the plastic supports loosened and could be lifted away. The thin, gelatinous film of emulsion is very fragile at this stage because it no longer has any support and there is a tendency for it to curl back on itself or stretch, which will distort the image, so great care must be taken. The emulsion was carefully floated and adhered to a piece of pre-cut glass, which was then dried in a dust-free environment. In effect the negative was taken back a couple of steps in photographic production technology, almost akin to the production methods of nineteenth-century glass plates.

The plate was then stored in a new acid-free, silver sleeve and placed in a conservation board negative box. Details such as the original negative number, the caption, the date and accession numbers were all transferred to the new sleeve (using a soft pencil).

Completing this process means that the original negative was preserved for posterity and can now be printed from in the same way as any other glass plate. The whole treatment can take from anywhere up to five hours to complete and the lengthy process makes wholesale conservation of large acetate collections difficult, so it is important to target and prioritise which images to salvage from a collection.

Far Left: The degraded cellulose acetate negative with its original glassine sleeve. The negative shows channels in the film layers and small bubbles, both typical examples of deterioration in acetate-film stock.

Centre: It is necessary to separate the silver emulsion and the individual acetate film layers. The negative was soaked in a solvent solution until separation occurred. The acetate can be detached in a single piece or broken up into smaller pieces, which makes the separation a more intricate process.

Left: The silver-halide emulsion pellicle layer was placed on to a sheet of glass. Air bubbles were removed with a brush, and the glass was dried in a dust-free environment.

Below: The original condition of the negative (shown left), and after the conservation process (shown right).

Chapter Five
Curating a Collection

Even with a budget in mind, it can still be difficult to decide which is the best possible approach to take when beginning a photographic collection. Whether aiming to start your collection with a single expensive 'dream' acquisition, or investing in a wider range of emerging photographers, there are many routes you can take and all have their merits.

A good collection will ideally reflect an equal mixture of informed pragmatic decision and the collector's personal taste. To help demystify this process, this chapter documents the response of five experts in the photographic arena, all of whom were asked to suggest a 'virtual' collection of photographs. The collections are based on a range of different starting budgets, and each contributor provides an explanation for their selection.

The examples chosen also provide a visual picture of the breadth and scope of potential collections, and the curatorial benefits of applying a coherent approach to collecting, as well as some personal curatorial advice. The background of these experts spans the photographic canon, and each of their roles provides a different perspective. Note, also, how the budgetary constraints affect the approach taken.

The Photographer

Curator: Stephen Gill
Budget: £1000/US$1850

Stephen Gill is a successful London-based photographer whose work can be found in a variety of private and public collections, including those housed in The National Portrait Gallery, London, The Victoria and Albert Museum, London, and Agnes B, Paris.

Gill's photographs often appear in many major international magazines including the *Guardian's Weekend* magazine, *I-D* magazine, *Granta*, the *New York Times* magazine, *Tank*, the *Telegraph* magazine, the *Observer*, *Le Monde*, *Blind Spot* and *Colors*.

I have a selection of photographs that have either been given to me or swapped and I have made occasional purchases over the years.

Since a great deal of my understanding and pleasure in contemporary and historical photography comes from books, I suppose that is mostly what feeds my appetite of enjoying the photographic image. Music, much like books, is something I like to surround myself with as it can so greatly inspire the visual experience. Live music though is something else, perhaps comparable to an actual photographic print rather than a reproduction of an image in a book. There is that feeling of something raw and in the flesh. An argument against this could be that the book is the definitive object, presenting images within a fixed sequence.

Collecting photography can be seen as a daunting venture. The image, the value, the author, the investment, the archival nature of the paper and the printing process, are all things to think about. Strictly, at the top of the list should be the image and how, for one reason or another, it speaks to you.

If I were to have £1000/US$1850, I would buy a single print to start a collection. I would happily blow the whole lot on one of Neeta Madahar's great images of birds (or squirrels). The subject alone is something very close to my heart, as the very first images that I took were of birds in my back garden in Bristol. Madahar's images are beautiful and have the ability to stand alone as well as sit within a series.

Madahar's bird photographs are busy and chaotic with rich colours aided by flash, which freezes the creatures, allowing the tempo of life to be turned up for a single moment. If I had any change left I would keep my eye open at flea markets for the volumes of wonderful pictures that are continuing to surface at such places. Again bird photographs would be on my mind, but I would not rule out anything else that took my fancy.

'Sustenance #114', 2003. Neeta Madahar

The Art Advisor

Curator: Aphrodite Gonou
Budget: £5000/US$9200

Aphrodite Gonou received an MA in Contemporary Art from Sotheby's Institute, (validated by Manchester University) and an MBA in Finance (which included a dissertation on the art market as an alternative investment option) from City University, London. She has worked for Christie's in Athens, Greece and at Sadie Coles HQ in London.

Since then Gonou has worked as an art advisor for a number of contemporary collections around the world. Even though her work covers the whole field of contemporary art, she has a special interest in photography and for the past few years Gonou has advised the curators of the Marinopoulos photography collection in Athens, Greece. She has also lectured on contemporary art and photography at Sotheby's Institute.

As an advisor to contemporary art collections, I see my role as helping collectors find the highest quality work available within their budgetary constraint. In the recent past, photography has become an integral part of contemporary art and this is reflected in the number of photographic works included in contemporary collections. The fact that each photographic work exists in multiple editions is a good starting point for new collectors, as it is easier to get hold of work and the prices are not as high as they would be for unique works. Photography prices have increased in recent years, but a budget in the region of £5000/US$9200 still provides a number of options for acquiring great photography; from a single work by an established photographer to several pieces by younger artists.

For the purpose of this exercise, I chose work by young artists who have however had shows in commercial and public spaces around the world. I saw the budget as the imaginary total budget of a starting collector, so I tried to think of works that could create an interesting dialogue with one another, formally and thematically.

In this context I would choose one work from Martina Mullaney's 'Turn In' series. Mullaney was born in Ireland in 1972 and lives and works in London. She received a Master's Degree from the Royal College of Art in 2004. Mullaney's work has been exhibited at the Gallery of Photography in Dublin, Ireland, and Ffotogallery in Wales amongst others. 'Turn In' was shown at the Yossi Milo Gallery in New York and The Fraenkel Gallery in San Francisco.

For this series, Mullaney photographed empty beds in hostels for homeless people in England and Wales. Each photograph follows the same format; the mattress comprises the lower third of the

image, while the colour of the empty wall covers the rest of the image. The consistent point of view, the seriality and the simplicity of this work gives it a minimalist feel, which brings to mind photographers like Hiroshi Sugimoto, and the importance of colour in her work takes it closer to photographers like William Eggleston and Stephen Shore. But in Mullaney's work the choice of subject introduces an emotional level. Looking at the seductive wall colours, the worn-out sheets and the used-up mattresses, one is struck by their unexpected formal beauty, and the tension between this beauty and the feelings of loneliness and emptiness that emanate from them. These beds are provided by society, but are not really a part of society. These are places to rest, for those who have found themselves on the lonely journey of the outsider. The photographs carry this loneliness, the loneliness of all the people who have turned in these beds and into themselves.

Right and Above Right: 'Untitled', taken from the series 'Turn In', 2000. Martina Mullaney

The experience of living outside society is what lies behind the other work I chose, by Shanghai-based artist Yang Fudong. He was born in 1971 in Beijing and graduated from the China Academy of Fine Arts, Hangzhou in 1995. His work has been shown at the 50th Venice Biennale, at the Georges Pompidou Centre in Paris, the Kunsthalle Wien in Vienna, The Marian Goodman Gallery in Paris and The ShanghART Gallery in Shanghai, among others.

This work is a film still from Fudong's *Seven Intellectuals in Bamboo Forest II*, and is based on the story of seven intellectuals who lived during the third and fourth centuries in China. They were famous poets and artists who chose to live outside society in a bamboo forest. Fudong's work investigates the tension between the need to be free and the need to be part of society through the intellectuals' solitary meditations on individuality, freedom and liberty.

The strength of this particular work lies in the fact that even though it is a film still, it carries the essence of the film, while retaining a real formal strength in itself. The bathtub, the hand, the tattoo and the way it repeats the profile of the woman create a poetic pattern of repeated forms. All this is held together by the intensity of the woman's gaze. This is a self-reflective gaze, closed-in, yet powerful. The bathtub, soothing and protective on the one hand, looks containing and suppressing, much like Mullaney's hostel beds or even like society itself.

'Seven Intellectuals in Bamboo Forest II, Nr. 2', 2004.
Yang Fudong

The Photographers' Gallery, London

Curator: Katrina Moore
Budget: £10,000/US$18,500

Katrina Moore has had extensive experience on both sides of the camera. Beginning her career as a photographer's assistant, she subsequently moved to the print sales department of The Photographers' Gallery, one of the most important venues for photography in the UK.

In her capacity as the gallery's deputy print sales manager, Katrina curates exhibitions and promotes and represents a diverse range of talent. Her close relationship to the gallery's represented artists provides her with a unique insight into the creative and commercial side of collecting photography.

Although the budget I have been given would enable me to purchase one or two prints by such distinguished photographers such as George Rodger or Robert Adams, I have instead chosen to select prints from series of works by emerging photographers.

This selection is governed by a personal agenda. I was initially fascinated by photography as a child because it enabled me to record and communicate and create awareness of events that I had experienced. As the years have gone by I still find that it is this sharing of personal observations which inform and expand horizons, and this is to me the most significant aspect of a body of work.

The prints that I have chosen are by Kevin Griffin, Martin Cole, Angus Boulton, Mischa Haller and Stephen Vaughan. Although formally very different, they are unified by the aspect of the photographer's approach to their individual projects, which directs attention to the subject matter via skilfully composed photographic documents. To me these types of photographs are the closest recorded representation of the reality that surrounds us. I believe that through their honest and passionate depiction these photographers have produced bodies of work that will continue to engage generations of people in the future.

There are many other photographers that I would have liked to include in this

'Wave #25'. Kevin Griffin

'Wave #43'. Kevin Griffin

'Wave #8'. Kevin Griffin

'Wave #3'. Kevin Griffin

'Wave #36'. Kevin Griffin

'Wave #13'. Kevin Griffin

collection, but I set myself strict boundaries. I decided to only buy 8 x 10-inch prints as I wanted this collection to be made up of series of works, which I felt would need to be composed of at least three prints (in any single series) in order to retain the structure and effect of each body of work. I also set a budget of a maximum of £300/US$550 per print. Even so I managed to go over budget by £200/US$370, but felt that I could afford this extra expenditure to keep the continuity of my collection. Kevin Griffin's wave studies series was inspired by his fascination with the vital link between water and human life, and the changing forms of the Atlantic Ocean, specifically the body of water just off the west coast of Ireland. Griffin's images allow us to be captivated by a moment, drawing our attention to the shape and form that is created by the culmination of force and energy built up through a continual journey. There is overwhelming and unnerving power, but at the same time an intriguing delicate beauty in the detail, which makes his work a unique portrayal of the ocean.

'Wave #36', 2004. Kevin Griffin

'Grid A', taken from the 'Hillsides' Series, 2003.
Martin Cole

Created on the South Downs, near to his
Sussex home, Martin Cole's 'Hillsides'
series presents an unusual and dramatic
view of the English landscape. Each image
is closely observed and when the images
are seen together as a series of nine, the
photographs overwhelm the viewer in
ways not expected. Close framing and the
repetition of angles and motifs within a
succession of photographs remove from
the viewer the normal points of reference
and draw us in to a very modern
interpretation of an age-old subject.

Above Right: Images taken from the 'Richtung Berlin' Series, 1998–99. Angus Boulton

Below Right: Images taken from the 'Forty One Gymnasia' Series, 1998–Present. Angus Boulton

Angus Boulton has spent a number of years working in and around Berlin. One series of photographs (shown top right) documents the city itself, examining a place that has experienced immense change in a relatively small number of years and depicting both the perceptions and misconceptions a visitor might have.

Boulton has also created a parallel body of work photographing the abandoned Soviet-era military bases in the region around Berlin (shown bottom right), focusing in particular on the bases' gymnasia. These photographs are important concrete historical documents and also simultaneously more abstract musings on the concepts and realities of time, politics and war.

With the photographs in his 'On Bute' series, Mischa Haller documents the natural and manmade environments of the Scottish Isle of Bute, and photographs encounters with the islanders as they go about their day-to-day activities. The series is a continuation of Haller's interest in showing the small details and fleeting moments of 'ordinary' lives. Although based on close and stringent observation, Haller's work goes far beyond surface appearances, creating an all-encompassing view that distils the essence of place.

Top: 'High Road, Port Bannatyne, Bute', 2004. Mischa Haller
All Images taken from the 'On Bute' Series, 2004. Mischa Haller

In his 'Opened Landscape' series, Stephen Vaughan documents the bog landscapes of Lindow Moss, Cheshire. Close to where he grew up, it is a place where the body of an Iron Age person remained, almost perfectly preserved, for thousands of years until exposed by the digging of peat; a practice that has reached such intensity that one can see the bog lands being literally opened up and the past brought to light.

Vaughan's later series 'Ultima Thule' is based upon the journey made by Pytheas of Massalia in 325 BC to the unknown north Atlantic and the Arctic Circle, as well as other historic and fictional journeys of discovery. Both series incorporate broad vistas and minute studies as Vaughan closely examines the landscape and uses it to consider the layered nature of time.

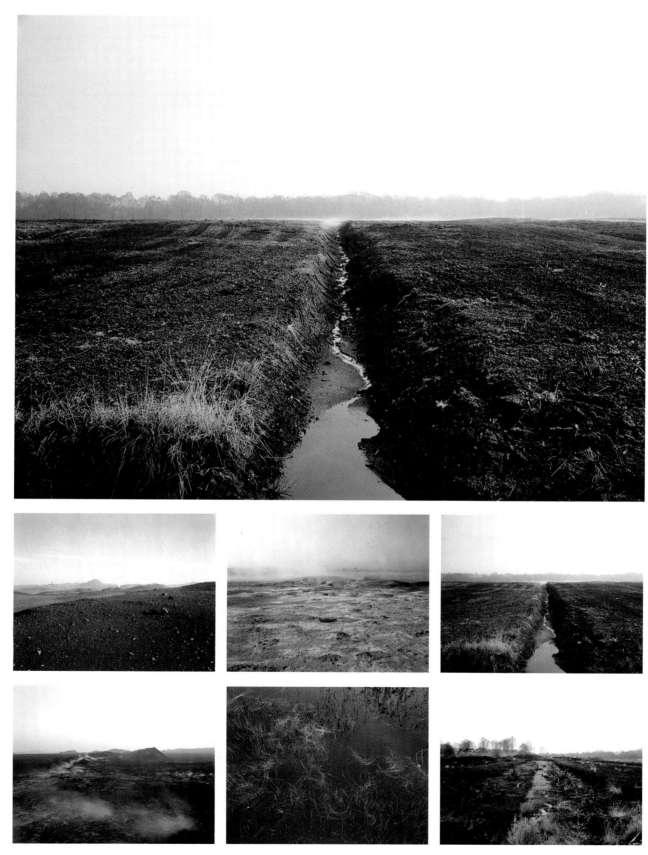

Top: 'Lindow'. Stephen Vaughan
Middle: Images taken from the 'Opened Landscape' Series, 2003. Stephen Vaughan
Bottom: Images taken from the 'Ultima Thule' Series, 2005–06. Stephen Vaughan

The Gitterman Gallery, New York

Curator: Tom Gitterman
Budget: £15,000/US$28,000

Tom Gitterman has been working in the world of fine-art photography since graduating from Ithaca College (cum laude) with a major in art history and a minor in sculpture in 1990. He is the owner of The Gitterman Gallery, which was founded in 2003 and opened its first exhibition in February 2004.

The Gitterman Gallery specialises in the medium of photography, and exhibits and represents artists and estates, while also maintaining an inventory of work in a full range of styles and periods. Beyond owning and running a gallery, Tom occasionally teaches classes on collecting photography, gallery management, and open critic classes to photographers at graduate, undergraduate, and further education levels.

When considering buying a work of art, I always suggest leading with your heart. The experience of being inspired by art is a profound one. I am fortunate to live in such a way that I get to experience this wonder on a daily basis with photography. Moreover, just as the sunset is more beautiful when shared with another, so is a photograph and I have the opportunity to share the medium with others by helping them find this experience for themselves.

If I was starting to collect again and had £15,000/US$28,000 to spend I would buy a vintage print by David Heath, entitled 'Vengeful Sister, Chicago' (1956). It probably wouldn't cost that much now but in a few years it will.

This image has a powerful effect on me. It is one of my favourite pieces in my own collection. The image of the young girl running away and laughing, as a young boy cries, curled up in a fetal position, evokes so many thoughts and emotions. Depending upon my state of mind, I sometimes laugh along with her, while at other times I feel his pain. Sometimes I think of the image as a motif of more 'adult' relationships, and at other times I wonder if that early childhood pain ever goes away. My twin brother, a psychotherapist, would have a field day analysing this!

Whatever the mood or emotion the work might evoke, the fact that another human being found such a scene worth sharing suggests to me that our thoughts or feelings are not unique. This work of art continues to regularly empower me with this sense of human interconnectedness. For me such an experience is priceless.

'Vengeful Sister, Chicago', 1956. David Heath

The Howard Greenberg Gallery, New York

Curator: Howard Greenberg
Budget: £25,000/US$46,000

Howard Greenberg is one of the world's top photography dealers. He is an authority on nineteenth- and twentieth-century photography and has been an acknowledged leader of establishing its value on the fine-art market. In recognition of these efforts, and his matchless collection of more than 20,000 photographs, *American Photo* magazine proclaimed Greenberg one of the 25 most important people in photography in 2005.

Greenberg has built a reputation for rediscovering significant photographers from the past and establishing a market for their work. He also represents and exhibits photographs by many of the acknowledged masters, including Alfred Stieglitz, Edward Weston, Eugene Atget, Walker Evans, Brassaï, and Henri Cartier-Bresson. Greenberg also represents the estates of Edward Steichen, Imogen Cunningham, William Klein, Roman Vishniac and many others.

Greenberg began his career as a freelance photojournalist in 1972. Prominent newspapers and magazines such as the *New York Times*, the *Washington Post*, and the *Woodstock Times* published his work. He was also featured in a series of solo exhibitions. In 1977, Greenberg established The Center for Photography in Woodstock: a non-profit gallery and educational institution where he served as executive director until 1980. One year later, he entered the commercial side of photography by establishing the Photofind Gallery, which exhibited and sold prints. In 1986, he moved Photofind from Woodstock to New York City. Five years later, The Photofind Gallery became The Howard Greenberg Gallery. In September 2003, after thirteen years at his 120 Wooster Street address in Soho, Howard Greenberg moved his gallery to the Fuller Building at 41 East 57th Street.

Since the universe of collectible photographs is so vast, choosing one, two or three images, to begin a collection with, within a given budget, is a task that requires much personal preference. The individual would need to explore their taste in aesthetics and content, their desire for well-known or perhaps lesser-known photographers and photographs, as well as how and where the photographs might be viewed. Therefore my choices here are dictated by my own personal preferences. Hopefully, however, given many years of looking at and learning about photographs, these choices will have relevance and meaning for many would-be collectors.

At this point in the photography market, £25,00/US$46,000 will not buy an excellent quality, classic, vintage piece by grand masters such as Alfred Stieglitz, Edward Steichen, Edward Weston or Henri Cartier-Bresson. But the budget (or less) will buy absolutely terrific and significant photographs by all of the most important practitioners in the history of the medium. Please note that I am considering only 'vintage' prints, meaning photographs printed close to the same time that the picture was originally made. I am also sticking to the twentieth century, a period with which I've been primarily involved and have the greatest knowledge.

With this in mind, I've chosen two photographs, out of dozens, which have personal meaning. Other vintage prints of these images may not be easily attainable, but these two choices will illustrate what is possible.

The first is a photograph by Robert Frank. Frank is arguably the most important post-war photographer, certainly in the tradition of personally expressive street photography. It is not from his seminal book *The Americans* or even from *Lines of My Hand*, but it is an image that has haunted me since the first time I saw it many years ago. The photograph is of his son Pablo, and taken in Times Square. It is a picture that has many layers of meaning expressed in both emotional and photographic terms. I find it transcendent and when the opportunity to acquire a print presented itself, I didn't wait. I believe the current value of this print to be about £17,000/US$31,500.

The second photograph is a by a woman named Consuelo Kanaga. Kanaga is not nearly as well known as Frank, but had a long and interesting career in photography and made many memorable images. Kanaga's portrait of a young girl is also a photograph I knew and thought about for many years before having the opportunity to acquire a print of it. It was used for the catalogue cover of a show I co-curated and toured nearly twenty-five years ago about The Photo League in New York, 1936–51. This photograph, for me, is one of the greatest informal portraits ever made. I searched for a vintage print of it for twenty years until finally this one came into my life. Another similar print would currently be valued around £10,000/US$18,500.

In conclusion, there are no specific photographs that you should acquire to build your collection. However, there are many wonderful and personally meaningful images to chose from. The enjoyment and education to be had in discovering what these photographs are, and the great pleasures they will provide as you look at them over the years, will dictate the right choices for you.

'Young Girl in Profile', taken from the 'Tennessee' Series, 1948. Consuelo Kanaga

Appendix

The following is intended to be a guide for your own further research and exploration of the photography market. You should be aware that a directory of this nature could never hope to be fully comprehensive. The reputations of galleries will wax and wane, new establishments will blossom and grow, while others may shift their focus as trends and fashions dictate. Furthermore, the international scope of the photography industry is simply too broad to cover in its entirety within the limits of these pages. Instead, use this directory as a basic starting point from which to plan your journey and navigate your own path into the rewarding and fulfilling world of collecting photography.

Galleries and Dealers
(Alphabetically by Country/City/Gallery)

Australia

MELBOURNE
LEICA GALLERY MELBOURNE
20 Smith Street
Collingwood
Victoria 3066
Tel: +61 3 9416 5329
Fax: +61 3 9419 5622
Email:
leica@leicagallerymelbourne.com
Website:
www.leicagallerymelbourne.com
*Contemporary and vintage
photography, specialising in
photojournalism and documentary
images*

SYDNEY
ROSLYN OXLEY9 GALLERY
8 Soudan Lane
Paddington
Sydney
NSW 2021
Tel: +61 2 9331 1919
Fax: +61 2 9331 5609
Website: www.roslynoxley9.com.au
Contemporary art and photography

SANDRA BYRON GALLERY
11/2 Danks Street
Waterloo
Sydney
NSW 2017
Tel: +61 2 9318 0404
Fax: +61 2 9318 0004
Email:
info@sandrabyrongallery.com.au
Website:
www.sandrabyrongallery.com.au
*Nineteenth-century and
contemporary Australian and
international photography*

SHERMAN GALLERIES
16-20 Goodhope Street
Paddington
Sydney
NSW 2021
Tel: +61 2 9331 1112
Fax: +61 2 9331 1051
Email: info@shermangalleries.com.au
Website:
www.shermangalleries.com.au
Contemporary art and photography

Austria

SALZBURG
GALERIE FOTOHOF
Erhardplatz 3,
A-5020 Salzburg
Tel: +43 662 84 92 96
Fax: +43 662 84 92 96 4
Email: fotohof@fotohof.at
Website: www.fotohof.at
*International contemporary
photography gallery run by a co-
operative. They also have Austria's
largest specialised photo library.*

VIENNA
FOTOGALERIE WIEN
Währinger Strasse 59,
A-1090 Vienna
Tel: +43 1 408 54 62
Fax: +43 1 403 04 78
Email: fotogalerie-wien@wuk.at
Website: www.fotogalerie-wien.at
*Association for the promotion of
photography*

GALERIE JOHANNES FABER
Brahmsplatz 7
A-1040 Vienna
Tel: +43 1 505 7518
Email: office@jmcfaber.at
Website: www.jmcfaber.at
*Specialises in Czech and Austrian
photography in addition to American
classic and contemporary
photography*

WESTLICHT
Westbahnstrasse 40
A-1070 Vienna
Tel: +43 1 522 6636
Fax: +43 1 523 1308
Email: info@westlicht.com
Website: www.westlicht.com
*Largest photography and camera
gallery in Vienna*

Belgium

AALST
EYE-SEE GALLERY
Stationstraat 17
B-9300 Aalst
Tel: +32 475 33 7566
Email: gaby.degraeve@telenet.be
Website: www.eye-see.com
*Contemporary fine-art photography
and Latin American photo-based art*

ANTWERP
FIFTY ONE FINE ART PHOTOGRAPHY
Zirkstraat 20
2000 Antwerp
Tel: +32 3 289 8458
Fax: +32 3 289 8459
Email: 51@pandora.be
Website: www.gallery51.com
*Specialises in vintage, classic, fashion,
African and contemporary
photography*

GALERIE BAUDELAIRE
Sint Paulusstraat 41
B-2000 Antwerp
Tel: +32 3 227 2640
Fax: +32 3 227 3519
Email: info@galeriebaudelaire.be
Website: www.galeriebaudelaire.be
*International contemporary art
photography*

BRUSSELS
CROWN GALLERY
Hopstraat 7
Rue du Houblon
B-1000
Tel: +32 2 514 0123
Fax: +32 2 514 0123
Email: jacques.vandaele@skynet.be
Website: www.crowngallery.be
Contemporary art and photography

TACHÉ-LÉVY GALLERY
74 Rue Tenbosch
B-1050
Tel: +32 2 344 2368
Fax: +32 2 343 5127
Email: info@tache-levy.com
Website: www.tache-levy.com
Contemporary art and photography

Brazil

SÃO PAULO
LEICA GALLERY SÃO PAULO
Rua da Mata, 70
São Paulo SP
Brazil CEP 04531-020
Tel: +55 3079 0300
Fax: +55 3079 0300
Email: cliff@namata.com.br
Website:
www.namata.com.br/leica_gallery/
leic a.shtml
*Contemporary and vintage
photography, specialising in
photojournalism and documentary
photography*

Canada

TORONTO
GALLERY 44
401 Richmond Street West
Ste 120
Toronto, ON
M5V 3A8
Tel: +1 416 979 3941
Fax: +1 416 979 1695
Email: info@gallery44.org
Website: www.gallery44.org
*Centre for contemporary
photography*

CORKIN SHOPLAND GALLERY
55 Mill Street
Bldg 61
Toronto, ON
M5A 3C4
Tel: +1 416 979 1980
Fax: +1 416 979 7018
Email: info@corkinshopland.com
Website: www.corkinshopland.com
*Contemporary, nineteenth- and
twentieth-century art and
photography*

STEPHEN BULGER GALLERY
1026 Queen St West,
Toronto, ON
M6J 1H6
Tel: +1 416 504 0575
Fax: +1 416 504 8929
Email: info@bulgergallery.com,
Website: www.bulgergallery.com
*Specialists in Canadian photographers
and showing primarily documentary
photography*

China

BEIJING
LA GALLERY BEIJING
319 East End Art
Cao Chang Di
Cui Ge Zhuang Village
Chaoyang District
Beijing 100015
Tel: +86 10 6432 5093
Fax: +86 10 6432 5073
Email: info@la-gallery-beijing.com
Website: www.la-gallery-beijing.com
Contemporary photography

RED GATE GALLERY
798 Dashanzi
2 Jiu Xianqiao
Chaoyang District
Beijing
Tel: +86 10 6438 1005
Fax: +86 10 6432 2624
E-mail: redgategallery@aer.net.cn
Website: www.redgategallery.com
Contemporary art and photography

HONG KONG
ART STATEMENTS GALLERY
5 Mee Lun Street
Central
Hong Kong
Tel: +852 1222 9657
Fax: +852 9502 3842
Email: info@artstatements.com
Website: www.artstatements.com
Contemporary art and photography

Czech Republic

PRAGUE
CZECH CENTRE FOR PHOTOGRAPHY
Náplavni 1
Prague 2
CZ 12000
Tel: +420 2 24 92 27 26
Email: ccf@volny.cz
Specialists in Czech photography

PRAGUE HOUSE OF PHOTOGRAPHY
Vaclavske Namesti 31
Prague 1
CZ 11000
Tel: +420 2 22 24 32 29
Email: php@ecn.cz
Website: www.php-gallery.cz
Dedicated photography exhibition space

Denmark

COPENHAGEN
FOTOGRAFISK CENTRE
Gammel Strand 48
DK-1202
Copenhagen
Tel: +45 33 93 09 96
Fax: +45 33 93 09 97
Email: fc@photography.dk
Website: www.photography.dk
Classic and contemporary photography

ODENSE
BRANDTS MUSUEM OF
PHOTOGRAPHY
Brandts Torv
DK-5000
Odense C
Tel: +45 65 20 70 30
Fax: +45 65 20 70 42
Website: www.brandts.dk/foto
Twentieth-century and contemporary photography

Finland

HELSINKI
GALLERIA PIRKKO-LIISA TOPELIUS
Uudenmaankatu 40
00120 Helsinki
Tel: +358 96 434 52
Email: topelius@galleriat.net
Website:
www.galleriat.net/gallery.asp?cid=27
Contemporary art and photography

KUOPIO
VICTOR BARSOKEVITSCH
PHOTOGRAPHIC CENTRE
Kuninkaankatu 14-16
70100 Kuopio
Tel: +358 17 261 5599
Fax: +358 17 261 5844
Email: info@vb.kuopio.fi
Website: www.vb.kuopio.fi
Twentieth-century and contemporary photography

France

PARIS
AGNES B – GALERIE DU JOUR
44 rue Quincampoix,
75004 Paris
Tel: +33 1 44 54 55 90
Fax: +33 1 40 29 01 69
Email: jour@agnesb.fr
Website: www.galleriedujour.com
Contemporary art and photography

A L'IMAGE DU GRENIER SUR L'EAU
45 rue des Francs Bourgeois
75004 Paris
Tel: +33 1 42 71 02 31
Fax: +33 1 42 71 89 66
Email: image.di-maria@wanadoo.fr
Nineteenth- and twentieth-century photography

BAUDOIN LEBON
38 rue Saint Croix de la Bretonnerie
75004 Paris
Tel: +33 1 42 72 09 10
Fax: +33 1 42 72 02 20
Email: baudoin.lebon@wanadoo.fr
Website: www.baudoin-lebon.com
Contemporary art and twentieth-century photography

DES PHOTOGRAPHIES
21 rue Saint Paul
75004 Paris
Tel: +33 1 48 87 69 27
Email:
sylvaincalvier@desphotographies.com
Website:
www.desphotographies.com
Nineteenth- and twentieth-century photography

GALERIE 1900-2000
8 rue Bonaparte
75006 Paris
Tel: +33 1 43 25 84 20
Fax: +33 1 46 34 74 52
Email: info@galerie1900-2000.com
Website: www.galerie1900-2000.com
Contemporary art and photography. Opened in 1972 with an exhibition of forty of Man Ray's rayograms.

GALERIE AGATHE GAILLARD
3 rue du Pont Louis-Phillipe
75004 Paris
Tel: +33 1 42 77 38 24
Fax: +33 1 42 77 78 36
Email: info@agathegaillard.com
Website: www.agathegaillard.com
Contemporary photography with an emphasis on French photojournalism

GALERIE ANNE BARRAULT
22 rue St Claude
75003 Paris
Tel: +33 1 44 78 91 67
Fax: +33 6 62 28 51 68
Email: info@galerieannebarrault.com
Website:
www.galerieannebarrault.com
Contemporary photography

GALERIE AU BONHEUR DU JOUR
11 rue Chabanais
75002 Paris
Tel: +33 1 42 96 58 64
Email:
aubonheurdujour@curiositel.com
Website:
www.curiositel.com/aubonheurdujour
Specialises in vintage nineteenth- and twentieth-century photography

GALERIE CAMERA OBSCURA
268 Boulevard Raspail
75014 Paris
Tel: +33 1 45 45 67 08
Fax: +33 1 45 45 67 90
Email: cameraobscura@free.fr
Small photography gallery specialising in twentieth-century and contemporary photography

GALERIE ESTHER WOERDEHOFF
36 rue Falguiere
75015 Paris
Tel: +33 1 43 21 44 83
Fax: +33 1 43 21 45 03
Email: galerie@ewgalerie.com
Website: www.ewgalerie.com
Specialises in vintage French and American prints from the 1930s to the 1960s and also represents contemporary conceptual photographers

GALERIE FRANÇOISE PAVIOT
57 rue Sainte-Anne
75002 Paris
Tel: +33 1 42 60 10 01
Fax: +33 1 42 60 68 08
Email: info@paviotphoto.com
Website: www.paviotfoto.com
Vintage and contemporary photography

GALERIE HYPNOS
52 rue de l'Université,
75007 Paris
Tel: +33 1 45 44 99 71
Fax: +33 1 45 44 99 71
Email: hypnos@hypnos-photo.com
Website: www.hypnos-photo.com
Nineteenth- and twentieth-century photography

GALERIE KAMEL MENNOUR
60 & 72 rue Mazarine
75006 Paris
Tel: +33 1 56 24 03 63
Fax: +33 1 56 24 03 64
Email: contact@galeriemennour.com
Website: www.galeriemennour.com
Contemporary photography

GALERIE LAURENT HERSCHTRITT
5 rue Jacques Callot
75006 Paris
Tel: +33 1 56 24 34 74
Fax: +33 1 56 24 34 74
Email: galerieherschtritt@free.fr
Specialises in nineteenth- and twentieth-century vintage photography

GALERIE MARIAN GOODMAN
79 rue du Temple
75003 Paris
Tel: +33 1 48 04 70 52
Fax: +33 1 40 27 81 37
Email: parisgallery@mariangoodman.com
Website: www.mariangoodman.com
Paris expansion of the New York-based contemporary art and photography gallery

GALERIE VU
2 rue Jules Cousin
75004 Paris
Tel: +33 1 53 01 85 81
Fax: +33 1 53 01 85 80
Email: gilou@abvent.fr
Website: www.galerie-vu.com
Contemporary and vintage photography

MAGNUM PHOTOS
19 rue Hégésippe Moreau
75018 Paris
Tel: +33 1 53 42 50 00
Fax: +33 1 53 42 50 03
Email: magnum@magnumphotos.fr
Website: www.magnumphotos.com
Vintage and contemporary photography by Magnum members

SERGE PLANTUREUX
4 Galerie Vivienne
75002 Paris
Tel: +33 1 53 29 92 93
Fax: +33 1 47 03 08 85
Email: info@sergeplantureux.fe
Website: www.sergeplantureux.fr
Nineteenth- and twentieth-century vintage photography

Germany

BERLIN
CARLIER / GEBAUER
Holzmarkstrasse 15-18
Bogen 51/52
D-10179 Berlin
Tel: +49 30 280 81 10
Fax: +49 30 280 81 09
Website: www.carliergebauer.com
Contemporary photography

GALERIE BARBARA WEISS
Zimmerstrasse 88-91
10117 Berlin
Tel: +49 30 262 42 84
Fax: +49 30 265 16 52
Email: mail@galeriebarbaraweiss.de
Website: www.galeriebarbaraweiss.de
Contemporary art and photography

GALERIE BERINSON
Auguststrasse 22
10117 Berlin
Tel: +49 30 28 38 79 90
Fax: +49 30 28 38 79 99
Email: info@berinson.de
Website: www.berinson.de
Fine-art and vintage photography, specialising in Bauhaus, Dada, constructivism, surrealism, expressionism and new objectivity

GALERIE BODO NIEMANN
Linienstrasse 148
D-10115 Berlin
Tel: +49 30 28 39 19 28
Fax: +49 30 28 39 19 27
Website www.bodonie.com
Contemporary photography

GALERIE CAMERA WORK
Atelierhaus
Kantstrasse 149
D-10623 Berlin
Tel: +49 30 315 047 83
Website: www.camerawork.de
Twentieth-century and contemporary photography at the former offices of Camera Work magazine

GALERIE KICKEN BERLIN
Linienstrasse 155
D-10115 Berlin
Tel: +49 30 288 77 882
Fax: +49 30 288 77 883
Email: kicken@kicken-gallery.com
Website: www.kicken-gallery.com
Nineteenth- and twentieth-century, and contemporary photography, specialising in the German and Czech avant-garde of the 1920s and 1930s

GALERIE THOMAS SCHULTE
Mommsenstrasse 56
10629 Berlin – Charlottenburg
Tel: +49 30 324 00 44
Fax: +49 30 345 15 96
Email: mail@galeriethomasschulte.de
Website:
www.galeriethomasschulte.de
Contemporary conceptual art and photography

SPIELHAUS MORRISON GALERIE
Reinhardstrasse 10
D-10117 Berlin
Tel: +49 30 280 405 77
Fax: +49 30 280 41 898
Email: info@spielhaus-morrison.com
Website: www.spielhaus-morrison.com
Contemporary art and photography

COLOGNE
BÜR FÜR FOTOS
Schaafenstrasse 25
50676 Köln
Tel: +49 221 73 929 36
Fax: +49 221 73 929 36
Email: art@burofurfotos.de
Website: www.burofurfotos.de
Specialises in twentieth-century and contemporary photography

GALERIE THOMAS ZANDER
Schönhauserstr. 8
D-50968 Köln
Tel: +49 221 93 488 56
Fax: +49 221 93 488 58
E-Mail: mail@galeriezander.com
Website: www.galeriezander.com
Twentieth-century and contemporary photography

GALERIE ULRICH FIEDLER
Lindenstrasse 19
D-50674 Köln
Tel: +49 221 923 0800
Fax: +49 221 249 601
Email: info@ulrichfiedler.com
Website: www.ulrichfiedler.com
Contemporary and vintage photography

SABINE SCHMIDT GALERIE
An der Schanz 1a
50735 Köln
Tel: +49 221 257 8441
Fax: +49 221 258 0979
Email: galerie@sabineschmidt.com
Website: www.sabineschmidt.com
Nineteenth-century photography and contemporary art

MUNICH
GALERIE DANIEL BLAU
Odeonsplatz 12
80539 München
Tel: +49 89 29 73 42
Fax: +49 89 29 58 48
Email: contact@danielblau.de
Website: www.danielblau.de
Specialises in nineteenth-century photography

SOLMS
LEICA GALLERY SOLMS
Leica Camera AG
Oskar-Barnack-Strasse 11
35606 Solms
Germany
Tel. +49 644 220 80
Website: www.leica-camera.com
Contemporary and vintage photography, specialising in photojournalism and documentary photography

Hungary

BUDAPEST
VINTAGE GALLERY
H-1053 Budapest
Magyar utca 26
Tel: +36 1 337 0584
Fax: +36 1 337 0584
Email: vintage@c3.hu
Website: www.vintage.hu
*Vintage and contemporary
Hungarian photography*

Iran

TEHERAN
FANOOSPHOTO
24, Dr Ghandi
St Sohrevardi Av
Terheran
Tel: +98 912 1406755
Email: info@fanoosphoto.com
Website: www.fanoosphoto.com
*Occasional exhibitions specialising in
Iranian photojournalism*

Israel

JERUSALEM
VISION / NEIL FOLBERG GALLERY
PO Box 2101
18 Yosef Rivlin St
91020, Jerusalem
Tel: +972 2 622 2253
Fax: +972 2 622 2269
Email: visiongallery@bezegint.net
Website: www.neilfolberg.com
*Nineteenth- and twentieth-century
vintage and contemporary
photography*

Italy

MILAN
PHOTOLOGY GALLERY
Via della Moscova 25
20121 Milano
Tel: +39 02 659 5285
Fax: +39 02 654 284
Email: photology@photology.com
Website: www.photology.com
*Nineteenth- and twentieth-century
and contemporary photography*

Japan

OSAKA
PICTURE PHOTO SPACE
Miyako Fashion Building, 3F
2-8-26 Higashi Shinsaibashi
Chuo-ku
Osaka 543-0083
Tel: +81 6 6251 3225
*Specialises in twentieth-century and
contemporary photography*

TOKYO
GALLERY KOYANAGI
Koyanagi Bldg 8F
1-7-5 Ginza Chuo-Ku
Tokyo 104-0061
Tel: +81 3 35 61 18 96
Fax: +81 3 35 63 32 36
Email: mail@gallerykoyanagi.com
Website: www.gallerykoyanagi.com
Contemporary art and photography

PHOTO GALLERY INTERNATIONAL
4-12-32 Shibaura
Minato-ku
Tokyo 108-0023
Tel: +81 3 3455 7827
Fax: +81 3 3455 8143
Email: info@pgi.ac
Website: www.pgi.ac
*Specialises in twentieth-century and
contemporary photography*

LEICA GALLERY
Matsushima Gankyoten 3F
3-5-6 Ginza Chuo-ku
Tokyo 104-0061
Tel: +81 3 356 767 06
Fax: +81 3 356 767 06
Website: www.leica-camera.com
*Contemporary and vintage
photography, specialising in
photojournalism and documentary
photography*

Luxembourg

GALERIE CLAIREFONTAINE
Espace 1
7 Place de Clairefontaine
1341 Luxembourg
Espace 2
21 rue du St Esprit
1475 Luxembourg
Tel: +352 47 23 24
Fax: +342 47 25 24
Email: galerie.clairefontaine@gms.lu
Website: www.galerie-
clairefontaine.lu
Contemporary photography

The Netherlands

AMSTERDAM
0031
Haarlemmerdijk 171hs
NL-1013 KH Amsterdam
Tel: +31 20 427 00 14
Email: info@gallery0031.nl
Website: www.gallery0031.nl
Contemporary photography

ART AFFAIRS
Wittenburgergracht 313
NL-1018 ZL Amsterdam
Tel: +31 20 620 6433
Fax: +31 20 638 1630
Email: office@artaffairs.net
Website: www.artaffairs.net
Contemporary art and photography

ARTSPACE WITZENHAUSEN GALLERY
Hazenstraat 60
NL-1016 SR Amsterdam
Tel: +31 20 644 98 98
Fax: +31 20 644 96 12
Email: witzenhausen@art-space.nl
Website: www.art-space.nl
Contemporary art and photography

FOAM (Fotographie Museum
Amsterdam)
Keizersgracht 609
NL-1017 DS Amsterdam
Tel: +31 20 551 6500
Email: info@foam.nl
Website: www.foam.nl
*Museum of photography with
contemporary exhibits*

GALERIE PAUL ANDRIESSE
Prinsengracht 116
NL-1015 EA Amsterdam
Tel: +31 20 623 6273
Fax: +31 20 639 0038
Email: info@paulandriesse.nl
Website: www.galeries.nl/andriesse
Contemporary art and photography

GALERIE SERIEUZE ZAKEN / ROB
MALASCH
Lauriergracht 96-1
NL-1016 RN Amsterdam
Tel: +31 20 427 5770
Fax: +31 20 427 5770
Email: info@serieuzezaken.com
Website:
www.galeries.nl/serieuzezaken
Contemporary photography

TORCH GALLERY
Lauriergracht 94
NL-1016 RN Amsterdam
Tel: +31 20 626 02 84
Fax: +31 20 623 88 92
Email: mail@torchgallery.com
Website: www.torchgallery.com
Contemporary art and photography

EINDHOVEN
GALERIE PENNINGS
Geldropseweg 61B
NL-5611 SE Eindhoven
Tel: +31 40 293 0270
Fax: +31 40 293 0277
Website: www.galeriepennings.nl
Contemporary photography

UTRECHT
FLATLAND GALLERY
Lange Nieuwstraat 7
Abraham Dolehof
NL-3512 PA Utrecht
Tel: +31 30 231 5181
Fax: +31 30 236 8424
Email: info@flatlandgallery.com
Website: www.flatlandgallery.com
Contemporary art and photography

TON PEEK GALLERY
Oudegracht 295
NL-3511 PA Utrecht
Tel: +31 30 231 2001
Email: photo@tonpeek.com
Website: www.tonpeek.com
*Nineteenth- and twentieth-century
vintage photography*

Spain

BARCELONA
KOWASA GALLERY
Mallorca, 235, Bajos
08008 - Barcelona
Tel. +34 93 215 80 58
Fax +34 93 215 80 54
Email: info@kowasa.com
Website: www.kowasa.com/gallery
*Vintage and contemporary
photography*

Switzerland

ZURICH
ARS FUTURA GALERIE
Bleicherweg 45
8002 Zurich
Tel: +41 1 201 8810
Fax: +41 1 201 8811
Email: info@arsfutura.com
Website: www.arsfutura.com
Contemporary art and photography

United Kingdom

BELFAST
BELFAST EXPOSED PHOTOGRAPHY
The Exchange Place
23 Donegall Street
Belfast
BT1 2FF
Tel: +44 02890 230 965
Fax: +44 02890 314 343
Email: info@belfastexposed.org
Website: www.belfastexposed.org
*Northern Ireland's only dedicated
photography gallery, specialising in
contemporary photography*

LONDON
ANTHONY REYNOLDS GALLERY
60 Great Marlborough St
London
W1F 7BG
Tel: +44 020 7439 2201
Fax: +44 020 7439 1869
Email: info@anthonyreynolds.com
Website: www.anthonyreynolds.com
Contemporary art and photography

ARTANDPHOTOGRAPHS LTD
13 Mason's Yard
St. James's
London
SW1Y 6BU
Tel: +44 020 7321 0495
Fax: +44 020 7321 0496
Email: info@artandphotographs.com
Website:
www.artandphotographs.com
*Nineteenth- and twentieth-century
and contemporary photography.
By appointment only.*

ATLAS GALLERY
49 Dorset Street
London
W1U 7NF
Tel: +44 020 7224 4192
Fax: +44 020 7224 3351
Email: info@atlasgallery.com
Website: www.atlasgallery.com
*Modern limited edition and vintage
prints*

CHISENHALE
64 Chisenhale Road
London
E3 5QZ
Tel: +44 020 8981 4518
Fax: +44 020 8980 7169
Email: mail@chisenhale.org.uk
Website: www.chisenhale.org.uk
Contemporary art and photography

EMILY TSINGOU GALLERY
10 Charles II Street
London
SW1Y 4AA
Tel: +44 020 7839 5320
Fax: +44 020 7839 5321
Email: info@emilytsingougallery.com
Website:
www.emilytsingougallery.com
Contemporary art and photography

FLOWERS EAST
82 Kingsland Road
London
E2 8DP
Tel: +44 020 7920 7777
Fax: +44 020 7920 7770
Email: gallery@flowerseast.com
Website: www.flowerseast.com
Contemporary art and photography

FLOWERS CENTRAL
21 Cork Street
London
W1S 3LS
Tel: +44 020 7439 7766
Fax: +44 020 7439 7733
Email: central@flowerseast.com
Website: www.flowerseast.com
Contemporary art and photography

FRITH STREET GALLERY
59-60 Frith Street
London
W1D 3JJ
Tel: +44 020 7494 1550
Fax: +44 020 7287 3733
Email: info@frithstreetgallery.com
Website: www.frithstreetgallery.com
Contemporary art and photography

GAGOSIAN GALLERY
6-24 Britannia Street
London
WC1X 9JD
Tel: +44 020 7841 9960
Fax: +44 020 7841 9961
Email: info@gagosiangallery.com
Website: www.gagosiangallery.com
*Twentieth-century contemporary art
and photography*

GETTY IMAGES
101 Bayham Street
London
NW1 0AG
Tel: +44 0800 376 7981
Email:
europeaneditorial@gettyimages.com
Website: www.gettyimages/archival
Photography within the Getty archive

GIMPEL FILS
30 Davis Street
London
W1K 4NB
Tel: +44 020 7493 2488
Fax: +44 020 7629 5732
Email: info@gimpelfils.com
Website: www.gimpelfils.com
Contemporary art and photography

HACKELBURY FINE ART
4 Launceston Place
London
W8 5RL
Tel: +44 020 7937 8688
Fax: +44 020 7937 8868
Email: katestevens@hackelbury.co.uk
Website: www.hackelbury.co.uk
*Twentieth-century and contemporary
photography*

HAMILTONS
13 Carlos Place
London
W1Y 2EU
Tel: +44 020 7499 9493
Fax: +44 020 7629 9919
Email: art@hamiltonsgallery.com
Website: www.hamiltonsgallery.com
*Twentieth-century and contemporary
art and photography*

HAUNCH OF VENISON
6 Haunch of Venison Yard
London
W1K 5ES
Tel: +44 020 7495 5050
Fax: +44 020 7495 4050
Email: info@haunchofvenison.com
Website: www.haunchofvenison.com
Contemporary art and photography

HOULDSWORTH
50 Pall Mall Deposit
124-128 Barlby Road
London
W10 6BL
Tel: +44 020 8969 6166
Email: gallery@houldsworth.co.uk
Website: www.houldsworth.co.uk
Contemporary art and photography

LISSON GALLERY
29 & 52-54 Bell Street
London
NW1 5DA
Tel: +44 020 7724 2739
Fax: +44 020 7724 7124
Email: contact@lisson.co.uk
Website: www.lisson.co.uk
Contemporary art and photography

MICHAEL HOPPEN GALLERY
3 Jubilee Place
London
SW3 3TD
Tel: +44 020 7352 3649
Fax: +44 020 7352 3669
Email:
gallery@michaelhoppengallery.com
Website:
www.michaelhoppengallery.com
*Twentieth-century and contemporary
photography*

THE PHOTOGRAPHERS' GALLERY
5/8 Great Newport Street
London
WC2H 7HY
Tel: +44 020 7831 1772
Fax: +44 020 7836 9704
Email: printsales@photonet.org.uk
Website: www.photonet.org.uk
*Twentieth-century vintage and
contemporary photography*

PHOTOFUSION
17a Electric Lane
Brixton
London
SW9 8LA
Tel: +44 020 7738 5774
Fax: +44 020 7738 5509
Email: info@photofusion.org
Website: www.photofusion.org
Contemporary photography

THE PROUD GALLERY CENTRAL
Buckingham Street
London
WC2N 6BP
Tel: +44 020 7839 4942
Fax: +44 020 7839 49475
Email: info@proud.co.uk
Website: www.proud.co.uk
Contemporary photography

THE PROUD GALLERY CAMDEN
The Gin House
The Stables Market
Chalk Farm Road
Camden
London
NW1 8AH
Tel: +44 020 7482 3867
Email: info@proud.co.uk
Website: www.proud.co.uk
Contemporary photography

ROCKET GALLERY
Tea Building
56 Shoreditch High Street
London
E1 6JJ
Tel: +44 020 7729 7594
Fax: +44 020 7729 0079
Email: js.rocket@btinternet.com
Website: www.rocketgallery.com
Contemporary art and photography

SADIE COLES HQ
35 Heddon Street
London
W1B 4BP
Tel: +44 020 7434 2227
Fax: +44 020 7434 2228
Email: press@sadiecoles.com
Website: www.sadiecoles.com
*Twentieth-century and contemporary
photography*

STEPHEN FRIEDMAN GALLERY
25-28 Burlington Street
London
W1S 3AN
Tel: +44 020 7494 1434
Fax: +44 020 7494 1431
Email: info@stephenfriedman.com
Website: www.stephenfriedman.com
Contemporary art and photography

SERPENTINE GALLERY
Kensington Gardens
London
W2 3XA
Tel: +44 020 7298 1515
Fax: +44 020 7402 4103
Website: www.serpentinegallery.org
Contemporary art and photography

TOM BLAU GALLERY
21 Queen Elizabeth Street
Butlers Wharf
London
SE1 2PD
Tel: +44 020 7940 9171
Fax: +44 020 7278 5126
Email: info@tomblaugallery.com
Website: www.tomblaugallery.com
Contemporary photography

VICTORIA MIRO GALLERY
16 Wharf Road
London
N1 7RW
Tel: +44 020 7336 8109
Fax: +44 020 7251 5596
Email: info@victoria-miro.com
Website: www.victoria-miro.com
Contemporary art and photography

THE WHITECHAPEL GALLERY
80 Whitechapel High Street
London
E1 7QX
Tel: +44 020 7522 7878
Fax: +44 020 7522 7887
Email: info@whitechapel.org
Website: www.whitechapel.org
*Public contemporary art and
photography gallery. Sells some
limited edition prints.*

WHITE CUBE
48 Hoxton Square
London
N1 6PB
Tel: +44 020 7930 5373
Fax: +44 020 7749 7480
Email: enquiries@whitecube.com
Website: www.whitecube.com
Contemporary art and photography

YORK
IMPRESSIONS GALLERY
29 Castlegate
York Y01 9RN
Tel: +44 01904 654 724
Fax: +44 01904 651 509
Email: enquiries@impressions-
gallery.com
Website: www.impressions-
gallery.com
Contemporary photography

OTHER UK DEALERS
ROBERT HERSHKOWITZ LTD
Cockhaise
Monteswood Lane
Nr Lindfield
Sussex
RH16 2QP
Tel: +44 01444 482 240
Fax: +44 01444 484 777
Email: prhfoto@hotmail.com
*Early European masterworks.
By appointment only.*

United States

BOSTON, MA
ROBERT KLEIN GALLERY
38 Newbury Street
Fourth Floor
Boston, MA 02116
Tel: +1 617 267 7997
Fax: +1 617 267 5567
Email: inquiry@robertkleingallery.com
Website: www.robertkleingallery.com
Nineteenth- and twentieth-century
and contemporary photography

CHICAGO, IL
STEPHEN DAITER GALLERY
311 West Superior Street
404 & 408
Chicago, IL 60610
Tel: +1 312 787 33 50
Fax: + 1 312 787 33 54
Email: info@stephendaitergallery.com
Website:
www.stephendaitergallery.com
*Twentieth-century vintage European
and American avant-garde and
documentary photography*

DALLAS, TX
AFTERIMAGE GALLERY
The Quadrangle #141
2800 Routh Street
Dallas, TX 75201
Tel: +1 214 871 9140
Fax: +1 801 858 5282
Email: images@afterimagegallery.com
Website: www.afterimage.com
*Twentieth-century and contemporary
photography*

PHOTOGRAPHS DO NOT BEND
GALLERY
3115 Routh Street
Dallas, TX 75201
Tel: +1 214 969 1852
Fax: +1 801 969 5464
Email:
gallery@photographsdonotbend.com
Website:
www.photographsdonotbend.com
*Twentieth-century vintage and
contemporary photography*

LOS ANGELES, CA
APEX FINE ART
152 North La Brea Ave
Los Angeles
CA 90036
Tel: +1 323 634 78 87
Fax: +1 323 634 78 85
Email: info@apexfineart.com
Website: www.apexfineart.com
*Twentieth-century photography,
specialising in American
photojournalism, architectural and
Hollywood photography*

FAHEY/KLEIN GALLERY
148 North La Brea Ave
Los Angeles
CA 90036
Tel: +1 323 934 2250
Fax: +1 323 934 4243
Email: fahey.klein@popbox.com
Website: www.faheykleingallery.com
*Nineteenth- and twentieth-century
vintage and contemporary
photography*

JAN KESNER GALLERY
164 North La Brea Ave
Los Angeles
CA 90036
Tel: +1 323 938 6834
Fax: +1 323 938 1106
Email:
jankesner@jankesnergallery.com
Website: www.jankesnergallery.com
*Twentieth-century and contemporary
photography*

PAUL KOPEIKIN GALLERY
6150 Wilshire Blvd
Los Angeles
CA 90048
Tel: +1 323 937 0765
Fax: +1 323 937 5974
Email: info@paulkopeikingallery.com
Website:
www.paulkopeikingallery.com
*Nineteenth- and twentieth-century
and contemporary photography*

STEPHEN COHEN GALLERY
7358 Beverly Boulevard
Los Angeles
CA 90036
Tel: +1 323 937 5525
Fax: +1 323 937 5523
Email: sc@stephencohengallery.com
Website:
www.stephencohengallery.com
*Vintage and contemporary
photography*

LA JOLIA, CA
JOSEPH BELLOWS GALLERY
7661 Girard Avenue
La Jolia
CA 92037
Tel: +1 858 456 5620
Fax: +1 858 456 5621
Email: info@joesephbellows.com
Website: www.josephbellows.com
*Twentieth-century vintage and
contemporary photography*

NEW YORK, NY
BONNI BENRUBI GALLERY
41 East 57th Street 13th Floor,
New York,
NY 10022
Tel: +1 212 888 6007
Fax: +1 212 751 0819
Email: benrubi@bonnibenrubi.com
Website: www.bonnibenrubi.com
*Twentieth-century and contemporary
photography*

CHARLES SCHWARTZ LTD
21 East 90th Street
New York
NY 10128
Tel: +1 212 534 4496
Fax: +1 212 534 0313
Email: csltd@cs-photo.com
Website: www.cs-photo.com
*Nineteenth- and twentieth-century
vintage photography.
By appointment only.*

EDWYNN HOUK GALLERY
745 Fifth Ave
New York
NY 10151
Tel: +1 212 750 7070
Fax: +1 212 688 4848
Email: info@houkgallery.com
Website: www.houkgallery.com
*Twentieth-century and contemporary
American photography specialising
in the 1920s and 1930s*

GITTERMAN GALLERY
170 East 75th Street
New York
NY 10021
Tel: +1 212 734 0868
Fax: +1 212 734 0869
Email: info@gittermangallery.com
Website: ww.gittermangallery.com
*Exhibits and represents various artists
and estates. Maintains an inventory
of work in a full range of styles and
periods.*

HOWARD GREENBERG GALLERY
41 East 57th Street
Suite 1406
New York
NY 10022
Tel: +1 212 334 0010
Fax: +1 212 941 7479
Email: info@howardgreenberg.com
Website:
www.howardgreenberg.com
*Twentieth-century and contemporary
photography specialising in
photojournalism and offering genres
and styles spanning from pictorials to
modernism*

JANET BORDEN INC.
560 Broadway
New York
NY 10012
Tel: +1 212 431 0166
Fax: +1 212 274 1679
Email: mail@janetbordeninc.com
Website: www.janetbordeninc.com
*Twentieth-century vintage and
contemporary photography*

JOHN STEVENSON GALLERY
338 West 23rd Street
New York
NY 10011
Tel: +1 212 352 0070
Fax: +1 212 741 6449
Email: mail@johnstevenson-
gallery.com
Website: www.johnstevenson-
gallery.com
*Specialising in rare photographic
processes*

JULIE SAUL GALLERY
535 West 22nd Street
6th Floor
New York
NY 10011
Tel: +1 212 627 2410
Fax: +1 212 627 2411
Email: mail@saulgallery.com
Website: www.saulgallery.com
*Contemporary and vintage
photography*

LAURENCE MILLER GALLERY
20 West 57th Street
New York
NY 10019
Tel: +1 212 397 3930
Fax: +1 212 397 3932
Email: lmg@laurencemillergallery.com
Website:
www.laurencemillergallery.com
*Nineteenth- and twentieth-century
and contemporary photography*

LEICA GALLERY NY
670 Broadway
Suite 500
New York
NY 1001
Tel: +1 212 777 3051
Fax: +1 212 777 6960
Email: leicaphoto@aol.com
Website: www.leica-camera.com
*Contemporary and vintage
photography, specialising in
photojournalism and documentary
photography*

MAGNUM PHOTOS
151 West 25th Street
New York
NY 10001
Tel: +1 212 929 6000
Fax: +1 212 929 9325
Email: info@magnumphotos.com
Website:www.magnumphotos.com
*Vintage and contemporary
photography by Magnum members*

MARIAN GOODMAN GALLERY
24 West 57th St
New York
NY 10019
Tel: +1 212 977 7160
Fax: +1 212 581 5187
Email:
Goodman@mariamgoodman.com
Website: www.mariamgoodman.com
*Contemporary art and photography
gallery*

METRO PICTURES GALLERY
519 West 24th Street
New York
NY 10011
Tel: +1 212 206 7100
Fax: +1 212 337 0070
Email:
gallery@metropicturesgallery.com
Website:
www.metropicturesgallery.com
Contemporary art and photography

PACE/MACGILL GALLERY
32 East 57th Street
New York
NY 10022
Tel: +1 212 759 7999
Fax: +1 212 759 8964
Email: info@pacemacgill.com
Website: www.pacemacgill.com
Nineteenth- and twentieth-century photography

ROBERT MANN GALLERY
210 Eleventh Avenue
New York
NY 10001
Tel: +1 212 989 7600
Fax: +1 212 989 2947
Email: mail@robertmann.com
Website: www.robertmann.com
Twentieth-century vintage and contemporary photography

ROBERT MILLER GALLERY
524 West 26th Street
New York
NY 10001
Tel: +1 212 366 4774
Fax: +1 212 366 4454
Email: rmg@robertmillergallery.com
Website: www.robertmillerygallery.com
Nineteenth- and twentieth-century vintage and contemporary photography

STEVEN KASHER GALLERY
521 West 23rd Street
Second Floor
New York
NY 10011
Tel: +1 212 966 3978
Fax: +1 212 226 1485
Email: info@stevenkasher.com
Website: www.stevenkasher.com
Nineteenth- and twentieth-century and contemporary photography

YANCEY RICHARDSON GALLERY
535 West 22nd Street
3rd Floor
New York
NY 10011
Tel: +1 646 230 9610
Fax: +1 646 230 6131
Email: info@yanceyrichardson.com
Website: www.yanceyrichardson.com
Contemporary photography

SAN FRANCISCO, CA
CHARLES A HARTMAN GALLERY
PO Box 15385
San Francisco,
CA 94115
Tel: +1 415 440 1680
E-mail: charles@hartmangallery.com
Website: www.hartmangallery.com
Nineteenth- and twentieth-century photography

FRAENKEL GALLERY
49 Geary Street
San Francisco,
CA 94108
Tel: +1 415 981 2661
Fax: +1 415 981 4014
Email: mail@fraenkelgallery.com
Website: www.fraenkelgallery.com
Nineteenth- and twentieth-century, and contemporary photography

ROBERT KOCH GALLERY
49 Geary Street
San Francisco
CA 94108
Tel: +1 415 421 0122
Fax: +1 415 421 6306
Email: info@kochgallery.com
Website: www.kochgallery.com
Nineteenth- and twentieth-century, and contemporary photography, specialising in modernist and experimental photography of the 1920s and 1930s

SCOTT NICHOLS GALLERY
49 Geary Street
4th floor
San Francisco
CA 94108
Tel: +1 415 788 4641
Fax: +1 415 555 1212
Email: scott@scottnicholsgallery.com
Website: www.scottnicholsgallery.com
Vintage and contemporary photography

THOMAS V MEYER FINE ART
169 25th Ave
San Francisco
CA 94121
Tel: +1 415 386 1225
Fax: +1 415 386 1634
Email: thomas@meyerfineart.com
Website: www.meyerfineart.com
Twentieth-century and contemporary photography. By appointment only.

VANCE MARTIN
373 Coventry Rd
Kensington
CA 94707
Tel: +1 510 559 9336
Email: photoart@vancemartin.com
Website: www.vancemartin.com
Specialising in classic and contemporary male and female nude photography. By appointment only.

SANTA FE, NM
ANDREW SMITH GALLERY
202 West San Francisco Street
Santa Fe
NM 87501
Tel: +1 505 984 1234
Fax: +1 505 983 2428
Email: info@andrewsmithgallery.com
Website: www.andrewsmithgallery.com
Nineteenth- and twentieth-century vintage and contemporary photography

SANTA MONICA, CA
PETER FETTERMAN GALLERY
2525 Michigan Ave
Gallery A7
Santa Monica
CA 90404
Tel: +1 310 453 6463
Fax: +1 310 453 6959
Email: info@peterfetterman.com
Website: www.peterfetterman.com
Black-and-white vintage and contemporary photography with humanist imagery

ROSE GALLERY
Bergamot Station Arts Center
2525 Michigan Ave
Building G-5
Santa Monica
CA 90404
Tel: +1 310 264 8440
Fax: +1 310 264 8443
Email: info@rosegallery.net
Website: www.rosegallery.net
Twentieth-century vintage and contemporary photography

SEATTLE, WA
G GIBSON GALLERY
300 So. Washington Street
Seattle
Washington
98140
Tel: +1 206 587 4033
Fax: +1 206 587 5751
Email: gail@ggibsongallery.com
Website: www.ggibsongallery.com
Nineteenth- and twentieth-century and contemporary photography

TUCSON, AZ
ETHERTON GALLERY
135 South 6th Avenue
Tucson
AZ 85701
Tel: +1 520 624 7370
Fax: +1 520 792 4569
Email: info@ethertongallery.com
Website: www.ethertongallery.com
Nineteenth- and twentieth-century and contemporary photography, specialising in landscapes

WASHINGTON, DC
KATHLEEN EWING GALLERY
1609 Connecticut Ave
Washington
DC 20009
Tel: +1 202 328 0955
Fax: +1 202 462 1019
Email: ewingal@aol.com
Website: www.kathleenewinggallery.com
Nineteenth- and twentieth-century vintage photography

Photography Fairs, Festivals and Events
(Alphabetically by Country/Calendar Month)

Czech Republic

PRAGUE BIENNALE
SEPTEMBER
PRAGUE, CZECH REPUBLIC
Karlin Hall
Thamova 8
Prague 8
Prague
Czech Republic
Tel: +42 222 314 690
Email: info@praguebiennale.org
Website:www.praguebiennale.org

France

ARLES PHOTOGRAPHY FESTIVAL
(RENCONTRES INTERNATIONALES DE
LA PHOTOGRAPHIE D'ARLES)
JULY-SEPTEMBER
ARLES, FRANCE
Les Recontres d'Arles
10 rond point des Arènes,
13200 Arles
France
Tel: +33 4 90 96 76 06
Fax: +33 4 90 49 94 39
Email: info@rencontres-arles.com
Website: www.rencontres-arles.com
*Over 130,000 people regularly attend
the photography festival held in
Arles, featuring exhibitions,
workshops and lectures*

THE INTERNATIONAL
PHOTOJOURNALISM FESTIVAL OF
PERPIGNAN
AUGUST–SEPTEMBER
PERPIGNAN, FRANCE
2e BUREAU
13 rue d'Aboukir
75002 Paris
France
E-mail: contact@visapourlimage.com
Website: www.visapourlimage.com

PARIS PHOTO
NOVEMBER
PARIS, FRANCE
11 rue du Colonel Pierre-Avia
BP 571 - 75726
Paris cedex 15
France
Tel: +33 1 41 90 47 70
Email: parisphoto@reedexpo.fr
Website: www.parisphoto.fr
*Perhaps the world's leading
photography fair, Paris Photo features
more than 100 international
exhibitors and is the biggest
European art fair exclusively
dedicated to photography.*

Italy

VENICE BIENNALE
JULY
VENICE, ITALY
Ca' Giustinian
1364 San Marco
30124 Venezia
Tel:+39 041 5218711
Fax: +39 041 5218810
Email: ufficiostampa@labiennale.org
Website: www.labiennale.org
*One of the most prestigious
international contemporary art
festivals*

Spain

MADRID INTERNATIONAL
CONTEMPORARY ART FAIR (ARCO)
FEBRUARY
MADRID, SPAIN
ARCO
Feria de Madrid
28042 Madrid
Spain
Tel: +34 91 722 50 17
Fax: +34 91 722 57 98
Email: arco@ifema.es
Website: www.arco.ifema.es

PHOTOESPAÑA
JULY
MADRID, SPAIN
Alameda 9
28014 Madrid
Spain
Tel: +34 91 360 13 20
Fax: +34 91 360 13 22
Email: info@phedigital.com
Website: www.phedigital.com
International Festival of Photography
and the Visual Arts

Switzerland

ART BASEL
JUNE
BASEL, SWITZERLAND
Art Basel
Messeplatz 10
CH-4005 Basel
Tel: +41 58 200 20 20
Fax: +41 58 206 26 86
Email: info@artbasel.com
Website: www.art.ch
Contemporary visual art

UK

PHOTO LONDON
MAY
LONDON, UK
2nd Floor
13 Mason's Yard
St. James's
London SW1Y 6BU
Tel: +44 020 7839 9300
Email: info@photo-london.com
Website: www.photo-london.com
*A new addition to the annual
calendar, Photo London reflects the
city's growing profile in the
international photographic
community*

USA

PHOTO LA
JANUARY
LOS ANGELES, USA
7358 Beverly Boulevard
Los Angeles,
CA 90036
Tel: +1 323 937 5525
Email: info@photola.com
Website: www.photola.com

AIPAD PHOTOGRAPHY SHOW
FEBRUARY
NEW YORK, USA
Association of International
Photography Art Dealers
1609 Connecticut Avenue
NW #200
Washington DC 20009
USA
Email: aipad@aol.com
Website: www.aipad.com
*Long established and internationally
respected exposition of vintage and
contemporary fine-art photography*

PHOTO SAN FRANCISCO
JULY
SAN FRANCISCO, USA
7358 Beverly Boulevard
Los Angeles, CA 90036
Tel: +1 323 937 5525
Fax: +1 323 937 5523
Email: info@photosanfrancisco.net
Website: www.photola.com

THE ARMORY SHOW
MARCH
NEW YORK, USA
The Armory Show, Inc.
530 West 25th Street
Third Floor
New York
NY 10001
USA
Tel: +1 212 645 6440
Fax: +1 212 645 0655
Email: info@thearmoryshow.com
Website: www.thearmoryshow.com
International fair of contemporary art

PHOTO NEW YORK
OCTOBER
NEW YORK, USA
7358 Beverly Boulevard,
Los Angeles, CA 90036
Tel: +1 323 937 4659
Fax: +1 323 937 5523
E-mail: info@artfairsinc.com
Website: www.photola.com

ART BASEL MIAMI BEACH
DECEMBER
MIAMI, USA
Art Basel Miami Beach
PO Box
CH-4005 Basel
T +41 58 200 2020
F +41 58 206 3132
E-mail: miamibeach@artbasel.com
Website: www.art.ch
*American sister event of Art Basel
in Switzerland*

Auction Houses
(Alphabetically by Name)

BONHAMS (UK)
New Bond Street
101 New Bond Street
London W1S 1SR
United Kingdom
Tel: +44 020 7447 7447
Email: info@bonhams.com
Website: www.bonhams.com

BONHAMS AND BUTTERFIELDS (US)
San Francisco
Main Gallery & Corporate Offices
Bonhams & Butterfields
220 San Bruno Avenue
San Francisco, CA 94103
Tel: +1 415 861-7500
Fax: +1 415 861-8951
Website: www.butterfields.com

BONHAMS AND GOODMAN (AUS)
7 Anderson Street
Double Bay, NSW 2028
Australia
Tel: +61 2 9327 7311
Fax: +61 2 9327 2917
Email: info.aus@bonhams.com
*One of the world's oldest and largest
auctioneers of fine art and antiques,
Bonhams operate through
Butterfields in the US and Goodman
in Australia*

CHRISTIE'S
8 King Street
St. James's
London
SW1Y 6QT
UK
Tel: +44 020 7839 9060

20 Rockefeller Plaza
New York
NY 10020
USA
Tel: +1 212 636 2000

Email: info@christies.com
Website: www.christies.com
*Christie's is a prominent and highly
regarded auction house, offering
many specialist services*

DOROTHEUM
Dorotheergasse 17
A-1010 Vienna
Austria
Tel. +43 1 515 60 - 0
Fax +43 1 515 60 - 443
Website: www.dorotheum.com

NEUMEISTER
Barer Strasse 37
80799 Munich
Germany
Tel: +49 89 23 17 10 0
Fax: +49 89 23 17 10 55
Email: info@neumeister.com
Website: www.neumeister.com

PHILLIPS DE PURY & COMPANY
25-26 Albemarle Street
London
W1S 4HX
UK
Tel: +44 020 7318 4010
Fax: +44 020 7493 6396

450 West 15th Street
New York
NY 10011
USA
Tel: +1 212 940 1200
Fax: +1 212 924 3306
Email: info@phillips-dpl.com
Website: www.phillips-dpl.com
*Phillips de Pury & Company specialise
in American and contemporary art,
design and photography*

SOTHEBY'S
34-35 New Bond Street
London
W1A 2AA
UK
Tel: +44 020 7293 5000
Fax: +44 020 7293 5989

1334 York Avenue at 72nd Street
New York
NY 10021
USA
Tel: +1 212 606 7000
Fax: +1 212 606 7107

Website: www.sothebys.com
*Sotheby's specialise in the auction of
art and antiques and offer a wide
range of services to the art collector.
They have many international
branches, but London and New York
are the main outlets for photography.*

SWANN GALLERIES INC.
104 East 25th Street
New York
NY 10010
USA
Tel: +1 212 254 4710
Fax: +1 212 979 1017
Email: swann@swanngalleries.com
Website: www.swanngalleries.com
*Originally specialising in rare books
(and still the largest dealer in that
field), Swann have now expanded to
include fine arts and photography*

TAJAN
37 rue des Mathurins
F-75008 Paris
France

Tel: +33 1 53 30 30 30 (General)
Tel: +33 1 53 30 30 79 (Eric
Masquelier: Photography Specialist)
Email: info@tajan.com
Website: www.tajan.com
Largest auction company in France

VILLA GRISEBACH AUKTIONEN
Fasanenstrasse 25
10719 Berlin
Germany
Tel: +49 30 885 915 0
Fax: +49 30 882 41 45
Email: auktionen@villa-grisebach.de
Website: www.villa-grisebach.de
*German-based specialist art auction
house*

Further Resources

Photographic and Art History

Baldwin, G. *Looking at Photographs*
(The J. Paul Getty Museum, 1991)

Bernard, B. *Century*
(Phaidon Press, London, 2000)

Campany, D. (Ed.), *Art and Photography*
(Phaidon Press, London, 2003)

Clarke, G. *The Photograph*
(Oxford University Press, Oxford, 1997)

Davis, K. F. *An American Century of Photography From Dry-Plate to Digital. The Hallmark Photographic Collection*
(Hallmark Cards Inc. Kansa City, 1995)

Enyart, J. L. *Photographers, Writers and the American Scene*
(Arena Editions, Santa Fe, 2002)

The Friends of Photography, *Modern Photography in Japan 1915-1940*
(The Friends of Photography, San Francisco, 2001)

Frizot, M. *The New History of Photography*
(Könemann, Cologne, 1998)

Gersheim, H. *A Concise History of Photography*
(Dover Publications Inc. New York, 1965)

Grundberg, A. *Crisis of the Real: Writings on Photography Since 1974*
(Aperture Foundation Inc., New York, 1999)

Grundberg, A. *McCarthy Gauss K, Photography and Art: Interactions Since 1946*
(Abbeville Press, New York, 1987)

Jeffrey, I. *The Photography Book*
(Phaidon Press, London, 1997)

Jeffrey I, *Photography: A Concise History*
(Thames & Hudson, London, 1981)

Johnson, W. S. Rice, M. Williams, C.
Mulligan, T. & Wooters, D. (Eds)/George Eastman House, *1000 Photo Icons*
(Taschen, Köln, 2002)

Luminata Sabau (Ed.) with Cramer, I. and Kirchberg, P. *The Promise of Photography. The DG BANK Collection*
(Prestel, Munich, 1998)

McDarrah, F. D. McDarrah, G. S. and McDarrah, T. *The Photography Encyclopedia*
(Schirmer Books, New York, 1999)

Miller, R. *Magnum: Fifty Years at the Front Line of History*
(Grove Press, Texas, 1988)

Newhall, N. *From Adams to Stieglitz*
(Aperture Foundation Inc., New York, 1998)

Newhall, B. *The History of Photography*
(The Museum of Modern Art, New York, 1982)

Ritchin, F. *In Our Own Image: The Coming Revolution in Photography*
(Aperture Foundation Inc., New York, 1990)

Spira, S. F. with Lothroop Jr, E. S. and Spira, J. B. *The History of Photography as seen through the Spira Collection*
(Aperture Foundation Inc, New York, 2001)

Szarkowski, J. *Looking at Photographs*
(The Museum of Modern Art, New York, 1973)

Walsh, G. Naylor, C. and Held, M. (Eds), *Contemporary Photographers*
(Macmillan Publishing, Basingstoke, 1982)

Weski, T. and Liesbrock, H. *How You Look At It: Photographs of the 20th Century*
(Sprengel Museum, Hannover, Thames & Hudson, London, DAP, New York, 2000)

Conservation

Eastman Kodak Company, *Conservation of Photographs*
(Eastman Kodak Company, Rochester, 1985)

Ford, C. and Steinorth, K. (Eds), *You Press The Button We Do The Rest: The Birth of Snapshot Photography*
(Dirk Nishen Publishing, in Association with the National Museum of Photography, Film and Television, London 1988)

Lavédrine, B. *A Guide to the Preventative Conservation of Photograph Collections*
(Getty Conservation Institute, Los Angeles 2003)

Mace, O. H. *Collector's Guide to Early Photographs*
(Krause Publications, Iowa 1999)

Schaeffer, T. T. *Effects of Light on Materials in Collections: Data on Photoflash and Related Sources*
(Getty Conservation Institute, 2001)

Collecting Photography

Bennett, S. *How To Buy Photographs*
(Phaidon Press, London, 1987)

Blodgett, R. *Photographs: A Collector's Guide*
(Ballantine Books, New York, 1979)

Gilbert, G. *Collecting Photographica: The Images and Equipment of the First Hundred Years*
(Hawthorn Books, New York, 1976)

Wetling, W. *Collector's Guide to Nineteenth Century Photographs*
(Macmillan Publishing, New York, 1976)

Witkin, L. D. and London, B. *The Photograph Collector's Guide*
(McGraw Hill, New York and Secker & Warburg, London, 1979)

Pols, R. *Dating Old Photographs*
(The Federation of Family Societies (Publications) Ltd, Birmingham, 1992)

Photographic Interest

Adams, R. *Beauty in Photography*
(Aperture Foundation Inc., New York, 1996)

Adams, R. *Why People Photograph*
(Aperture Foundation Inc., New York, 1994)

Barthes, R. *Camera Lucida*
(Vintage, London, 2000)

Barthes, R. *Image, Music and Text*
(Fontana Press, an imprint of Harper Collins Publishers, London, 1977)

Barthes, R. *Mythologies*
(Jonathan Cape, London, 1972)

Friday, J. *Aesthetics and the Philosophy of Art*
(Ashgate Publishing Ltd., Aldershot, 2002)

Newhall, N. *From Adams to Stieglitz: Pioneers of Modern Photography*
(Aperture Foundation, Inc. New York, 1989)

General Interest

Fernandez, H. *Fotografía Publica: Photography in Print 1919–1939*
(Museo Nacional Centro de Arte Reina Sophia, Madrid, 1999)

Goldschmidt, L. and Naef, W. *The Truthful Lens: A Survey of the Photographically Illustrated Book 1844–1914*
(Gollier Club, New York, 1980)

The Open Book: A History of the Photographic Book from 1878 to the Present
(Hasselblad Center, Göteborg, Sweden, 2004)

Parr, M. and Badger, G. *The Photobook: A History Volume I*
(Phaidon Press, London, 2004)

Roth, A. *The Book of 100 Books: Seminal Photographic Books of the Twentieth Century*
(PPP Editions and Roth Horowitz LLC, New York, 2001)

Publications and Periodicals

APERTURE Magazine
Tel: +1 212 505 5555
Fax: +1 212 598 4015
Email: info@aperture.org
Website: www.aperture.org

BLINDSPOT Magazine
Tel: +1 212 633 1317
Fax: +1 212 627 9364
Email: orders@blindspot.com
Website: www.blindspot.com

EYEMAZING Magazine
Brains Unlimited BV
Van Miereveldstraat 3
1071 DW Amsterdam
The Netherlands
Tel: +31 20 584 92 50
Fax: +31 20 584 92 01
Email: info@eyemazing.com
Website: www.eyemazing.info

NEXT LEVEL Magazine

UK:
Next Level
Freepost NAT21142
London
E8 1BR
UK

Rest of the World:
Next Level
95 Greenwood Rd
London
E8 1NT
UK

Website: www.nextleveluk.com

PHOTOGRAPHIE INTERNATIONALE Photography Listings (International)
14 rue Goetz-Monin
CH-1205
Geneva
Switzerland
Tel: +41 22 320 75 36
Fax: +41 22 320 75 37
Email: info@photographie-internationale.com

PLUK Photography Listings (London, UK & Europe)
2nd Floor
13 Mason's Yard,
London SW1Y 6BU
UK
Tel: +44 020 7839 9300
Fax: +44 020 7321 0496
Email: info@plukmagazine.com
Website: www.plukmagazine.com/pages/about.htm

PORTFOLIO Contemporary Photography Magazine
43 Candlemaker Row
Edinburgh EH1 2QB
Scotland UK
Tel: +44 0131 220 1911
Fax: +44 0131 226 4287
Email: info@portfoliocatalogue.com
Website: www.portfoliocatalogue.com

Webography

www.artnet.com
Excellent general fine-art resource, with gallery and events listings, a price database and market trends analysis.

www.artprice.com
Searchable online database of the current market value of the works of many artists, based on the analysis of 2900 international auction houses.

www.ebay.com
The largest and most well known online auction house, selling millions of items daily. In 2002 eBay teamed up with Sotheby's to manage their online arm.

www.eyestorm.com
Browse and purchase contemporary art and photography online.

www.icollector.com
Represents many leading auction houses and features live online auctions. Specialises in selling art, antiques and collectables.

www.iphotocentral.com
A specialist website for the photography collector. Search listings of dealers and prints for sale and browse a comprehensive list of collectors' resources.

www.photography-guide.com
An excellent online resource, containing comprehensive listings of dealers and exhibitions.

Glossary

Albumen Print
Predominant type of print during the second half of the nineteenth century. Paper was soaked with albumen (from egg white) and then coated with silver nitrate solution. Exposure to light was made by gradual contact with a glass negative and made stable with a sodium hyposulphite fixing solution.

Artist's Proof
One of a small number from a limited edition of prints, usually reserved by the photographer/artist as a personal and reference print.

C Print
See C-type print.

Carbro Process Print
Made using carbon and bromide stages. An initial print is made on to paper with a silver bromide emulsion. A second print is then made by pressing this when wet in contact with a sensitised carbro tissue. The tissue is then separated and transferred by contact to a final print that is further washed and hardened. Colour carbro prints are achieved by making three of the first prints from negatives. These prints are produced with the red, green and blue filters for each image, and the tissue print contains the appropriate colour pigment to produce a final full-colour print.

Cibachrome Print
Colour print made from a positive image slide film. This process, also known as an R-type (reversal) print, is so called because it was developed by CIBA –Geigy and Ilford Photography Limited in the late 1960s.

Chromogenic Print
Generic term for colour print made from positive or negative film. The print, as with the film, contains three layers of emulsion that are sensitive to the primary colours of light (red, green and blue), and contain dye-couplers that are activated during processing to reproduce full-colour images.

Colour Polaroid 20 x 24 Inches
Polaroid is the brand name for the instant print process invented by Edward Land. The exceptionally large 20 x 24 inch film and camera combination is only available through the Polaroid Company.

Combination Print
As seen in the work of Joel-Peter Witkin, this refers to the process of scratching into the photographic surfaces and selectively exposing, developing and toning separate areas within an image.

C-type Print
Made from colour negative film and the most common type of photographic print, the C-type print contains three layers of emulsion that are sensitive to the primary colours of light (red, green and blue), and contain dye-couplers that are activated during processing to reproduce full-colour images.

Daguerreotype
Developed initially by Niepce and taken further by Daguerre in 1839, this is a process whereby the image is created on a copper plate, which is coated with silver. The plate is then exposed through a camera, developed in heated mercury and fixed in a solution of hyposulphite of soda.

Digital Chromogenic Fujicolor Crystal Archive Print
A thorough description of the print used for the work of Gregory Crewdson. Digital chromogenic refers to the process of producing a chromogenic photographic print from an original image recorded in digital data form. Fujicolor Crystal archive refers to the use of Fuji archive colour negative C-type print paper with archival qualities.

Digital C-type Print
A print made on colour-negative photographic paper, but the original image source is digital data recorded by digital camera rather than negative.

Dye-transfer Print
A specialised form of colour print. From an original colour-positive film image, three separate black and white film images are recorded through red, green and blue filters. From each of these a gelatin-coated film mould is made and then dyed with the colour complementaries cyan, magenta and yellow, from which a full-colour image is produced.

Edition Print
Where a photographer agrees to make only a limited number of prints from a film original. This procedure will often be verified by certification where the number of prints is verified and the film original then scored.

Ektacolour Print
A print made from a colour negative on Kodak colour-negative paper.

Fibre-based Silver Bromide, Selenium-toned
A combination of terms. Fibre-based refers to the print paper type that is a genuine paper base of paper as opposed to a resin-based print surface. Silver bromide refers to a gelatin silver print using silver bromide salts as opposed to silver chloride salts, which are less sensitive, or a combination chloro bromide paper, which is most common. Selenium toned refers to a process of toning a whole print that adjusts its tonal and hue qualities using selenium solution after development.

Gelatin Silver Print
A standard photographic print where the image is held on the paper by a coating or emulsion, which adheres to the print surface because it contains gelatin, and is sensitive to light because it contains crystals or salts of silver. When it is exposed to light through a negative the silver in the emulsion reacts by taking up and retaining a chemical change. This is held in the emulsion until the print is immersed in a developing solution that converts those changed particles into black metallic silver, where the negative image of the film becomes positive in the print.

Gelatin Silver Print Collage
See Gelatin Silver Print. Collage is the process of combining different visual elements making different layers on the surface of one print.

Gelatin Silver Print Colour
See Gelatin Silver Print and Chromogenic Print.

Gelatin Silver Print with Applied Colour
See Gelatin silver print. Applied colour refers to the local application of colour to a print after it has been processed.

Gravure
See Photogravure.

Hand-coloured Vintage Gelatin Silver Print
See Gelatin Silver Print and Vintage Gelatin Silver Print. Hand-colouring is when the processed print is subsequently coloured by hand using inks, dyes or paints.

Hand-painted Albumen
See Albumen print. Hand-painted is when the processed print is subsequently individually coloured by hand using paints.

Heliograph
The first photographic images produced by Niepce in 1826. They were made using a camera obscura and exposing a polished pewter plate coated with bitumen. After long exposure the plate was washed with a mixture of lavender oil and white petroleum, producing a permanent image on the plate.

Incorporated Colour Coupler Print
See Chromogenic Print. This refers to the dye-couplers that are integrated into the emulsion.

Iris (or Giclee) Print
Iris prints are made on digital printers made by manufacturers of that name in Massachusetts, USA. They use an ultra-fine stream of ink that is sprayed on to archival paper or canvas and is then mounted on to a drum which rotates during the process. Iris prints have more recently been called 'Giclee' prints, which is a French term meaning to 'spray forcefully'. Iris/Giclee prints are considered superior to other drum or ink jet prints in both image permanence and tonal quality.

Light Box Print
Images that are printed as an enlarged transparency image, and then mounted on to a back-projection light box of the same size to enable viewing in ambient light conditions.

Platinum Palladium
See Platinum Print.

Platinum Print
Printing process from the 1870s. Paper sensitised with a solution of potassium and iron was contact printed until a faint image was produced. The paper was developed in a potassium chloro-platinate solution, producing platinum where the exposure had taken place. Selective development could be achieved by the use of glycerin, change of temperature and using additional colouring agents. When the price of platinum rose in the 1920s they were in part replaced by cheaper palladium prints using a similar process. Platinum printing is recently coming back into use.

Photogravure
A method of transferring the image on to an etched plate, allowing multiple prints to be made. Working from a black-and-white negative, the image is transferred to a copper plate by means of a tissue coated with gelatin. The gelatin hardens as it is exposed through the negative. It is then pressed on to the copper plate, where the gelatin acts as a resistant force when the plate is acid-etched. The plate is then inked and the image printed.

Printing Out Paper
This is a method popular around the turn of the century. Lee Friedlander used the technique to achieve a greater tonal range when printing from E. J. Bellocq's plates. The print was made by exposing the plates to the printing out paper by indirect sunlight. Exposure can take anywhere from three hours to seven days, depending on the plate's density. The paper is then given a toning bath of the gold chloride type, fixed and washed carefully in the usual manner. Care must be taken due to the fragility of the printing-out-paper emulsion.

Salted-paper Print or Salt Prints
These were invented by Fox Talbot in 1840 and were the first form of photographic positive prints. The print was made by immersing a sheet of paper with a salt solution and then coating one side with silver nitrate; the resulting silver chloride was light sensitive. This sheet could then be placed in contact with a negative image (see Talbotype) under glass and exposed to light until the image appeared. The process was arrested and the image fixed using hyposulphite of soda.

Sepia-toned Gelatin Silver Print
See Gelatin Silver Print. This method of toning a whole print involves immersing a black-and-white print in bleach and then in a toning solution of sodium sulphide. This gives a brown toning to the the image and also gives some added permanence.

Silver Bromide Print
See Gelatin Silver Print. The silver salts contained in the emulsion of a silver gelatin print are either silver bromide, silver chlrorine or a combination of the two. The less common chlorides were used for making contact prints without development, whereas the silver bromide papers are those used for making prints by projection enlargement and development as described. The combination chloro-bromides also act in this way.

Talbottype
Invented by Fox Talbot and also called calotype, this was a process for making paper negatives (see Salted-paper Print). A silver nitrate solution was brushed on to paper and allowed to dry. It was then floated on a potassium iodide solution and, prior to exposure, lightly recoated with silver nitrate. Thus the damp paper could then be exposed in the camera, but the image was not visible until it was developed in a bath of silver nitrate and acid.

Toned Gelatin Silver Print
See Gelatin Silver Print. Toning of images refers to the placing of prints into a solution during or after development to adjust their tonal and hue qualities (see Sepia-toned Gelatin Silver Print). There is a very wide range of other methods and processes.

Vintage Print
The term 'vintage' in relation to photographic prints refers to prints made at the time, or close to the time of the taking of the original image on film. Prints made subsequently at later dates are sometimes referred to as modern prints.

Vivex Colour Process Print
An early colour printing process used in the 1920s and 1930s. Prominently used by Madame Yevonde in the UK during the period, it involved producing glass negative plates separating the three complementary colours of light cyan, magenta and yellow by the use of filters.

Picture Credits

Cover
Neeta Madahar, 'Sustenance 114', 2003. Copyright Neeta Madahar.

Author portrait by Jocelyn Bain Hogg

Neeta Madahar, 'Sustenance 101', 2003. Copyright Neeta Madahar.

Introduction
p.9. André Kertész, 'Satiric Dancer', 1926. Estate of André Kertész, copyright 2006. Courtesy of Silverstein Photography

p.10. Linda Connor, 'Monks Watching a Religious Festival, Lamayuru Monastery, Ladakh, India', 1998. Copyright Linda Connor.

Chapter 1
p.15. John Kippin, 'Hidden', 1991. Copyright John Kippin.

p.17. Joseph Nicephore Niepce, 'View from the Window at Le Gras', c.1826. Courtesy of Getty Images/Hulton Archive.

p.18. Anon, 'The three daughters of the fifth Duke of Richmond'. Courtesy of Getty Images/Hulton Archive.

p.19. William Henry Fox Talbot, 'York Minster from Lop Lane', 1845. Courtesy of Paula and Robert Hershkowitz.

p.20. W. H. Sipperly, 'Congress Park Ramble'. Courtesy of Getty Images/Hulton Archive.

p.21. David Octavius Hill and Robert Adamson, 'The House of Death', 1844. Courtesy of Robert Hershkowitz, Charles Isaacs and Hans Kraus.

p.22. Felice Beato, 'At Her Toilet'. Courtesy of Getty Images/Hulton Archive.

p.23. Philip Henry Delamotte, 'The Nave from the South End'. Courtesy of Getty Images/Hulton Archive.

p.24. Roger Fenton, 'Artillery Wagons. Balaklava in the Distance', 1855. Courtesy of Paula and Robert Hershkowitz.

p.25. Auguste Salzmann, 'Sarcophage Judaique', 1854. Courtesy of Robert Hershkowitz, Charles Isaacs and Hans Kraus.

p.26. Charles Negre, 'Tympanum, St. Trophime, Arles', 1852. Courtesy of Paula and Robert Hershkowitz.

p.27. Felix Teynard, 'Ile de Fileh: Vue Generale Prise du Point 1', 1851. Courtesy of Paula and Robert Hershkowitz.

p.27. Francis Frith, 'The Pyramids at El-Geezeh', 1858. Courtesy of Paula and Robert Hershkowitz.

p.28. Charles Marville, 'Rue des Lavandieres', c.1867. Courtesy of Howard Greenberg, Charles Isaacs, Robert Hershkowitz and Hans Kraus.

p.29. Samuel Bourne, 'Akbar's Tomb, Agra', c.1867. Courtesy of Paula and Robert Hershkowitz.

p.31. Peter Henry Emerson, 'Gathering Water Lilies', 1886. Courtesy of Paula and Robert Hershkowitz.

p.32. Anon, 'Johnnie and J.P.', 1910. Courtesy of Getty Images/Hulton Archive.

p.33. Frederick Evans, 'York Minster: Doorway to the Chapter House', c.1900. Courtesy of Paula and Robert Hershkowitz.

p.35. Henri Becquerel, 'Autoradiograph', 1903. Courtesy of Paula and Robert Hershkowitz.

p.37. Frantisek Drtikol, 'Composition', 1929. Copyright Ruzena Knotková-Boková/Courtesy of Gitterman Gallery.

p.39. Paul Strand, 'Rebecca, New York', 1922. Copyright 1976 Aperture Foundation Inc., Paul Strand Archive.

p.41. Robert Capa, 'The Falling Soldier', 1936. Copyright Robert Capa/Magnum Photos. Courtesy of Gitterman Gallery.

p.43. Issues of the *Picture Post*. Courtesy of Getty Images/Hulton Archive. Photographed by James Finlay.

p.45. Aaron Siskind, 'Jerome 21, 1949', 1949. Copyright Aaron Siskind Foundation. Courtesy of Robert Mann Gallery

p.46. Ed Clark, 'Graham Jackson; Franklin D. Roosevelt [Death]', 1945. Copyright Ed Clark/Time & Life Pictures/Getty Images.

p.48. Andreas Feininger, 'Solarized Nude, Standing', 1941. Copyright The Estate of Andreas Feininger. Courtesy of Bonni Benrubi Gallery, NYC.

p.49 Margaret Bourke-White, 'Margaret Bourke-White', 1943. Copyright Margaret Bourke-White/Time & Life Pictures/Getty Images.

p.51 Louis Faurer, 'Broadway Convertible', 1950. Copyright The Estate of Louis Faurer.

p.53. Josef Koudelka, 'Jarabina', 1963. Copyright Josef Koudelka/Magnum Photos.

p.55 Miroslav Tichý, 'Untitled', 1960–1980. Copyright Stiftung Tichý Ocean. Courtesy of The Michael Hoppen Gallery.

p.57. Richard Prince, 'Untitled (Fashion)', 1982–84. Copyright Richard Prince. Courtesy of Gladstone Gallery, New York.

p.59 Naoya Hatakeyama, 'River Series, No.4', 1993. Copyright Naoya Hatakeyama. Courtesy of Taka Ishii Gallery.

Chapter 2
p.63. Berenice Abbott, 'Newsstand, E. 32nd and 3rd Ave.', 1935. Copyright Berenice Abbott/Commerce Graphics Ltd., Inc., NYC.

p.65. Robert Adams, 'Sheridan Boulevard, Lakewood', 1970-72. Courtesy of Fraenkel Gallery, San Francisco.

p.66. Anderson & Low, 'National Danish Gymnastic Team #1', 1998. Copyright Anderson & Low.

p.69. Noboyushi Araki, 'Personal Photographic Emotionalism', 2000. Copyright Nobuyoshi Araki. Courtesy of Taka Ishii Gallery.

p.71. Eve Arnold, 'Marilyn Monroe During the Filming of *The Misfits*', 1960. Copyright Eve Arnold/Magnum Photos.

p.72. Roger Ballen, 'Portrait of a Sleeping Girl', 2000. Copyright Roger Ballen.

p.75. Hans Bellmer, 'La Poupeé', 1935/1949. Copyright ADAGP, Paris and DACS, London, 2006. Courtesy Ubu Gallery, New York and Galerie Berinson, Berlin.

p.76. Ernest James Bellocq, 'Storyville Portrait', c.1912. Copyright Lee Friedlander. Courtesy of Fraenkel Gallery, San Francisco.

p.79. Werner Bischof, 'Women Praying for their Men at War', 1952. Copyright Werner Bischof/Magnum Photos.

p.80. Bill Brandt, 'Nude, Campden Hill 1938', 1938, Copyright Bill Brandt/Bill Brandt Archive Ltd.

p.83. Brassaï, 'Lovers in a Café', 1932. Copyright Estate Brassaï R.M.N.

p.84. Adolphe Braun, 'Floral Study', c.1854. Courtesy of Paula and Robert Hershkowitz.

p.85. Julia Margaret Cameron, 'Sir John Herschel', 1867. Courtesy of Paula and Robert Hershkowitz.

p.86. William Christenberry, 'Still Life with Okra and Peas, Pickens County, Alabama, 1984', 1984. Copyright William Christenberry. Courtesy of Pace/MacGill Gallery, New York.

p.87. Larry Clark, 'Untitled, (Tulsa)', 1971. Copyright Larry Clark. Courtesy of the Artist and Luhring Augustine, New York.

p.88. Gregory Crewdson, 'Untitled', 2001. Courtesy of the Artist and Luhring Augustine, New York.

p.91. Imogen Cunningham, 'Phoenix Recumbent', 1968. Copyright The Imogen Cunningham Trust.

p.92. Bruce Davidson, 'East 100th Street. Spanish Harlem', 1966. Copyright Bruce Davidson/Magnum Photos. Courtesy of Howard Greenberg Gallery, New York.

p.95. André-Adolphe-Eugène Disdéri, 'Portraits of M. Gray', 1860. Courtesy of Paula and Robert Hershkowitz.

p.96. Mike Disfarmer, 'Bonnie Dell Gardner', 1943. Copyright Mike Disfarmer. Courtesy of Peter Miller Gallery and Howard Greenberg Gallery, New York.

p.98. Joan Fontcuberta, 'Centaurus Neardentalensis, 'Fauna', Barcelona' 1988. Copyright Joan Fontcuberta.

p.99 Lee Friedlander, 'Mechanics' Monument, San Francisco, CA', 1972. Copyright Lee Friedlander. Courtesy of Fraenkel Gallery, San Francisco.

p.100. Paul Fusco, 'RFK Funeral Train', 1968. Copyright Paul Fusco/Magnum Photos.

p.101. Adam Fuss, Taken from the 'My Ghost' Series, 2000. Courtesy of Fraenkel Gallery, San Francisco.

p.103. Stephen Gill, Taken from the 'Hackney Wick' Series, 2005. Copyright Stephen Gill.

p.104. Fay Godwin, Taken from the 'Lings' Secret Lives' Series, 1993/4. Copyright Estate of Fay Godwin.

p.105. Milton H.Greene, 'Marilyn in the Pool, Connecticut', 1955. Copyright 2005 Milton H. Greene Archives, Inc., www.archivesmhg.com.

p.106. Andreas Gursky, '99 cent', 1999. Copyright Monika Sprueth Galerie, Koeln/VG Bild-Kunst, Bonn and DACS, London, 2006. Courtesy of The Broad Art Foundation, Santa Monica.

p.109. Todd Hido, '1975-A', Taken from the 'House Hunting' Series, 1996. Courtesy of Todd Hido and Stephen Wirtz Gallery, San Francisco

p.110. Lewis W. Hine, 'Icarus, High Up on Empire State', 1931. Courtesy of Photography Collection, Miriam and Ira D. Wallach Division of Art, Prints and Photographs, The New York Public Library, Astor, Lenox and Tilden Foundations.

p.112. Candida Höfer, 'Palacio Real Madrid I', 2000. Courtesy of Sonnabend Gallery.

p.114. John 'Hoppy' Hopkins, 'Thelonious Monk's Hands', 1966. Copyright John 'Hoppy' Hopkins, www.hoppy.be.

p.115. Frank Horvat, 'Yvette in the Dressing Room', 1956. Copyright Frank Horvat; www.horvatland.com.

p.116. Eikoh Hosoe, 'Ordeal by Roses (Barakei), No. 32', 1961. Copyright Eikoh Hosoe. Courtesy of Howard Greenberg Gallery, New York.

p.117. Michael Kenna, 'Fierce Wind Shakushi, Honshu, Japan', 1995. Copyright Michael Kenna.

p.119 Dorothea Lange, 'Migrant Mother, Nipomo, California', 1936. Courtesy of the Dorothea Lange Collection, Oakland Museum of California.

p.120. Gustave Le Gray, 'Landscape Study, Fountainebleau', 1852. Courtesy of Robert Hershkowitz and Hans Kraus.

p.121. Helen Levitt, 'New York', c.1940. Courtesy of Fraenkel Gallery, San Francisco.

p.123. Steve McCurry, 'Afghan Girl', 1985. Copyright Steve McCurry/Magnum Photos.

p.125. Richard Misrach, 'Shrapnel, Bomb and Bus', 1987. Courtesy of Fraenkel Gallery, San Francisco.

p.126. Daido Moriyama, 'National Highway 1 at Dawn (Asahi-cho, Kuwana City, Mie Prefecture)', 1968. Copyright Daido Moriyama. Courtesy of Taka Ishii Gallery.

p.127. Nadar (Felix Tournachon), 'Jules Janin', c.1857. Courtesy of Paula and Robert Hershkowitz.

p.129. Simon Norfolk, 'Government Building Close to the Former Presidential Palace, Darulaman, Afghanistan', 2002. Copyright Simon Norfolk.

p.130. Martin Parr, 'Bonchurch' Taken from the 'Think of England' Series, 1995-1999. Copyright Martin Parr/Magnum Photos.

p.132. Man Ray, 'Larmes' (Tears), 1932-33. Copyright Man Ray Trust ARS-ADAGP. Courtesy of The J. Paul Getty Museum, Los Angeles.

p.133. George Rodger, 'Korongo Nuba Wrestling Match, Kordofan, Southern Sudan', 1949. Copyright George Rodger/Magnum Photos.

p.137. Auguste Sander, 'Beggar', 1930. Copyright Die Photographische Sammlung/SK Stiftung Kultur - August Sander Archiv, Köln/VG Bild-Kunst, Bonn and DACS, London, 2006.

p.138. Stephen Shore, 'Horseshoe Bend Motel, Lovell, Wyoming, July 16, 1973', 1973. Courtesy of 303 Gallery, New York.

p.140. Frederick Sommer, 'Cut Paper', 1977. Copyright Frederick & Frances Sommer Foundation.

p.141. Chris Steele-Perkins, 'Playing Bushkashi', 1995. Copyright Chris Steele-Perkins/Magnum Photos.

p.142. Alfred Stieglitz, 'Spring Showers', 1911. Copyright 2005 The Georgia O'Keeffe Foundation/Artists Rights Society (ARS), New York. Courtesy of Lee Gallery.

p.143. Joseph Szabo, 'Priscilla', 1969. Copyright Joseph Szabo. Courtesy of Gitterman Gallery

p.144. William Henry Fox Talbot, 'Study of Lace', 1844. Courtesy of Paula and Robert Hershkowitz.

p.145. Captain Linnaeus Tripe, 'Rangoon. View near the Lake', 1855. Courtesy of Paula and Robert Hershkowitz.

p.147. Weegee (Arthur Fellig), 'Cop Killer', 1941. Copyright Weegee (Arthur Fellig)/International Centre of Photography/Getty Images.

p.148. William Wegman, 'Evolution of a Bottle in Space V', 1999. Copyright William Wegman.

p.150. Bob Willoughby, 'Dustin Hoffman & Ann Bancroft – *The Graduate*', 1967. Copyright Bob Willoughby.

p.151. Garry Winogrand, 'White Sands National Monument, New Mexico', 1964. Copyright The Estate of Garry Winogrand. Courtesy of Fraenkel Gallery, San Francisco.

p.153. Joel-Peter Witkin, 'Portrait of a Dwarf', 1987. Copyright Joel-Peter Witkin. Courtesy of Hasted Hunt.

p.154. Madame Yevonde, 'Persephone', Taken from 'The Goddesses' Series, 1935. Copyright Yevonde Portrait Archive.

Chapter 3
p.159. Bill Jacobson, 'Song of Sentient Beings #1617', 1995. Copyright Bill Jacobson. Courtesy of Julie Saul Gallery, New York.

p.160. Ruth Orkin, 'Man in Rain, NYC', 1952. Copyright Ruth Orkin. Courtesy of Mary Engel, Ruth Orkin Photo Archive.

p.162. W. P. Dando, 'Chimpanzee, Regent's Park Zoo, London', c.1890. Courtesy of Paula and Robert Hershkowitz.

p.165. Louis-Auguste Bisson, 'La Côte', c.1841. Courtesy of Paula and Robert Hershkowitz.

p.167. (Top) All three images Courtesy of Getty Images/Hulton Archive. Photographed by James Finlay.

p.167. (Bottom) David Parker, 'Siren XXXV', 2005. Copyright David Parker. Courtesy of Michael Hoppen Gallery.

p.169. Jillian Edelstein, 'Mrs Msweli', 1997. Copyright Jillian Edelstein.

p.170. Guy Bourdin, 'Charles Jourdan – Spring 1968', 1968. Copyright Estate of Guy Bourdin/Art + Commerce.

p.172. (Top) Joel Sternfeld, 'Looking East on 30th Street on a Monday Morning in May 2000', Taken from the 'Highline' Series, 2000. Courtesy of the Artist and Luhring Augustine, New York.

p.172. (Bottom) Joel Sternfeld, 'A View Towards the Empire State Building, November 2000', Taken from the 'Highline' Series, 2000. Courtesy of the Artist and Luhring Augustine, New York.

p.173. Joel Sternfeld, 'Looking South on a May Evening (the Starrett-Lehigh Building), May 2000', Taken from the 'Highline' Series, 2000. Courtesy of the Artist and Luhring Augustine, New York.

p.174. Julien Vallou de Villeneuve, 'Orientalist Study', c.1853. Courtesy of Paula and Robert Hershkowitz

p.175. Fernand Fonssagrives, 'Les Berlinglots', 1954-58. Copyright Fernand Fonssagrives. Courtesy of Michael Hoppen Gallery.

p.176. Dennis Stock, 'James Dean – Times Square', 1955. Copyright Dennis Stock/Magnum Photos.

p.177. Henri Le Secq, 'Têtes par Jean Goujon', 1854. Courtesy of Paula and Robert Hershkowitz.

p.179. Edward Steichen, 'Lillian Gish as Ophelia', 1936. Reprinted with permission of Joanna T. Steichen/Bequest of Edward Steichen by Direction of Joanna T. Steichen.

p.181. Robert ParkeHarrison, 'Flying Lesson', 2000. Copyright Robert and Shana ParkeHarrison.

Chapter 4
p.185. Edouard Baldus, 'Railway Tracks', c.1855. Courtesy of Paula and Robert Hershkowitz.

p.186. Image Courtesy of Howard Greenberg Gallery.

p.187. Image Courtesy of Howard Greenberg Gallery.

p.188. Image Courtesy of Michael Hoppen Gallery.

p.191. Images Courtesy of Michael Hoppen Gallery.

p.192. Emmanuel Nguyen Ngoc, 'Paris Photo 2005 Carrousel du Louvre, Paris', 2005. Copyright Emmanuel Nguyen Ngoc

p.194. Reverse of photograph by Robert Doisneau. Courtesy of Getty Images/Hulton Archive. Photographed by James Finlay.

p.195. Alvin Langdon Coburn, 'Auguste Rodin'. Courtesy of Getty Images/Hulton Archive.

p.196. Anon, 'Maharaja of Mysore'. Courtesy of Getty Images/Hulton Archive. Photographed by James Finlay

p.197. Thurston Hopkins 'Reverend Reindorp', 1954. Courtesy of Getty Images/Hulton Archive. Photographed by James Finlay

p.198–211. Courtesy of Getty Images/Hulton Archive. Photographed by James Finlay.

Chapter 5
p.215. Neeta Madahar, 'Sustenance 114', 2003. Copyright Neeta Madahar.

p.217. Martina Mullaney, 'Untitled', Taken from the 'Turn-In' Series, 2000. Copyright Martina Mullaney. Courtesy of Yossi Milo Gallery, New York.

p.218. Yang Fudong, 'Seven Intellectuals in Bamboo Forest II, Nr. 2', 2004. Copyright Yang Fudong. Courtesy of ShanghART Gallery, Shanghai.

p.220–21. Kevin Griffin, Images Taken from the 'Wave Studies' Series. Copyright Kevin Griffin. Courtesy of The Photographers' Gallery.

p.222. Martin Cole, 'Grid A', Taken from the 'Hillsides' Series, 2004. Copyright Martin Cole. Courtesy of The Photographers' Gallery.

p.223. (Top), Angus Boulton, Images Taken from the 'Richtung Berlin' Series, 1998–99. Copyright Angus Boulton. Courtesy of The Photographers' Gallery.

p.223. (Bottom), Angus Boulton, Images Taken from the 'Forty One Gymnasia' Series, 1998–Present. Copyright Angus Boulton. Courtesy of The Photographers' Gallery.

p.224. Mischa Haller, Images Taken from the 'On Bute' Series, 2004. Copyright Mischa Haller. Courtesy of The Photographers' Gallery.

p.225. (Middle), Stephen Vaughan, Images Taken from the 'Opened Landscape' Series, 2003. Copyright Stephen Vaughan. Courtesy of The Photographers' Gallery.

p.225. (Bottom), Stephen Vaughan, Images Taken from the 'Ultima Thule' Series, 2003. Copyright Stephen Vaughan. Courtesy of The Photographers' Gallery.

p.227. David Heath, 'Vengeful Sister, Chicago', 1956. Copyright David Heath. Courtesy of Howard Greenberg Gallery, New York.

p.229. Consuelo Kanaga, 'Young Girl in Profile', Taken from the 'Tennessee' Series, 1948. Copyright Brooklyn Museum. 82.65.11. Gift of Wallace B. Putnam from the Estate of Consuelo Kanaga. Courtesy of Howard Greenberg Gallery.

Index

Acknowledgements

This book is a collaboration, and one that would not have been possible without contributions from, and the support of, a number of individuals.

In addition to enormous gratitude for all those individuals, galleries and organisations that kindly provided images for inclusion in the book (credited on pages 246–249), special thanks are due to the following individuals for their insight, advice and sheer hard work.

Jocelyn Bain Hogg
Matthew Barnett
Charlotte Bourne
Lelia Buckjune
Matthew Butson
John Buckle
James Finlay
Tom Gitterman
Howard Greenberg
Lenny Hanson
Sara Harper
Claire Hoddinot
Michael Hoppen
David Low
Renee Last
Fiona McDonald
Sarah McDonald
Brian Morris
James Noble
Karina and Ian Noblett
Richard Raper
Brett Rogers
Elizabeth Smith
Parker Stephenson
Kate Suiter
Graham Taylor
Caroline Walmsley